A journey of a thousand li starts
with one's step.

—Laozi

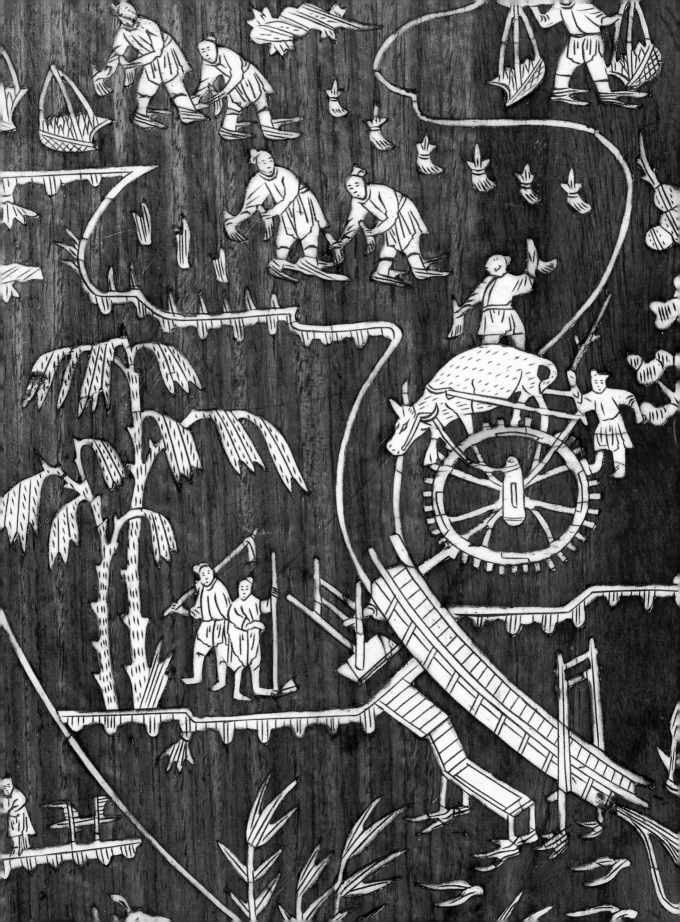

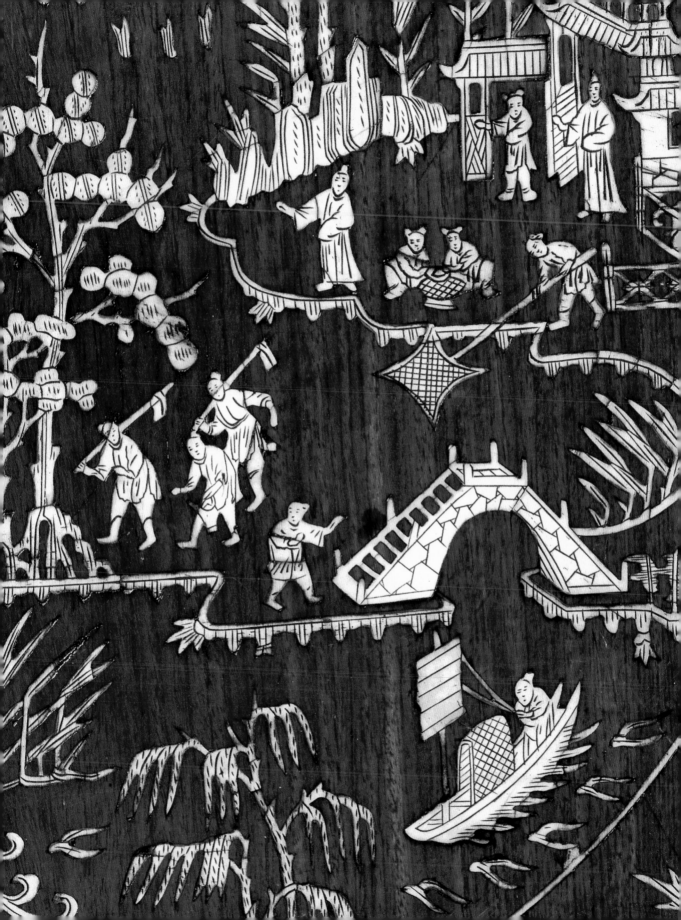

年鳥語報平

月

Captions by José Frèches

Text by Anne Loussouarn,
Catherine Zittoun, Zao Wou-ki, Dai Sijie,
Jean Leclerc du Sablon, and José Frèches

CHINA

Yann Layma

Abrams, New York

AN INVITATION TO VOYAGE

When China suddenly opened its borders to the world in 1979 by granting the first individual travel visas, I experienced something of an epiphany, and the revelation of a future vocation—the manifest destiny to open myself to the Other, over there, and to immerse myself willingly, body and soul, in the immensity of that great center of human culture, that quarter of humanity. At sixteen I resolved to live in a different way, to dedicate my life to the naive attempt to gain the ability to draw, eventually, on some far-off day, this portrait of the Giant. A carefree teenager, my resources were limited to a strong ambition to attain my improbable goal, my youthful outlook, my emotions, and especially my ignorance. The challenges I faced were loneliness, fear, and the difficulties of a world that was then so closed, in which everything was unknown to me.

Twenty-five years later I have nothing but good memories and no regrets. I could never have imagined that this youthful decision could take me so far, beyond my own life, after so many trips to the four corners of the "Middle Empire," discovering in the end the love of another culture and merging slowly with the landscape in a sort of hybridization. I have always been avid for books filled with images in color in order to learn without analysis. I have relied upon my own experience, often too sensitive to the ups and downs of life, hesitant, fragile, keeping my distance from reports written by Westerners and the Chinese, so that the impressions I experienced on the spot could live freely, and fill me with wonder, teaching me their language and another way of thinking, and sharing the fascinating ferment of the tremendous changes in contemporary China, far from the news and photographic fashions. I have trusted to time, to work, and to travel, in order to see over and over again, to discover even more, while pushing my camera's shutter release as often as possible.

Through the years I have learned to love China for a billion and a half good reasons. I have learned to love learning about, observing, and admiring this great culture, more alive now than ever. I have never felt threatened there, neither in my person nor in my possessions. I caught no diseases there. The road has been good, and the wellsprings many. I have been thrilled to discover so often a good-natured ambience, so characteristic, so welcoming, smiling, cheerful, and always ready to share the good feeling of a mutual discovery in a respect for other cultures. My passion for the discovery of this Chinese world has remained intact. It has profoundly transformed me, moving my heart deeply, revealing within me so many unsuspected horizons, bearing another name: Yan Lei, "Thunderbolts of the Warrior of the Gates of Hell."

I have learned that if photography means "to write with light" in the West, in China it means "to capture the shadows, or make the flash of light appear and seek resemblances." I must have spoiled some hundreds of thousands of photographs in order to gather together, with my close friends, these structured moments, which reveal the best of this marvelous journey of initiation, this dream of youth, this visual quest in that country where so often truth and beauty are joined tenderly together. This selection of images today brings me a great pleasure, that of being able to offer you the fruit of my passion, a portrait of the eternal Dragon, a profound emotion that continues to guide my dreams. Thus I have returned to wish you a pleasant journey.

—Yann Layma

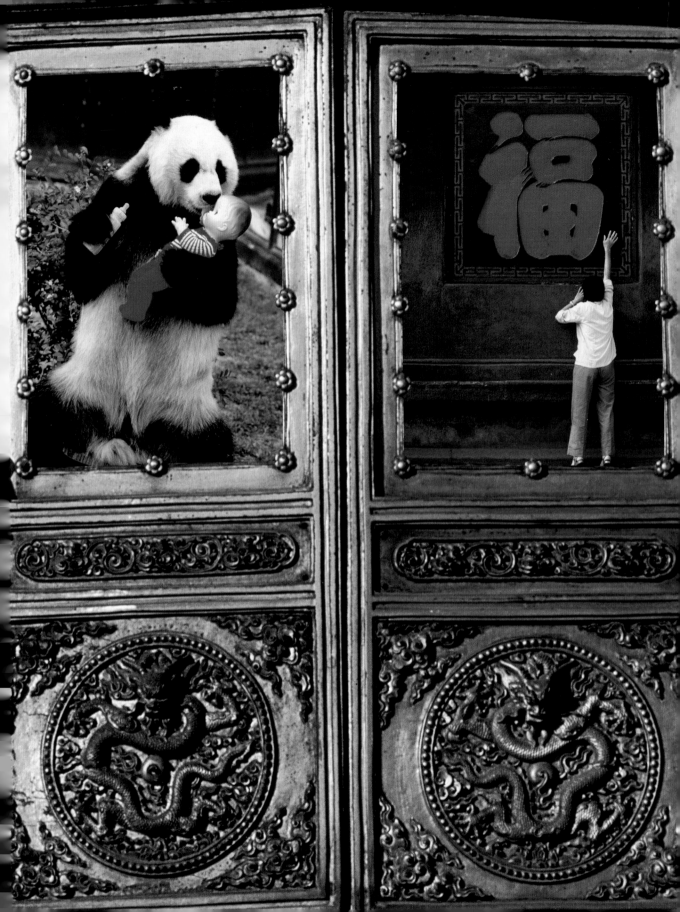

A TIGER, BUTTERFLIES, AND THE DRAGON

Traveling relentlessly with intense commitment. For Yann Layma, travel is necessary to life itself. Photography is his instrument, his emotional catalyst, the magic wand that captures junks in mid-flight and blazing rice paddies.

How did this young Frenchman meet China head-on at the end of the 1970s? The voyage began with a schoolboy's path, a butterfly net in his hand. For eight years, every weekend, Yann traveled throughout France with Paul Berger, a priest by vocation and an ardent entomologist. He taught Yann the "subtle hunt" for nature's secrets, patience, and a passion for observation and learning. In 1979 Yann collected thousands of superb exotic specimens in the jungles of Mexico but these were confiscated by an American customs agent. His passion was brutally extinguished. He renounced these hunts for color on the wing. But the powers of observation awakened in the sixteen-year-old entomologist would mark the future photographer: a stubborn patience to keep a low profile, the quest for instants of beauty as furtive as the beating of wings, an eye for the sudden light that reanimates the dance of the dragonfly. For Yann, taking a photograph is like catching a spot of color in flight, a spark of light, a look, an instant of surreptitious truth.

Nineteen seventy-nine was also the year the first issue of *GEO* magazine appeared. Everything suddenly fell into place: a passion for travel, images, and observation. After having dreamed as a child of the world with the help of a large globe in his playroom, he decided that photography will be his new, inoffensive undertaking. At that time, the Chinese frontier, closed for forty years, was beginning to open slightly, and the first individual visas began to dribble out. Deng Xiaoping, "the Little Helmsman," had begun the economic reforms that would raise the country out of its general poverty over the course of the next twenty years. In southern China special economic zones were created to experiment with an embryonic market economy. Decollectivization revolutionized the lives of the peasants, who now could manage the land themselves. The first free markets appeared: The country had begun a metamorphosis whose pace would only accelerate.

In the land of Mao, Westerners knew only the propaganda of the Cultural Revolution. The notorious Band of Four, led by Jiang Qing, Mao's wife, had been arrested only three years previously. Yann had not been "ML"—Marxist-Leninist in revolutionary jargon—nor a Maoist. He hadn't seen Jean-Luc Godard's *La Chinoise*, or even opened the *Little Red Book*. But China suddenly attracted him. It was a complete unknown to be discovered on a wild bet: He wanted to become a specialist, to dedicate his life to recording, without political preconceptions, the portrait of this enormous country. The country makes you dream or frightens you, conjures up an imagery that is often far removed from reality. "From the Western point of view, China is quite simply the other pole of human experience," as the sinologist Simon Leys put it.

The country had not yet revealed to the eyes of foreign photographers its rice paddies tracing the contours of mountains, its spartan cities, its milky mists, its age-old treasures. The Westerner is suspect, his curiosity upsetting. As for the photographer, he must learn how to behave when confronting this different world. To make contact, it's better to forget clichés and certainties and to accept your own ignorance and tackle the Confucian saying: "Learning is the key to the problem."

The initiation of the future sinologist-photographer took place at the European Business School and the Institute of Oriental Languages and Civilizations, where in the very first class students begin to learn the four tones of the Mandarin language by repeating "China is very large," accompanied with expansive gestures of their hands. This was a turning point at the beginning of the 1980s, between the hippies of 1968 and the yuppies who sharpened the weapons they would use to amass their fortunes. Yann found that he was a hybrid between the two cultures. The long-haired, bearded hippie with worn-out sneakers and an Indian tunic clashed with the business school. This extra training would enable him to live his passion to the full.

A road is a friend, a wall is an enemy.
Popular Proverb

November 1982, Taiwan

I had dreamed of it, and now the world of China is here. I am excited to see the first blue glimmers of the Taiwanese port of Chi-lung emerge in front of my eyes. After traveling for forty-eight hours on the ferry from Japan, where I had just finished my first magazine pieces, my impatience grows. It is a black night, but the sultry heat of the air and the cursing in Chinese already spark my imagination. As I set foot on the ground, I have a feeling that my life is changing forever. These great turns of fate make me a little bit dizzy. Like most students of Oriental languages, I prefer to enter into the world of China through this island rather than the Chinese mainland. The conditions of student housing and the weight of politics in the People's Republic are terrifying.

Following the customary ritual, Little Eagle, my landlord, solemnly gives me a Chinese name: Yan Lei. He is inspired by the name of the warrior who guards the gates of hell, Yan Louwang. "Lei" means thunder or lightning in Chinese. It's as though he called me "Thunderbolts of the Warrior of the Gates of Hell" in English. A teasing, bantering name that always makes my Chinese friends laugh.

I was lucky to discover the Taipei Museum: five millennia of treasures buried in a museum-bunker beneath a mountain. Paintings from every dynasty, sculptures, sumptuous jades, porcelain, lacquer, bronze, Imperial miniatures, which for centuries were reserved exclusively for the "Son of Heaven" in the Forbidden City and the nobles in their provincial palaces. Seized during the turmoil of history during the 1930s and 1940s, these fragile marvels were stolen by Chiang Kai-shek and tossed around for more than two decades at the mercy of the Nationalist Party's military offensives and retreats. The richness of this museum is such that it would take twelve years to exhibit each

of the collections for three months! Every weekend, I spend entire days wandering in contemplation of the quintessence of Chinese art, and spend hours, tears in my eyes, in a darkened room dedicated to a single painting from the beginning of the Ming dynasty. The painting, entitled Listening to the Wind in the Pines, *depicts a sage in meditation. Each painting is a poem that invites me into another cultural dimension.*

As I wander through the city, I love to explore the serenity of the parks in the early morning, where each person seems to take flight toward an interior peace as they engage in their favorite exercises. The performances of the Bejing Opera also punctuate my daily life. This highly formalized art plunges the spectator into a world of legends, sublime heroes, weeping maidens, calculating old crones, clowns, or fools dwelling in the sweet madness of wisdom. Each crash of the gong leads me a little deeper into the certainty that my discovery of China must finally take me to the Continent.

Taiwan is also rain, rain, and more rain. A concert of raindrops: from the whisper of the drizzle, to the crashing of storms, to the furious roaring of the typhoons. I am dissolving in the ambient humidity, my spirits at half-mast, my camera in the cupboard. A year of rain, worthless photographs. To pay for my studies, I teach English and Spanish. On the way to Hong Kong, I spend hours on the hillsides at the customs post at Lowu peering through the Bamboo Curtain. I am longing to plunge into the immensity of China on a scooter. The country fascinates me, has become an obsession. While waiting, I can only observe from afar a little fishing village of 20,000 inhabitants, Shenzhen, bristling with red flags and cranes. Twenty years later, the village would become an untamed megalopolis of five million inhabitants. After nine months of incessant rain, I decided to leave Taiwan when I learned that the rainy season was about to begin. I was ready to set off for Communist lands.

1984, Year of the Wood Rat. The Communist Party officially adopts the ideologically acrobatic term "socialist market economy." For Yann, the nudge of destiny came from the French presidential palace. Two years were spent far from Beijing, under the wainscoting of the Elysée Palace. François Mitterand had finally agreed to the photographer's project: to document the president's day-to-day life for a year. Yann gets advice from the greats—Marc Riboud, Raymond Depardon, Yann Arthus-Bertrand, Raghubir Singh—on the subject of composition, lighting, movement, the mood of his photos, which will reveal the palace behind the scenes: from the atomic-bomb shelter to the procedures for firing nuclear weapons, from the attics to the private apartments, including the table service. The story is a first: twenty pages in *Paris Match*, German and French *GEO*, the *Sunday Times*. During this time China pursued its inexorable metamorphosis. In 1985, Deng Xiaoping was named "Man of the Year" by *Time* magazine.

The first days Yann spent that year in Guangzhou and Beijing were times of intense emotion. He learned to take his time. To lose himself on a bicycle in the snowy lanes, to disappear in the morning mists in the parks, to observe the slow, full movements of the practitioners of Tai Chi, and the poetry of the elderly as they took their caged birds for a walk; to eat mutton kebabs while stamping with

the cold. The young photographer stayed on the eighteenth floor of the Beijing Hotel, with a view of the Forbidden City and Tiananmen Square. Chance granted him a prestigious neighbor: Joris Ivens, the famous Dutch documentary filmmaker. At the age of almost ninety, the mythical director was shooting his last film, *A Tale of the Wind*, with his wife, Marceline Loridan. The film is a poetic quest that takes him to the Gobi Desert in search of a legendary wind, which sweeps away history and its secrets. He had filmed the century's Communist turmoil with lyricism and partisan passion: In China he documented the struggle against the Japanese in *The Four Hundred Million*, began the Long March with Mao Tse-tung, into whose service he put his camera, and filmed a portrait of the Cultural Revolution, called *How Yukong Moves the Mountains*. For Yann, this meeting in the corridors of the Beijing Hotel was magical. The winds of history blew across his face with the passing of this splendid old man. He showed Ivens his photographs of Beijing, awaiting his verdict like a benediction. "One can tell that you love the Chinese, that you know how to observe, and that you have faith in time," Joris Ivens commented.

Next to the hotel, the Street of the Palace Well dares to open its first private stores. The photographer's eye scans the crowd that streams into the street, and captures a fleeting gesture, an instant, a moment of time, all the little sparks that make the anonymous figure, drowned in the masses, an individual. He refines his technique, a furtive and slow dance like Tai Chi, to make his subjects forget him and quietly captures fleeting images and the moment's mood without disturbing it. He melts into the flow, tries to remain unnoticed and quasi-invisible, to "look like an idiot," as he says. His tender gaze fixes the amused benevolence of an old man; the cheeks, reddened by the cold, of a little girl in Beijing frozen with shy curiosity about this foreigner. The curiosity captured in the faces from this period allow you to imagine the thousand stories about this "long-nose," suddenly encountered in the middle of the well-defined course of everyday life.

In a new place, raise your eyebrows,
but bring your eyes with you.
Popular Proverb

Guangzhou/Beijing, winter 1985
My first contact with the People's Republic left me speechless. In Guangzhou, the very milky gray light flows fully formed in a coating of uniformity, without contrast or color. A spectrum that I still don't know how to approach. There is a storm in my head. I don't know how to act, what attitude to adopt, but the easygoing atmosphere is seductive, the surprising mixture of sloppy relaxation and formal rigor intrigues and surprises me. I understand that it will take time to get beyond surface appearances, that the Chinese do not reveal their secrets to the first passerby. You have to earn them. For my first stories, I investigate the emotional signs of a country discovering a desire for change within itself: in Guangzhou they now devour every novelty with the intensity of the new convert: the first roller-skating rinks, romantic meccas, the first private stores, the first free markets. The curious populace lines up dressed in Mao jackets to visit the exhibition hall of the White Swan Hotel, fasci-

nated by the grandiloquent splendor of papier-mâché mountains, waterfalls hung with red paper lanterns, and marble floors that make it look like the wedding hall for the great leader. A few daring souls dress up as if they were from Hong Kong to sneak through security. And it works! The guards are too afraid of making a mistake to intervene.

In Beijing, the gray austerity takes hold of me like frigid water. The wind, dry and crackling, freezes life's little asperities, the smell of charcoal floats in the air. But the city has an outdated charm that clothes the spartan concrete with a certain poetry, the ballet of bicycles on the carless avenues, and the intimate life of old-fashioned lanes. I like to spend entire days in the Beijing train station. For me, this building, halfway between a pagoda and a Stalinist ocean liner, is the center of the Chinese world: Peasants arrive from the distant countryside, soldiers leave for home, city dwellers go to visit their families at the other end of the country. I also discover an unexpected China: the nocturnal courtship of homosexuals under the purple walls of the Forbidden City, the underground parties where the young try their hand at disco dancing, the first Chinese stock exchange in the basement of a gymnasium.

I'm delighted to be able to tame the subtleties or intensity of the Beijing light: these morning mists pierced by a timid orange sun, this milky white that makes the world look like an engraving, the dirty yellows of the springtime sandstorms blowing from the Gobi Desert, the deep blues of the sky as winter approaches, the famous golden hour of the magical morning and evening light that embellishes life with a warm contrast.

My roommate teaches me the absurdities of the system; I learn that it is more efficient to get a yogurt from the floor waiters by disconnecting the microphone with which our room is bugged, than to order it on the telephone.

My meeting with Wang Miao will be a turning point for me. A passionate colorist, she is recognized as the greatest Chinese photographer. Her photographs are published in GEO but she doesn't have access to foreign publications. Introduced by the French ambassador, she quickly becomes my big sister. She invites me to spend New Year's with her family. Following tradition, she lives with her father-in-law, the minister of agriculture. I discover that her studio is nothing but a tiny light-table hidden under the stairway. So much talent without wherewithal! Wang Miao wants to know everything about Western photography, how photographers live. She laughs at me, this very young man who wants to create a great portrait of China. We understand very quickly that we have an enormous amount to learn from each other. Faced with a cruel lack of access to foreign visual culture, we decide to establish a library of photography books at the Association of Chinese Photographers. I manage to collect more than a ton of books and magazines in France, and realize later on, as I crisscross China, that this gesture will win me an enormous number of friends over the next twenty years. Wang Miao shows me her favorite places in Beijing. Each of us observes the other, playing with our cameras, with the way we approach our art, with the way we see the multicolored beauties of daily life. This new year is the Year of the Tiger, my astrological sign. Tradition holds that these twelve months will be "the year of all my destiny."

After many expeditions, Yann decided to assemble a group of talented artists to create a subjective portrait of China. Their qualifications: the daring of youth, an offbeat humor, an unbridled creativity, and the casual attitude of traveling artists in the land of Communist rationalism. In April 1986, Yann and the group Kaltex (Simon Pradinas, Willy Pierre, and Soizic Arsal) get under way on a new three-month trip. They want to inaugurate a new kind of journalism, in which human experience will be painted, filmed, and photographed. Without assumptions or preconceived ideas, the collaborators leave from the Beijing airport one April morning, equipped with boxes of brushes, rolls of paper, cameras, and a fourteen-month-old baby, Alula, in a sling. China was not yet completely open to travelers; the few open cities are like the taste of things to come within the forbidden immensity.

Their power comes from the subjectivity demanded by the Western point of view. Kaltex accepts their position of being observers of situations created by their very presence. Their magic lies in accepting themselves as a vision from another world, astounding hairy barbarians who appear at the bend in a road. In China, people know only the socialist realism of propaganda, and it is difficult to accept that reality can also be there, painted live on the street corner, in this rush of frantic colors, in these daring portraits and disjointed photographs. In 1986, for a Guizhou peasant woman, a painting of her everyday life could not be art. Art? Art is a heroic spirit: heroes of the Revolution with manly jaws, armadas of ruddy tractors harvesting a rich blanket of wheat, smiling soldiers hurling grenades as they assume the poses of prima ballerinas. For the Chinese they meet, it is difficult to accept this riot of bright and sharply contrasting colors, these natural and unheroic poses. But some are drawn into the game, and wink back in the mirror of their surprise. The adventure led to a six-month exhibition in the Musée d'art moderne in Paris, a book, and movies. Yann learns to trust his daring, to continuously seek an original framing, a surprising light.

The instant provided by chance is better than the chosen moment.

We left for a three-month adventure. Simon began to paint as soon as we reached the airport terminal. He understood very quickly that you can't wait for things to happen, so he got out his pencil, sketched forms that he would go over in his hotel room. The spontaneity of the four barbarians unleashed a crazy curiosity among the passersby. The onlookers were astounded to see a foreigner take up so naturally an activity that was so unexpected. Here you don't sit on the ground with a brush in your hand to paint the daily grind. People surround us by the dozen, astonished, mistrustful, and interested in the image we create of China before their very eyes. It was disconcerting for them to discover a vision so different from their own in foreigners visiting their country.

The experience unfolds every day, but the situation will take an unexpected turn in the Beijing train station. That day we arrived from Xi'an. In the halls there strolled the usual crowd found in Chinese stations: peasants in khaki military jackets slumped on construction-site tarpaulins, plainclothes cops with crew cuts, city dwellers waiting to

leave, babies with split pants, the twisted and the naive. Soizic, Willy, and Simon are making a sketch for a painting. All these people see themselves on the canvas, crowded into a green-and-red station, an anonymous and tired crowd caught in a moment of waiting and abandon. When they unroll their painting in the station for me to photograph, the situation suddenly goes wrong for the first time. The onlookers interpret our actions as anti-Chinese, and the policemen take me in for questioning to a police station where I spend six Kafkaesque hours. I make them uncomfortable by taking the initiative in my self-criticism… standing up on the table! I explain that "I am a dunce in China to study the great Chinese culture, but I don't catch on very quickly." My confession mollifies them. I censor the painting myself. The black spots will be a part of its history. The cop performing Tai Chi in the middle of the painting is blotted out under a cloud of India ink. Scribbled out as well, the unfinished head lying on the station's floor. The painting will be called The Beijing Train Station in the Ink of Self-Criticism. Fifteen years later the censored figures will reappear slowly through the India ink.

Anshun, in Guizhou, had just been opened to foreigners. We were filled with wonder. An inextricable labyrinth of alleyways bordered with old houses of wood, the city lulled in another time. Different ethnic groups mixed together on market days in a riot of colors, silver jewelry, red and yellow umbrellas, a million miles from the shades of gray that pervade the big cities. We learn to recognize the Yao, with their black clothing embroidered with red; the Miao, who are crazy about the color blue and geometric designs, jewels, and wool turbans; and the Bouyei, with their batiks. For the first time, I experience the ethnic diversity of the mountains of southern China. To these villagers from distant valleys, the presence of Europeans is disconcerting. The looks of the passersby are at first strange. For them, our presence is impossible, unthinkable, astounding. They stare at us, their eyes pierce us like so many unspoken questions. Then a thought, a smile, or a gesture suddenly sparks fellow feeling. You just have to take your time, avoid forcing a rhythm that obeys its own constraints. These faces inspire a series of photos. Soizic, Willy, and Simon prepare a large multicolored canvas to serve as a backdrop, and with a Polaroid I snap portraits, which we give to the villagers. They adapt to the game with an amused surprise, standing in front of the canvas to please the foreigners. A peasant in pigtails poses with her bicycle like an Amazon, a Miao woman holds her baby with a smile that is both proud and sweet. Of his own accord, a young man suddenly holds up a ten Yuan note, as a declaration and an appeal to the world of his dreams. The mirror shatters. The session and the gifts are so well received that the next day two hundred people line up in front of the inn, waving their right hands. The gesture of drying a Polaroid!

Our luck does not last. The police confine us to the hotel for having broken the rules governing movement in the Forbidden Zone. The area around the city is not yet open. They photograph us like prisoners. Head-on, right profile, left profile. Fingers inked to take our prints. Then the wrestling for the inevitable self-criticism begins. We refused to sign in Chinese, "The error committed was involuntary." The zones don't have signs that they're forbidden—in English! After three days of negotiation, the fine is settled at six dollars apiece.

After two days, I decide to leave to try to get a few extra photos of the lush countryside. To escape the policeman who guards my door, I climb through the window by knotting together the sheets, and stop the first scooter. My driver quite cheerfully decides to invite me to lunch with his parents. Heavy gates of iron open onto a strange fortress flanked by watchtowers. Around the camp, men dressed in brown, shackles on their legs. It is a laogai, a camp for reeducation through work. His parents are jailers! Absolute foolishness and craziness. I had secretly escaped from the hotel to stroll into a work camp and toast the friendship between peoples with jailkeepers, while praying that they don't discover my cameras.

Yann began to accept his cultural difference, his identity as a laowei, as a "good old foreigner." He learns to disarm the people by playing the role of the "crazy foreigner." Humor allows him to touch people's hearts behind their shell of prohibitions, clichés, and fears. He meets foreigners who are bound to China viscerally, for life. Adventurers with lives that sound like novels. One of them is Andy Friend, son of an American Communist who sought political asylum in China. The only little blond-haired, blue-eyed student at the Chinese school during the Cultural Revolution, he plays on the absurd like a virtuoso to protect himself from the impossibility of integrating into Chinese society. No door is closed to him. He is the man to convince a military vehicle to drive them to a clandestine gold mine, a state secret in the closed zone. He has a gift the director Bernardo Bertolucci will recognize when he hires him as a diplomat between the Chinese and American crews when he's making The Last Emperor. Steven Spielberg will follow suit. For Yann, the young American represents a mythical cultural mixture, which is in fact completely illusory. Yann learns to clown around, pass through the walls, play with absurdity, break the rules, dance in the middle of the police station during interrogations, laugh at the wrong time to break the ice. Andy also teaches Yann to appreciate China better, to feel more at ease as a foreigner. Andy is seduced by passion for photography. "Yann was intoxicated with China. His presence was like a passion, a personal rather than professional experience. He was calm, very slow, as if his qi (vital spirit) was already adjusted to that of the Chinese. He was there, then no longer there, disappearing just behind you. The click of his Leica's shutter slipped by as he did, without noise, unobtrusively," he remembers.

Yann begins to reject a life spent among foreigners, confined to deluxe hotel lobbies and diplomatic residences where the cocktails are sweet and the words so carefully measured. The pioneers gravitate outside this cocoon; they are mavericks who aren't afraid of anything. A businessman living in a university dormitory with his wife; students willing to do anything to live with the Chinese despite the prohibitions. These were the slightly mad days when a European spy swapped the plans to an airport on the coast for tons of crab, which he then turned into cash in Japan. A few Chinese artists began to frequent these foreigners, a breath of fresh air, to forget the current regime. The delegates of the neighborhood committees who stared at them disapprovingly when they came in tipsy, the neighbors who liked to spy on the people they frequented in order to denounce their "deviations," and the identity checks at building entrances

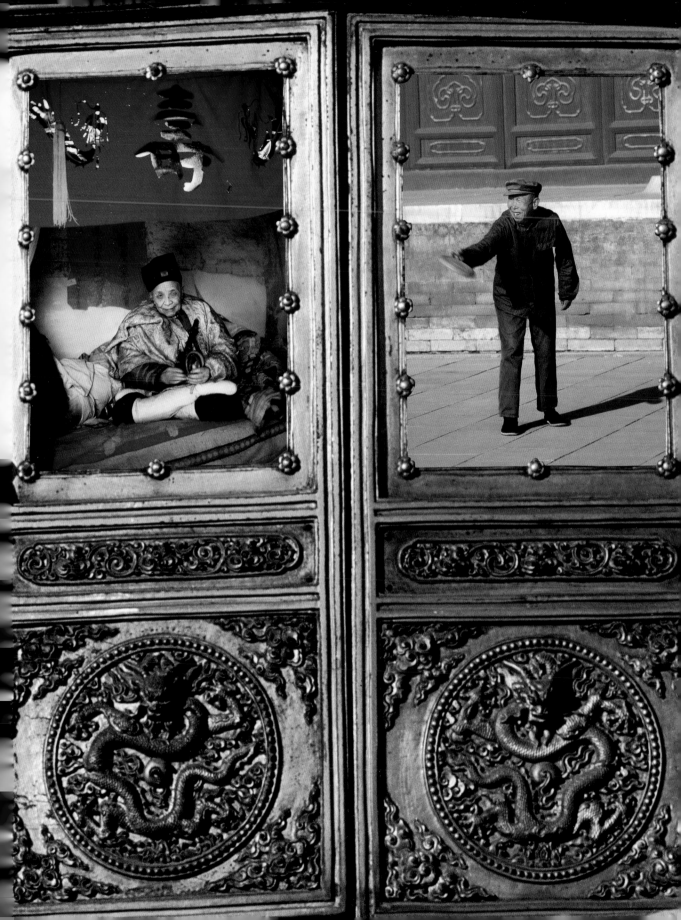

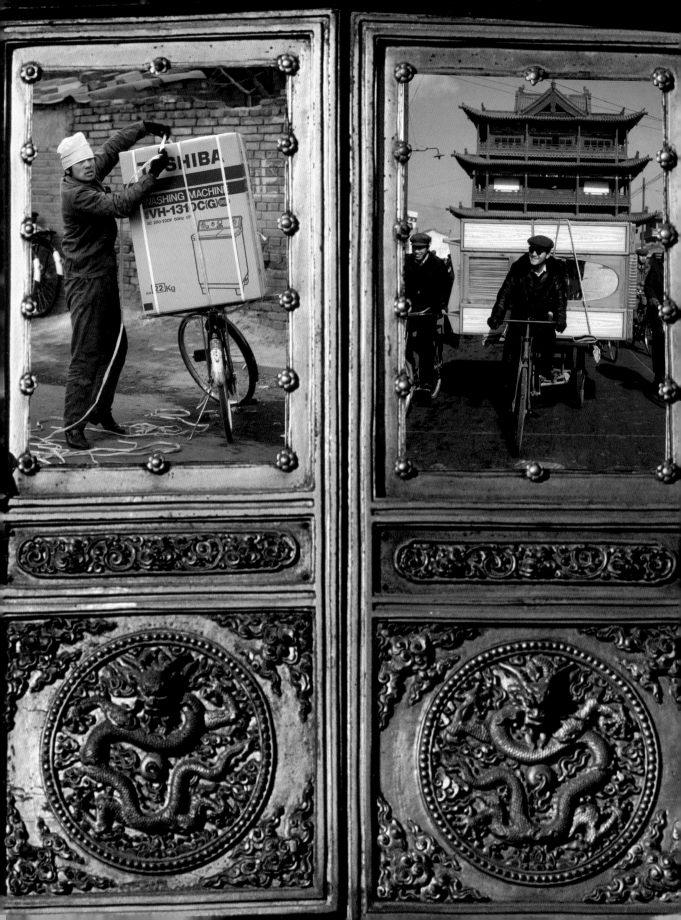

for foreigners made the atmosphere unbearable for Chinese youth who dreamed of another life. To be the friend of a foreigner is a daring identity in itself, a label, for a subversive element. An artist, by definition, marginal through pride and obligation. Rebel by survival instinct. They saw in these foreigners the gateway to freedom, creativity, perhaps emigration, and, reciprocally, became for those who were passionately interested in China an opening onto the Chinese reality.

They would all meet at secret parties, where the two factions would commune through a counterrevolutionary noise level and alcohol. There Yann met Niu Niu—"Minx." A student in Beijing, an artist on the fringes of society, rebellious, the young Sichuan woman became his princess at the other end of the world. Through her, the cause of artists also became a personal commitment and influenced his outlook. Yann was on the campus in the middle of the student demonstrations of 1986–87; he hunted for signs of the workers' defeat, the tired faces, the pollution: photos that are no longer dangerous today, but illustrate the end of an era.

It is better to light a little candle than to curse the darkness.

1989–90

I wasn't surprised by the student explosion in 1989. Two years earlier, I had clearly felt—and written—that the shudder that ran through the campus was only the first stirring of more serious events to come. I wasn't in Beijing in June when the authorities sent tanks against the students who occupied Tiananmen Square. In Paris, Niu Niu and I were in tears as we followed the events minute by minute on television and by telephone. We were also shocked by the discrepancy between the media coverage of the events, which emphasized the demand for Western-style democracy, and the spirit of this revolt, so familiar to me for several years: I had seen a need for freedom and change, and a great patriotic fervor against corruption. The repression put an end to the intellectual ferment of the preceding years.

I caught the first plane to the only possible destination, Shanghai, which was on the verge of exploding. More than a million people marched in the streets. Jiang Zemin, the mayor of the city, avoided a catastrophe. While this was happening, I decided to travel through the countryside of Sichuan, Henan, and Hubei, to learn what the peasants thought. They were angry with the well-to-do students of the big cities, who were intent on changing too fast. "Why stir up the sleeping snake, and risk losing everything we have gained?" they would ask me. The story will never be published.

This experience strengthened my desire for a new approach, more timeless; to free myself from the trend in the media that imposes an analysis through the political prism of Western-style democracy. I don't feel like a journalist. I want to take more time to learn, to travel, to go further in exploration, in the discovery and transmission of this passion of the magic of these encounters and these cultures. I felt that I finally had to get closer to the "real" world of China, a thousand miles from the trendy artists I knew. With Simon Pradinas, I left for six months in the Dong country in the south, to write a book and a magazine piece and to make a film, which would be free from current

events, where "the emperor is far away and the mountains are high." So high, in fact, that no foreigner had ever set foot there.

The Dong, an ethnic group of two million souls, whetted our hunger for adventure and knowledge. I had heard of these people, who expressed themselves in song and worshiped architecture like a god. They were shrouded in the most complete mystery; pictures and writings didn't exist. After many false starts, we found the entrance to the Dong country, a village called Sanjiang. From there an eleven-mile (eighteen-kilometer) trail leads into the mountains, which are devoid of any modern facility. There the Dong cultivate a daily life punctuated with songs, musical contests carried out between villages by teams equipped with mouth organs, in a world of barter, often without schools, cut off from the influences of the outside world by the high mountains.

In the most distant valleys, after we had hiked more than three days, the villagers ran away from us, convinced that we were ghosts. Some had never even seen a Han Chinese and had never seen money. Tian Bao, the only schoolteacher in the district, welcomed us with open arms, eager to learn more about distant places. Born of a Han father and a Dong mother, he quickly became an indispensable guide in discovering the local culture. He deciphered the Dong country for us—where nothing looks like anything in this world—on primitive maps that look like parchments of Treasure Island. My photographer's eye relished the Dong architecture, a hymn to the harmony of the elements with the spirits. On the way out of the village of Baxie, a majestic "bridge of rain and wind" crosses the river as it offers its pagoda roofs up to the heavens. The building, made of wood and tile, is built without nails or rivets, following the sacred rules of architecture. Tian Bao explained to us by the fireside that Dong is the most complicated tonal language in the world. Its fifteen tones—there are only four in Mandarin—are inaudible to our ears. The joys and sorrows of life are recounted in forty-four kinds of songs, which follow strict codes of musical rhymes. There are codified songs for politeness, for drunkenness, to practice the art of detouring on the road, for operas, for evenings of legends, lovers' encounters and separations, and songs to reconcile angry spouses.

In the 1990s, Yann witnessed the pride of a people who take back their beliefs, their culture, and their past. Traditions had been mistreated during the Cultural Revolution, which had tried to wipe the slate clean of the "Four Olds" (or "Four Old Things") and the past. In 1995 the photographer witnessed the rehabilitation of Confucianism at Qufu, the village where the sage was born. Encouraged by the complicit amusement of his Chinese friends, Yann immersed himself in the writings of this philosopher to understand the principles that had shaped Chinese society for more than 2,600 years.

Yann also set out in search of an architectural past that had often been swallowed in concrete and steel: a last wooden house clinging to a mountainside between two building sites in Chongqing, a pagoda standing next to the television tower in Beijing, the Grand Canal drowned in the milk-colored leaden sky in the middle of the month of August. The Grand Canal from Beijing to Hangzhou is one of those things in defiance of nature that the Chinese have made since the time of the dynasties. Dwarfing Panama and Suez in its

measurements (1,120 miles or 1,800 kilometers), this canal is older than they are by more than two millennia. Its extension in the seventh century required a titanic effort that ruined the Sui dynasty. Today, it starts only a couple hundred miles or a few hundred kilometers outside Beijing, to the south of the Yellow River, which has been so drained that it no longer even reaches the sea. Starting off on several wrong tracks in the Heibei countryside, the traveling companions spend more time in taxis and dust than on the barges they had dreamed about. Nonetheless, farther south the canal soon unveils its surprises: the Venetian canals of Suzhou, the lake to the west of Hangzhou—the height of romanticism and refinement in Chinese culture—and Weishan Lake, its immense surface covered with lotus flowers, where the cormorant fishers gently pick the most beautiful flowers and put the immense leaves on their heads for protection against a white-hot sun. But the mythical canal has also become a very crowded and polluted river highway. They spend whole days on barges playing mah-jongg with the crew, waiting to get through traffic jams of thousands of barges at the locks.

Throughout his reports, Yann's photographs are as attentive to the monuments testifying to a civilization that has lasted for several millennia as to the people who inhabit, use, and reinvent them every day. The gate to the Palace Temple is brought to life by the face of the monk who opens it, the giant statue of the Buddha, by the man seated at his feet. Yann's vision combines esthetics and tenderness. In the luxuriant countryside or the desert, he also sees the poverty of the villages, fatigue in movements and faces, the tattered clothing and filth, the miles of roads swallowing up bent backs carrying heavy burdens. His photographs capture, before anything else, the moments of dignity, of grace and communication, the burst of laughter unleashed by his presence, or the moments of celebration and work when everyone forgets him.

His passion for China becomes so obsessive that it is almost his undoing. Since his experience among the Dong, Yann can think only of getting back to the luxuriant sweetness south of the Yangtze River, where a sensual and generous nature replaces the dust and yellow-earth-colored landscapes of northern China. His dream suddenly takes the shape of the sculpted rice paddies that cling to the mountains of Ailao, near Vietnam, in Yunnan Province. No more hodgepodge of taxis, cranes, and department stores. Still persona non grata, Yann commits the foolish imprudence of entering illegally to photograph these new paddies.

If you don't know folly,
you can't be wise.

I had become persona non grata in China since the release of the film No Tears for Mao, *adapted from a novel published in 1988 by Niu Niu, my wife. The book describes the depravity that she supposedly experienced during the Cultural Revolution. The work became a bestseller in France and in the world; Niu Niu was on every television screen. Her rebellion is attractive, her past horrifying, her confessions moving. But the Chinese authorities thought, incorrectly, that I was the instigator of these politically embarrassing confessions. I was denied a visa. I learned much later that the supposedly tragic experience of*

my wife was in fact a tragic fiction to charm the West and myself, first and foremost. But during these years, I experienced the most beautiful, heavenly happiness. The letdown was very painful.

For five years, I had only to go through Hong Kong to get an express tourist visa. This trick let me venture to the Russian border at Xinjiang, ride with Cossack horsemen who hunted with eagles in the depths of the steppes, meet the drivers of the last steam locomotives as they tore through Manchuria in temperatures of −40˚F, report on the first paid vacations, and spend six months in the Forbidden Zone among the Dong.

Until 1992, when I was refused a visa in Hong Kong. I panicked. I had to meet up with Tao, my Chinese assistant, to make a film on the sculptors of the Yunnan mountains. I rushed to Bangkok, where I committed a monumental error: I bought a false passport. It was not without apprehension that I held out my usurped identity to the immigration authorities as I returned to Hong Kong. Who is this Stephen, the young Canadian in the passport? A backpacker who lost his papers? A criminal who juggles identities? The young customs agent enters my false name into a computer, then collapses in a heap. She punches a red button, terrified. I find myself strip-searched, naked, my belongings are gone over with a fine-tooth comb. The false passport I bought in Bangkok had belonged to a wanted drug smuggler. I managed to clear up the misunderstanding with the help of many friends and colleagues based in Hong Kong. But the error is a serious one, and I find myself in the cells of Victoria prison with "VIP" stamped in big letters in red on my file. In the lightless sub-basement, a heady stench, strange faces emerging from the sticky shadows. My cellmate, an overexcited, beefy forty-year-old, chews on his anger in volcanic spasms. This man has been indicted on some thirty charges, among them assault with a deadly weapon and murder. Afflicted with such a cell mate, I don't close an eye, rolled up in a damp, moth-eaten blanket on a concrete slab above a floor swimming with the piss of two centuries. A few days later, I am finally expelled from the territory in handcuffs, and punished with a fine of $1,700. A very mild sentence, I must admit. I am exhausted from being driven to such extremes by my passion: all these stratagems to film rice paddies! I'm not even interested in sensible journalistic subjects. The amiable Mr. Tian at the Chinese Embassy in Paris understands, pleads my case in Beijing to revise the file, and obtains the authorization necessary for my future projects. Now I have the "Open Sesame" that will let me access the new facets of the country.

Yunnan, "country south of the clouds," a region of blazing land nestled between the plateaus of Tibet and the jungles of Burma, Laos, and Vietnam. A land of poetry, simultaneously wild and sweet. The region lies along the roads of travel, commerce, and invasion. Kublai Khan, tea and spice merchants, and French missionaries have walked its roads and encountered the twenty-four ethnic groups that people its hills. The area was an independent kingdom for more than five hundred years, before being overthrown by Mongol conquerors in the middle of the thirteenth century. Yann heads toward the rice paddies of Yuangyang, near the Red River, far from traveled paths. The authorities, welcoming him with great ceremony, tell him that he is the first foreigner to visit these mountains. He has come to

seek out the sumptuous landscapes, costumes, and colors to evoke the happiness of traveling and discovery. The rice paddies here are magical, unique in the world. A real chameleon of the mineral world, these mountains covered with stacked, water-filled terraces change with the light. They make him want to tell the story of the peasants who have sculpted them with a painterly poetry for 2,500 years.

His palette of visual emotions operates through color. Always color, to respect the truth and the mood of the moment. Yann never uses black-and-white since, according to him, it elicits an emotion that is too conventional and stylized, forgetting the very essence of life. In color photography, black and white are for him "secondary elements with which to play." "Black is a friend that helps to delineate forms, white an enemy, a parasite that draws the eye away from the subject." The most beautiful photographs are often punctuated with red, the color of passion, of stimulation, but in China, first and foremost, of happiness. Green introduces more of a feeling of peace, blue is the color of the spirit. It is absolutely inconceivable to him to give up the richness of a palate that is both the mirror and the source of all the feelings that life has to offer.

Yann does not claim a particular style. He is hostile to any trace of "photographic signature," and always seeks an emotion that is more human than graphic. In this quest the camera is nothing but a tool, of the same order as a hammer for a carpenter. A tool that often reminds him of its technical limits in the milky ambience of the Chinese sky. Except in Yunnan, a region that offers luminous and intense colors, to the "south of the clouds."

Time opens the door for those who know how to wait

September 1992
Yuanyang is located 250 miles (400 kilometers) south of Kunming, the province's capital. I was welcomed with great fanfare by the local authorities, who showed their hospitality with banquets and feasts. I learned that every year many Hani villages join together with the Yi to build rice paddies for newly married couples. It is a collective ritual that takes place in the spring.

The Hani are a Tibeto-Burmese ethnic group for whom magic holds an important place. In this animist society, the shaman presides over the rituals worshiping the gods of the earth, water, and trees. He is the link between heaven and mankind. One day I am introduced to the Great Dragon, the village's wizard. I explain my film project to him, but he doesn't understand the Hani translator. He has never seen a television, and is at first suspicious about the intentions of the first foreigner he has ever met. We later become good friends, each learning from the other. Our two curious minds join together. We soon begin to spend our meals talking about our families, our respective cultures. He complains about the harshness of day-to-day life.

Each day of filming gives the crew and the Hani the pleasure of working together in harmony. Great Dragon adapted to technical limitations, although they were completely beyond him. As soon as the sun came up the old shaman mounted his buffalo, catching the film crew unawares. Six months later, I returned to screen the film for the villagers. A showing set up in Great Dragon's house lasted three days and

three nights. Several hundred people filed through to see this film that would be broadcast throughout the world. Some spectators perched on the charcoal stove and danced from one foot to another in order not to burn their feet. It was the first time that any of them had ever seen a televised image. They found it to be a form of narration very different from their oral tradition. Seeing someone they knew made them laugh. This first contact preceded the arrival of television in the villages: the dianshi or "electric window," would soon open a view onto the rest of the world. A little peephole that would let them glimpse the surprising and mysterious life of the big cities, where daily life, as described by propaganda, appeared so much easier. Some of them let themselves be seduced by the tube's illusions, and left their mountains to waste their health on building sites or in the factories along the coast.

This meeting with Grand Dragon became the most moving memory of my years in China. He is the heir of a long line of Hani wizards. One day the arrival of a foreigner disturbed his certitudes, which had been anchored in rock. The Hani are able to recite fifty-six generations of ancestors from memory. Only the fathers, of course. In a world so closed in upon its own rhythms, the film created an upheaval. I filmed divination using plants, animal sacrifice, invocations of the spirits at the foot of cliffs, the little house in the rice paddies where he shuts himself up for two weeks to prophesy about the coming year. His farewell speech showed that this upheaval had caused him new reflections about the world. He stood at the podium and said, "I want to thank these foreigners. In the end, we are alike in spite of appearances. We all have the same blood, the same eyes, and the same heart to reflect together and to join forces."

Ways of thinking change with a disconcerting speed. In 1992, Deng Xiaoping launched the process of economic reform during a tour in the southern part of the country. He blessed material appetites with his famous "enrich yourselves!" China experienced a sustained economic growth unequaled in the world; the average income tripled in a few years. Yann met the pioneers in business who made fortunes, built unbelievable palaces like the memories of childhood dreams; beautiful women for whom seduction no longer wears a toxic halo; young people who discover rock music and a few years later, techno and punk. Farewell to the days of baggy blue jackets and other shapeless working clothes. The Chinese discover makeup, style, and beautiful fabrics. Self-abnegation worn as a badge of revolutionary virtue is buried, once and for all. Marxist materialism fades away slowly before a new religion of the self. The cult of money, with all its excesses, becomes the grail of an entire society. In his photographs, Yann respects this materialism, which in fact reveals an enormous lust for life, after so many years of austerity and doing without. His vision does not make the flashy and garish modernism ugly. The race toward modernity takes on the look of a hymn to optimism through his photographs. He is at one with the Chinese who dream about the legends of self-made men, of peasants who become millionaires by inventing a hair lotion or a machine for making ice on the beach.

Yann spends several months crisscrossing the coast between Shenzhen and Shanghai, a coast in the midst of a real frenzy of development. This itinerary becomes the portrait of the metamorphosis of the Dragon. Nothing symbolizes this transformation better than

Wenzhou, the shoe capital of China, a coastal city in Zhejiang province. With the help of massive doses of resourcefulness, with a pinch of distrust for systems, and especially with the sweat poured out in the workshops, the inhabitants of Wenzhou have built an internationally recognized leather-craft empire. The once small and dusty town now throbs with neon. The Street of the People shamelessly exhibits its taste for luxury: furniture stores bursting with waves of pompons, purple velvet, baroque gilt, and cherubs with bulging bellies—an implausible adaptation of Louis XV style to local taste. This dynamic development has a cost: the pollution has become so terrible that hotels rent oxygen masks.

In 1997, Yann decides to move to Beijing. This step is necessary to take stock of his passion. He moves into the Inn of Friendship, an imperial residence of the Qing period hidden in a labyrinth of alleyways. In the 1930s, Chiang Kai-chek stayed there to enjoy the peacefulness of its classic gardens. Beijing becomes his base for long pilgrimages to the four corners of the country; he immerses himself in the aesthetics of the Chinese garden, travels down the Yellow River—cradle of Chinese culture—crisscrosses lanes and avenues in Shanghai, and the Tibetan area of Kham to the west of Sichuan province. The photographer looks everywhere for signs of the resurgence of various traditions. Behind the overlay of out-and-out modernism, he is convinced that we are seeing a real renaissance of traditional culture, of rites and religions; thirteen years after a first story in Wudang, he once again takes to the road for the monasteries of the holy mountain of Taoism.

Believing everything written in books would be worse than never having read a single one.
Mencius, third century BC

Wudang Mountain, 2000

Wudang is the most alive and the most magical mountain in China. It was the Emperor's private mountain; there he built a forbidden city around the Golden Pavilion, at the summit. The mountain is Taoism's place of worship, its true spiritual heart. I decided to spend two weeks scouting for locations about New Year's Eve of the year 2000. Here no one is interested in computer bugs, in parties and dances. The monks, with their hair arranged characteristically on the tops of their skulls, pray, meditate, and train in the martial arts. Wudang is the school of the "internal style," all restraint and circular movement, a force mastered. It's the art of defense, unlike Shaolin, which is the Buddhist temple of the school of attack, of the "external style," of rapidity and the spectacular. The two schools are not competitors, but love to confront each other during the annual matches. Just before my last visit, the monks of Wudang had won five fights to one against the monks of Shaolin.

At nightfall the monks join us in the refectory to drink a few beers. Normally they don't drink alcohol, but make an exception so as not to fail in the duty of hospitality at a moment that is so important to foreigners. We talk about the frenzy of change in the world. The monks think that everything is going forward too quickly, that the world has lost the path of wisdom, that the outburst of desire for consumption cannot be assimilated harmoniously by the Chinese. In their opinion,

China has lost the Way and the path of Virtue, the two fundamental principles of Taoism.

Master Zhong, recognized as the greatest master of martial arts in China, is the heir to the sacrosanct powers of Wudang. He has mastered the forty-four styles of the Taoist school. A serene power and natural refinement emanate from this thirty-eight-year-old man, difficult to photograph, since the master never demonstrates his art. Cloaked in this spiritual authority, he seems to be a thousand miles from the modernity that is seething some twenty miles from the monastery. But at the same time, he takes a malicious pleasure in filming me work with a digital camera in one hand and a cell phone in the other. Six trips to Wudang let me write the scenario for a long piece about the path of initiation and the spiritual ascension of a young student who becomes a master. Chen Long, the main character in the film, an eleven-year-old child, becomes my guide in the subtleties of the extremely demanding apprenticeship of the novitiate. The young boy from the countryside dared to dream of one day becoming a great kung fu master. First, he took the road to Wudang Mountain. Confucius said, "A journey of 10,000 miles begins with a single footstep."

"Like water, the world passes through you and for a time you borrow its colors," wrote the traveler Nicholas Bouvier in *The Way of the World*. China loaned its colors to Yann during a great human voyage. He has given a face to the unique metamorphosis of the society, passing in twenty years from a leaden austerity to effervescence and ferment rarely equaled. Through this testimony over twenty years, we see these men and women gradually take control of their own lives and their own dreams.

When I would catch a butterfly, my pride did not come from its capture but from the pleasure of opening the door to a certain understanding, a certain thought about ecology, and the happiness of an endless apprenticeship. The ultimate result of my passion for entomology was to discover a beauty that is so close to us we often forget to see it or to reap its benefits. Through these photos of China, I hope to suggest that we also need to learn to see China with our hearts. I have been lucky enough to discover this country and its inhabitants. Through the years, I realized that they were at least a billion and a half good reasons to love China. My photos also tell the story of a little boy who one day dreamed over a map of the world, and let himself be carried away by the pleasures of discovery. The road was beautiful and the journey luminous.

—Anne Loussouarn and Yann Layma

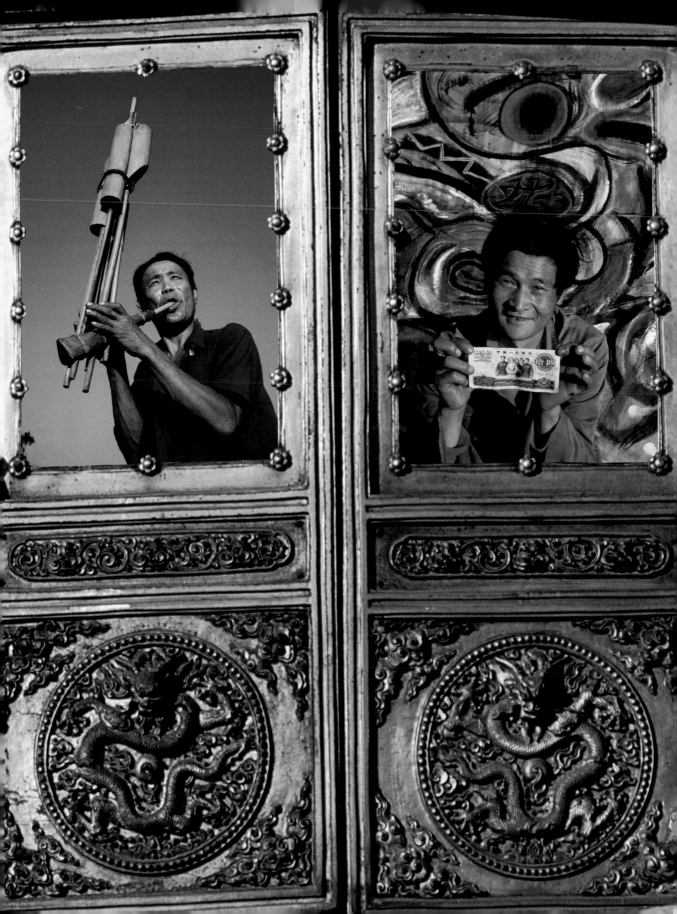

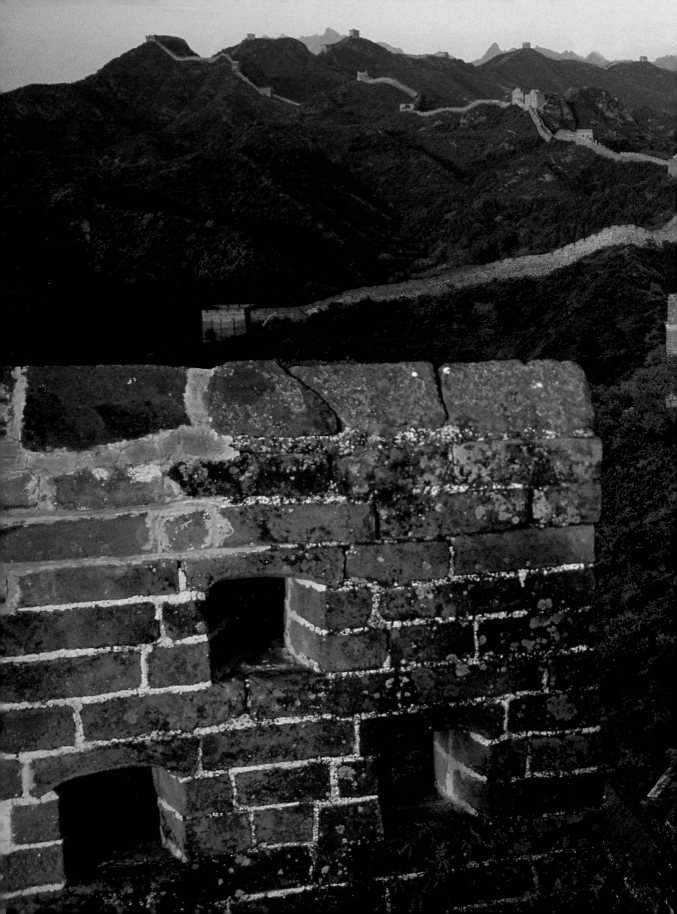

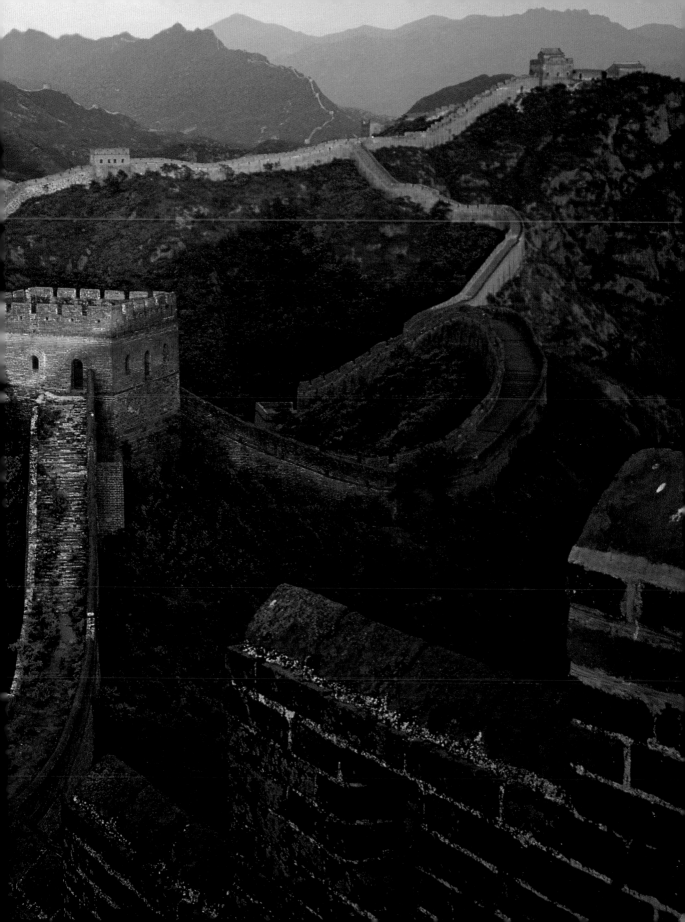

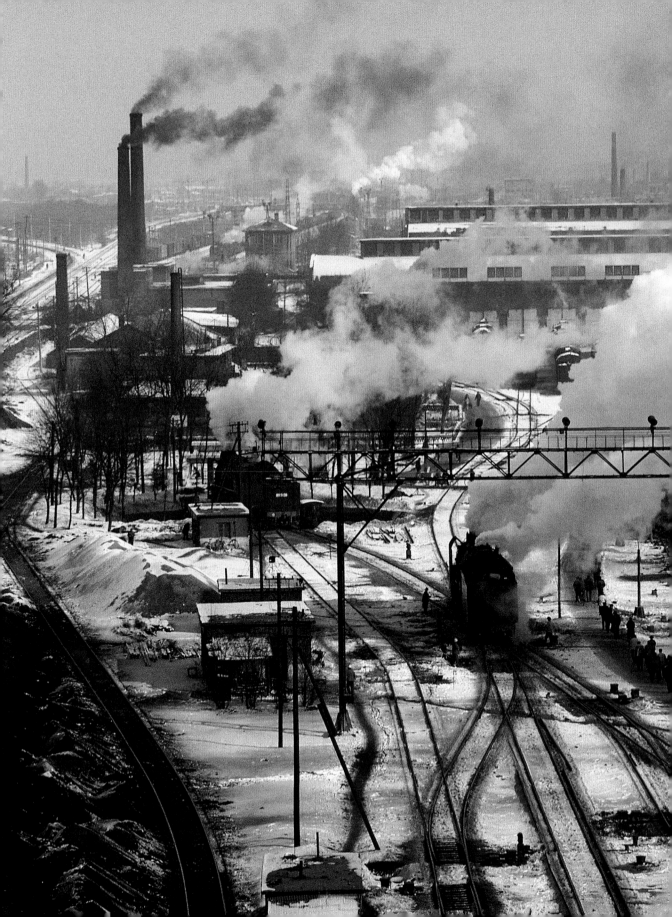

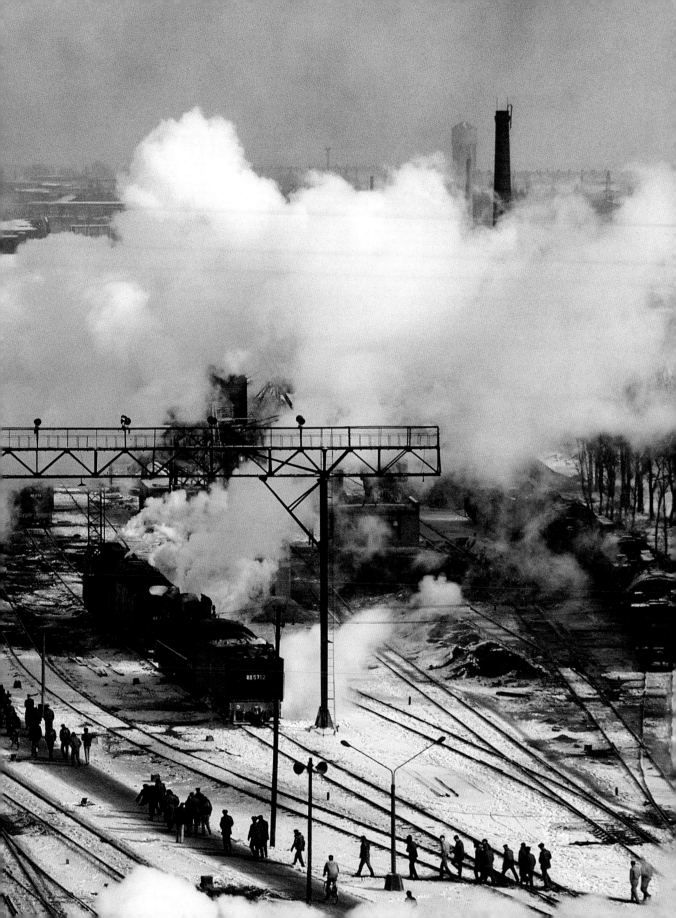

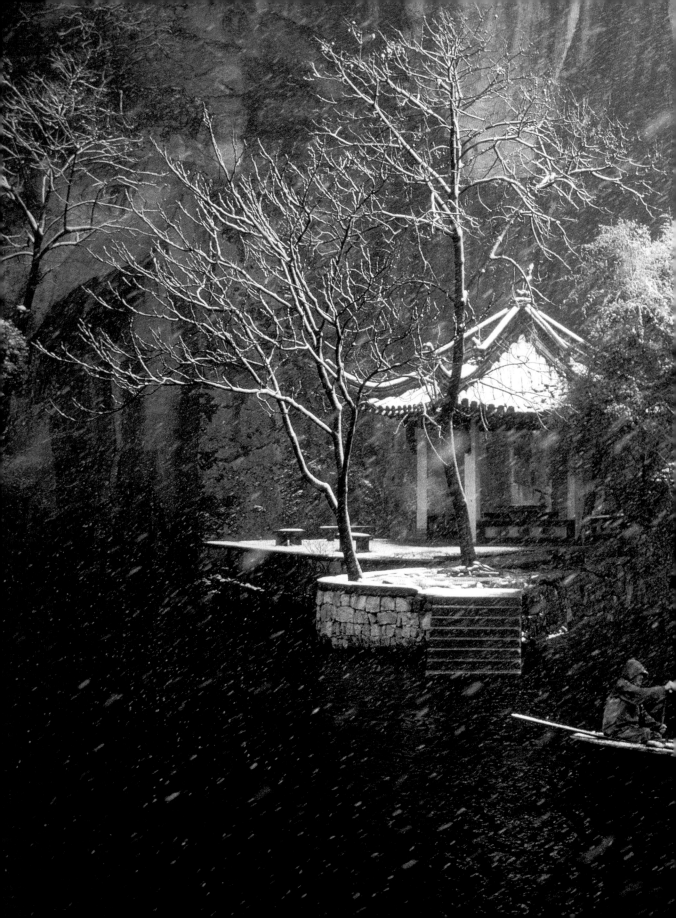

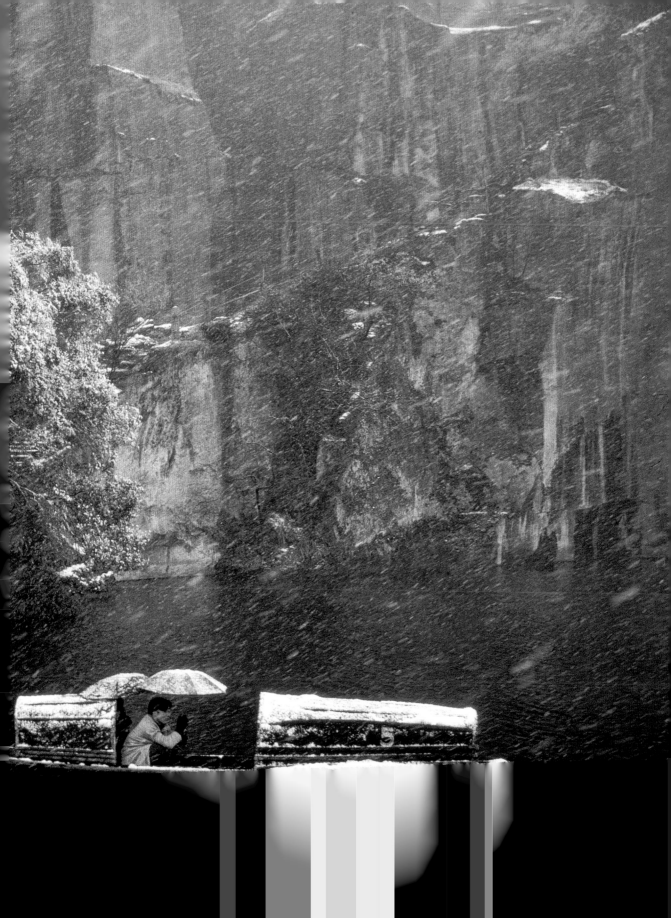

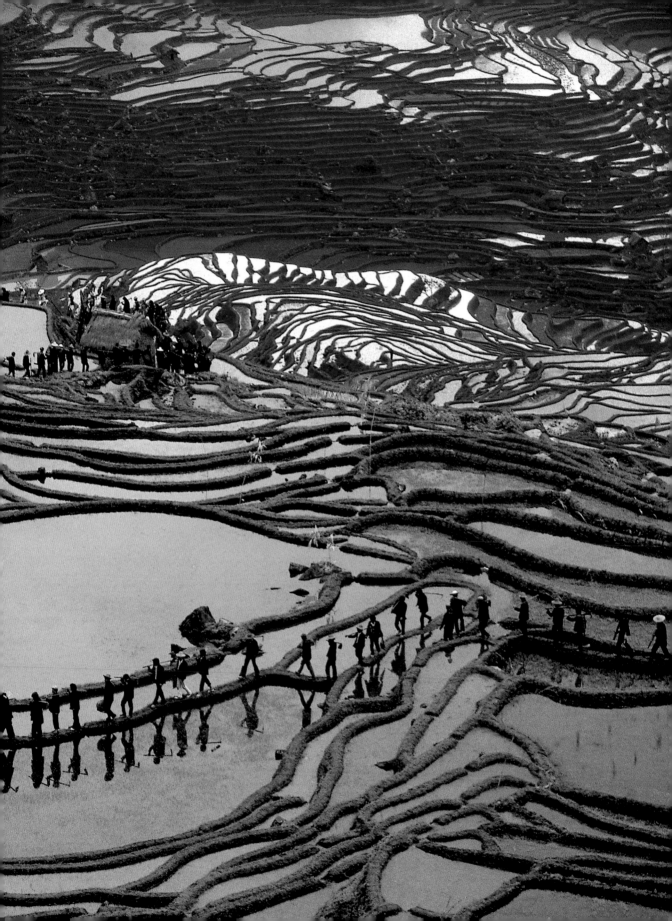

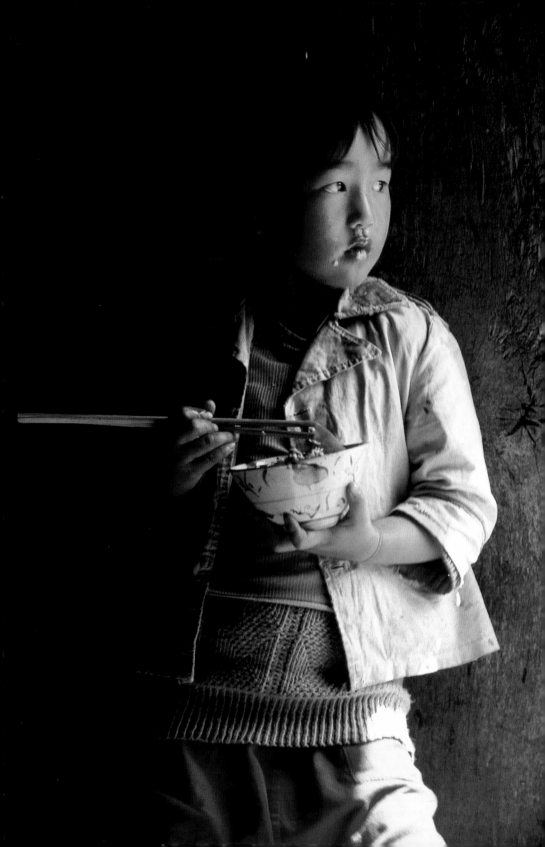

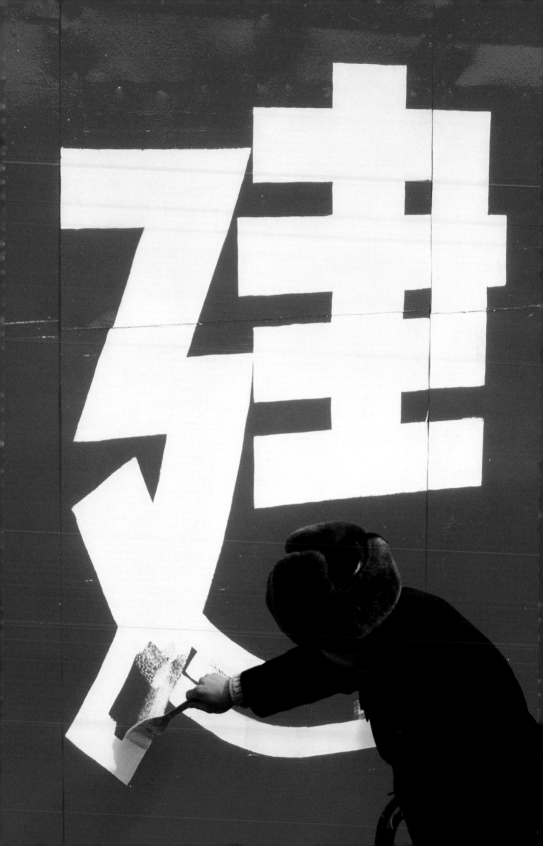

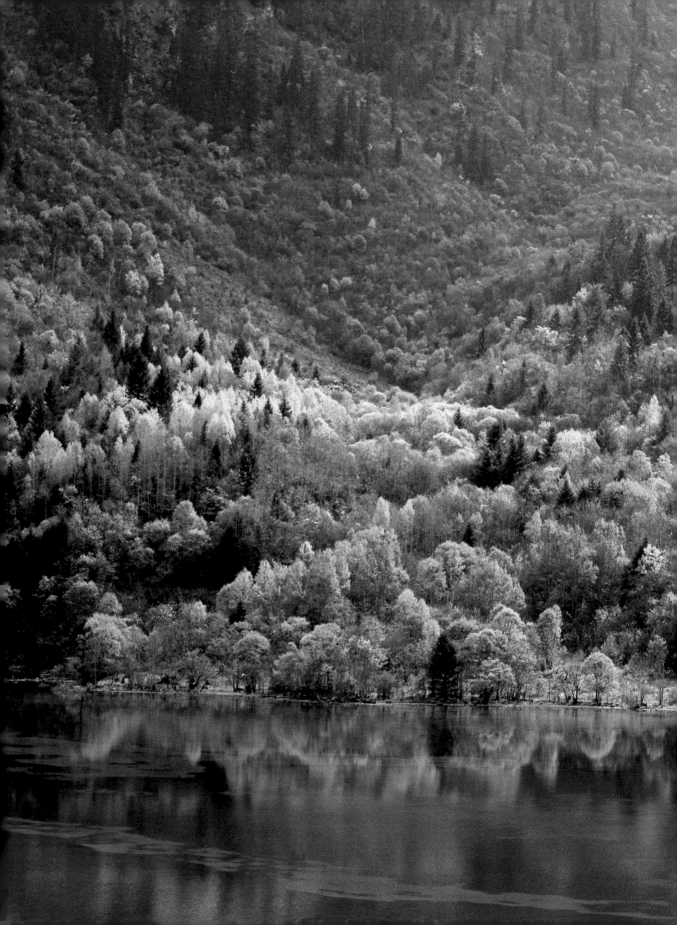

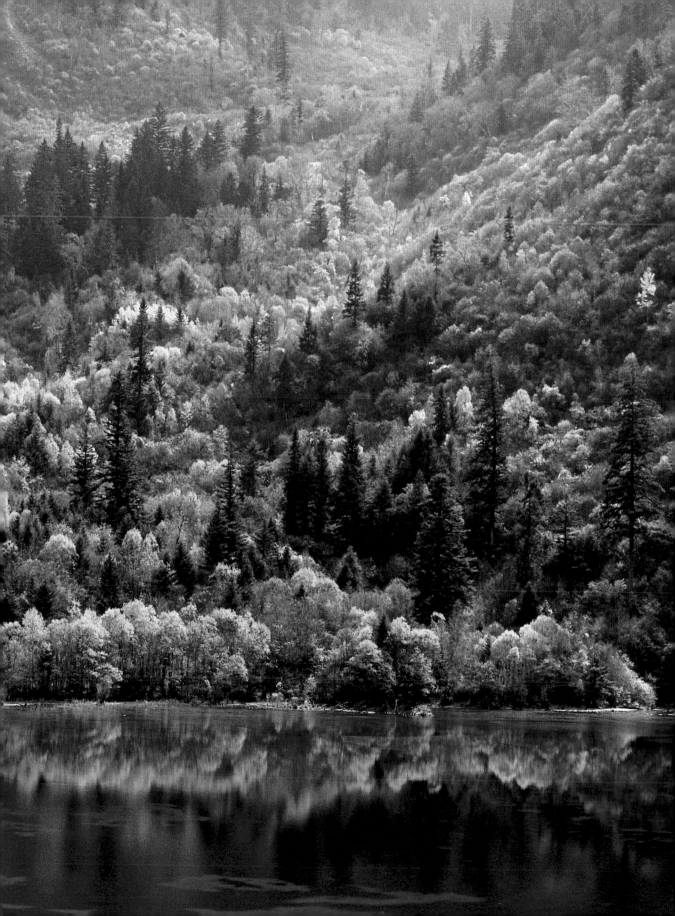

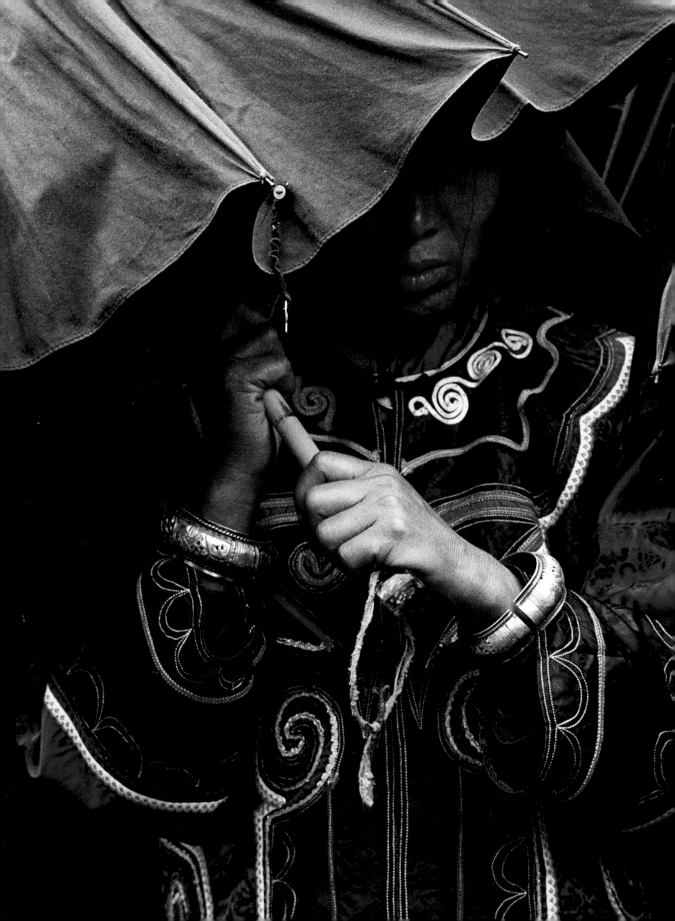

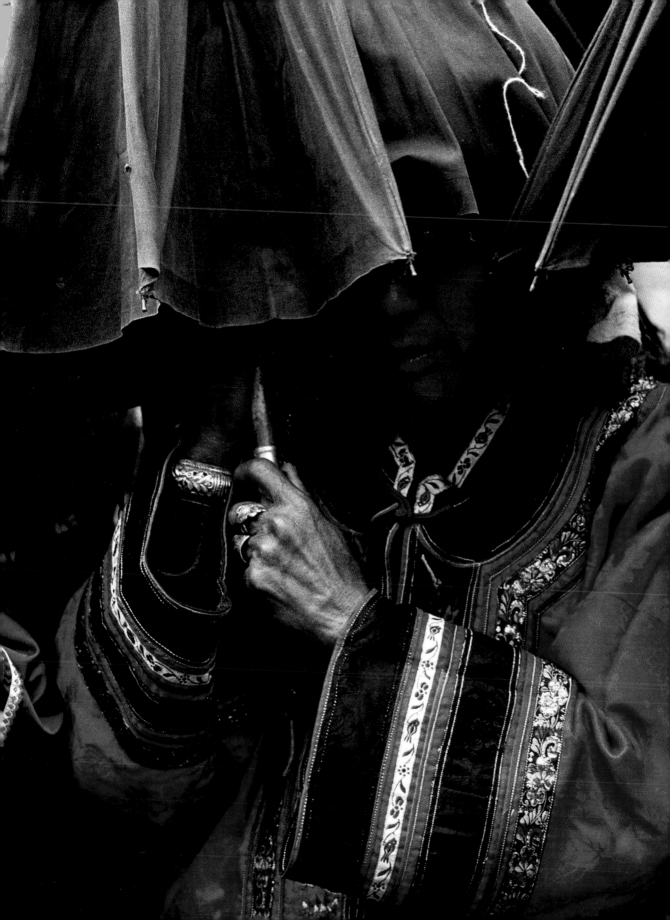

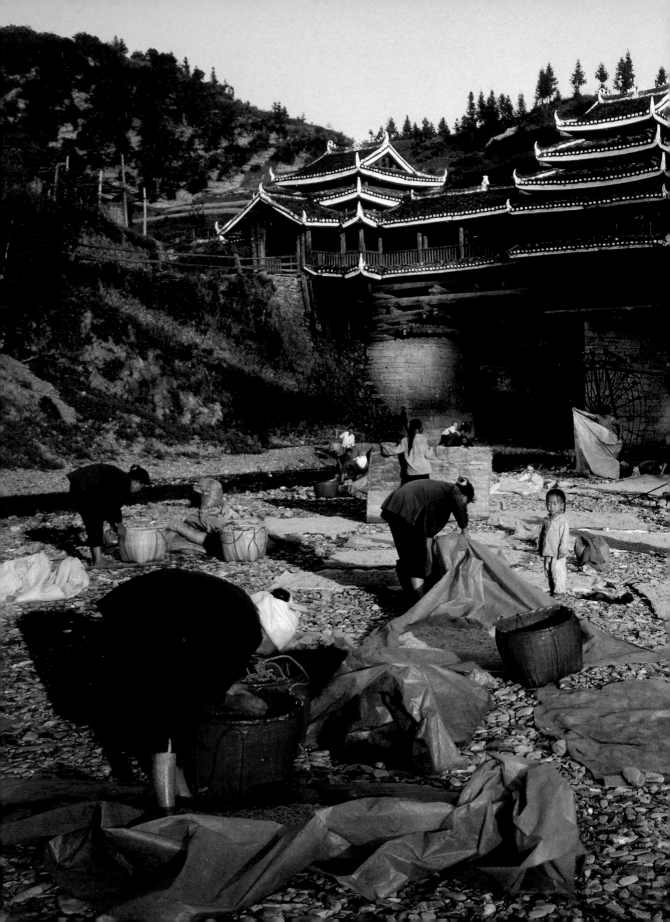

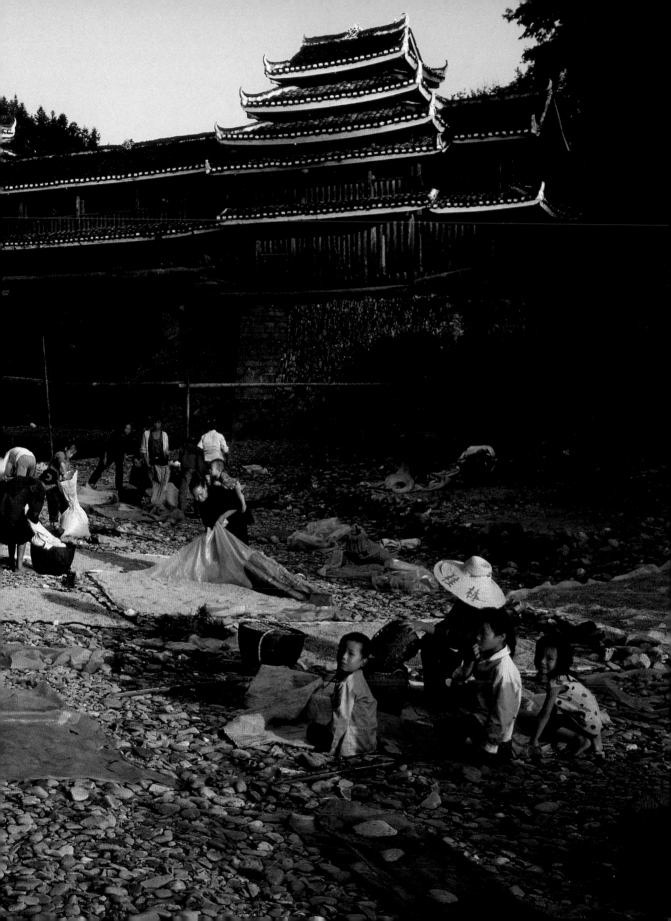

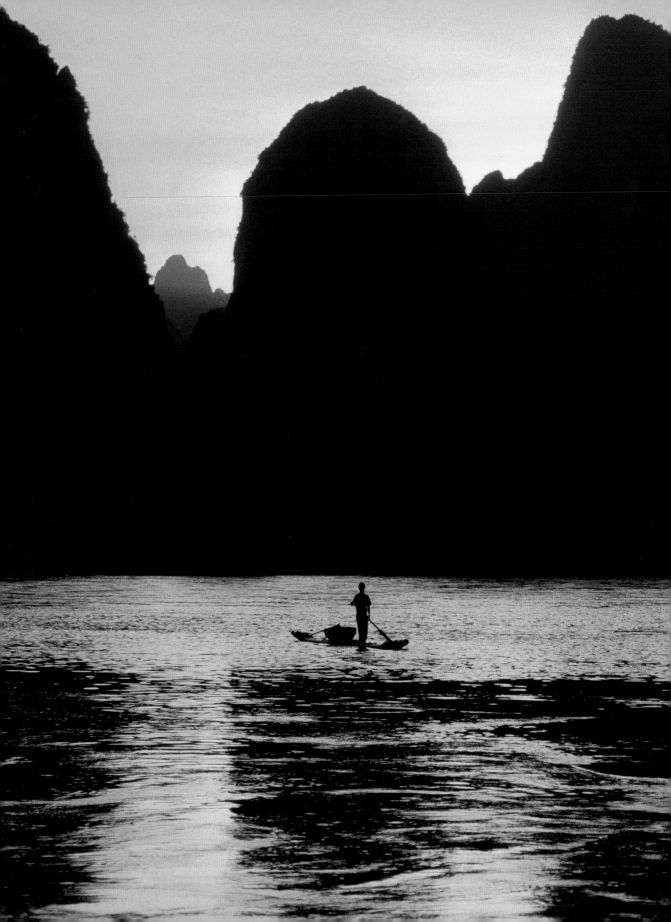

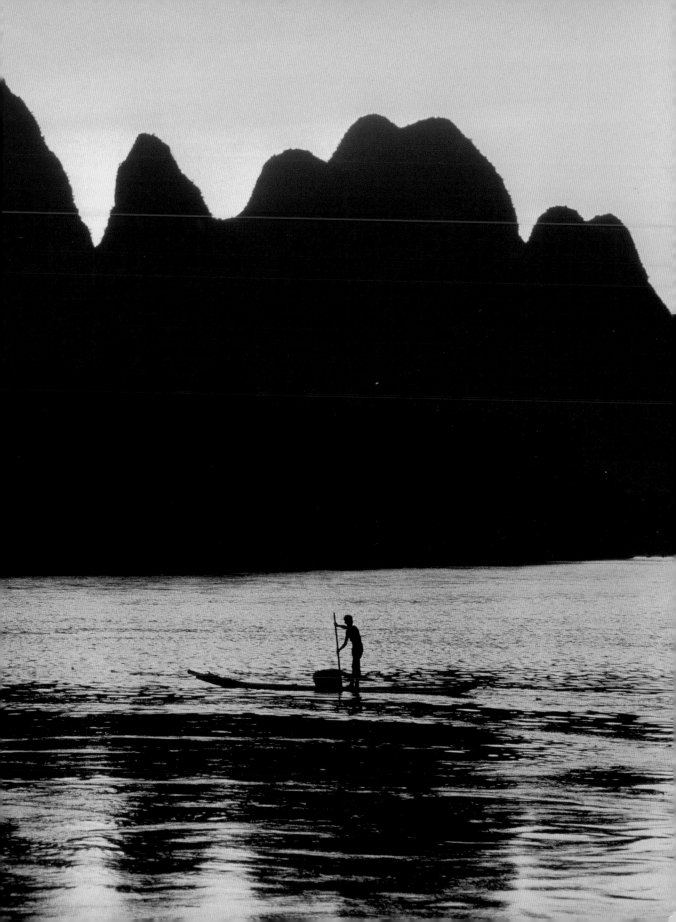

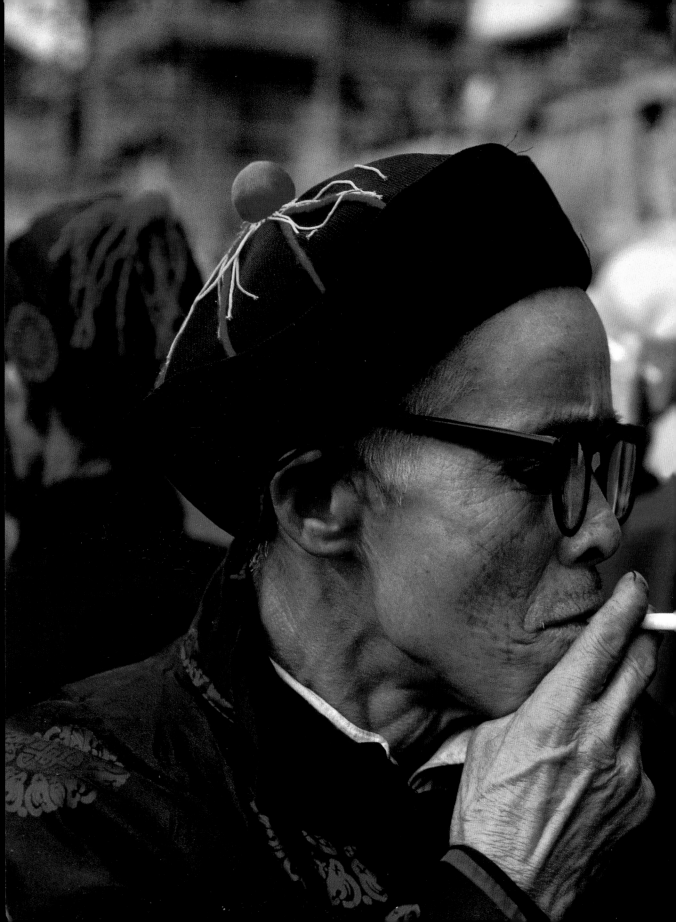

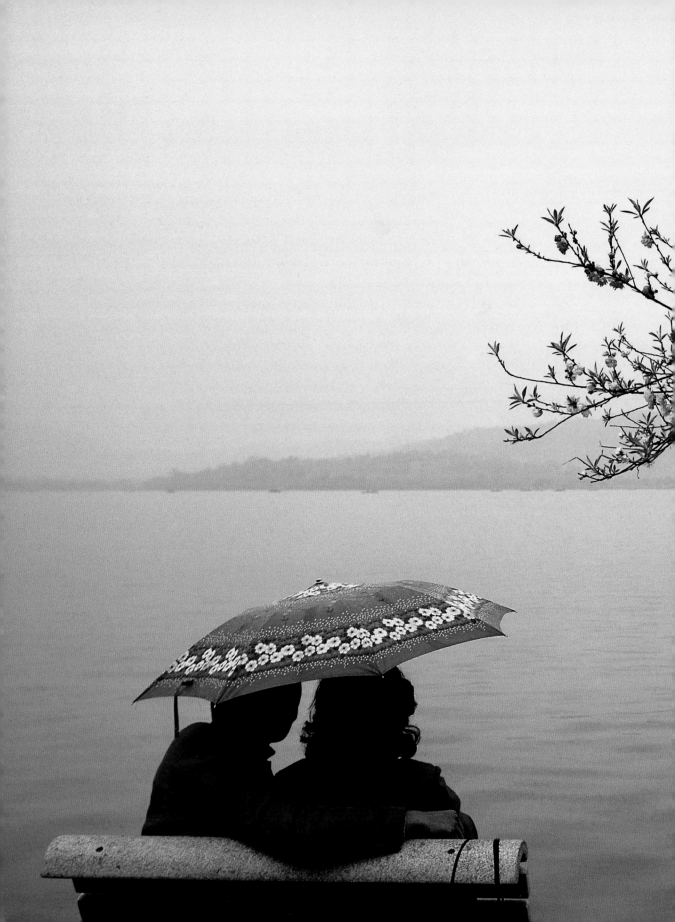

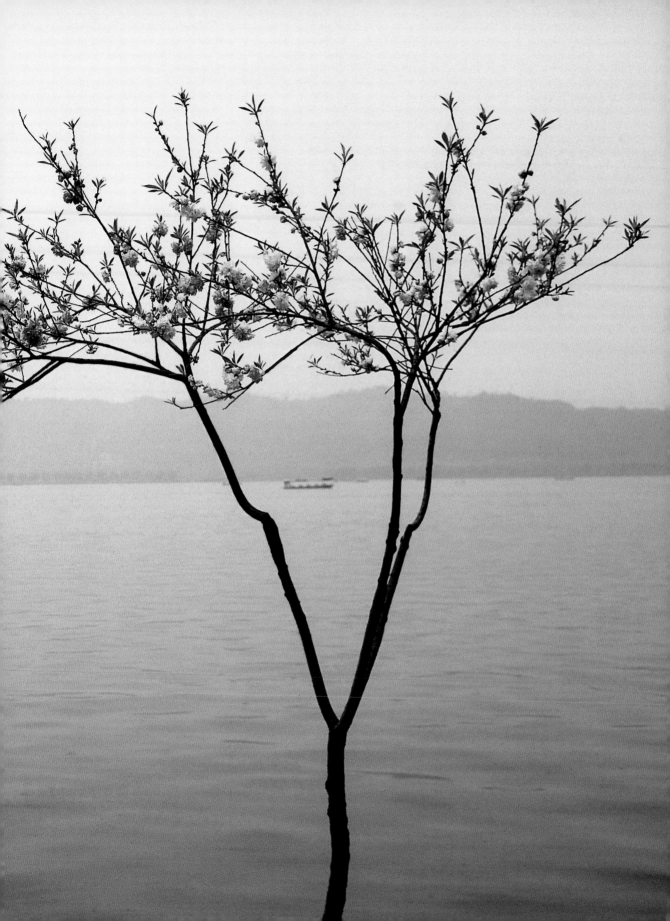

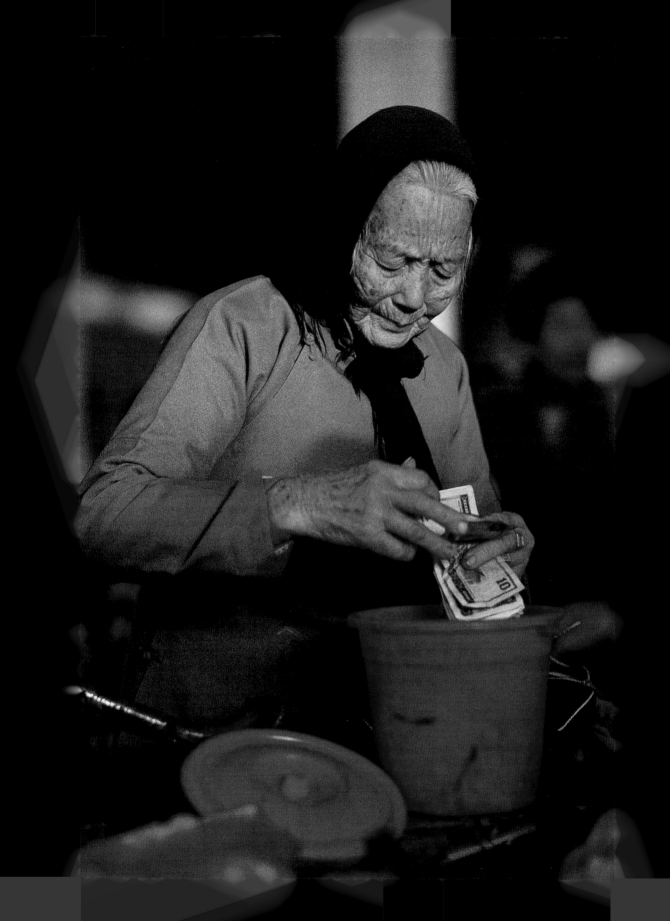

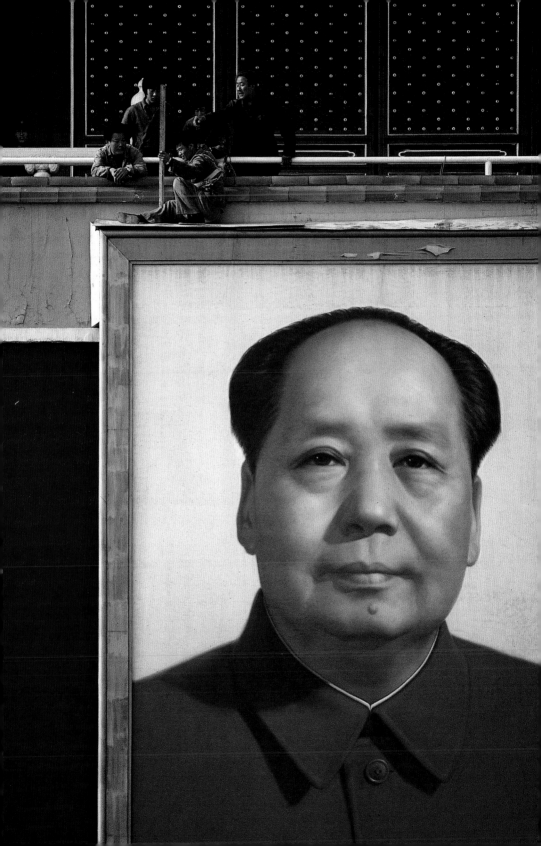

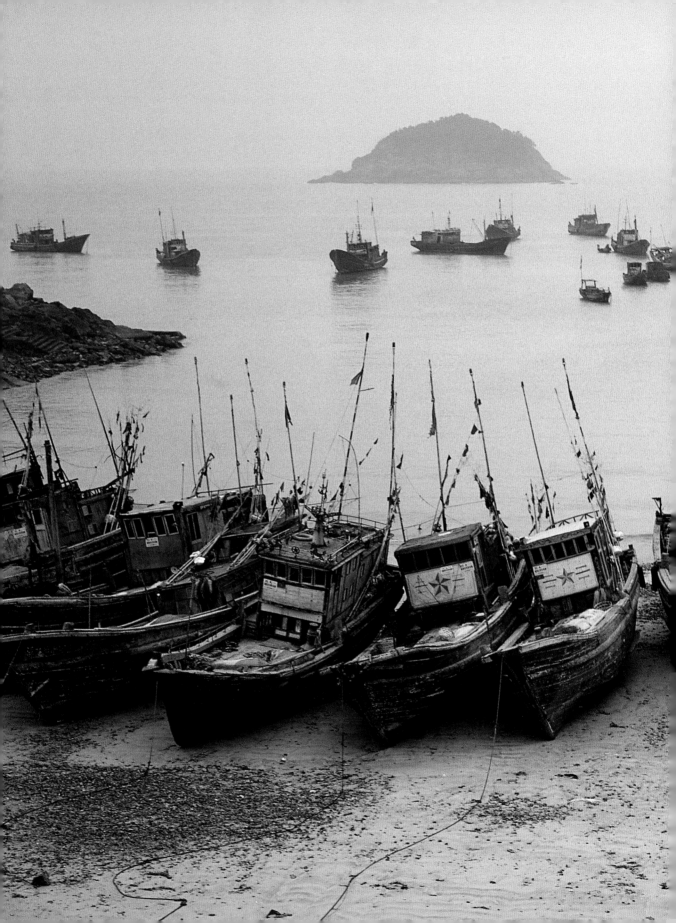

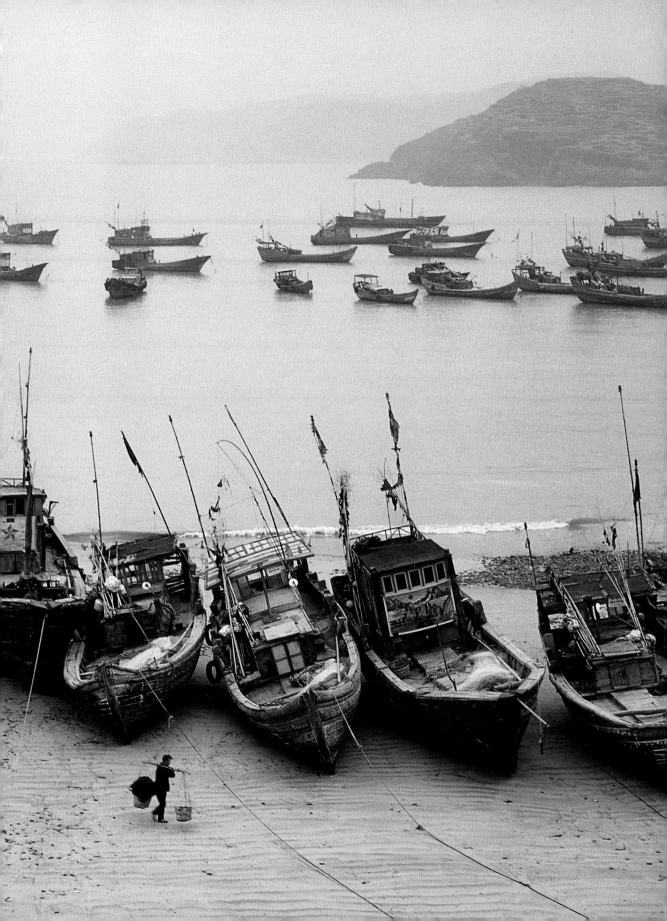

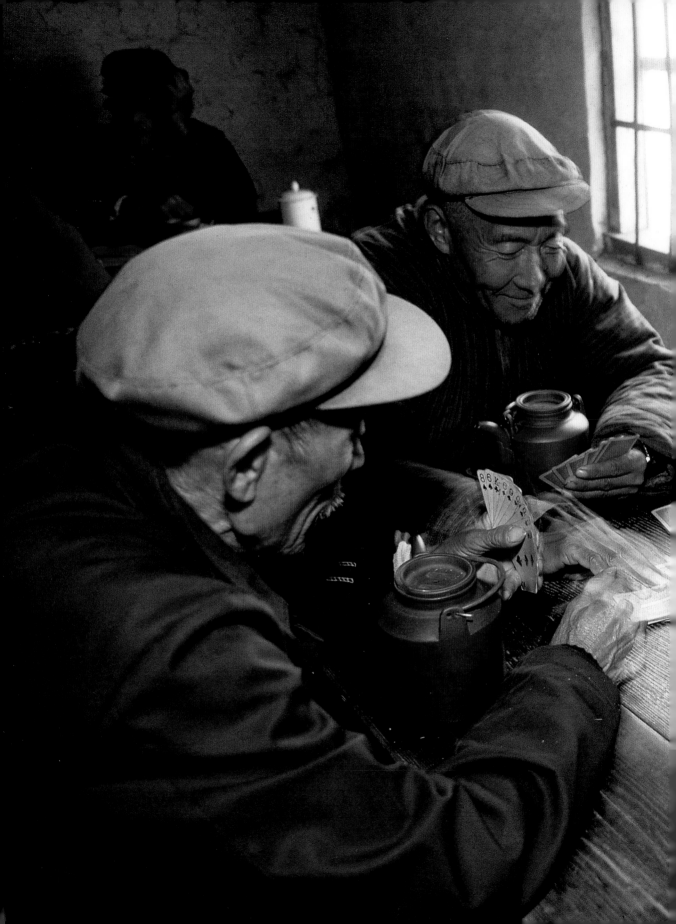

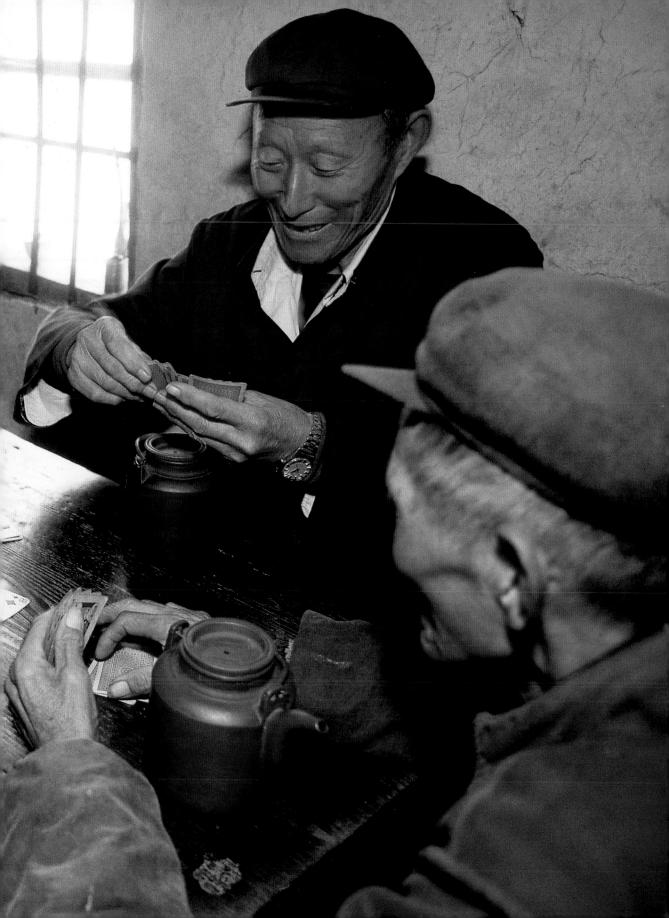

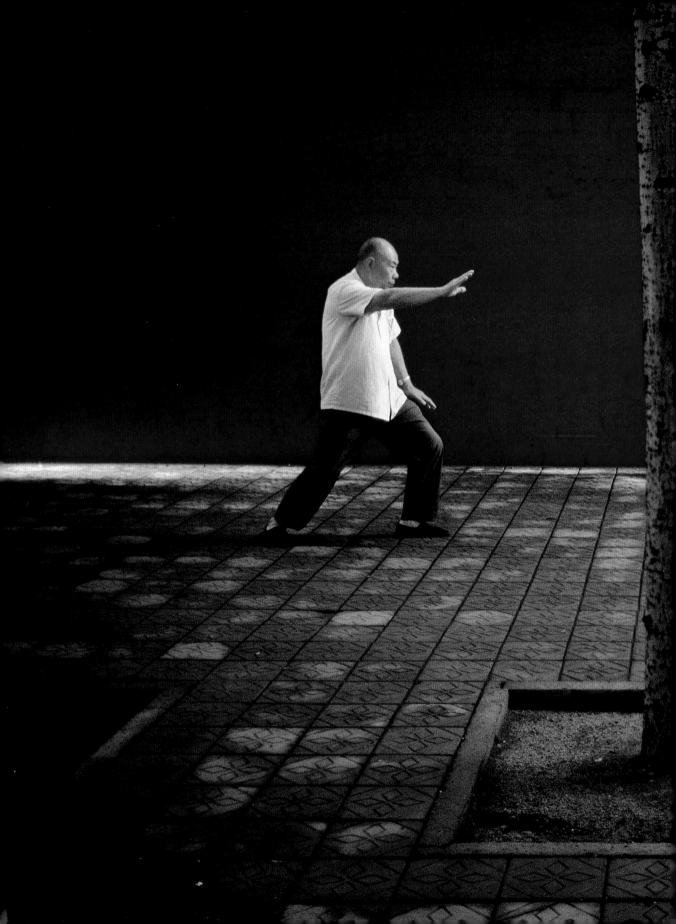

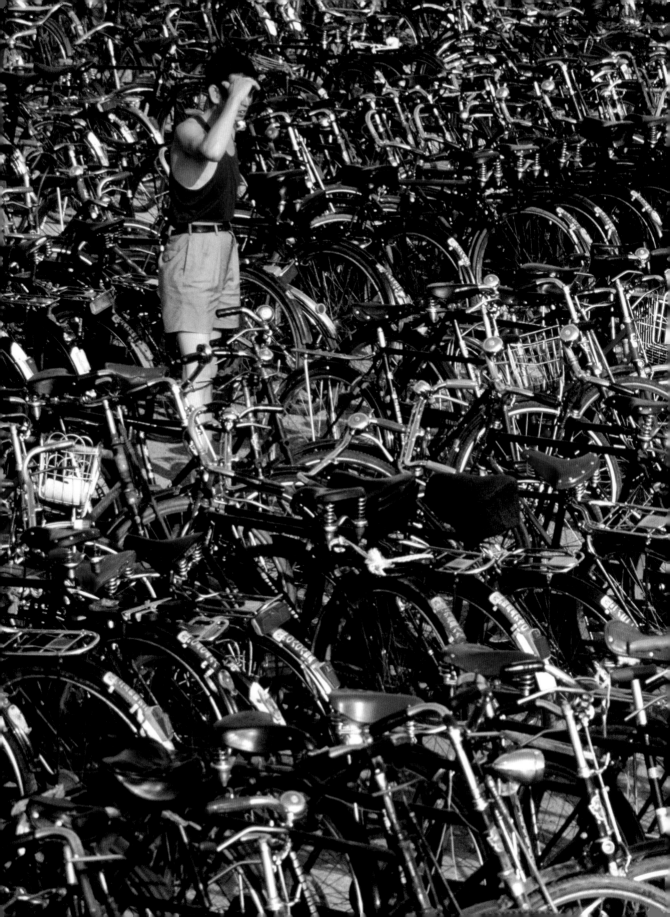

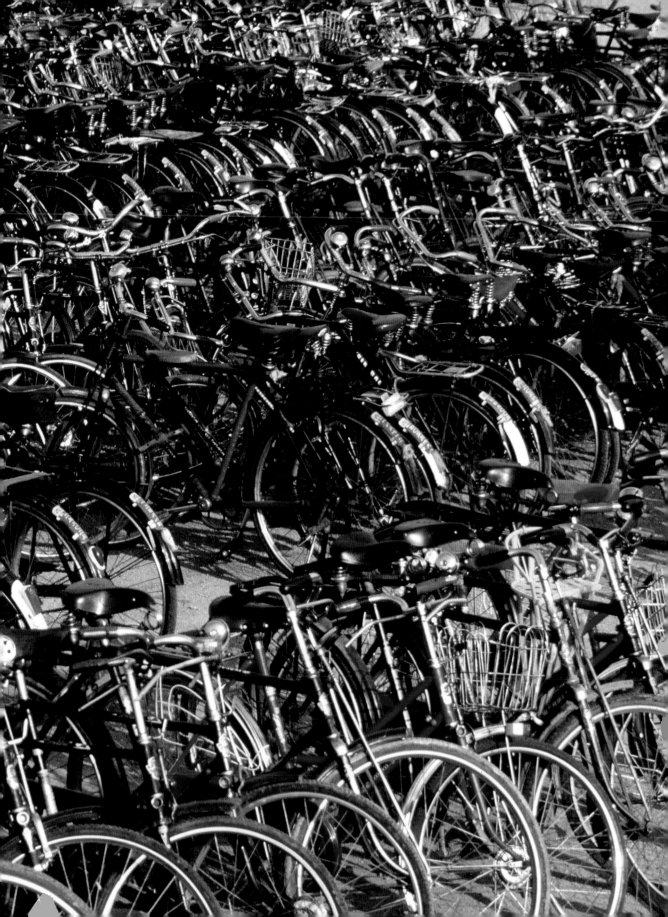

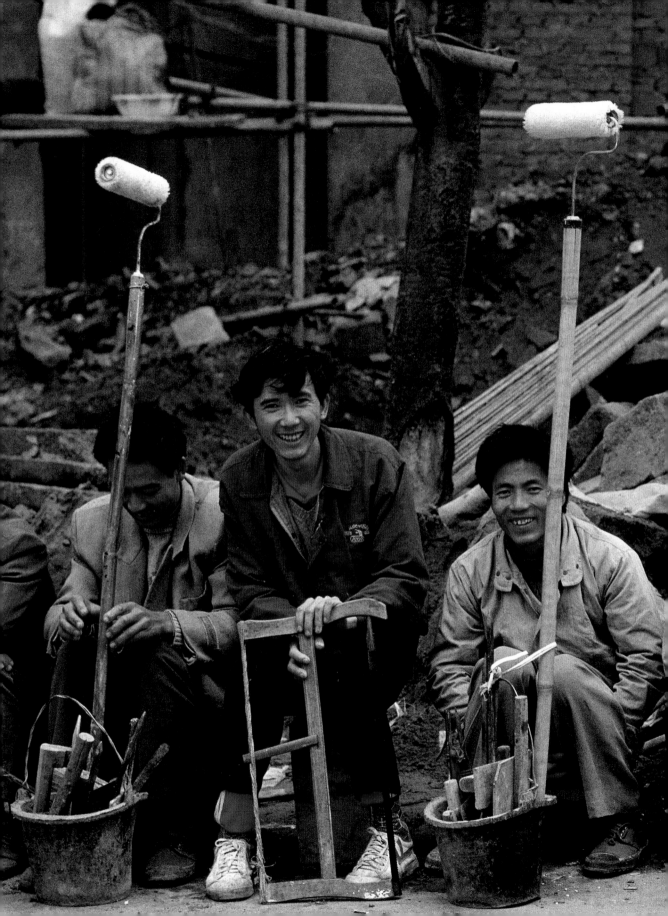

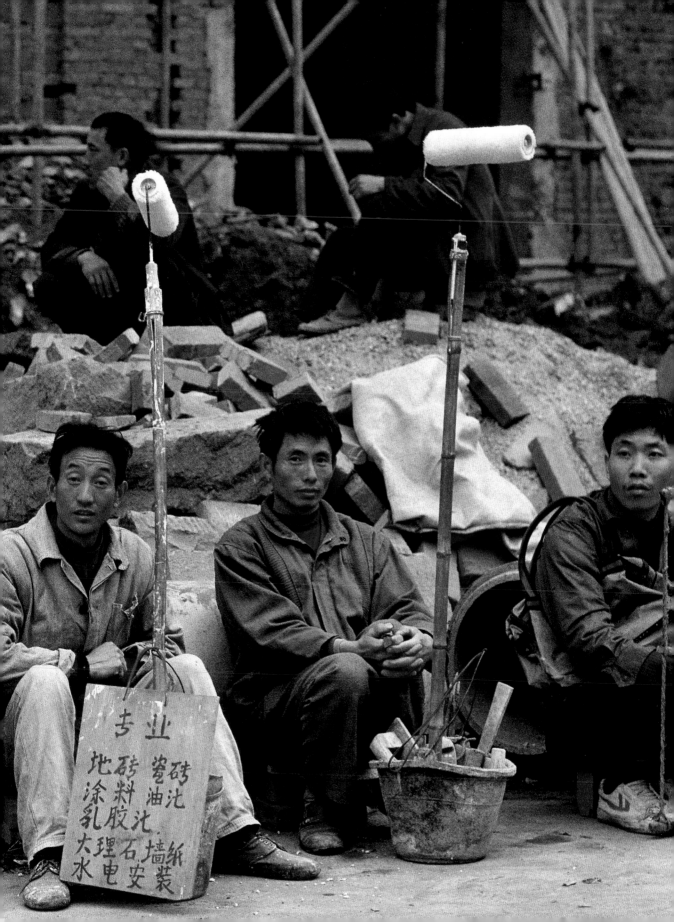

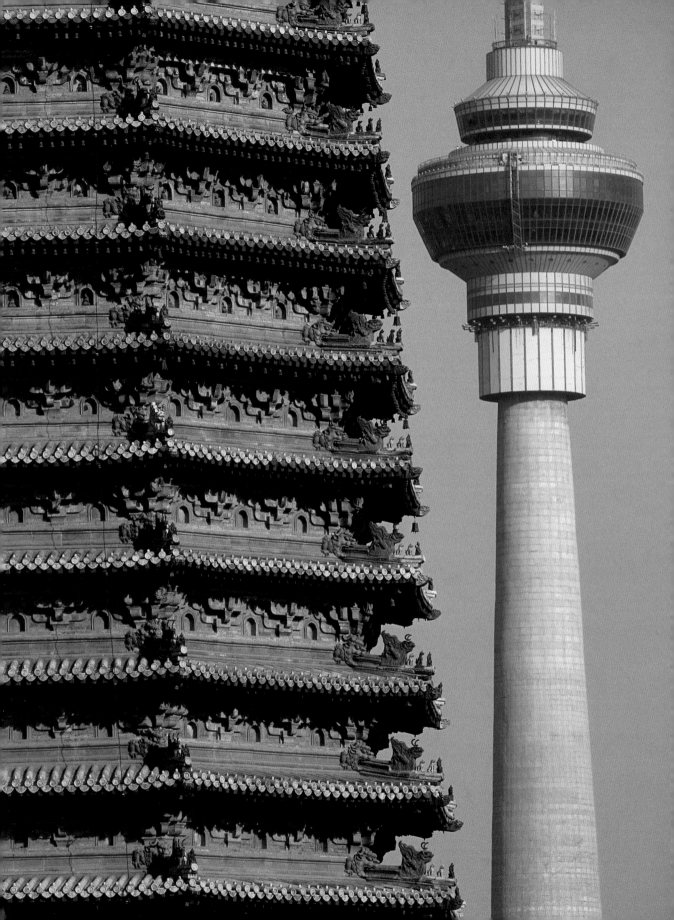

A WORLD UNTO ITSELF THROUGHOUT THE MILLENNIA

Yesterday's China, like China today, has always been a world unto itself. Chinese civilization is incontestably one of the oldest and richest in the world. But unlike those worlds that have disappeared, such as ancient Egypt, China continues to exist; unchanging and unique, it has withstood the test of time.

China has always been the most populous country in the world. This unique population density has, since its origins, been its most essential characteristic. Where people have always been so numerous, society and the state had to organize themselves in response early on. The fear of economic and social chaos has always haunted the rulers of the country, and by the Archaic period it led them to inaugurate a system in which the individual would always be required to defer to the community.

By the fourth millennium BC, at the bend of the Yellow River, where the first material traces appear of what is strictly speaking the Chinese culture, the population density was already noticeably higher than anywhere else on the planet. The weight of demographics explains why economic, social, and military organization were the first concern of primitive Chinese society from the start. Very early on, it was necessary to feed the population and organize its defense. As a result, very early on, the notion of a community institution financed by fiscal contribution appears. Very early on, it was decided that the community took precedence over the individual. Very early on, coercive structures were put in place, intended to prevent "chaos from taking hold," together with the notion of "Law," before which everyone is asked to give way, if need be by force, which will itself give rise to the current of "Legalism," that totalitarian philosophy upon which the Chinese authorities would rely to carry out the unification of the "Warring States" (sixth to third centuries BC), leading to the foundation by Emperor Cheng in 21 BC of the Chinese Empire, which would survive until 1911, when it was replaced by the Republic.

This demographic constraint remains the main key to understanding the manner in which the Chinese have been governed since the beginning. The notion of "celestial mandate," which, parenthetically, could be withdrawn from the person chosen by the heavens as soon as he no longer appears worthy of it (celestial displeasure manifesting itself in some natural catastrophe, for example, like a flood, earthquake, or devastating famine), remains intimately linked to a concept of power in which the ruler is judged by his capacity to organize things "so that chaos does not take hold."

As Chinese society gradually refined its methods of organization, there slowly emerged a feeling that China was the "country of the center," which is to say both the center of the world but also its center of gravity. This fact explains the particular position that is China's, an immense country, immensely populous compared to its neighbors, symbolized by the creation in the first millennium BC of the Great Wall, whose sections would finally be joined one by one by the first emperor, Cheng. The Great Wall, in fact, made Chinese territory a sanctuary, but it clearly marks, as well, the absence of imperialistic aims on the part of this immense empire, which always believed it had no need to conquer others, because its size was such that, in its own eyes, it was sufficient unto itself.

But this did not, by any means, prevent a cultural, religious, and economic exchange between China and the surrounding world, for this world unto itself has always been endowed with a formidable capacity to assimilate exterior elements, even those that appeared—at first sight—most remote, as much on the level of mentality as on that of economy or culture. We see this today with China's enthusiastic participation in globalization. We see it in the past with Buddhism, the religion from India that, beginning in the first century AD, profoundly transformed the Chinese way of thinking, and was finally adopted by Chinese authorities as their official religion several centuries later.

If the quintessence of Chinese civilization, like a true assimilating sponge, has succeeded in this way throughout the centuries by ignoring external events, it is because it is based on extremely profound notions having to do with the concept of Mankind and the Universe, in the forefront of which stands the relationship between time and space. They are actually inseparable, and explain the theory of the Five Elements or Five Agents (wood, fire, metal, earth, and water), which were thought to govern the universe. The Five Elements are associated with directions: east for wood, south for fire, west for metal, north for water, and the center for the earth; with colors, in the same order green, red, white, black, and blue, as well as the seasons. The Five Elements produce the spirits that are condensed from matter and energy. As the great Taoist philosopher Chuangtzu (ca. 350–275 BC) wrote, they may be "crystallized" to give their form and their state to mineral or vegetable matter, as well as to living things.

It is through this network of connections that the Chinese perceive the universal reality. This perception implies a cyclical notion of things and of time. We pass from one element to another as from one color or from one season to another. Time always returns.

This great circular model is illustrated by the sixty-four hexagrams of the *I Ching* (Book of Changes), whose

common basis is constituted by the famous eight divinatory trigrams (*bagua*), which are cosmological symbols, whose succession takes place without breaking continuity, passing from apogee to decline. These changes are linked to time, and develop according to a dynamic process, which only the attainment of the "happy medium" in a given situation is capable of halting. In this regard, the *I Ching* is unquestionably the most ancient and astonishing attempt at the graphic codification of the universe.

The concept of Tao, the principle of order, governs the world, man, and the cosmos. It has been at the heart of the Chinese way of thinking since its origins and flows from this cyclical conception of things. To follow the Tao amounts to following the path of universal harmony, where each element is in its place, according to a scheme perfectly illustrated by Yin and Yang, and the central place these two principles hold in the Taoist religion.

It is in the association of these two antagonistic principles (which are contrary or opposing principles: e.g., male/female, full/empty, dark/light, black/white, warm/cold) that is born in the "general harmony" that comes from their union—or fusion—which we must investigate. Neither of the two principles of Yin and Yang is superior to the other.

The notion of *qi*, this vital creative spirit without which nothing is possible, is nearly as important as that of the Tao. To find one's *qi*, to regenerate it in order to use it to good ends, is a fundamental preoccupation for every Chinese person, for whom physical exercise in nature is always the best way to begin the journey. This is why we see, when we walk through parks in Chinese cities early in the morning, large numbers of Chinese devoting themselves to the martial arts, breathing exercises, or simply to contemplating the trees from whose branches they have hung cages containing their pet birds, to encourage them to sing.

This permanent search for fusion and harmony—it could be called a homothetic transformation—with nature unfortunately does not mean that China is today the country in the world most concerned with ecology. This is because the Taoist conception of the human body, a microcosm perfectly identical to the universal macrocosm, is always compared to a "country," with the round heavens like a head, the Earth like the torso supporting the heavens, the limbs representing the four seasons, the human breath, the wind, blood, the rain, and so forth. The human body communicates with the outside world through its multiple orifices. If there is perfect harmony between the interior and the exterior, the being is at peace, since he is in perfect communion with nature, which surrounds him, and therefore with himself. In the opposite case, Man suffers and declines. To be healed, Man has a need for nature, for its harmony to be sure, but also for its plants and its biological, animal, or mineral substances. This essential relationship between

the human body and nature is the foundation of Chinese medicine, one of the most ancient in the world. The first treatise on medicine and pharmacology is said to have been written around 2,000 BC by the mythical Emperor Shennong (Yan Emperor), and includes no fewer than 365 remedies, or one for each day of the year. The mechanical procedures of Chinese medicine (acupuncture, reading the pulse, massage, and other respiratory exercises) have slowly been adopted in their turn by Western medicine. They bear witness to the often quite correct intuitions of the first Chinese doctors at a time when Western medicine was only taking its first halting steps.

The taste among Chinese men of letters for calligraphy and poetry relates to the same problematic. Chinese writing is composed of characters (ideograms) linked by association. They were a powerful unifying element in a country in which dialects, and even languages, have proliferated since its beginning. The extreme simplicity of its grammar makes up for the difficulty of learning the characters, which is indispensable to anyone who wants to understand the mysteries of an extraordinary language that does not easily lend itself to the oratorical art.

The Chinese language is first and foremost a visual language. For this reason we often call it a "written language." To write the Chinese characters while obeying the rules and stylistics of calligraphy is also a physical act that implies great self-control. Gesture therefore holds an important place. Writing a poem requires the same talent, since it can't be imagined, without a perfect harmony between the sense of the poem and the form of the ideograms that compose it. Thus one of the essential goals of Chinese poetry has always been a description of this harmony formed between the individual and his natural environment. The feeling for nature, and a description that it evokes on the part of the poet-scholar who contemplates it and is inspired by it, has always been held in the highest esteem.

Calligraphic poetry is often associated with painting. Sometimes it decorates the borders of the painting; other times it constitutes its written form and, as it were, its counterpoint.

Recent archeological discoveries have allowed examination of styles of painting going back to the period of the Warring States (sixth to third century BC), that are closer to craft than to art until the end of the Han dynasty, even though in this period we begin to find painted banners used in Taoist ritual. These banners bear scenes of the gods and include representations of human and divine forms. In the beginning of the Six Dynasties, or around the fifth century AD, the names of the first Chinese painters appear. Their works have disappeared, but they must have been quite beautiful if their authors' names have been passed down to posterity. This is a form of painting in which the human

figure still holds a primary position, unlike the landscape paintings that will become, beginning with the T'ang dynasty around the seventh century AD, the quintessence of the art, before attaining its full flowering under the Five Dynasties and the beginning of the Northern Sung. During this period washes and monochrome ink drawings are first used to represent the immensity of the landscape, in the midst of which humans are always represented as minuscule figures. In a microcosmic fashion, the detail of a plant or flower is evoked by a few colored lines subtly drawn by the painter with a simple gesture on the white paper with a tiny brush stroke. The economy of means and the dazzling quality of the line have also made Chinese painting a means of expression that is particularly suited to Chan (Chinese Zen) Buddhism, in which the concept of Sudden Illumination holds an important place.

In the land of the Sign—as well as the language of signs—the Chinese did not hesitate to scatter characters over the extraordinary bronze objects that Chinese craftsmen cast several thousand years before the present era. The Chinese used techniques that the West would only really master at the end of the Middle Ages. The use of the ritual vessel is coupled with its role as an archival witness, since it is not rare that the most important pieces be engraved with legal, nominal, or votive inscriptions.

In a country where the oldest dictionaries can include 30,000 characters, that which is written becomes sacred, and more or less eternal. Thus scholars and poets held a status apart, whose quintessence will be established by the figure of the "Mandarin-scholar" or the "painter-poet."

Books, then, are sacrosanct. It was the megalomaniacal madness of the First Emperor that led him to order, sometime before his death in 213 BC, a great burning of books, following the slogan (a sacrilege in China), "a clean break with the past," which will be repeated 2,200 years later during the Cultural Revolution by Mao Tse-tung himself. As for the famous *dazibao*, the slogans written on the walls by the revolutionary students, they only bear witness to the importance of everything that is written, in comparison with everything that may be spoken.

The relationship of the individual to the cosmos and to nature also constitutes one of the fundamental traits of Chinese civilization, which has come down through the centuries to our days. The art of gardening, which the Chinese referred to by the pretty expression "mountains and water" (*shanshui*), also bears witness to this distinctive conception of the relationship between Man and Nature that has characterized the Chinese way of thinking from its beginnings. The love of plants and trees, the contemplation of landscapes, and the appreciation of high mountains painfully climbed during treks that are a rite of initiation are also elements that have come down through the cen-

turies. They are evident in contemporary China, whether it be in urban parks, pleasure gardens, or, especially, the holy mountains that are visited every year by millions who climb to the summit to make a vow that will give them prosperity, health, and longevity.

For a contemporary Chinese, as for, parenthetically, the Chinese of yesterday, well-being operates through the constant verification that the body and its actions are in harmony with the heavens (divination, astrology) and with the earth (feng shui, geomancy), and that the Five Elements (wood, earth, iron, water, and fire) are correctly matched with their correspondents, whether they be colors, odors, flavors, or directions. To be in harmony with your surroundings, to absorb the proper nourishment, to take one's place in space without disturbing one's surroundings, are still the most important preoccupations in China today. This is why there does not exist in China that dichotomy between the Divine and the human, present in so many other civilizations, any more than the vision of the world as a creation born of a ritual or religious concept.

Religion for the Chinese must be above all efficacious: whether it be the cult of imperial ancestors, which enabled the dynasties to perpetuate themselves when things went badly for them, or the cult of the ancestors and family lineage, which an individual must never break. This pragmatism explains the facility with which Buddhism, originating in India, has continued to develop since its introduction in China along the Silk Road, in the first years of the Christian era, to become, under the T'ang dynasty (seventh to tenth centuries AD), the country's principal religion. Thus it is not surprising to see the faithful today, cell phones held to their ears, prostrating themselves indiscriminately in a Buddhist pagoda or in a Taoist or Confucian temple!

In the modern world in which science and technology have pushed back the frontiers of the marvelous so far, such an attitude cannot fail to surprise, even to shock, the Western mind. They also bear witness, however, to the attachment of the Chinese to the grand concepts that marked the first steps of their millennial culture; concepts that have come down through the centuries almost unchanged, quite simply because they concern the most intimate things that the human being possesses: the relationship to nature and to death, the sense of the self and its relationship to the Other.

In spite of China's enthusiastic entrance into globalization and modernity thanks to Deng Xiaoping, the "world unto itself" of China, its millennial traditions and fascinating components, continue to dictate this immense people's way of being.

—José Frèche

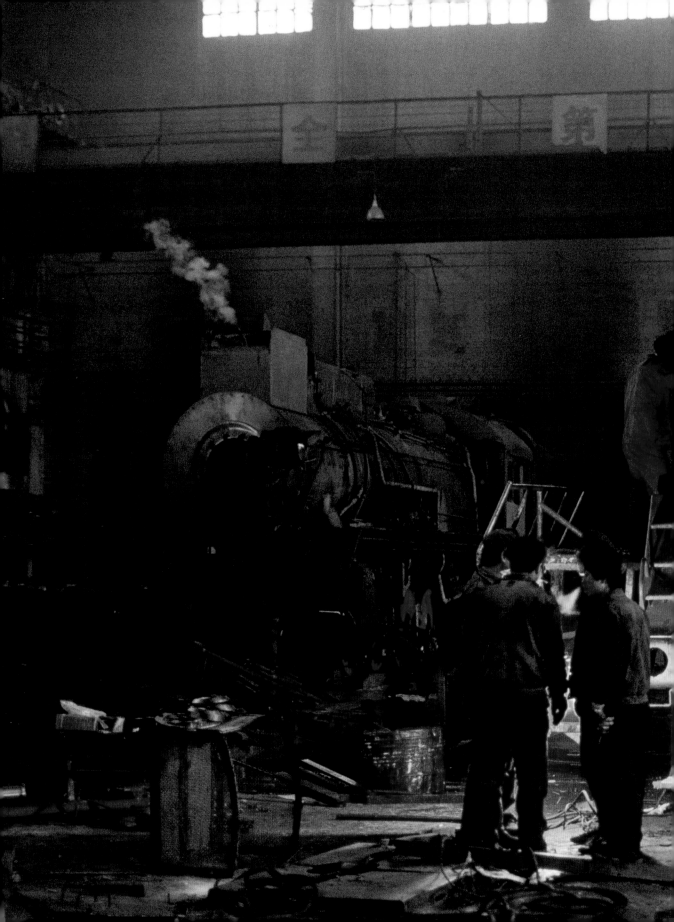

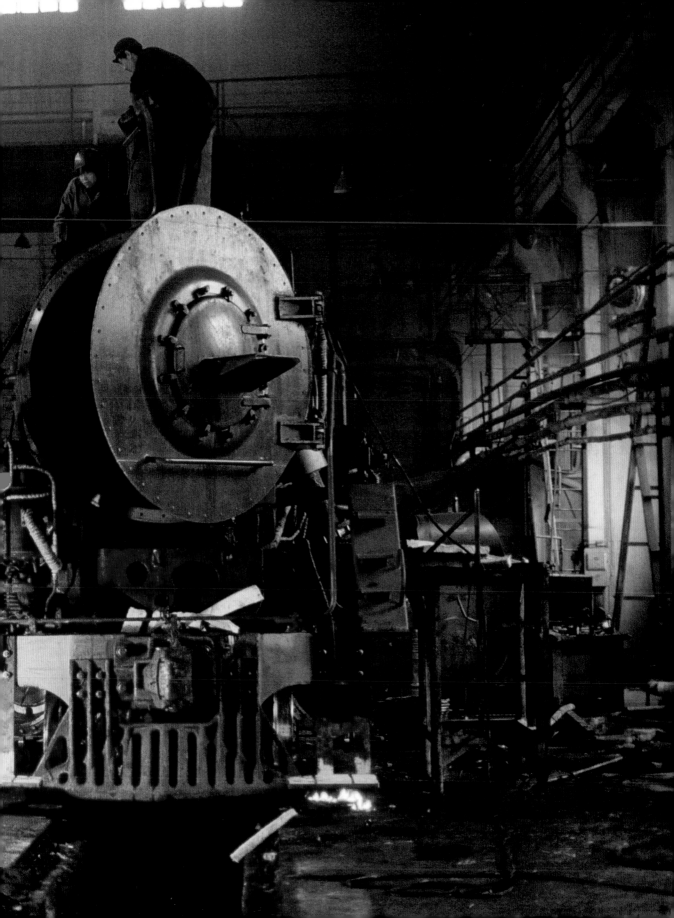

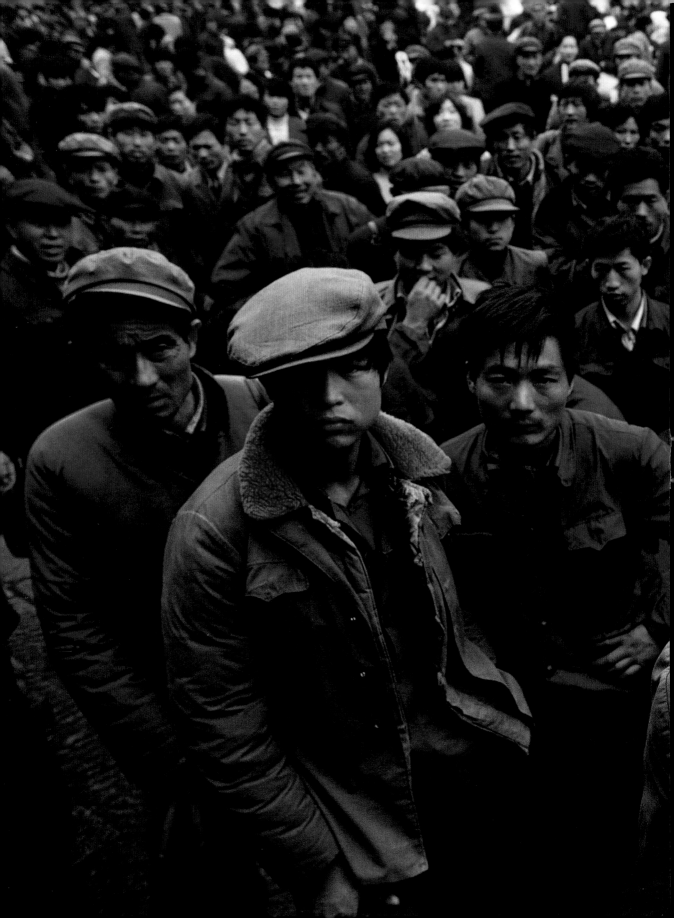

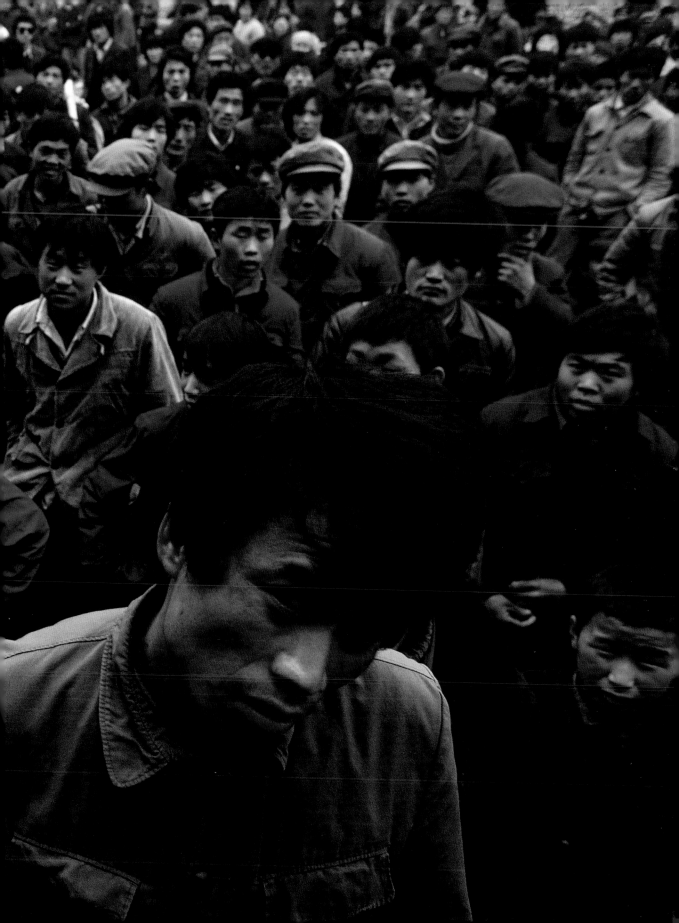

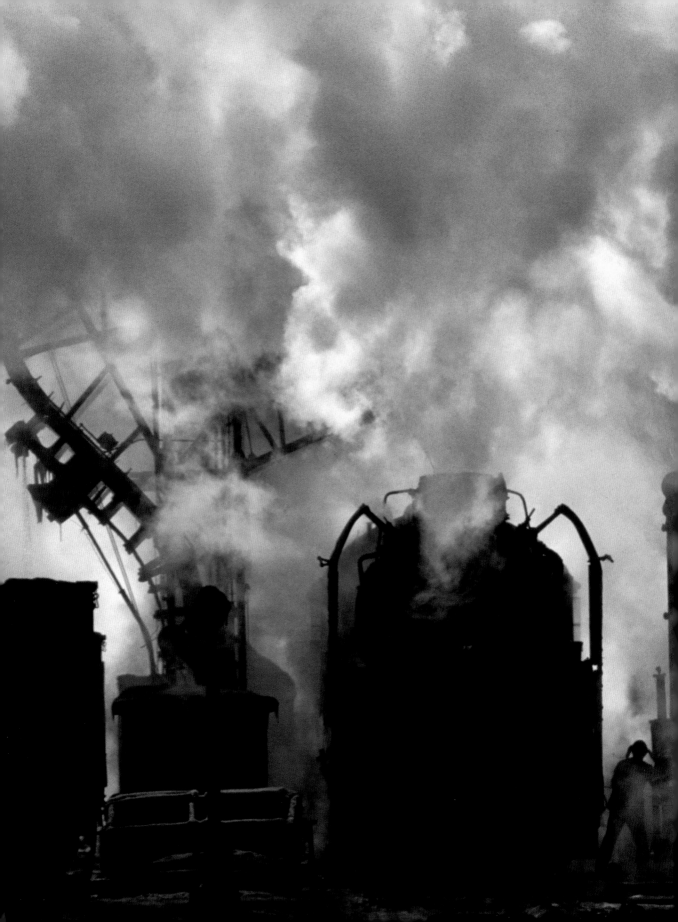

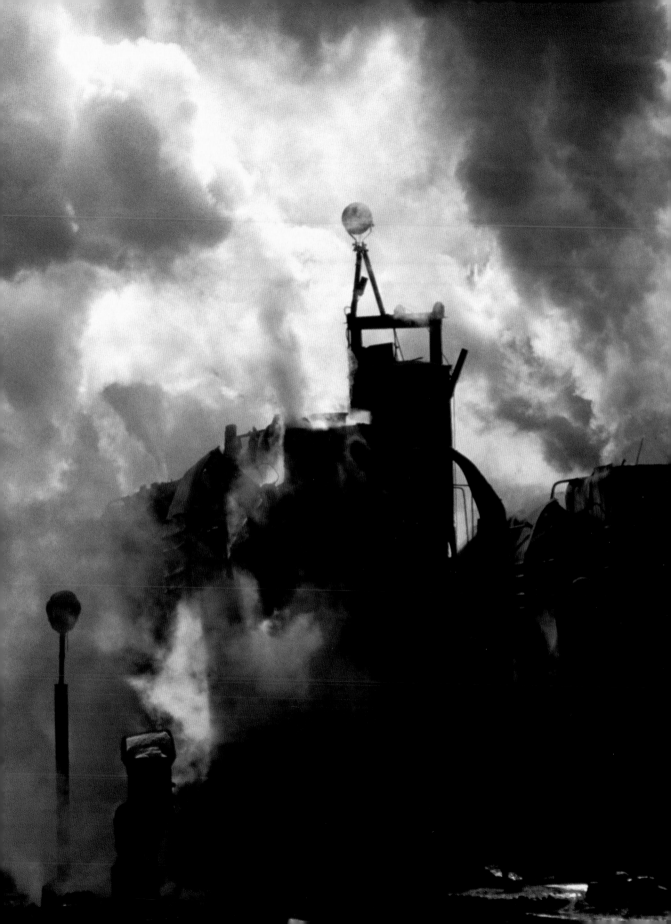

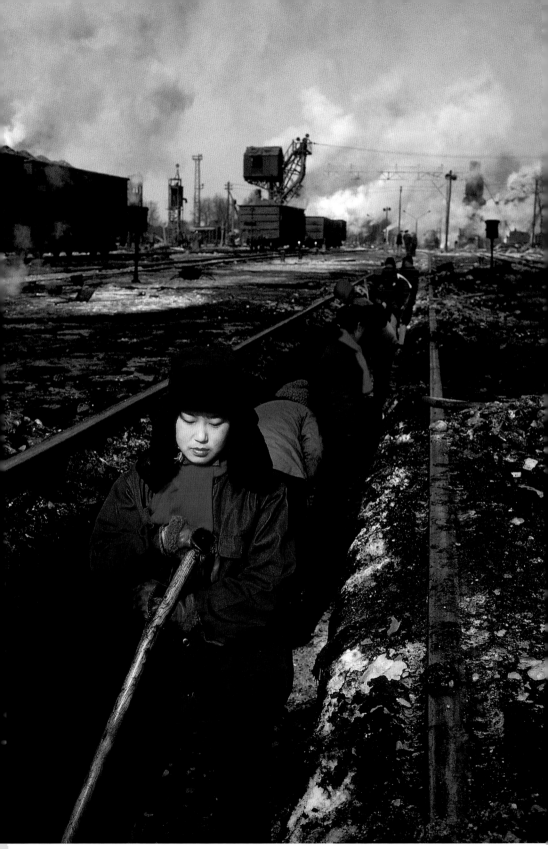

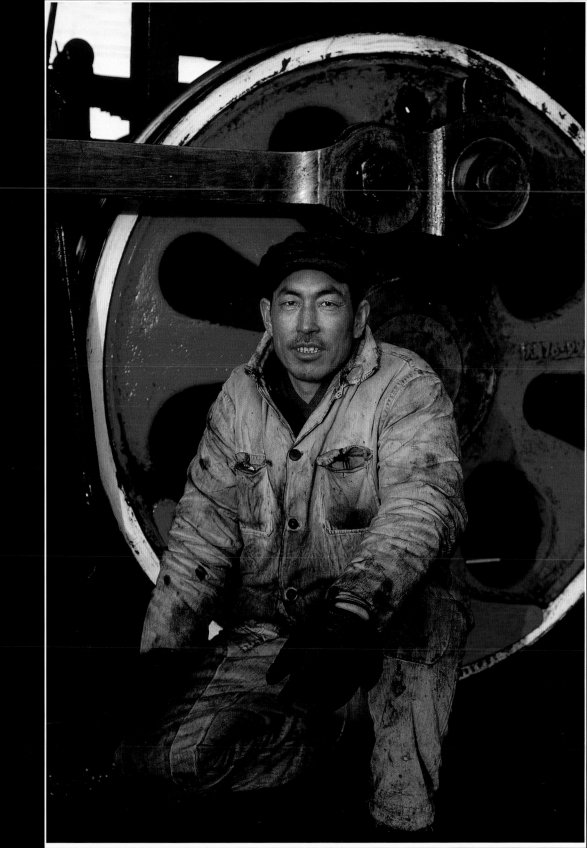

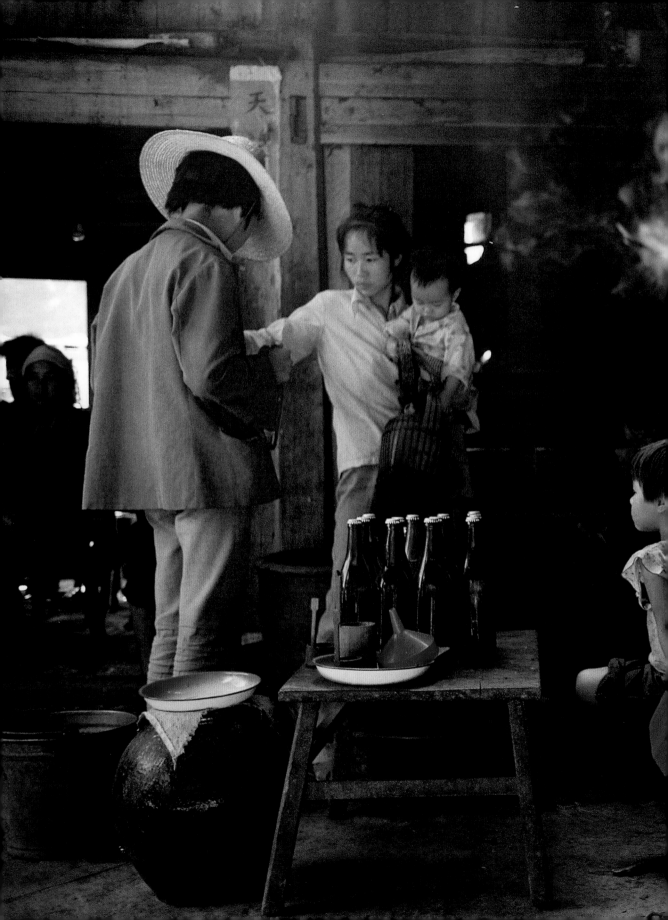

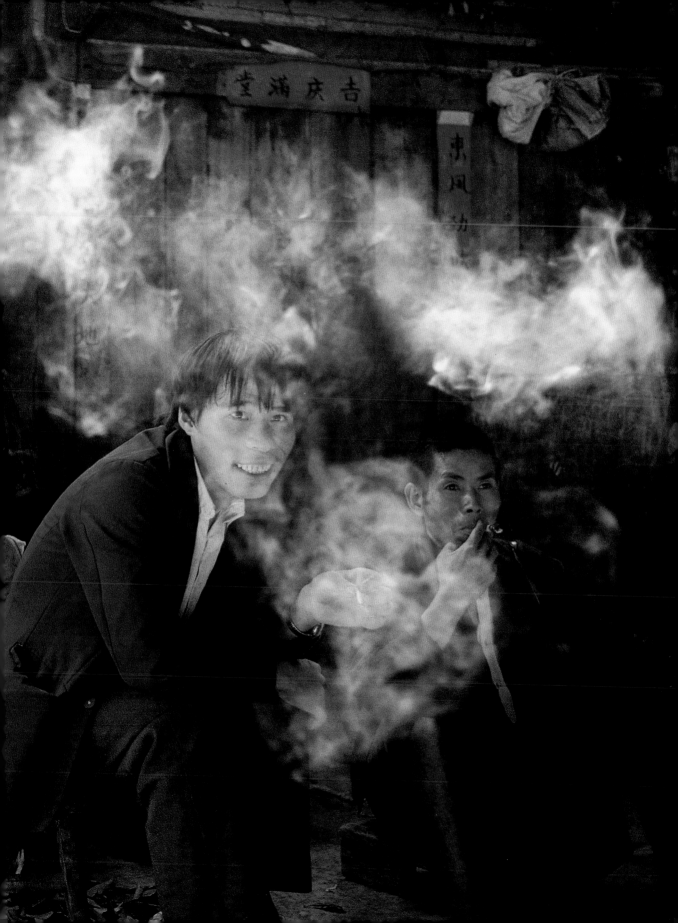

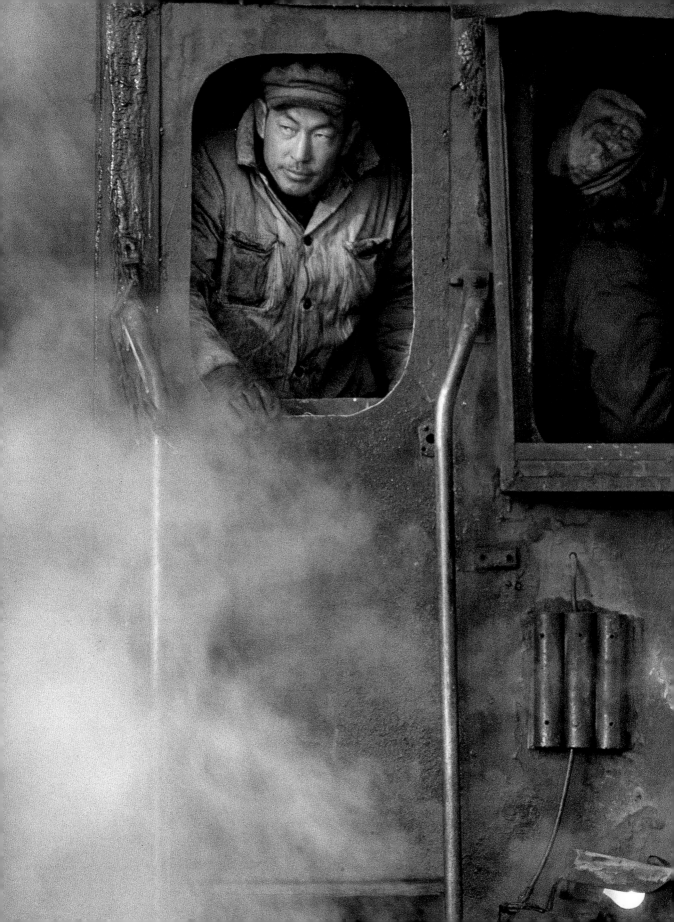

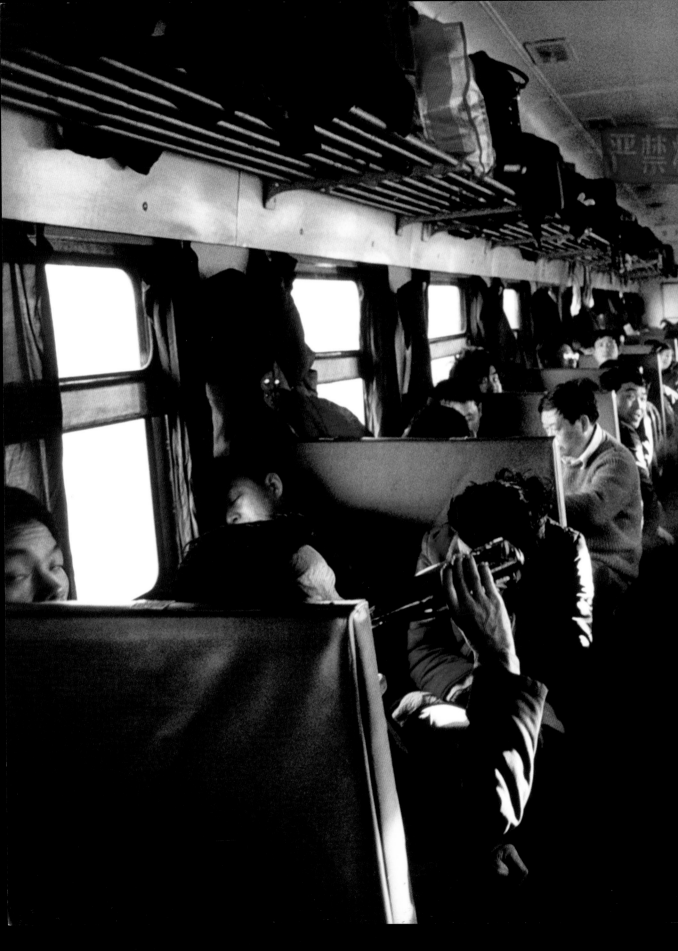

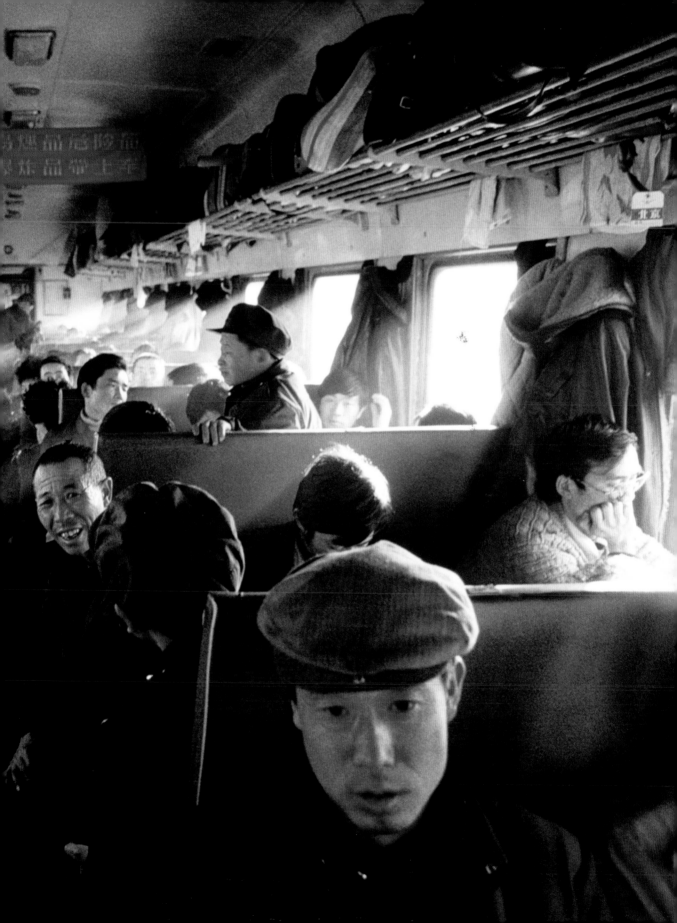

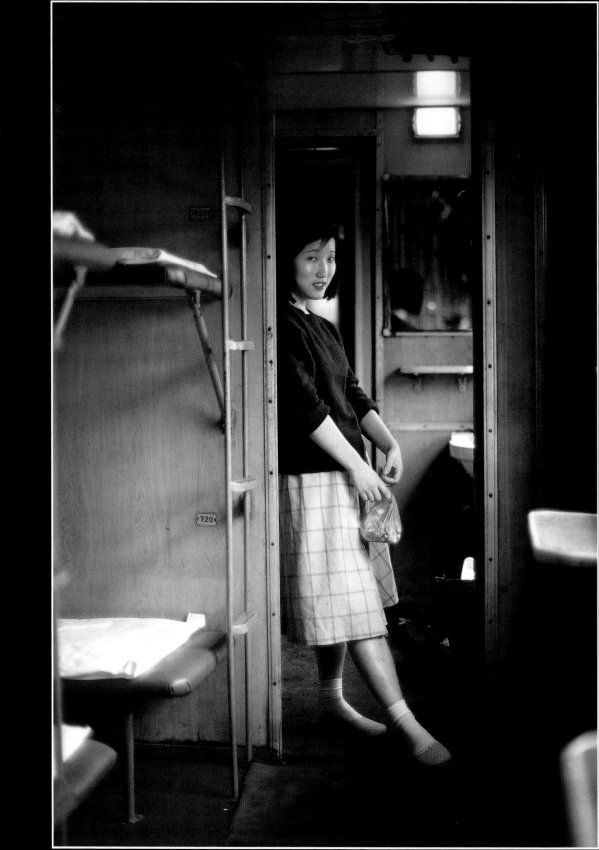

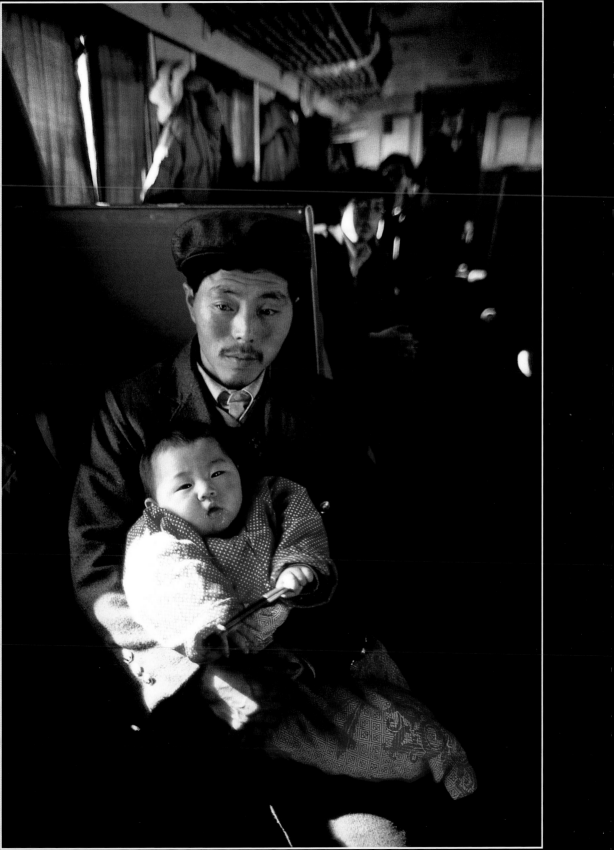

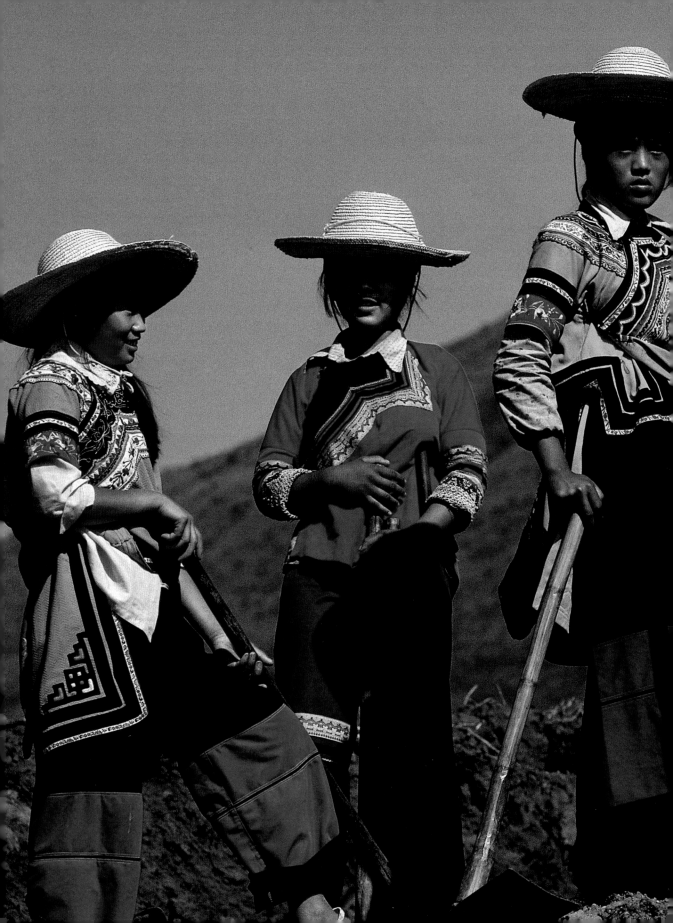

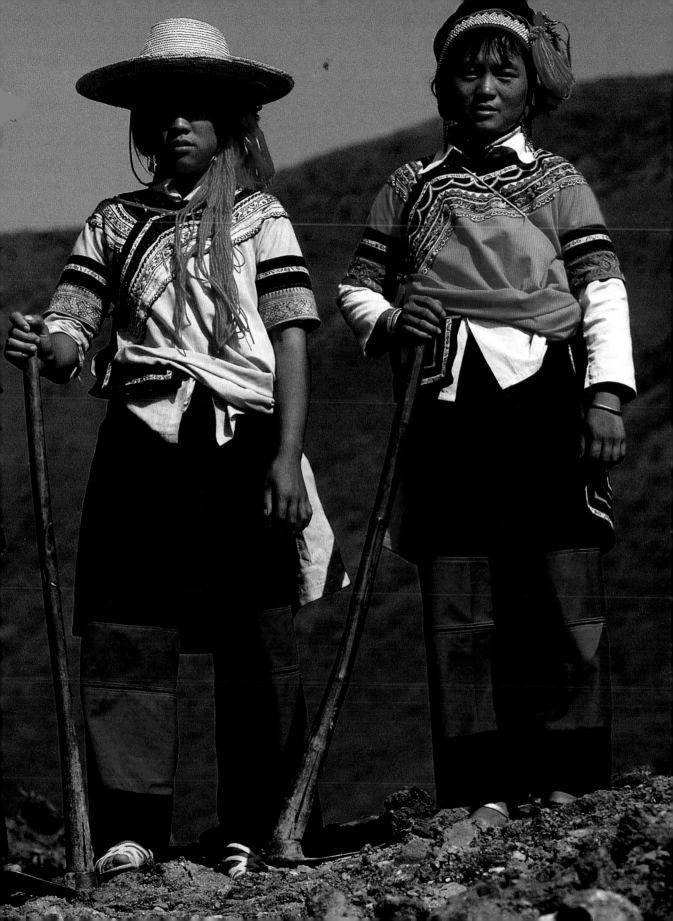

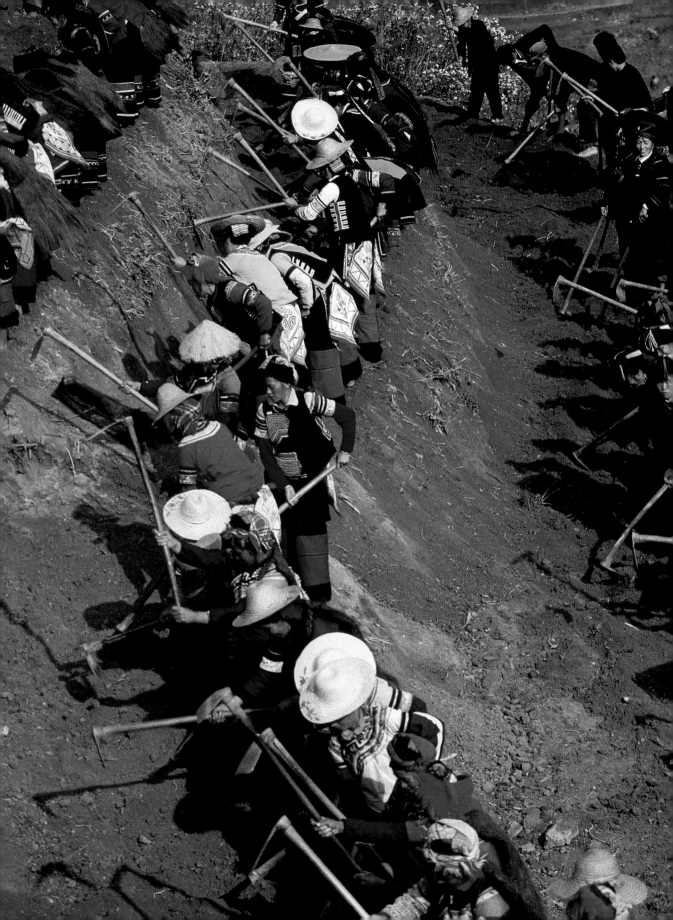

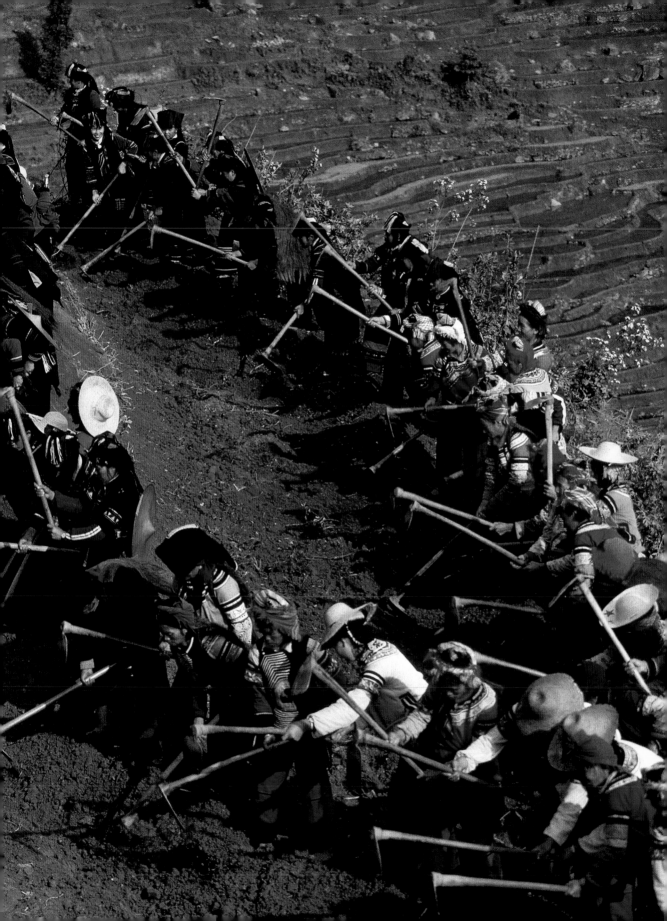

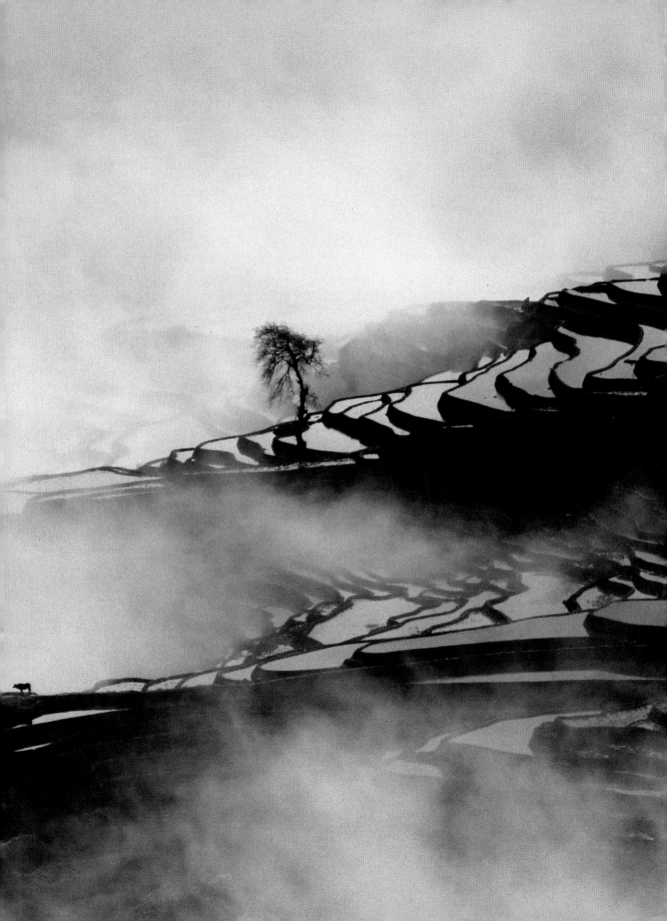

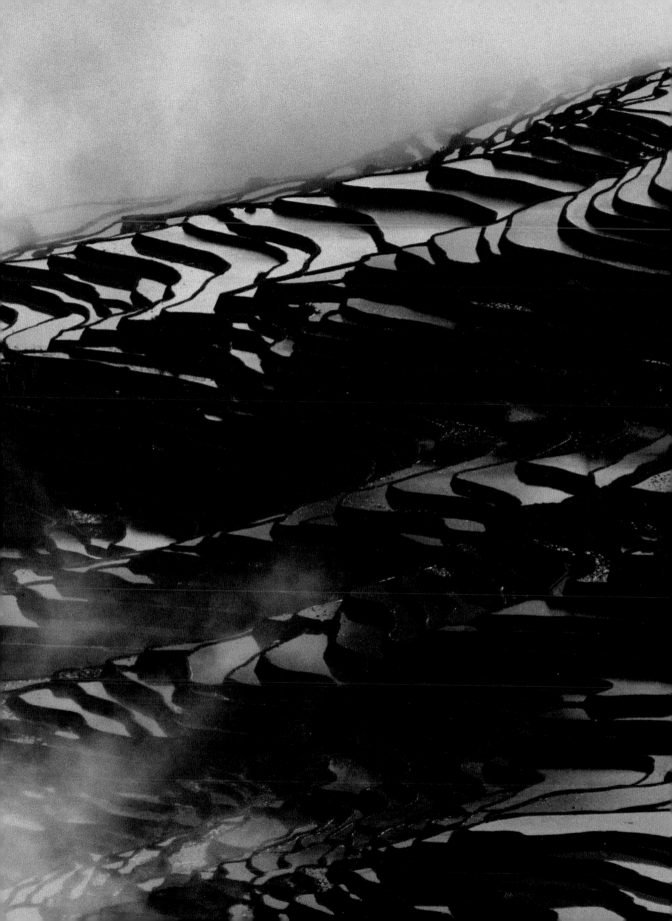

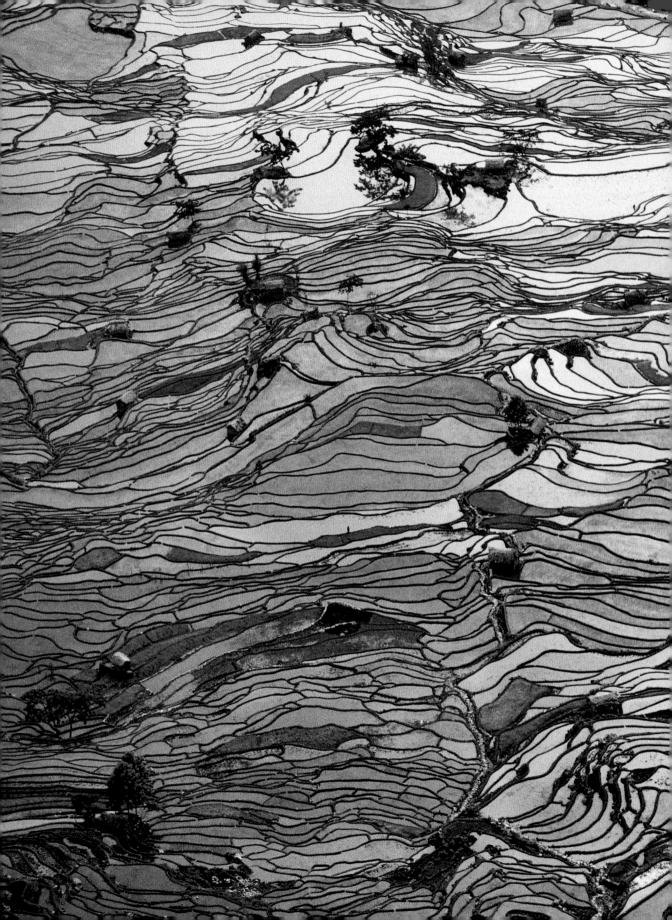

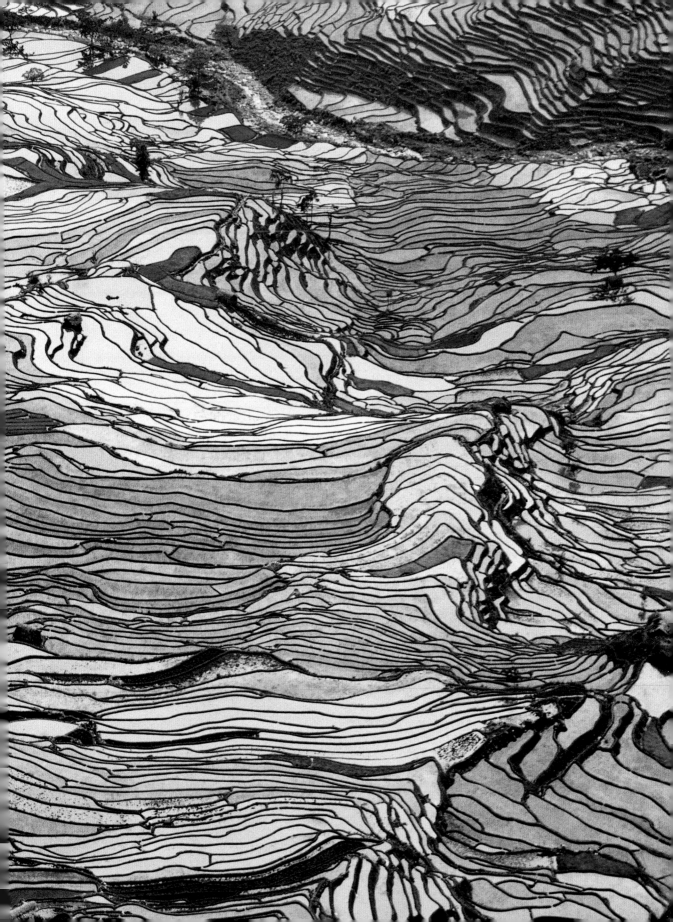

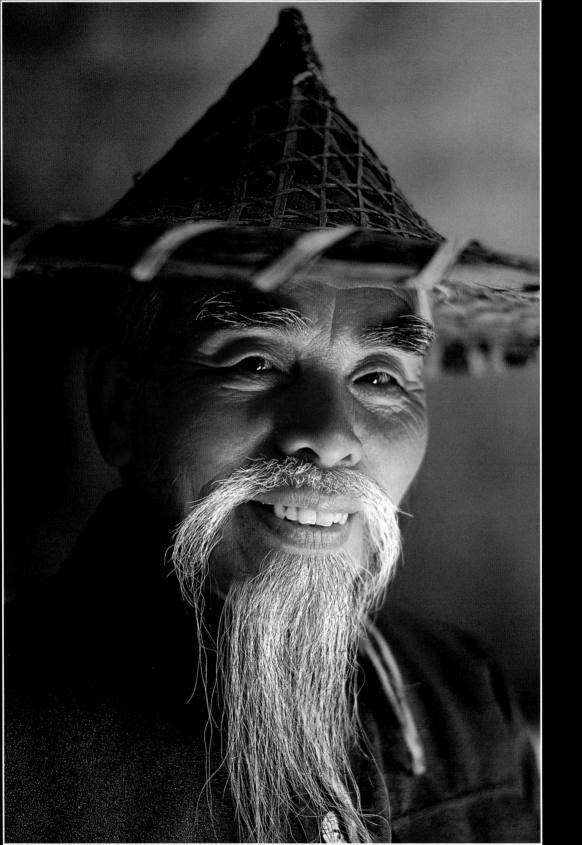

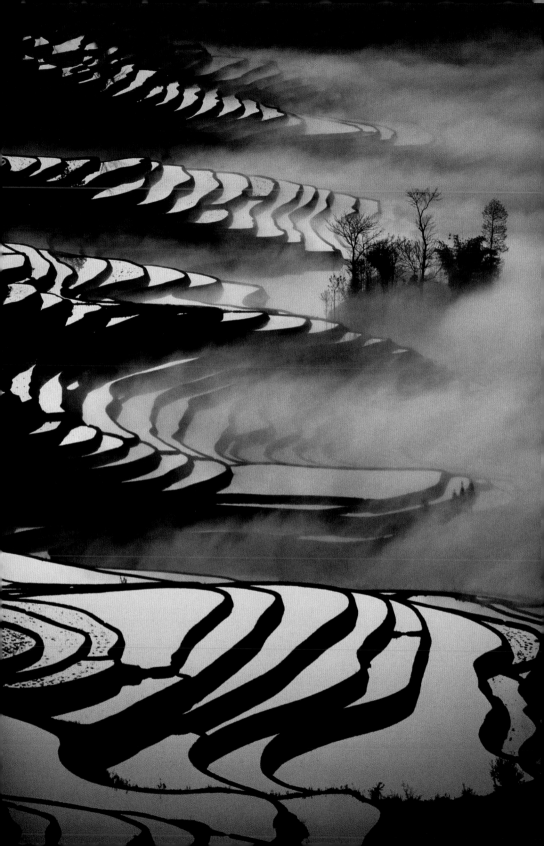

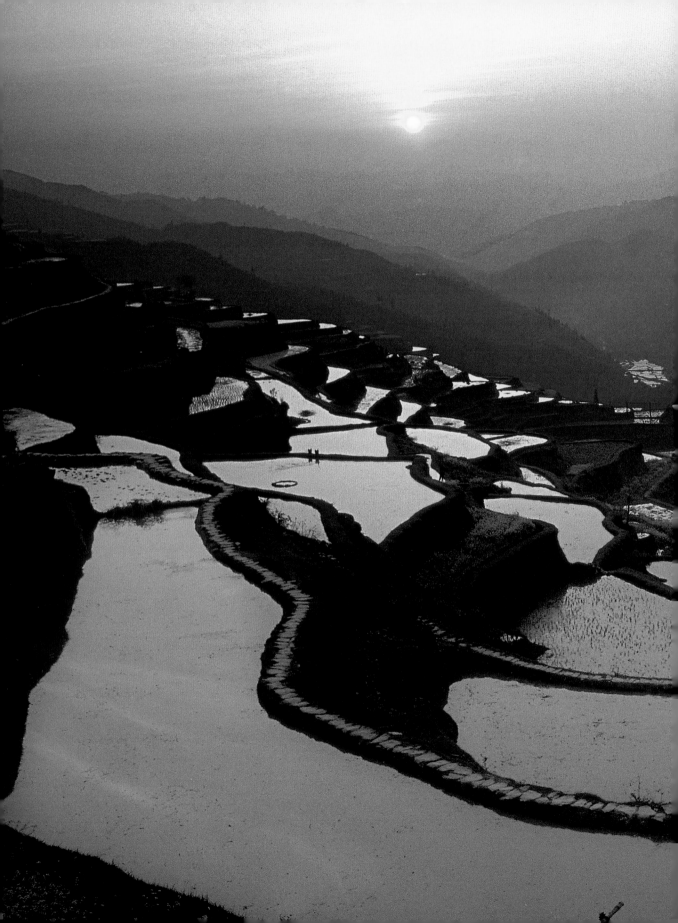

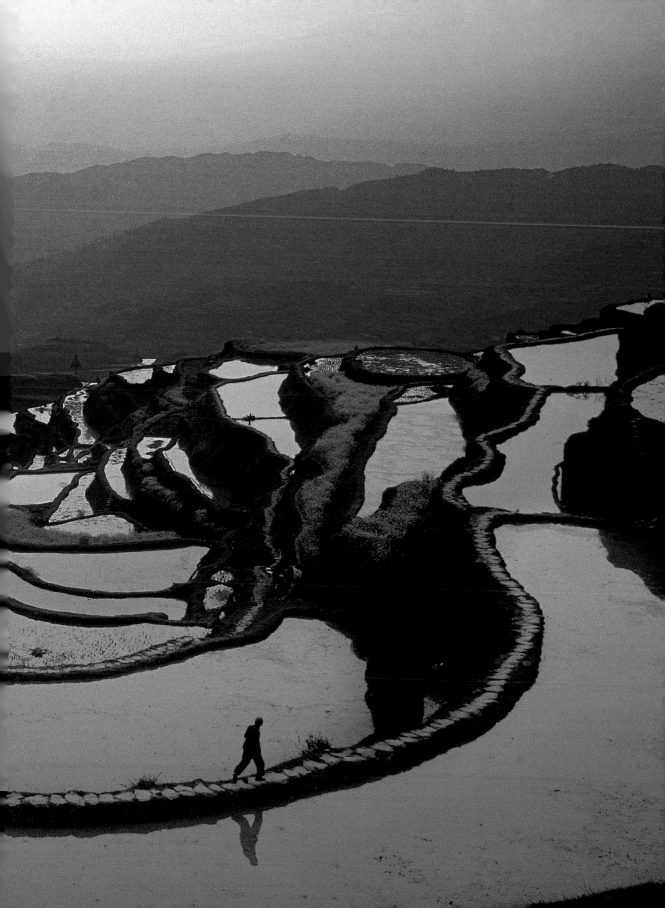

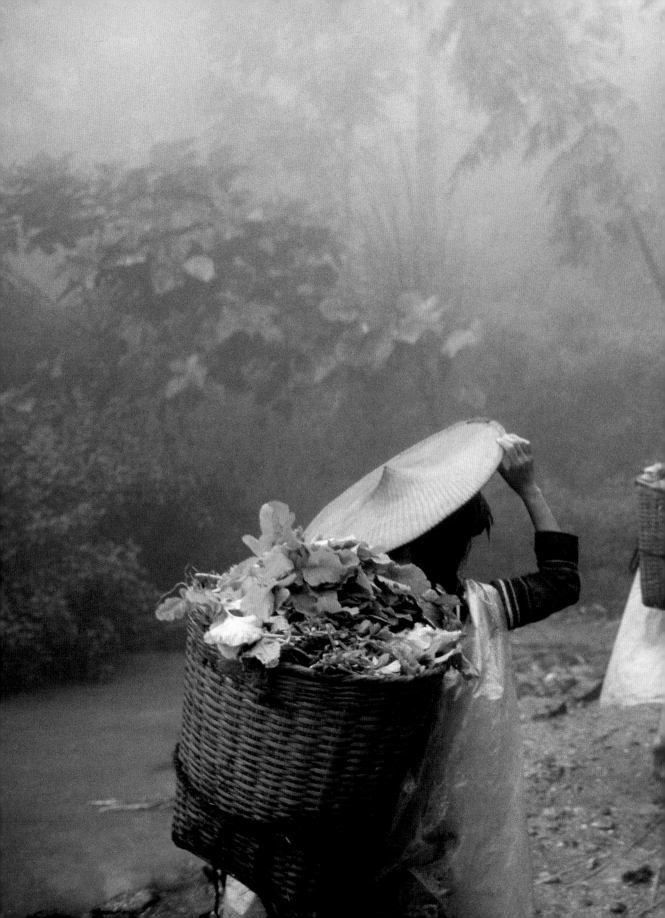

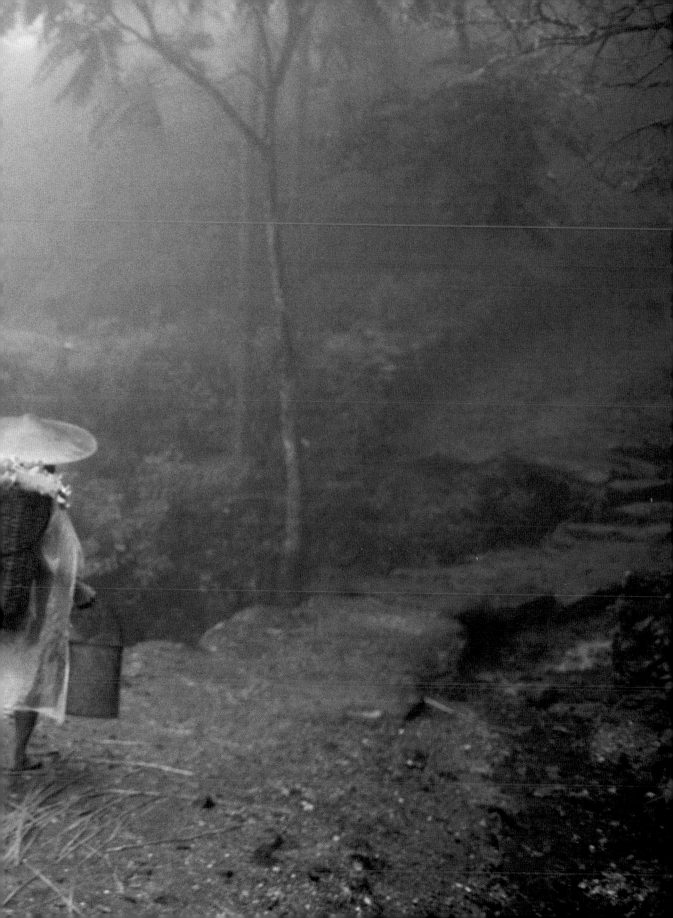

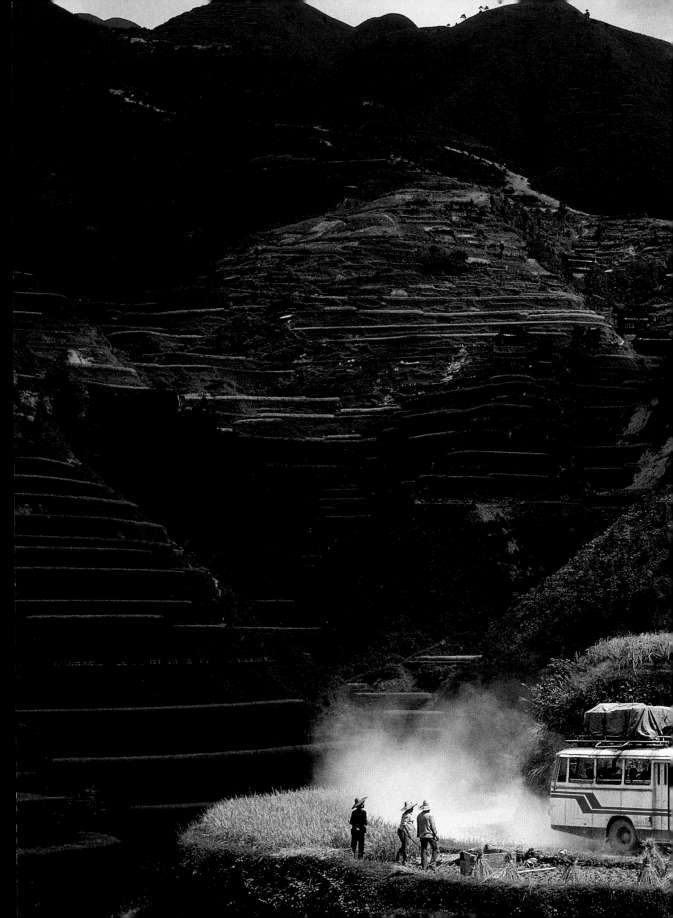

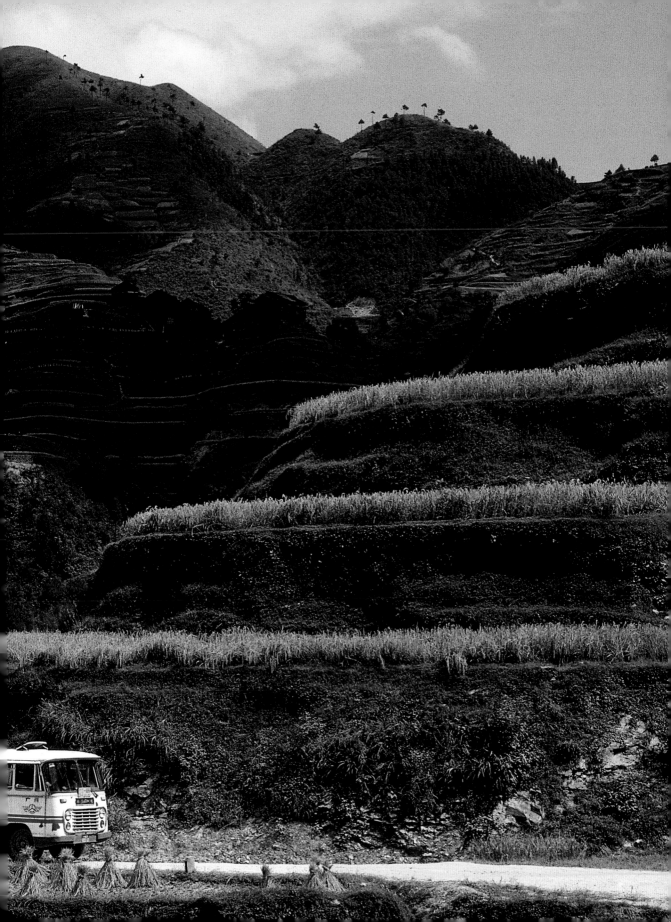

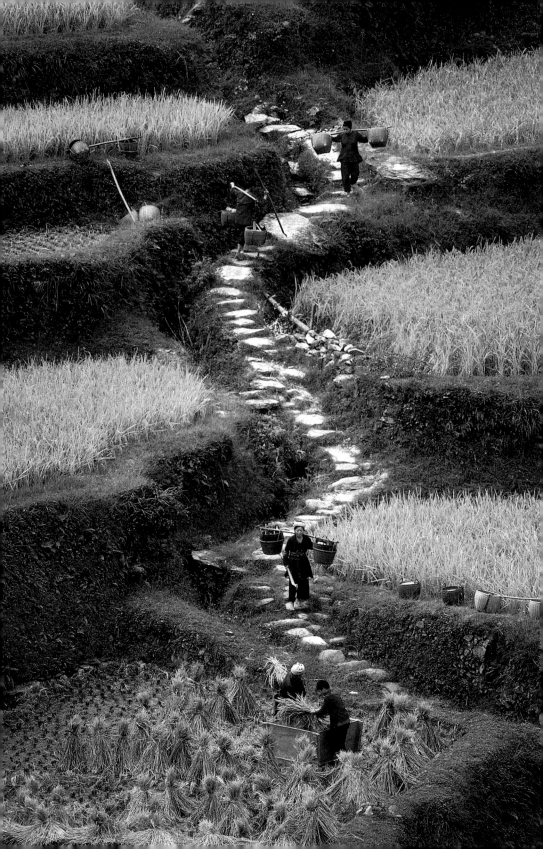

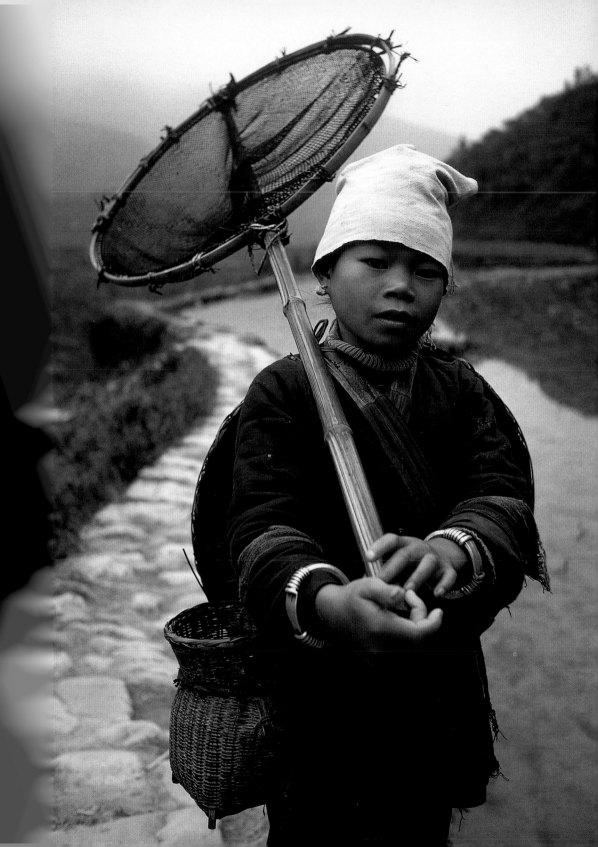

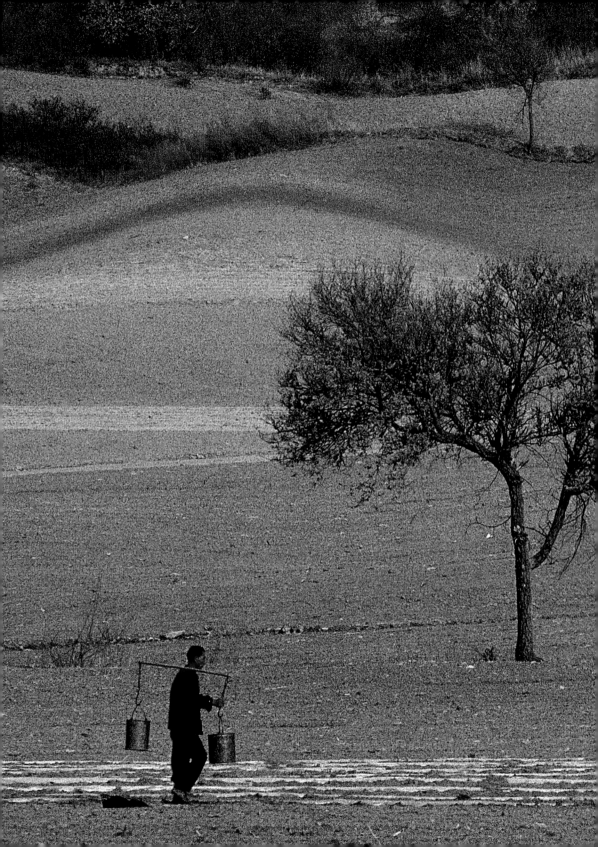

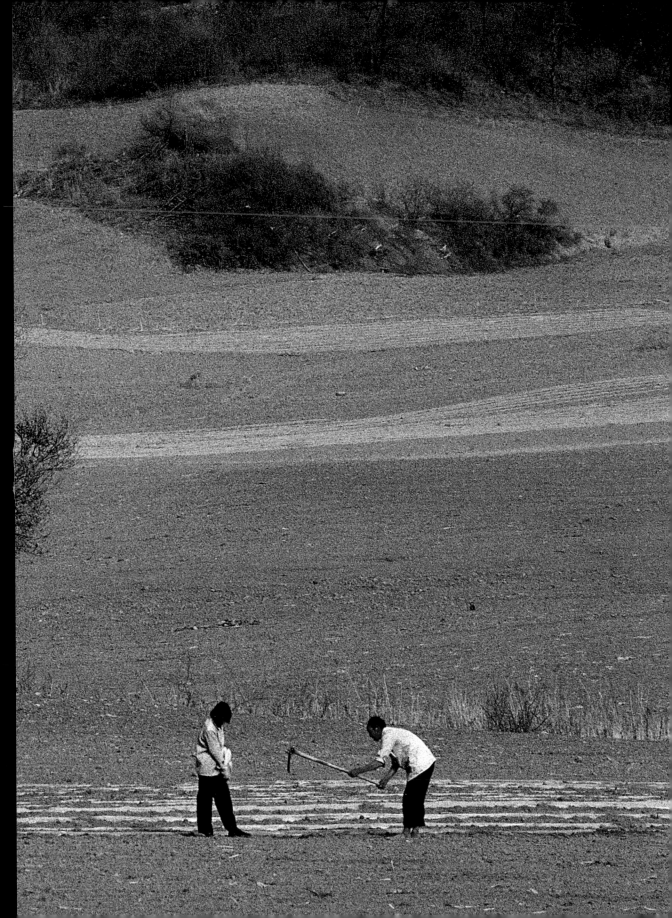

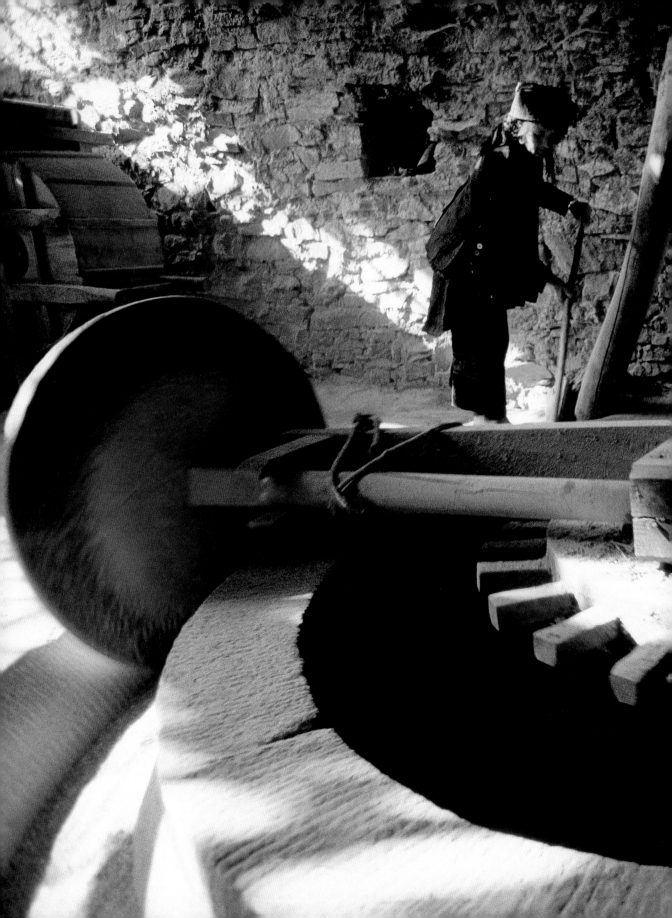

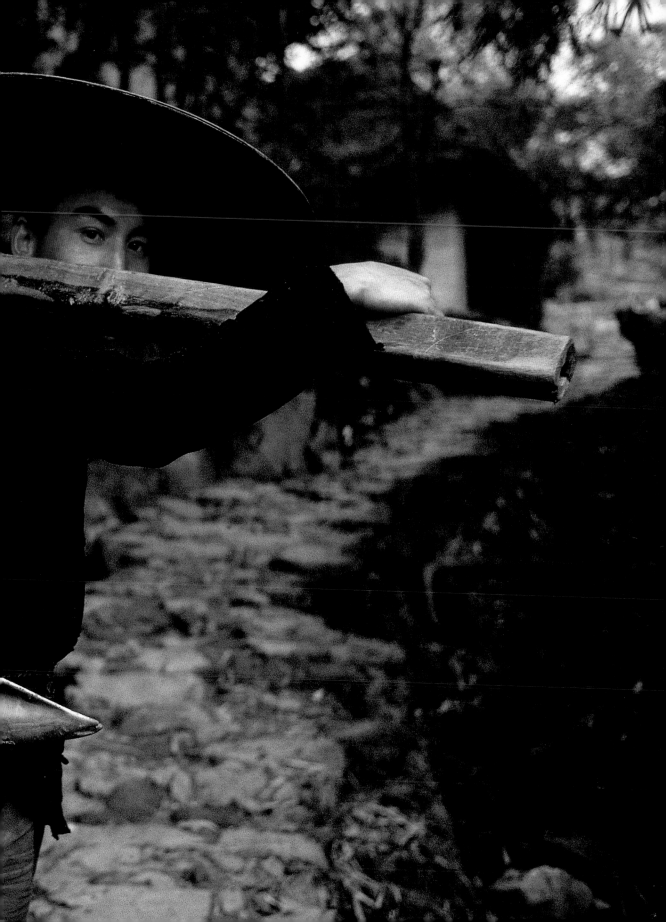

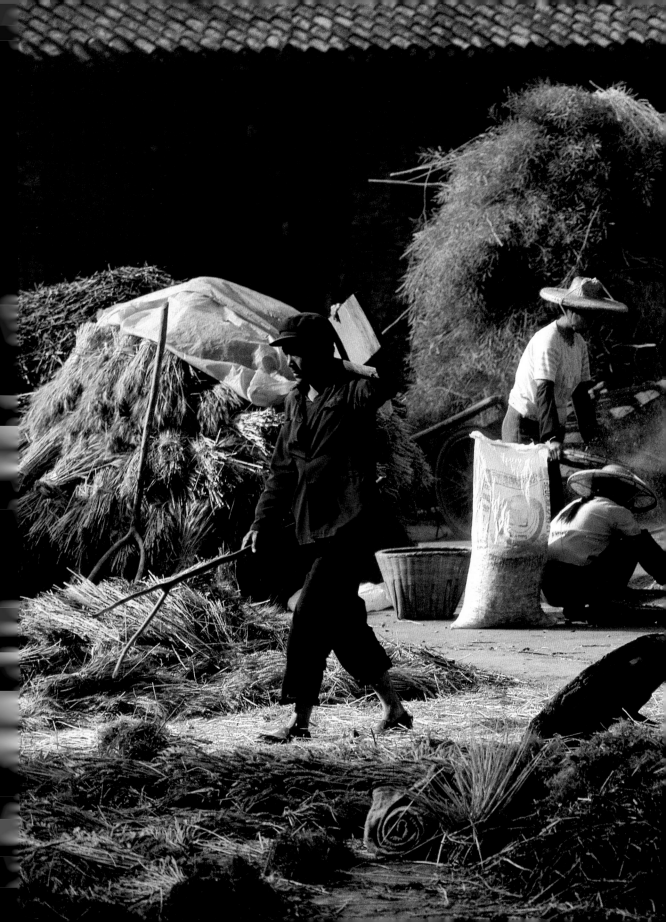

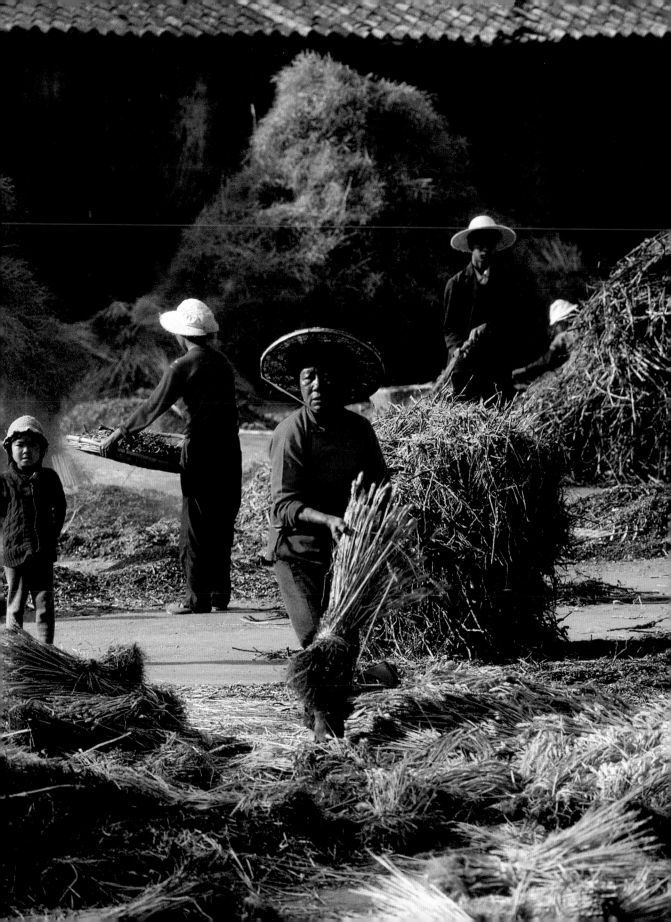

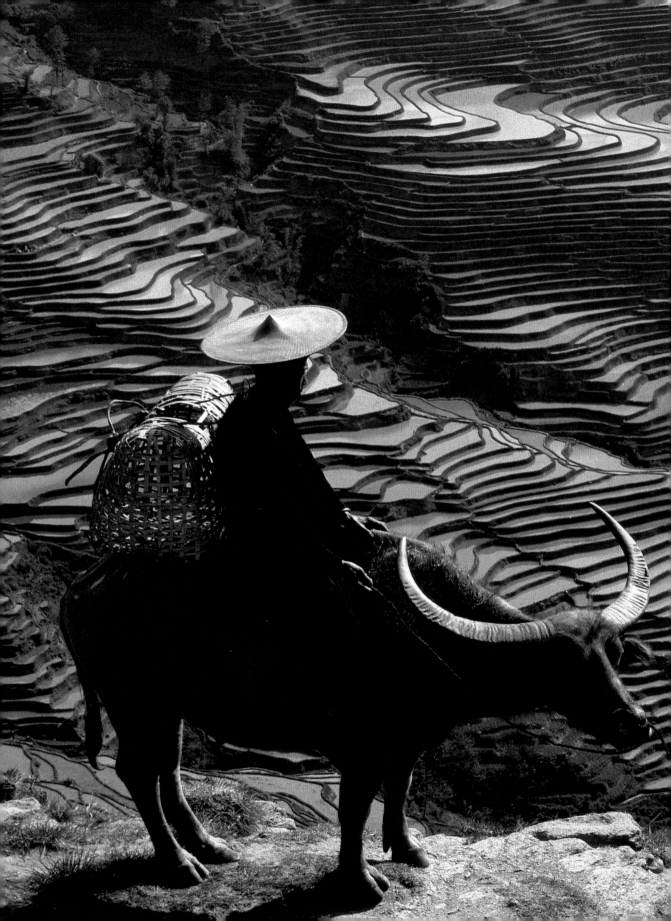

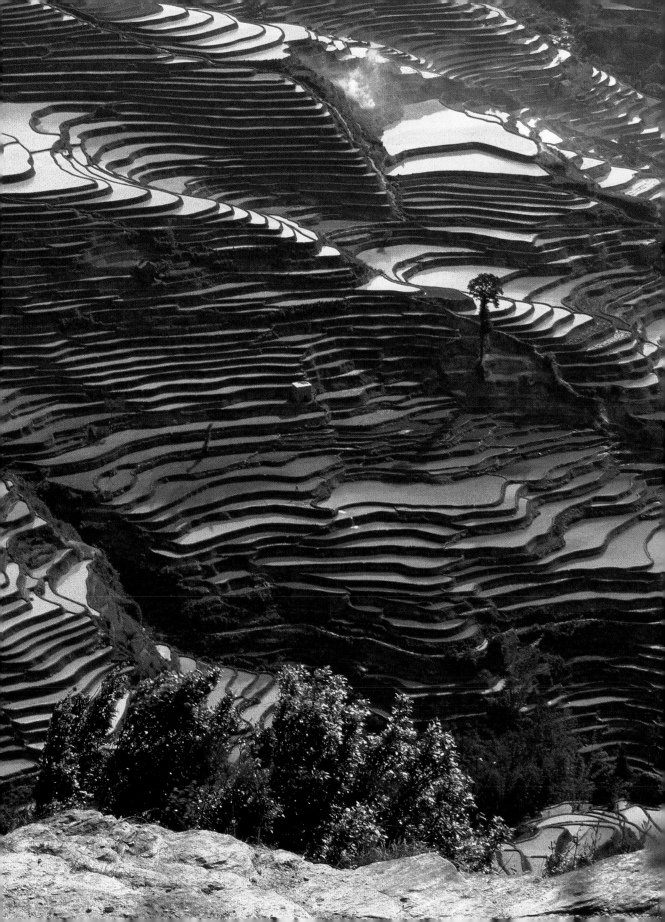

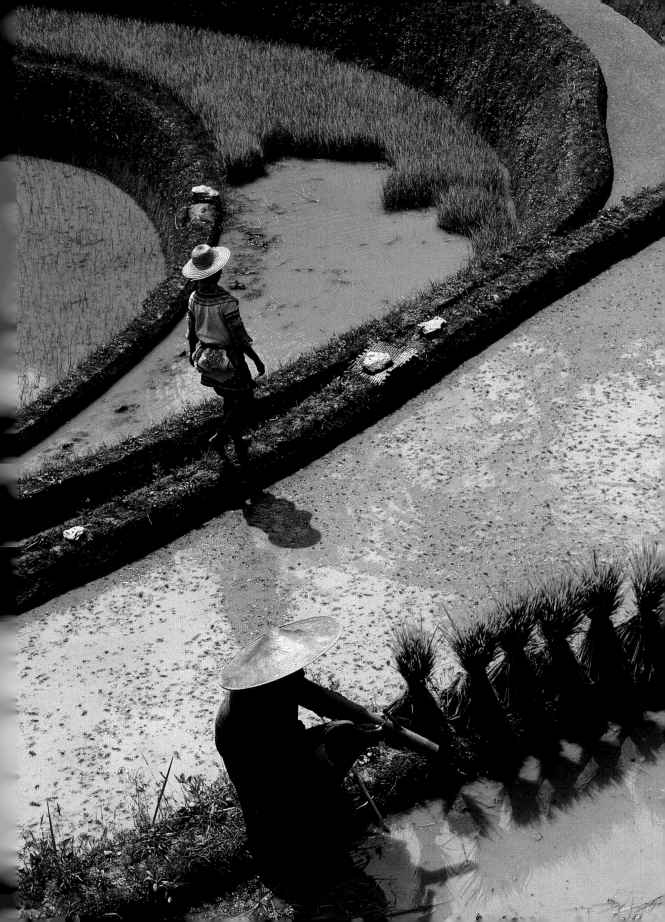

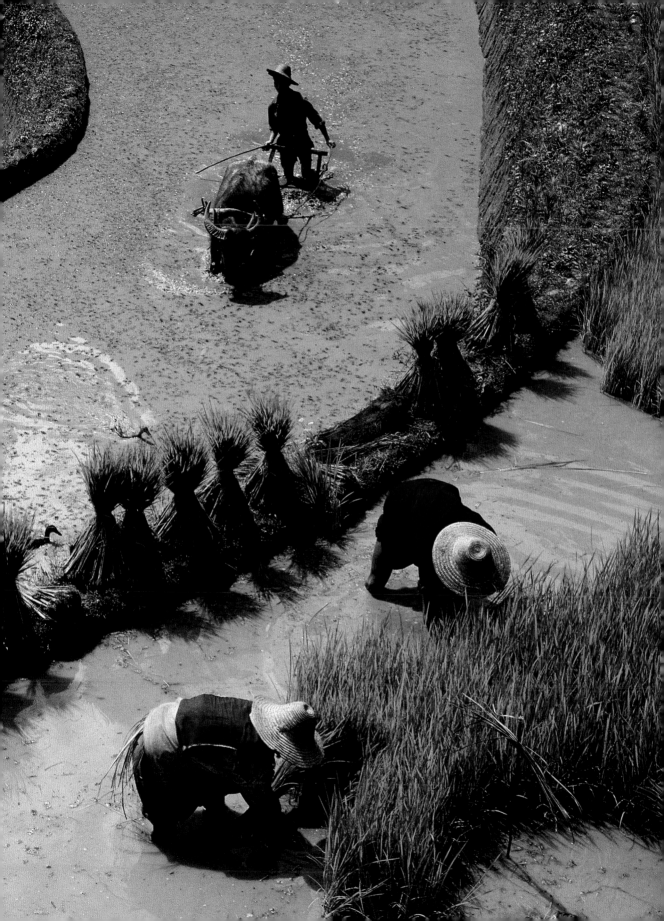

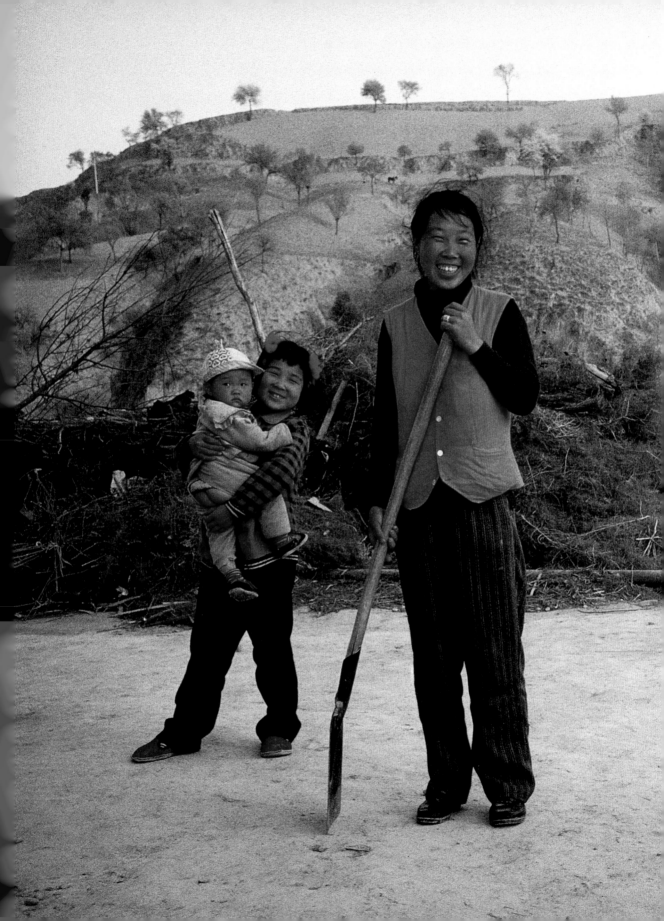

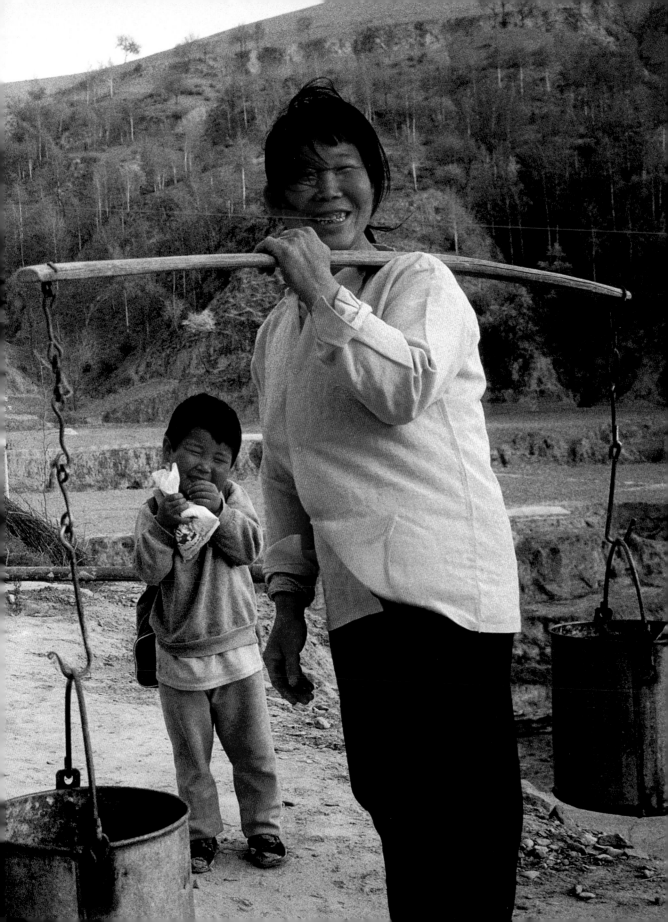

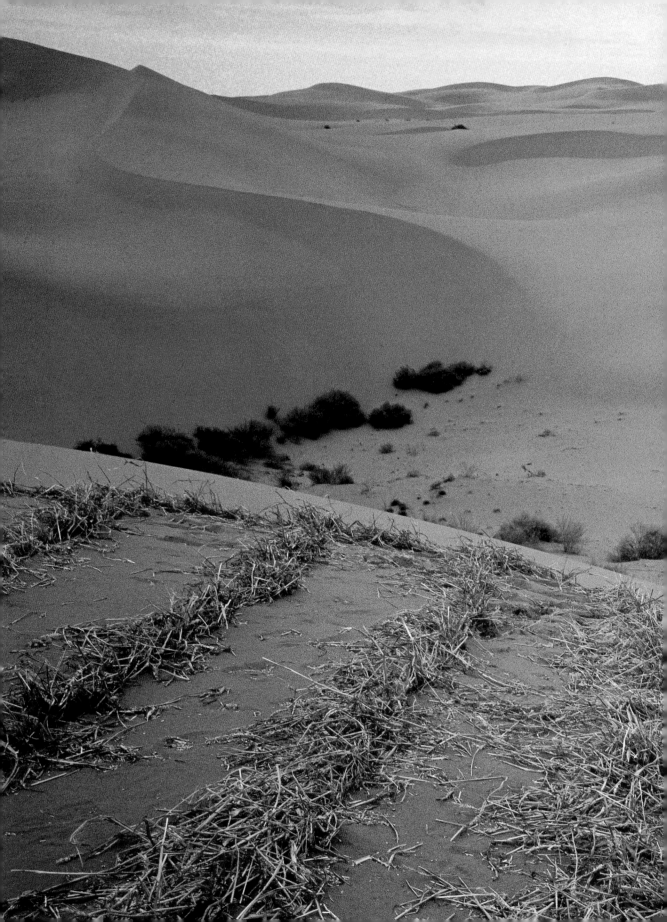

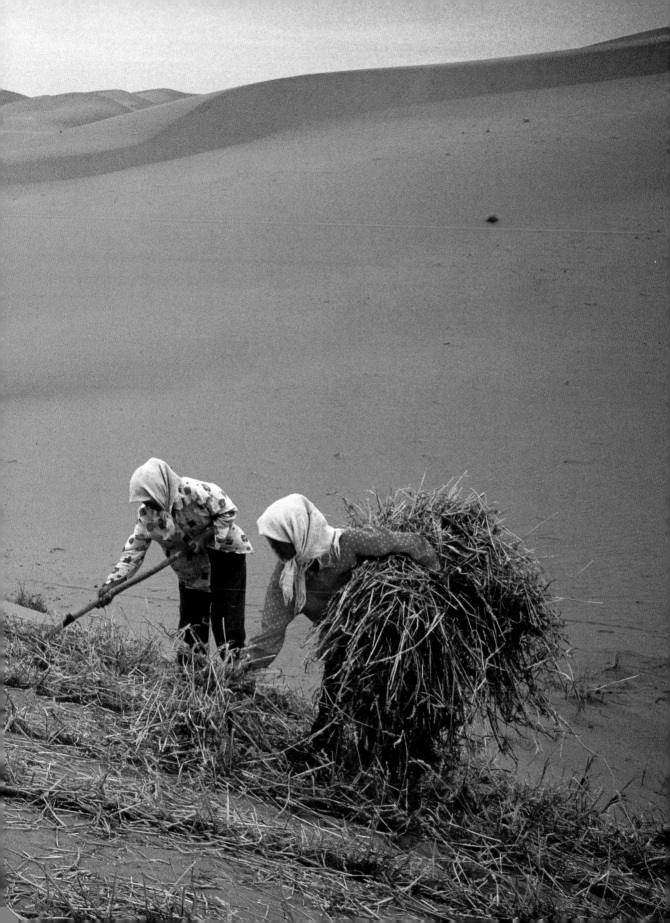

Do not forsake motion to seek tranquility within motion.

Mountain and sea will finally meet one day.

Silence is a friend that will never betray you.

It is better to see once than to read a hundred times.

To be human is to love people.

To be wise is to know them.

The moment presented by chance is better than the one you choose.

Do quickly what is not urgent, do slowly what is urgent.

*Do not speak well of yourself, for you will not be believed; nor ill of
 yourself, for you will be believed.*

Watch people instead of listening to them.

*If you doubt what you see,
 how can you believe what you are told?*

For those lacking foresight, sorrow is never far off.

Small impatience, great imprudence.

The rose has thorns only for the one who picks it.

The weighty is the root of the slight, calm is the master of movement.

Ten steps to go: nine is halfway there.

Do not be afraid of being slow; be afraid of not moving at all.

He who discovers the new in the old can be a master.

*Whoever is indifferent to slander looks upon events with
 detachment.*

Good makes no noise; noise does no good.

Time will open doors for those who wait.

One day is worth three for those who do each thing at its time.

The greater the daring, the loftier the art.

Who recognizes his ignorance is not ignorant.

A gentleman wishes to be slow to speak and quick to act.

*Calm water reflects the world; the mind of a wise man is the mirror
 of the universe.*

Happiness comes to those who know how to laugh.

If the division is equal, there will be no poor.

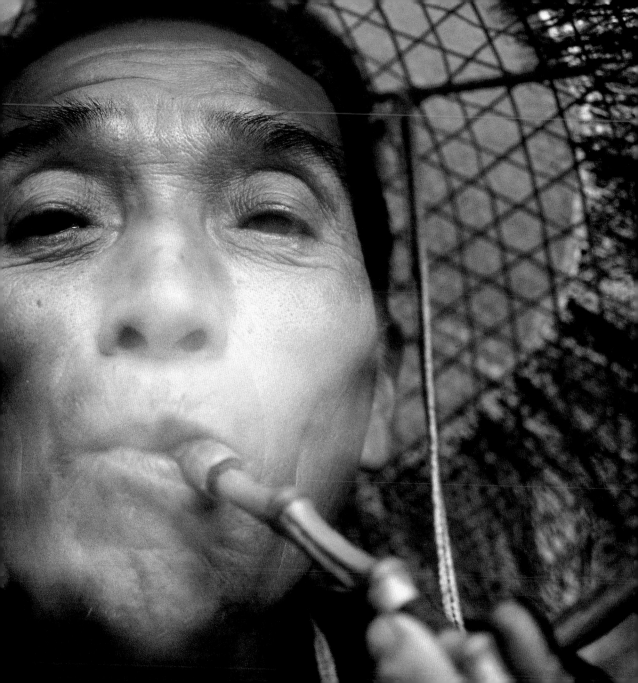

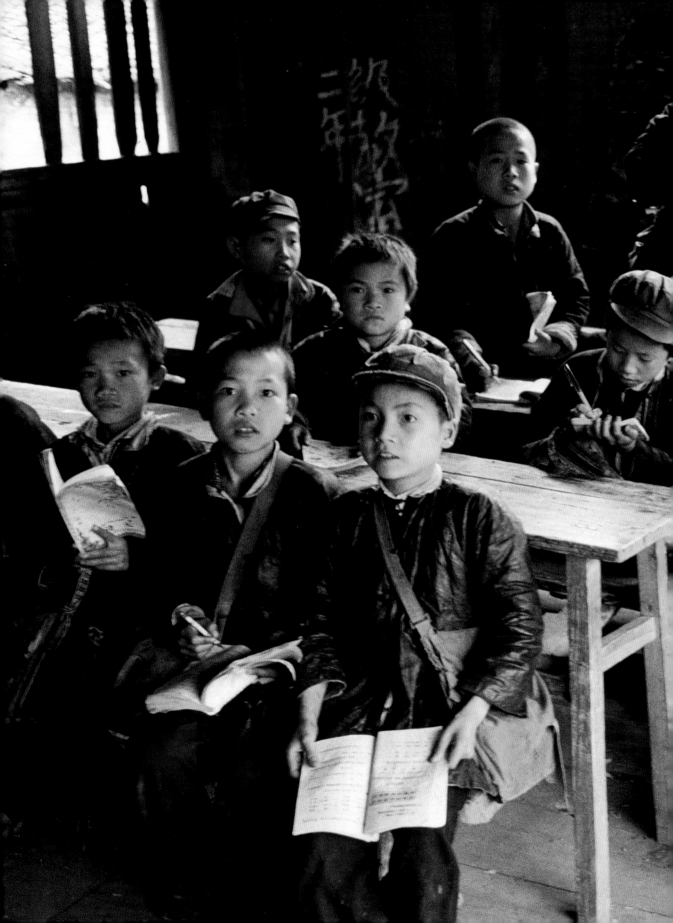

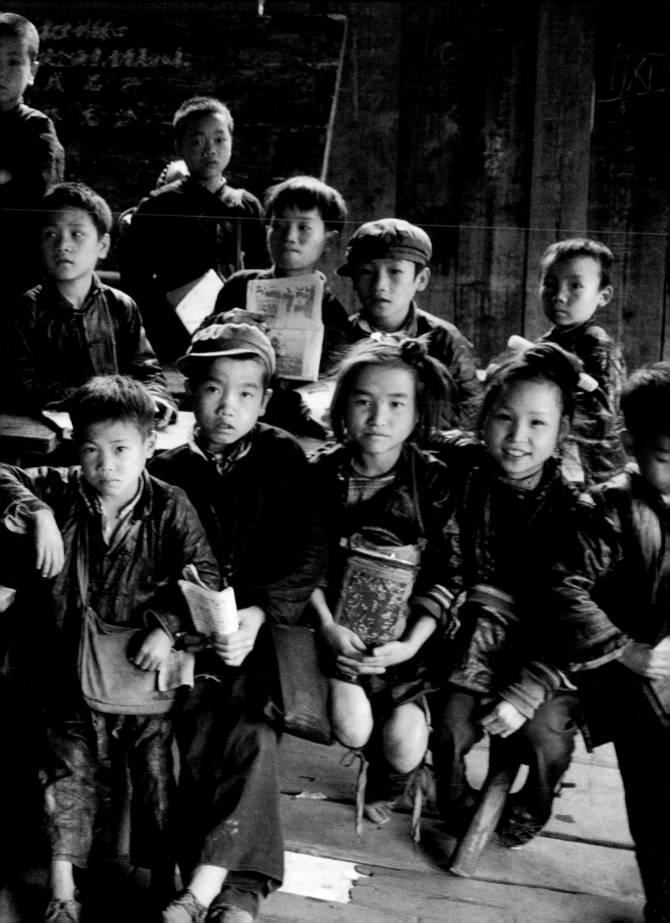

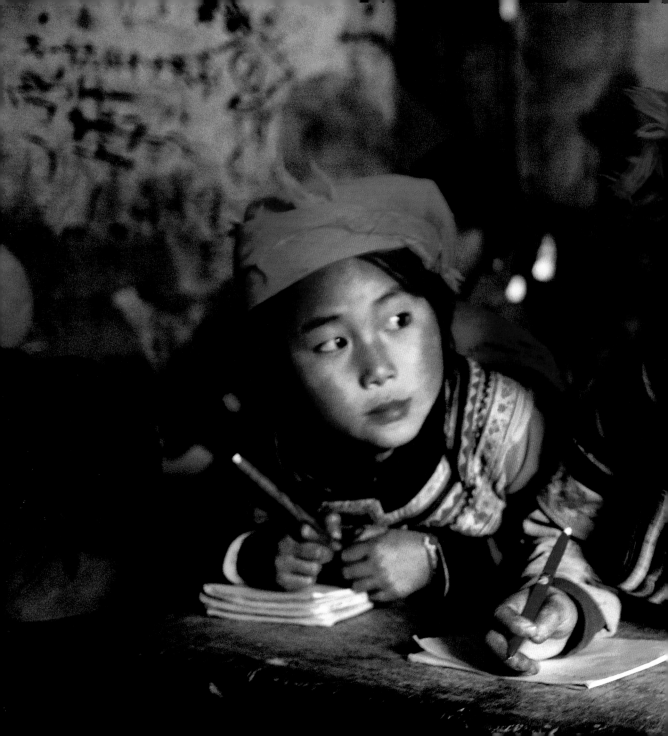

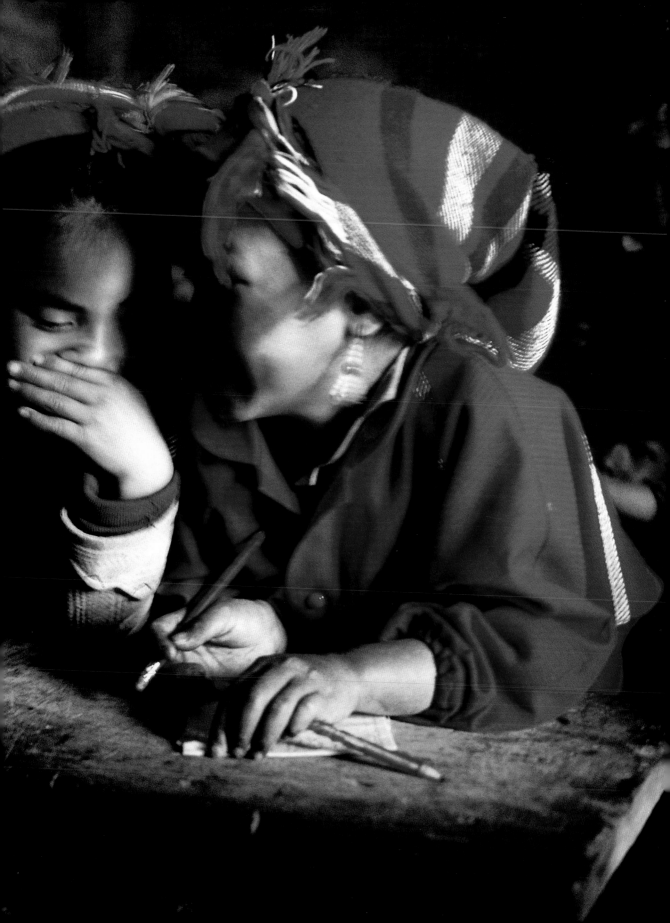

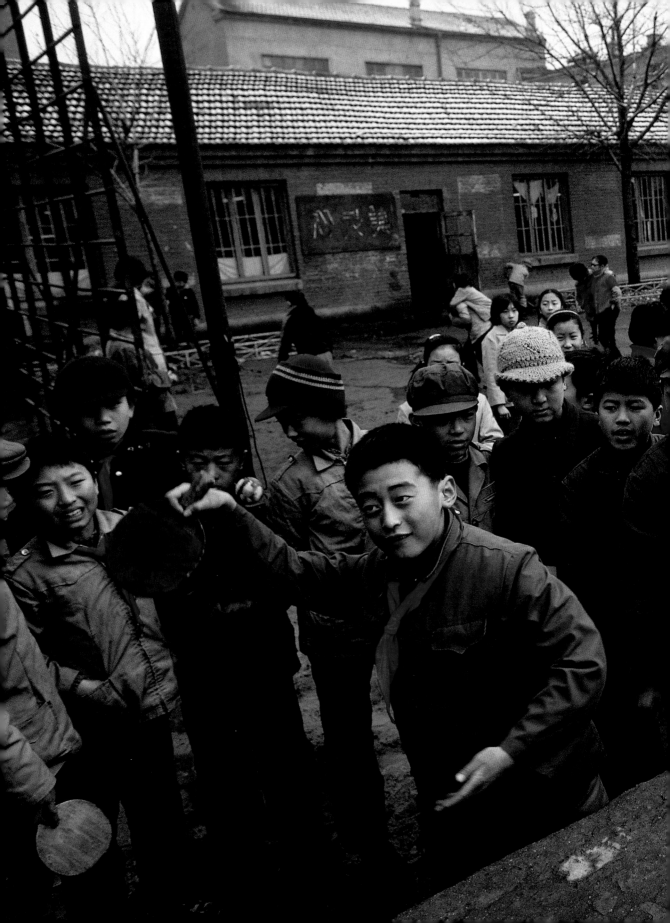

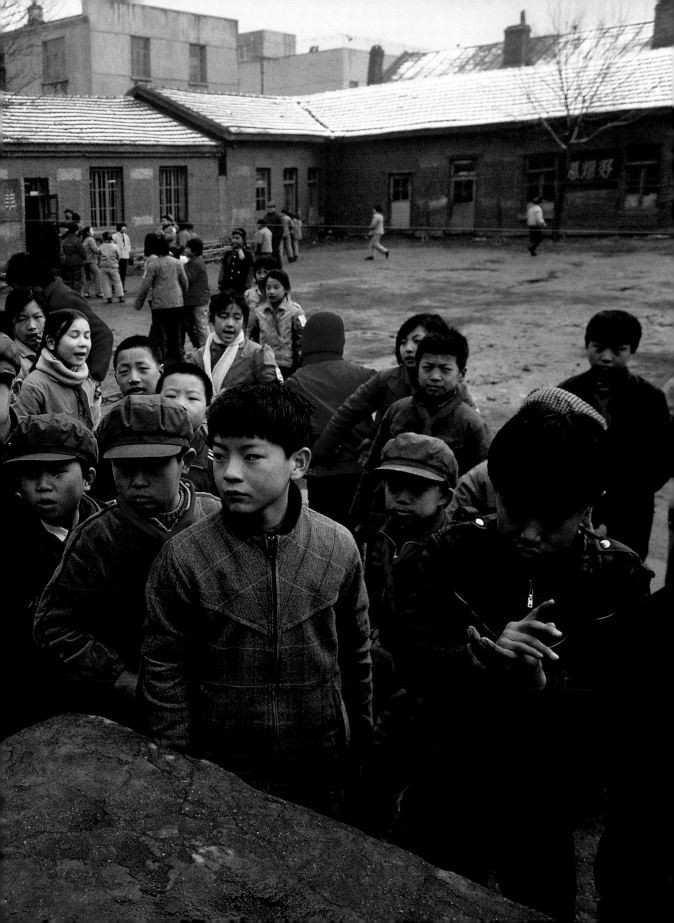

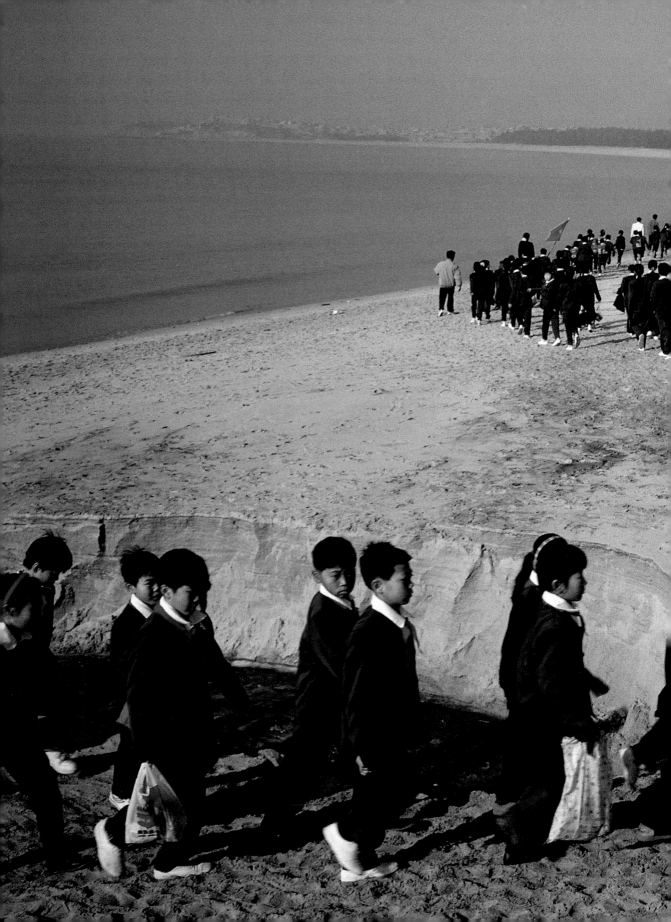

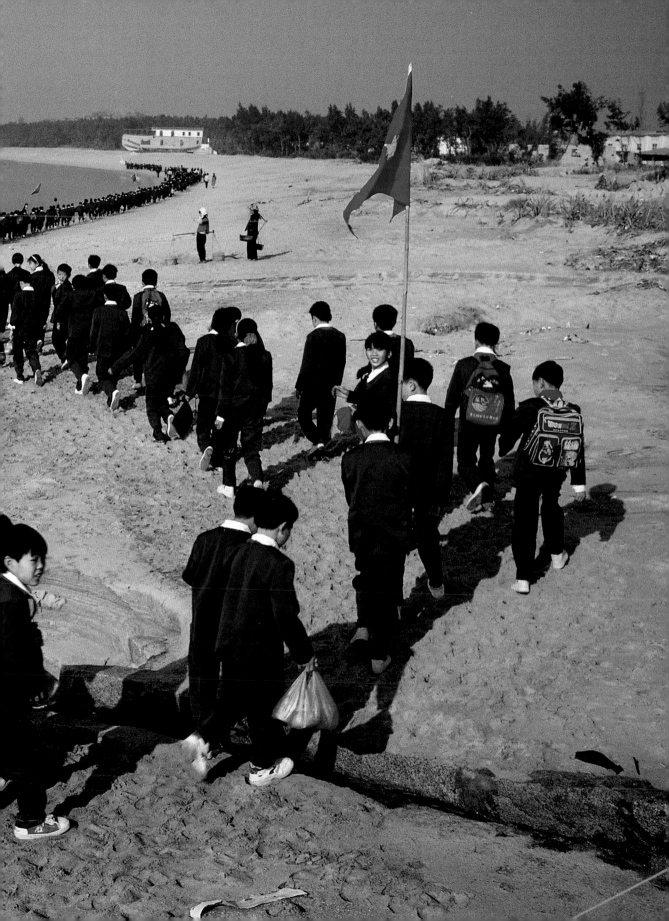

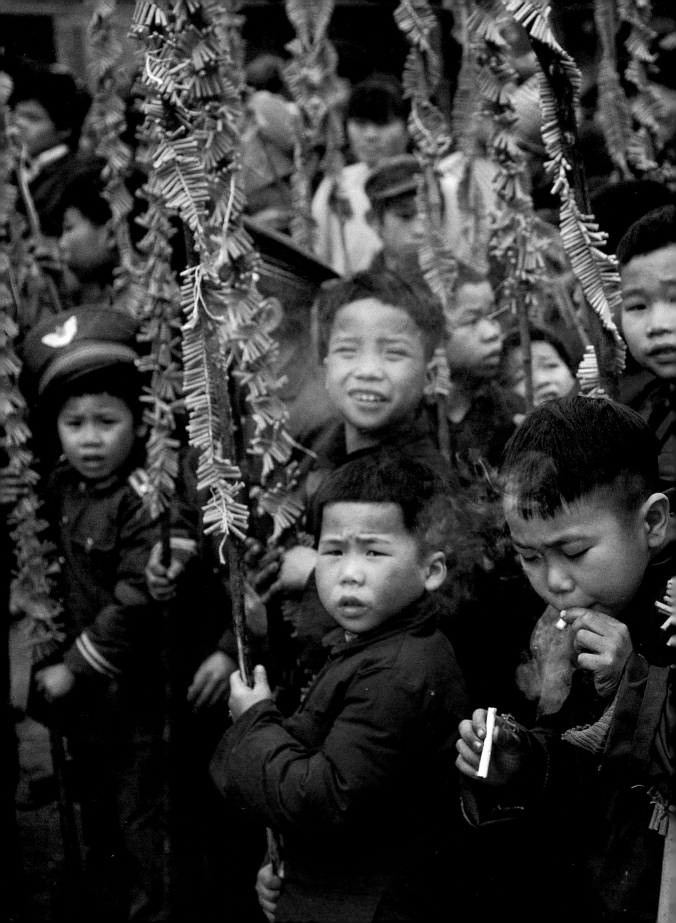

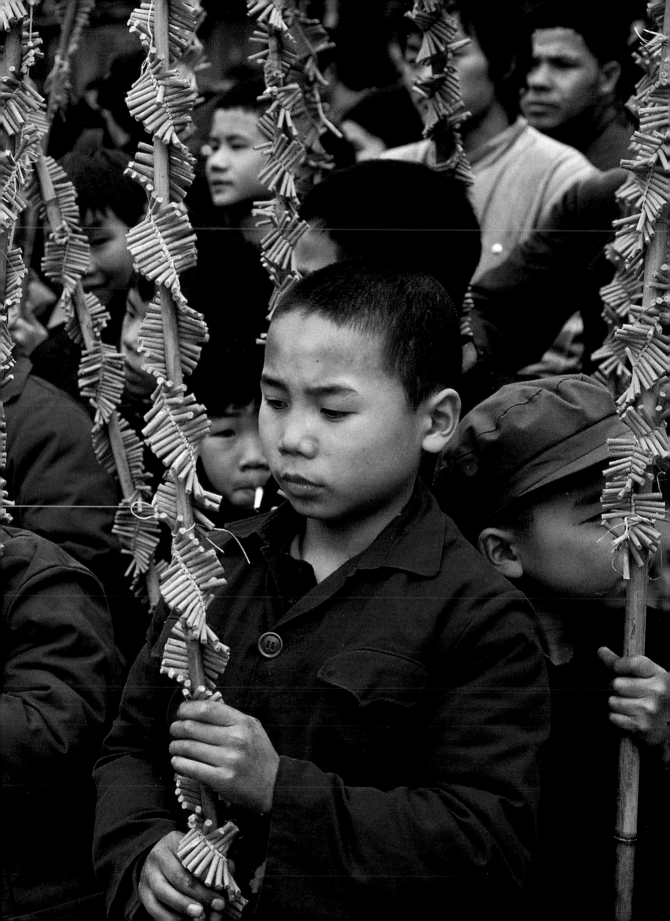

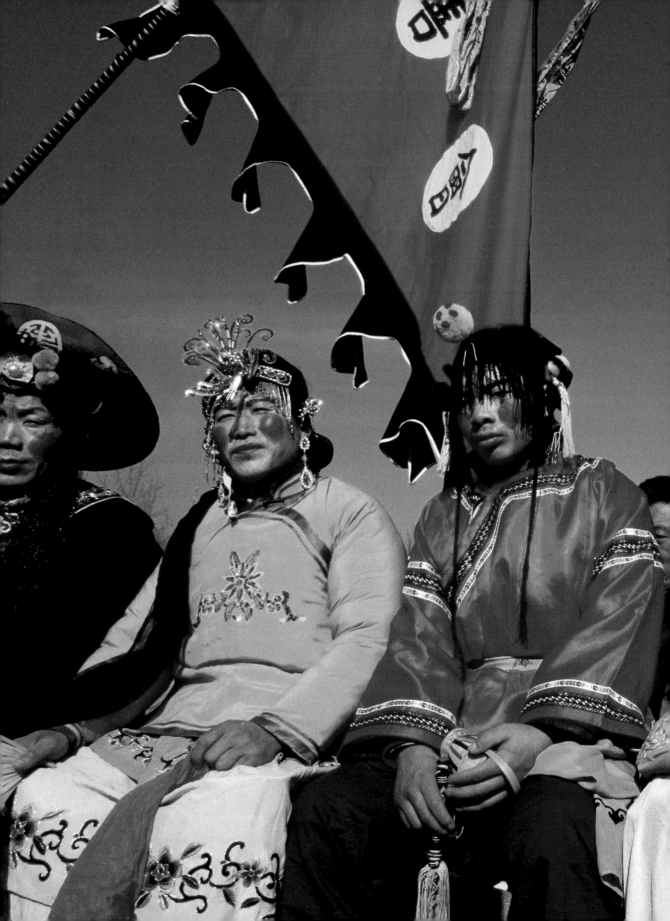

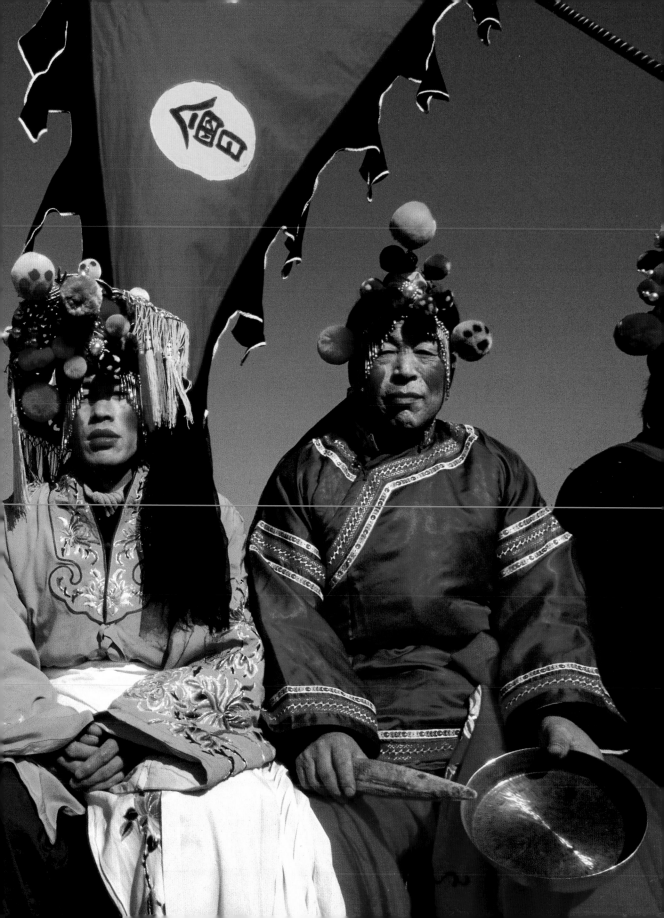

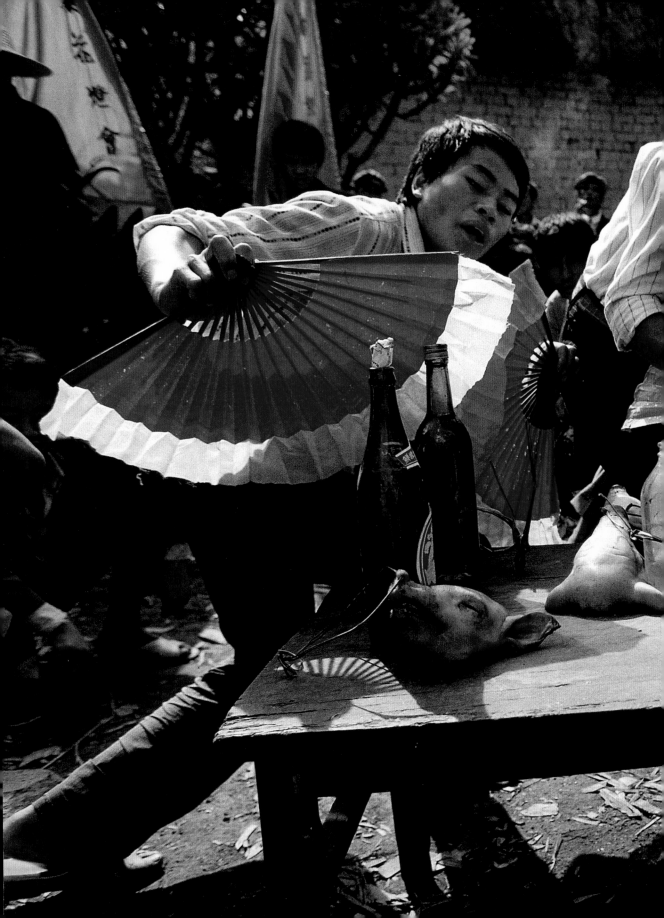

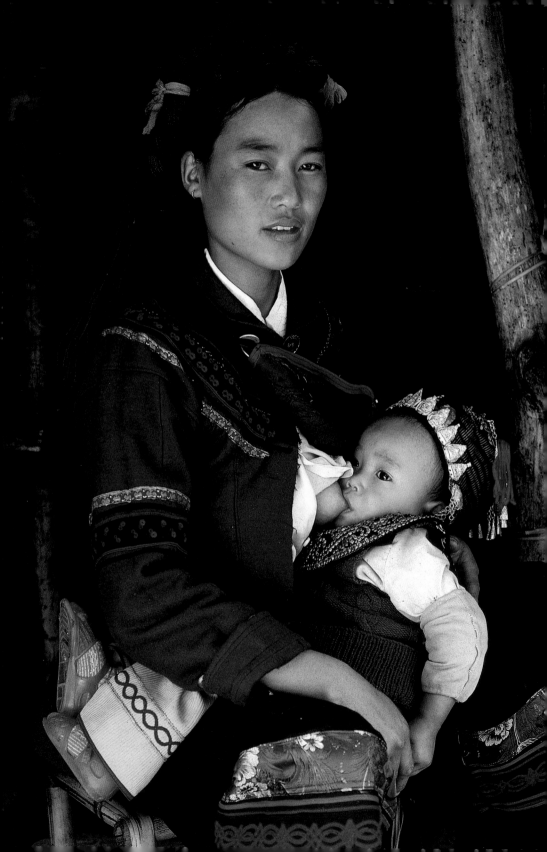

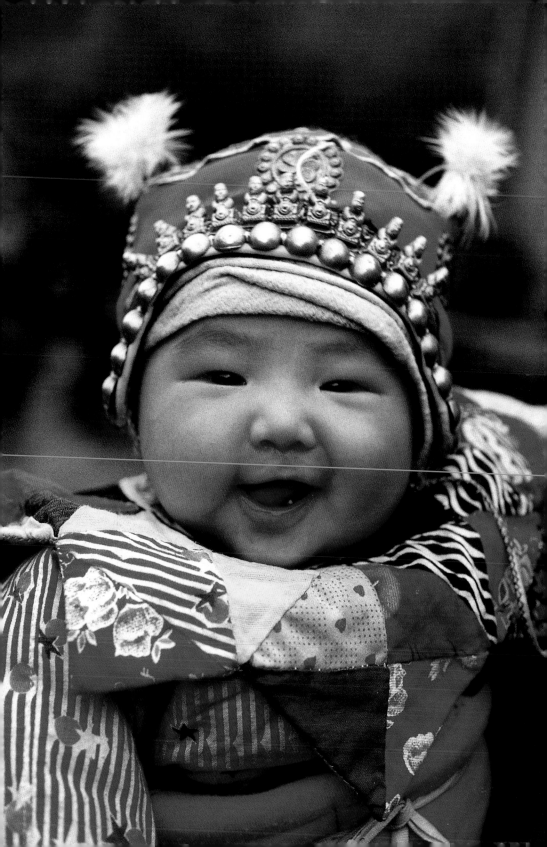

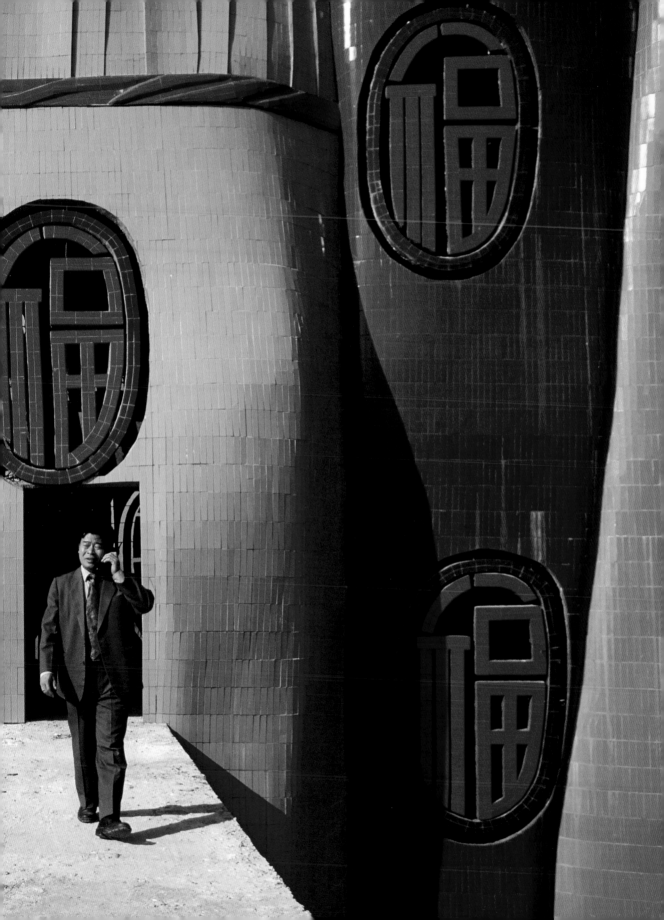

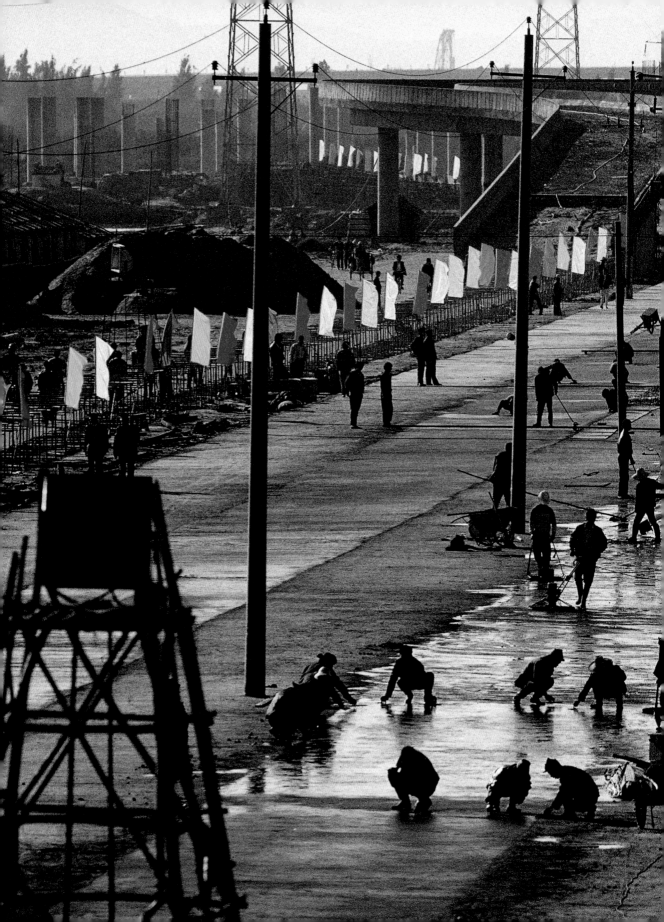

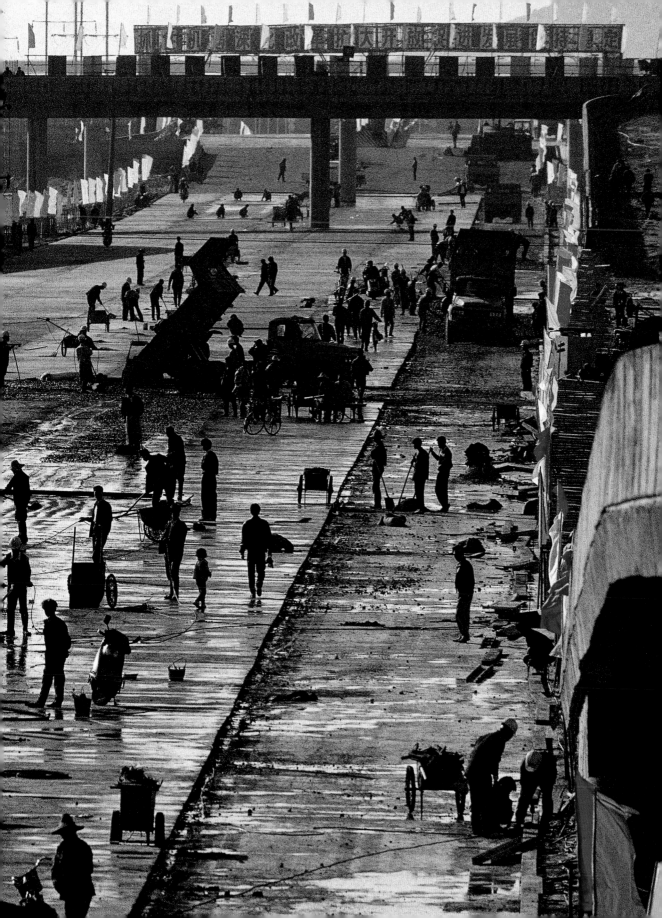

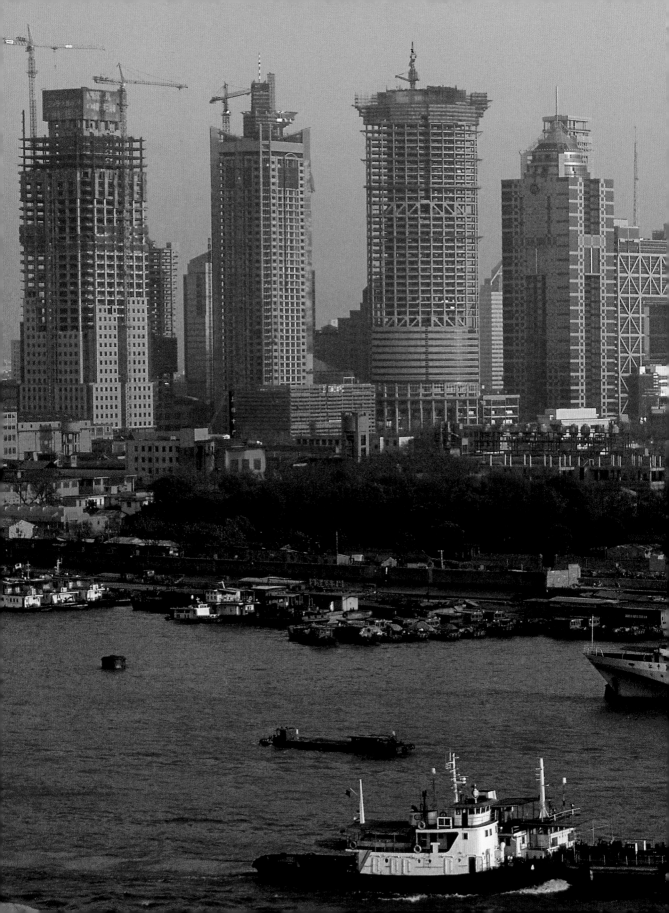

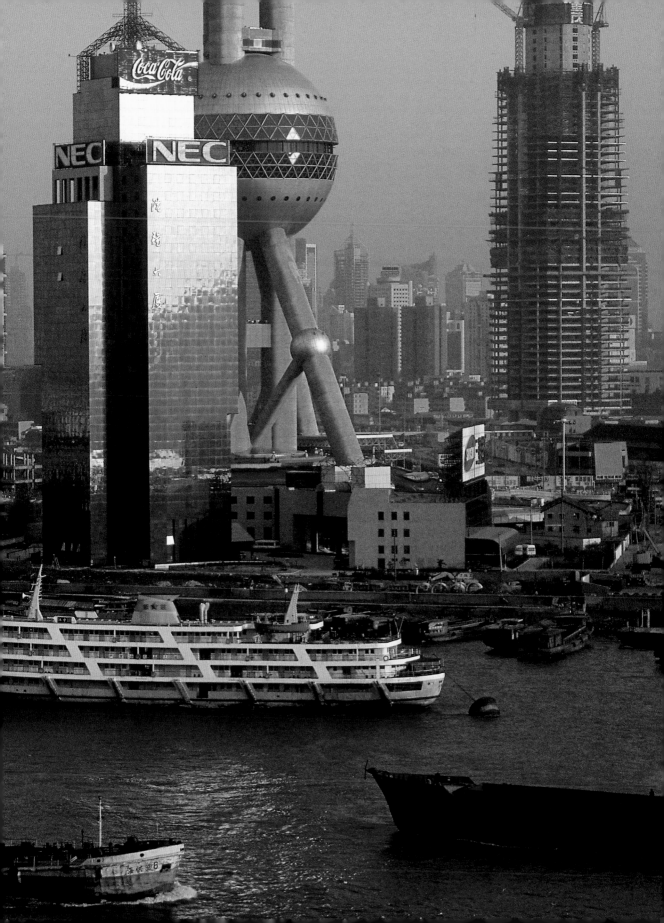

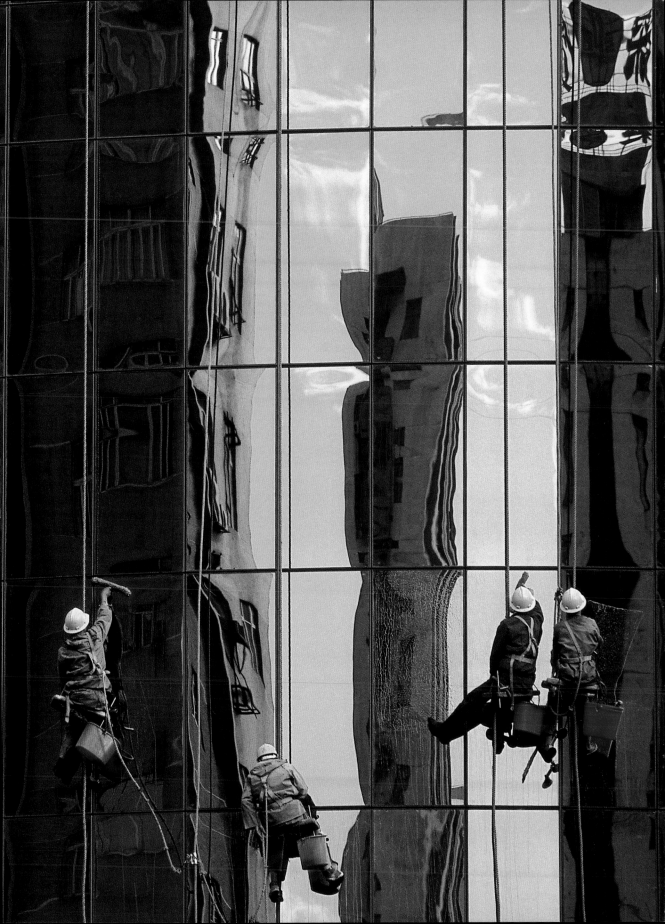

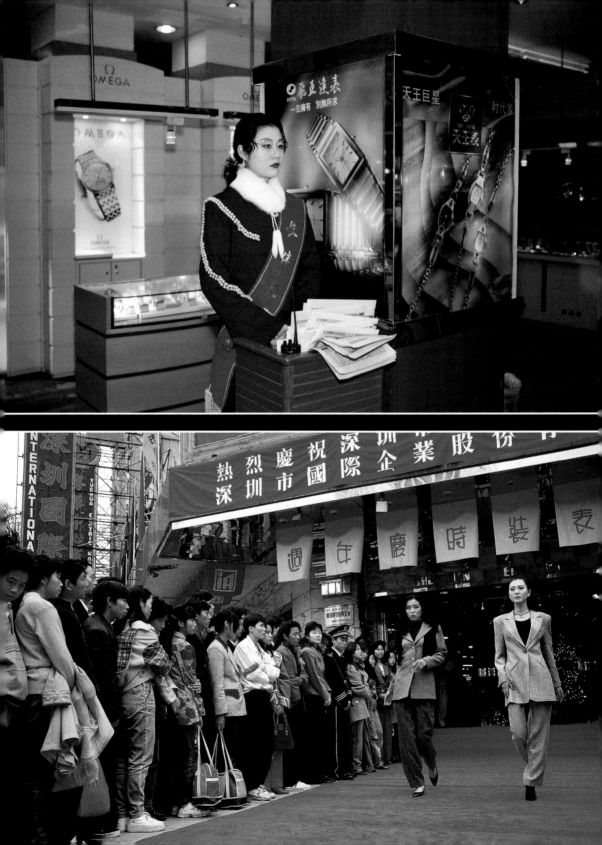

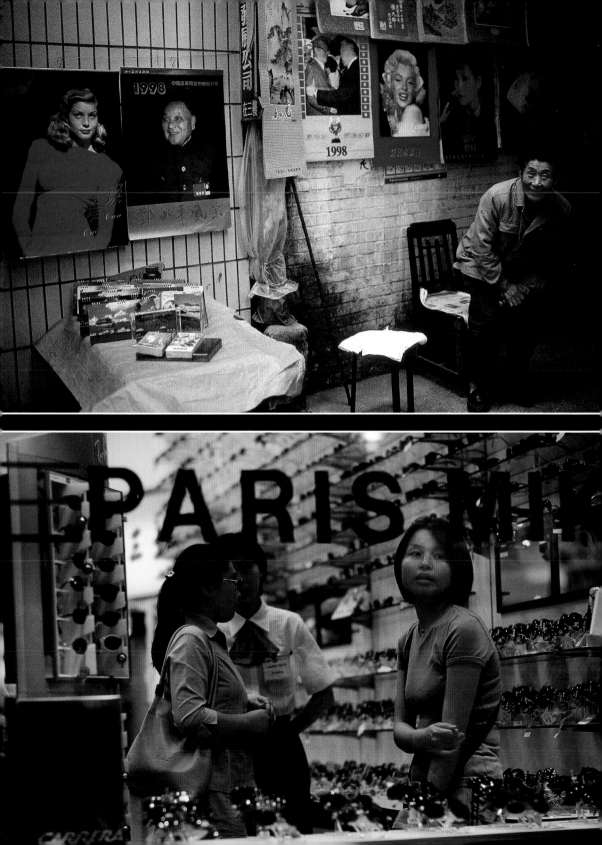

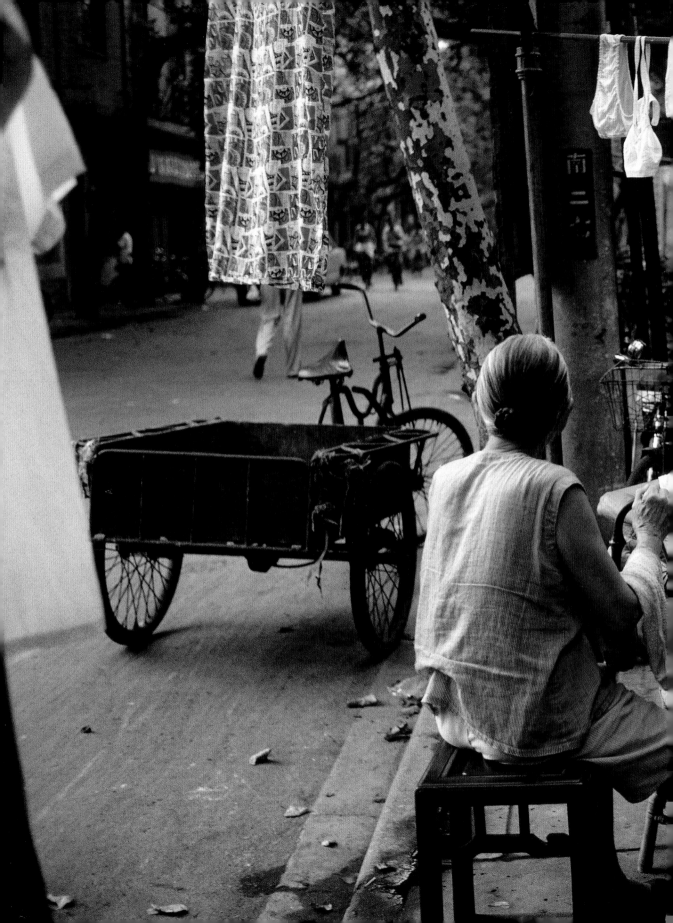

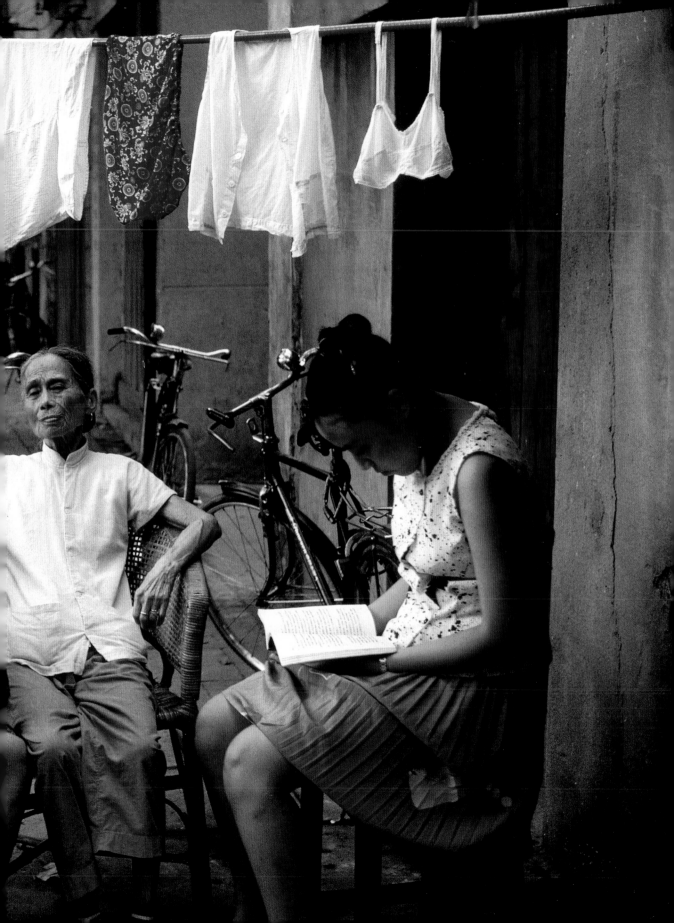

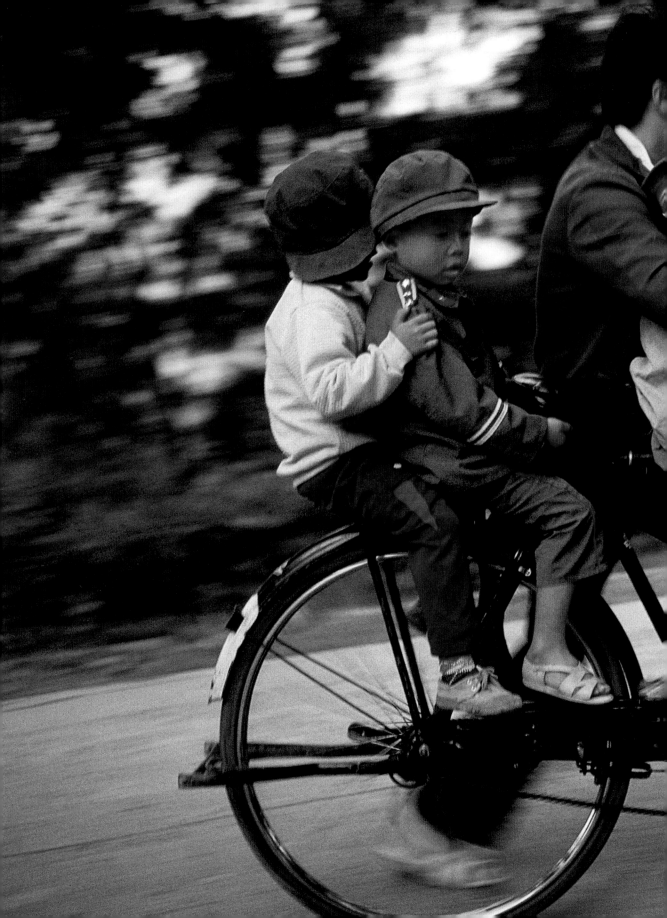

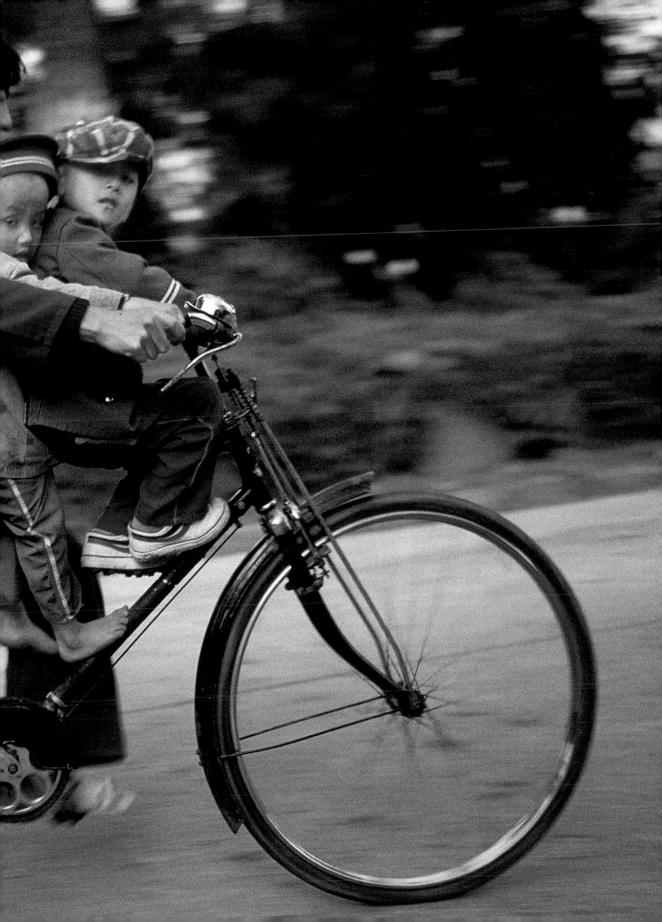

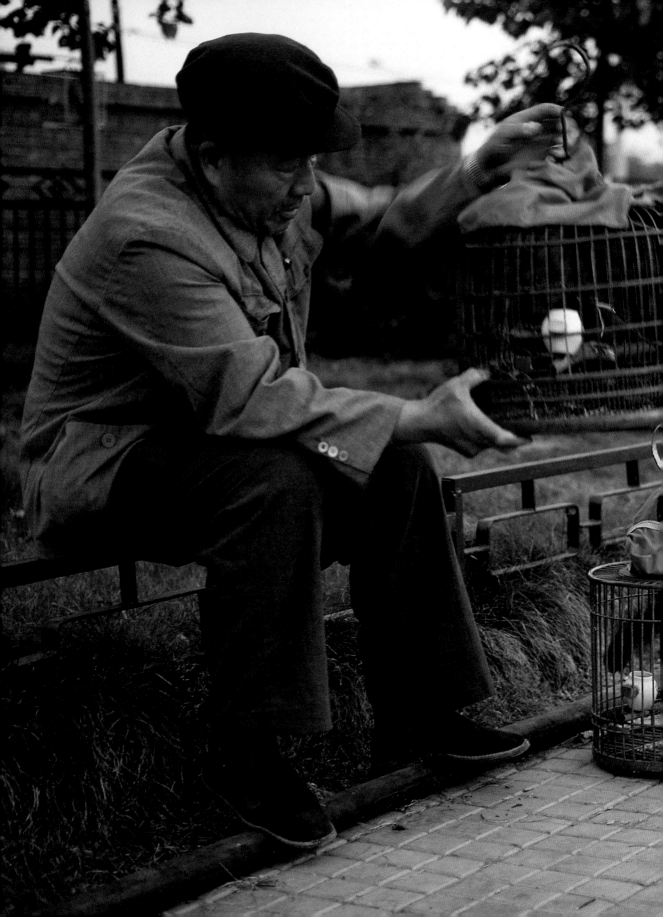

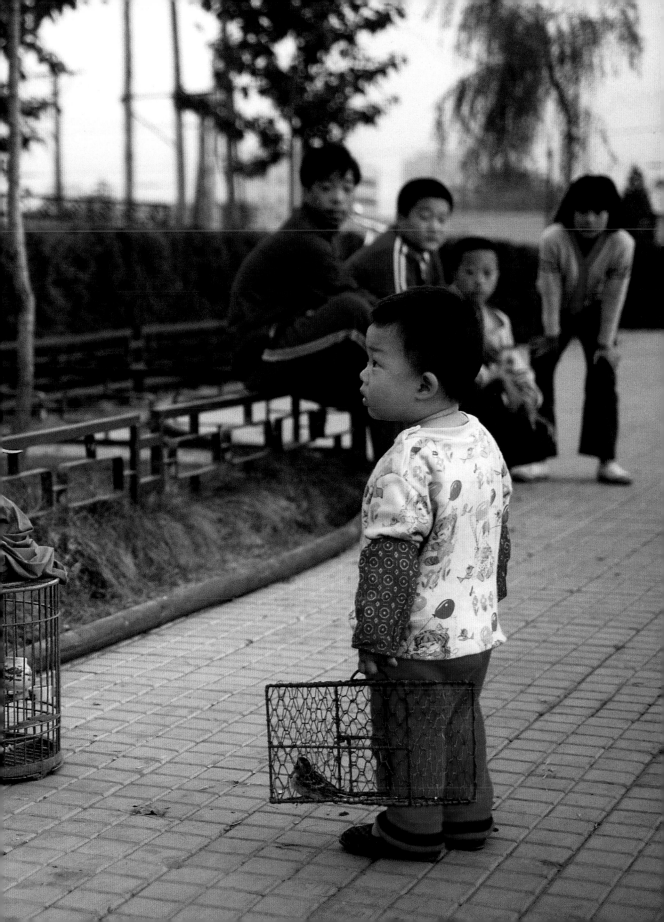

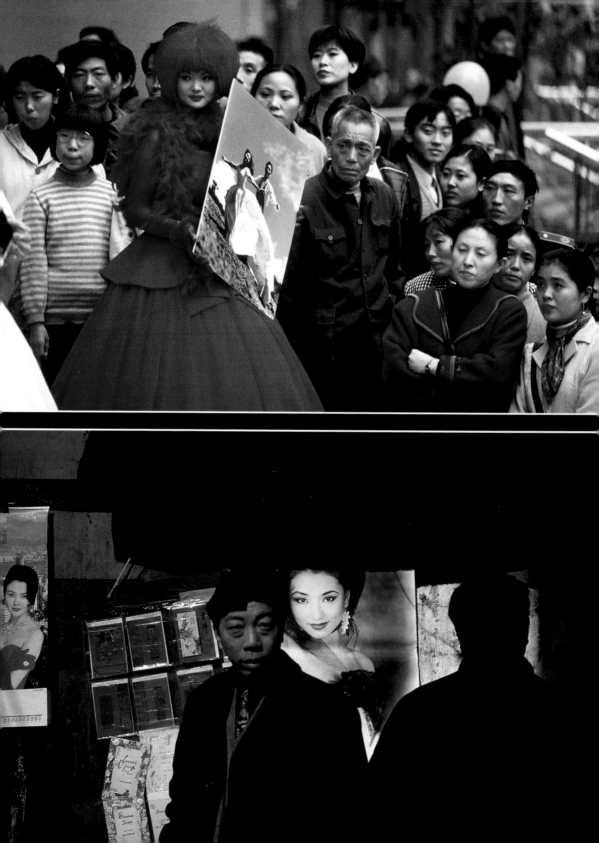

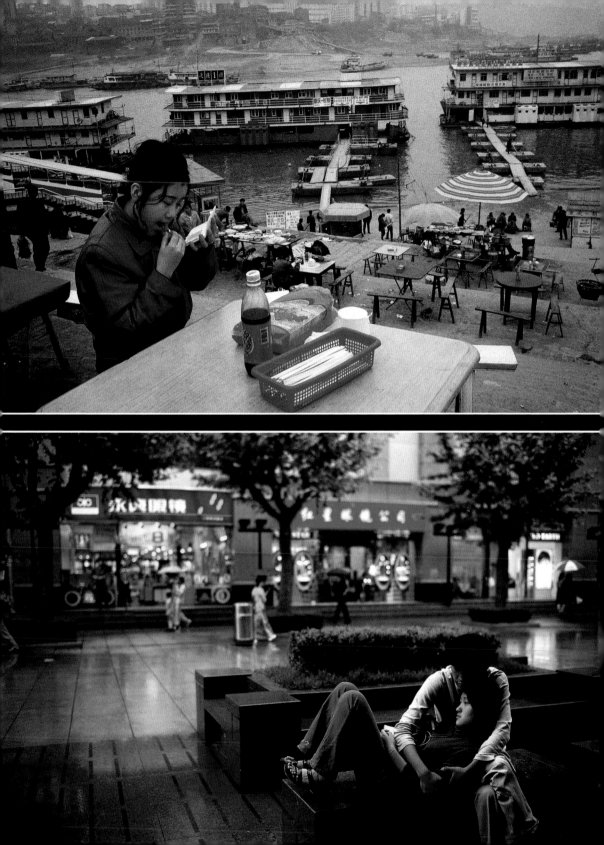

REDISCOVERING CHINA

I don't know how many times at screenings of my films or readings of my novel in various countries I've suddenly seen someone in the crowd raise a hand or stand up to ask me: "Could you tell as what were your first impressions when you arrived in Paris?" Each time this question catches me unawares. The only thing I remember is the date July 7, 1983. The rest is a complete fog: the first time I was on an airplane in my life, French customs, my first steps on French soil, my first pretty hundred-franc bill, etc. Each time I stammer, I sweat, I stutter, embarrassed by this shameful hole in my treacherous memory, as if I were afraid that someone were going to ask me to pay back my university scholarships.

However, what great emotion I experienced and can relive over and over again that morning in April 2000 when I first returned to Beijing, after a long, very long absence.

I had left Paris the night before with my production manager. At the time, the goal of our trip—to obtain permission to shoot a film adapted from my first novel—seemed as difficult as finding a star lost in the labyrinths of the distant heavens since the film's subject, the Cultural Revolution, is a dark time in Chinese history that the authorities in my country don't want to remember. The screenplays for my two previous films had suffered a rejection by Chinese censorship that could not be appealed, and I had to film one in the Pyrenees, the other in Vietnam.

We got into Beijing very late at night, and were staying at the Cui Ming Zuang Hotel. Its name is formed by three ideograms, which have a feeling of old scholarship: *Cui*, the color emerald-green; *Ming*, light; and *Zuang*, villa. It is a renovated ancient six-story building, with a roof of blue-glazed tiles. A big juniper tree with fissured black bark, a common tree in this city, stood in the middle of the courtyard, behind a building surrounded by a gray wall also topped with glazed tiles. It seems that before 1949 it was the second home of Mei Lan-fang, the most famous opera singer in Beijing. It stands in the heart of the city, next to the East Gate of the Forbidden City—where Marco Polo arrived eight hundred years ago with his exhausted caravan of tall, thin, long-haired camels heavily burdened with round bags filled with gifts—very close to Wang Fujin Street, China's brilliant (if not blinding) showcase, which we see today on television screens around the world.

It was impossible to sleep that night. I was as excited as I was the night before a big holiday as a child, when my father would take me and my cousins to see the sunrise on the summit of Emei Shan (Mount Emei), one of Buddhism's holy mountains.

I can still remember today how I was tormented by hunger that night in my room on the sixth floor of the Cui Ming Zuang Hotel. I had eaten almost nothing on the flight. My stomach grumbled. Outside, the bright signs flickered over a flood of enormous modern buildings; the blurred outline of the bridge stood above roofs covered with thin, minuscule, often broken tiles of some low old houses with their sinuous and complicated lines. Why don't I see you anymore, my former friends, dissident poets gone over to commerce, marginal painters boozing away furiously in a jazz bar, workers now on unemployment? Where are you? And you, my parents, who live in a distant province, are you sleeping? Little by little, my mental images of these individuals, frozen for so long in my memory, began to come back to life.

In the sleepy drone of this immense city, their images began to flow together, to become confused, to multiply, and even the regular, liquid, and melodious rumbling of my stomach became confused in the calm night with the sound of flushing toilets from nearby rooms, with a distant cough. It was cold outside. I threw my cigarette butt out the window, and it seemed as if I could hear the noise of its landing, like a frozen insect falling on the hard ground.

At five o'clock in the morning, I found myself in the street, alone, filled with excitement. It was still dark. It was one of those rare mornings in that season, under a sky that was serene but starless (because of the pollution, it turns out that for the last few years the stars

haven't been visible in Beijing). I still remembered the horrible wind that blew through that city, picking up sand, enormous quantities of sand, enough to cover the eyes, the sky, and everything else, but thank God there was no wind that morning.

In spite of the low temperature, a warmth enveloped my body as soon as I went outside. The air was easy to breathe. The street was poorly lit by the timid rays of one or two streetlights, clothed in a gas that was sometimes bluish, sometimes silvery. I slipped through the shadows, like a child in the morning. When I was a child, I always loved to hide in the darkness in a cupboard, under a quilt, etc. The street was still deserted, or almost so. I inhaled the familiar smells: the charcoal being lit in a nearby house, the oil someone was using to fry noodles, the, stench of the gutter, boiled milk that had overflowed and smelled burnt. I met a man with a chamber pot in his hand, who was walking toward the communal latrine, a marvelous little construction covered with white tiles. I said hello. He was so surprised that the swinging enameled chamber pot, shaped like a spittoon, almost slipped from his sleepy grasp, making a sloshing noise. A little bit farther, a cat was climbing a wall. I called to it. It came up to me. And when I petted it, I was filled with a sensation of "being back home," faint as a memory of my distant childhood.

When I was a student in Paris, I lived in the Concordia, the university residence near the rue Mouffetard. For one year, I shared a room with a Chinese friend, an architecture student. On one of the walls, he hung an old map of his native city Beijing. It was a lithograph. It showed a bird's-eye view of the whole Imperial City (which surrounded the Forbidden City) with its four gates, and the Tiananmen Gate in the middle. At the bottom of that map, blacked in with India ink, the turbulent profusion of *hutongs*, the little lanes of Beijing, were marked by lines of white that looked like a spider's web, with the sharpness of the finest engravings. These lines, often completely straight, intersected, spread from the east to west and north to south. Sometimes they became a supple ribbon meandering around the lakes, white spots spread here and there like romantic, nacreous pearls. Sometimes the straight lines were interrupted by bridges,

villas, aristocratic residences, or disappeared into the marshes. On every white line representing a *hutong* a name was written in the calligraphy of the period, which still has a great nobility. The future architect and I adored the names of these *hutongs*. We had a little electric hot plate on which, from time to time, we prepared Chinese food in secret, since the rules of the residence strictly forbade cooking in the rooms. We closed the door and the window, and while the rice boiled in the little saucepan and its domestic smell spread through the room, one of us would cut vegetables and meat, and the other would read aloud the names of the *hutongs* on the map. Both of us had very poor eyesight. From time to time the steam from the rice or the dishes frying in oil would fog our eyeglasses. We would take them off, wipe them off on our shirttails, and go on reading. Some of the names, in the composition of their ideograms, shone with the elegance of exquisite nuances, others bewitched us with their sound, now supple, now sensual, now exuberant, especially as pronounced by my friend in his lovely pure Beijing accent. Sometimes, while I was reading, or while I listened to my friend, I felt as if I were walking in these little streets, and could see a man on a bicycle, wearing a fur cap, floating toward me; or I imagined walking by an old man playing chess with his neighbor on his doorstep who looked up from his filthy oil-stained chessboard and winked at me.

So, on this early morning on April 2000, when I found myself alone near the East Gate of the Forbidden City, I could recall perfectly the geography of this neighborhood as it had been meticulously recorded by the engraver of the ancient map, and especially the detail formed by three ideograms in cursive hand at the crossing of the Street of the South Bank and the Avenue of the East Gate: the Pavilion of Eastern Joy. This name was fixed in my memory because I had read in Lu Xun's *Private Journal*, one of my favorite books at the time, that he had dined with Hu Shi, his sworn enemy, on two occasions (imagine Jean-Paul Sartre dining with François Mauriac) in this pavilion, which was one of the eight most famous restaurants in old Beijing. It was wonderful to hear this name pronounced by my friend, the future architect: "Dong Xin Lu." All the flavor of Imperial cui-

ones shouted loudly as they served their clients, this place was like a teahouse in my native province, Sichuan.

Beyond a shadow of a doubt, the best descriptions on the subject were written by Lao She, whose realer-than-real dialogues from his play *Teahouse* have become part of the cultural heritage of China. But he was writing about a Beijing teahouse. Teahouses in Hong Kong are famous for the great variety of food that the young waitresses push from table to table on carts. As for Sichuan teahouses, their particularity is that a storyteller sits in the middle of the room, his voice drowned out in the general hubbub of voices, and who is most often just a part of the decor.

I was nine or ten years old. Every day after school on my way back home I would pass a teahouse in Little India Street. It had bare wood walls and floors of bare earth permanently strewn with peanut shells and sunflower seeds spit out by the clients. I was drawn by the two old storytellers dressed in long traditional robes of faded blue, each holding a small wooden tablet in his hand. One specialized in stories, of the legendary bandits of the "Water Margin," also called "Outlaws of the Marsh," the other in stories from the "Romance of the Three Kingdoms." I would listen to them in fascination, until the day when, initiated by them, I myself became a little amateur storyteller.

The first breakfast on my return to Beijing came to an end as I bit into something hard, deeply buried in this steamed cake scented with pine.

It was a red Chinese date.

I tasted it with the tip of my tongue.

At that moment, I remembered what I hadn't been able to recall earlier. Of course, the Xi'an steamed cake! The happiness of my childhood, before the Cultural Revolution, in that teahouse on Little India Street! One afternoon on a far-off Sunday, for the first time in my life, I had climbed onto the rudimentary stage in the center of the teahouse in front of a hundred or so customers. With a trembling hand, I beat the wooden tablet on the table long and frenetically, until the hubbub of conversation died away. Then I began my story. I can't remember today what I performed that day. An episode of the "Water Margin," of the "Romance of the Three Kingdoms," or the story of Communist spies called "The Rocky Road"? The only thing I can remember is that as soon as the words began to leave my mouth, I became someone else. The audience, more and more attentive, laughed, interrupted me to ask questions or make comments, and laughed again, completely won over. About a quarter of an hour later, at the moment at which the dramatic tension reached its peak, I stopped, following my teachers' example. I climbed down from the stage, a metal plate in my hand, and asked the spectators for a gesture of kindness. With a crystalline noise the coins fell into the plate. I climbed back onto the stage and continued. When it was over, I ran, ran drunk with joy, to my house to give my mother everything I had earned: three yuan. She took me down to the street where she bought me a steamed cake. The vendor was an old man with a Xi'an accent. When my mother, overwhelmed and proud, told him that her nine-year-old son had become a storyteller, he congratulated me. "The next time," he said, "I'll make a steamed cake especially for you, with even more Xi'an plums inside."

Blood-red, salty, sweet, bitter, this thousand-year-old plum from my childhood is my own China, my China found once again.

Happy.

—Dai Sijie

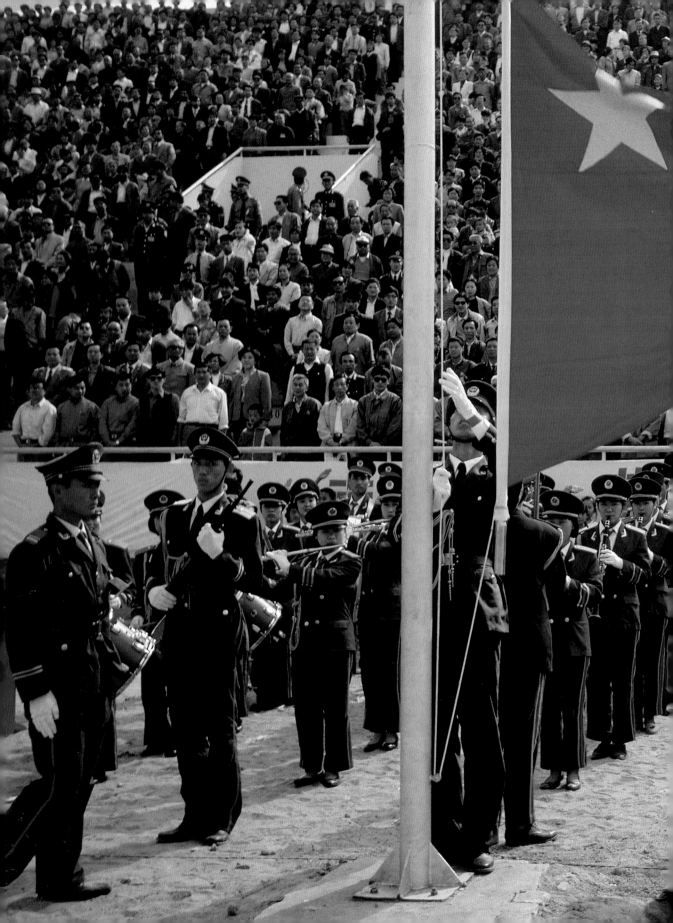

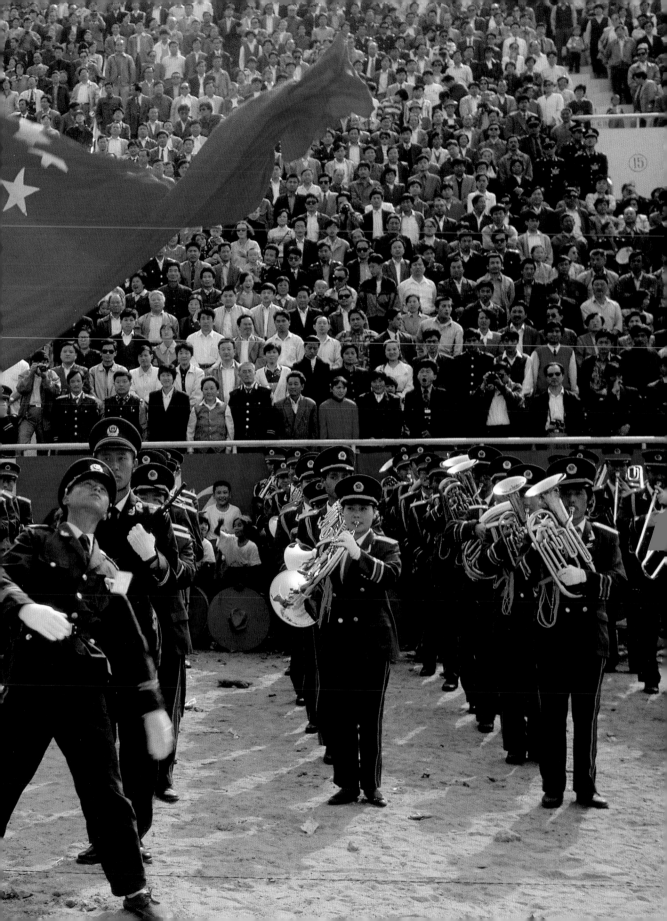

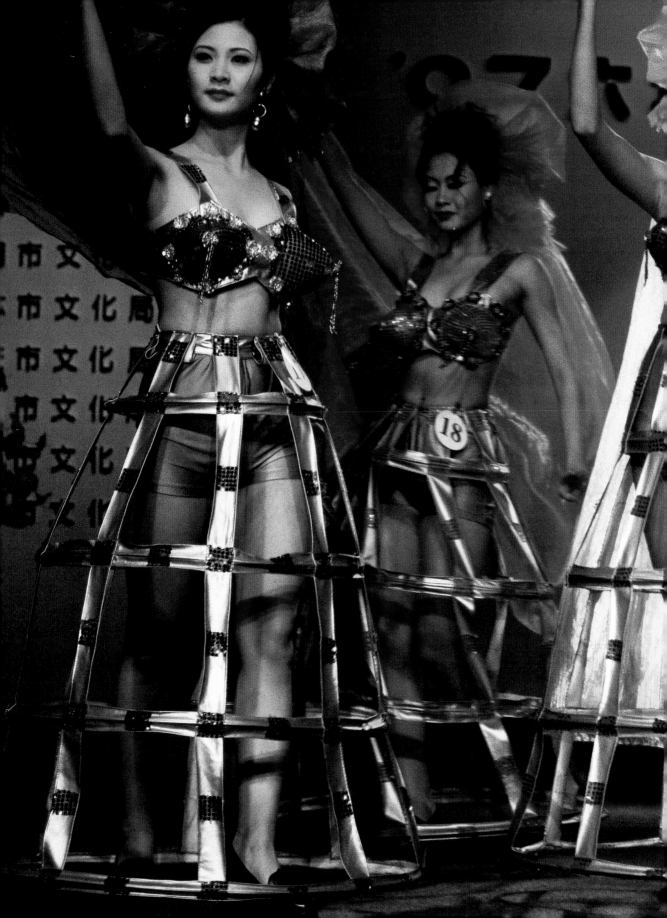

Learning is the key to the problem.

The road is made by people walking.

The past illuminates generations to come.

Unpleasant truths are often the most useful.

Taking a book is not stealing.

Knowledge banishes doubt; kindness banishes anxiety; courage
banishes fear.

Failure is the foundation of success.

The biggest mistake is the one not corrected.

Do not fear being misunderstood by others; fear misunderstanding
them.

What is learned in childhood

is engraved more deeply than in stone.

He who knows that he doesn't know, teach him.

He who knows that he knows, listen to him.

He who doesn't know that he knows, awaken him.

He who doesn't know that he doesn't know, flee him.

If you want to climb a mountain, begin at the bottom.

Not to read for a long time is to lose a friend.

All men are brothers under the sky; only their cultures differ.

He who has money but no children is not rich;

He who has children but no money is not poor.

Laugh three times a day and you won't need any medicine.

He who must learn is near to knowledge;

He who likes to ask advice will grow.

Words are the keys that open hearts.

Have I been happy lately?

The right road is lined with wellsprings.

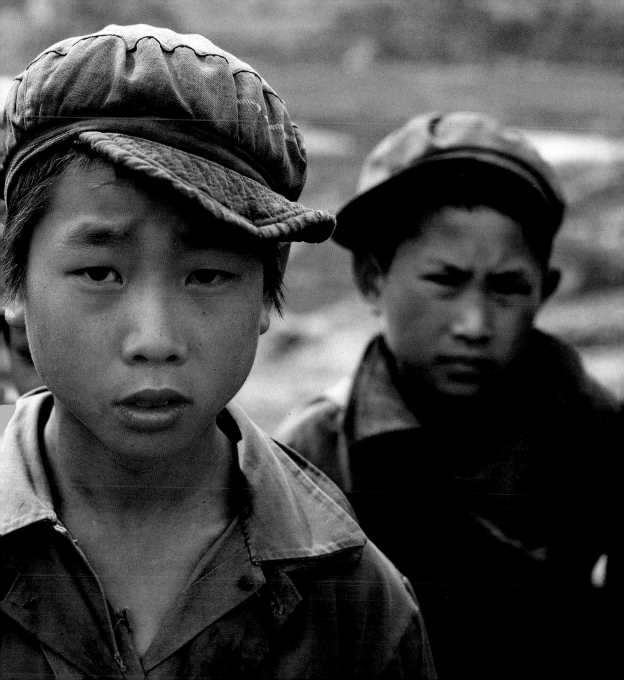

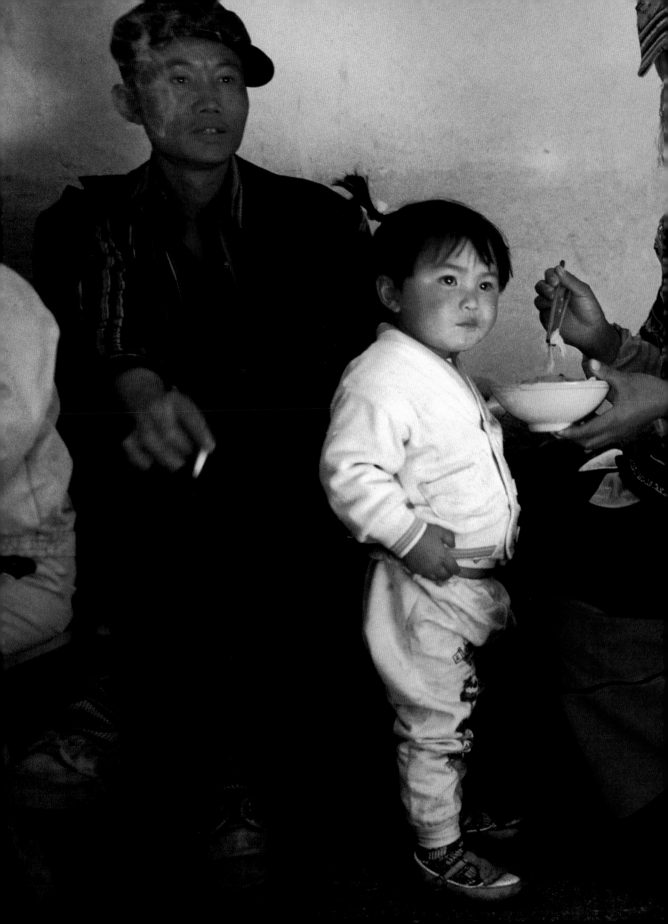

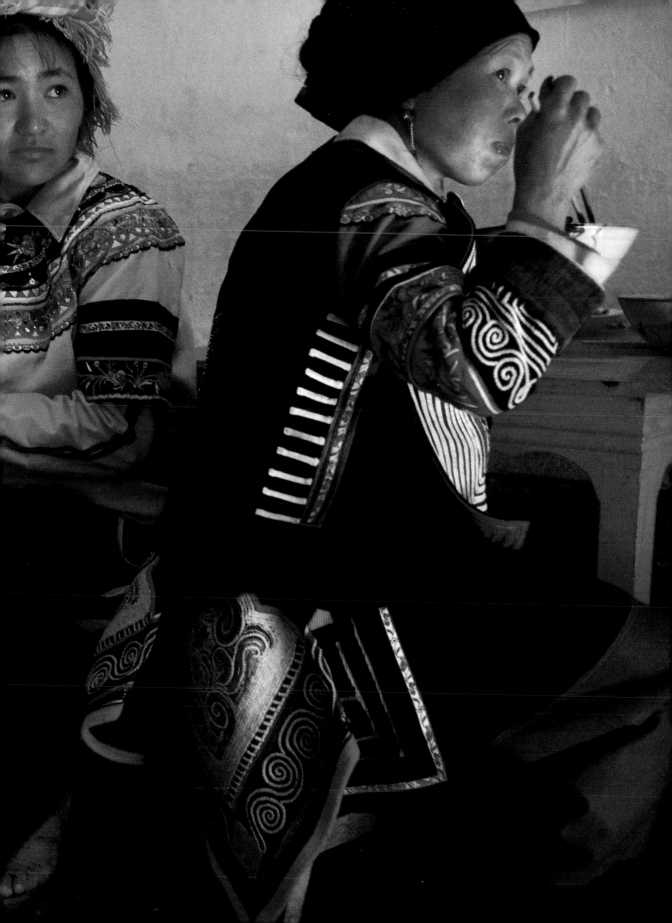

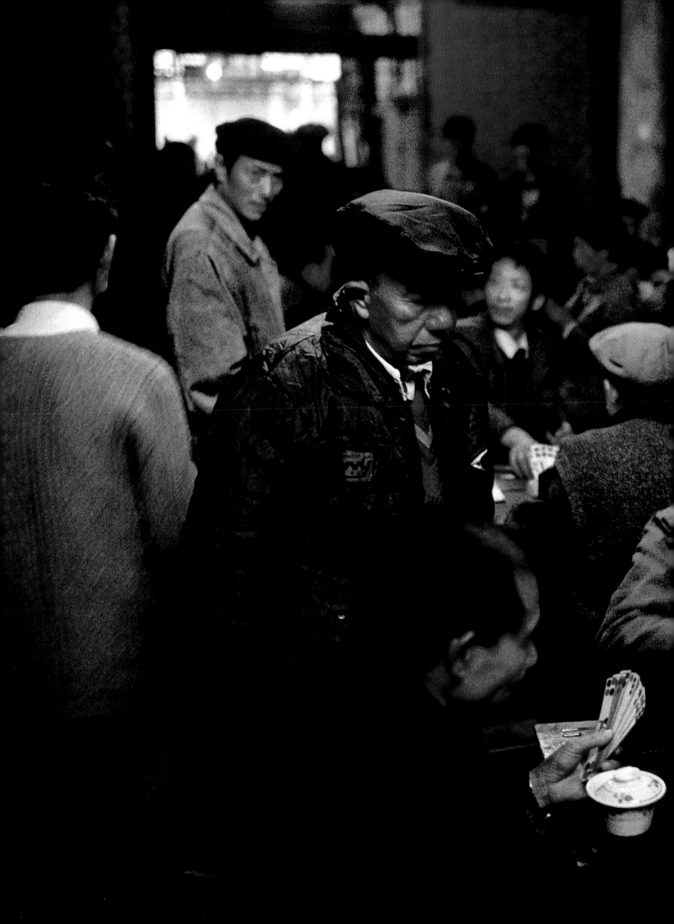

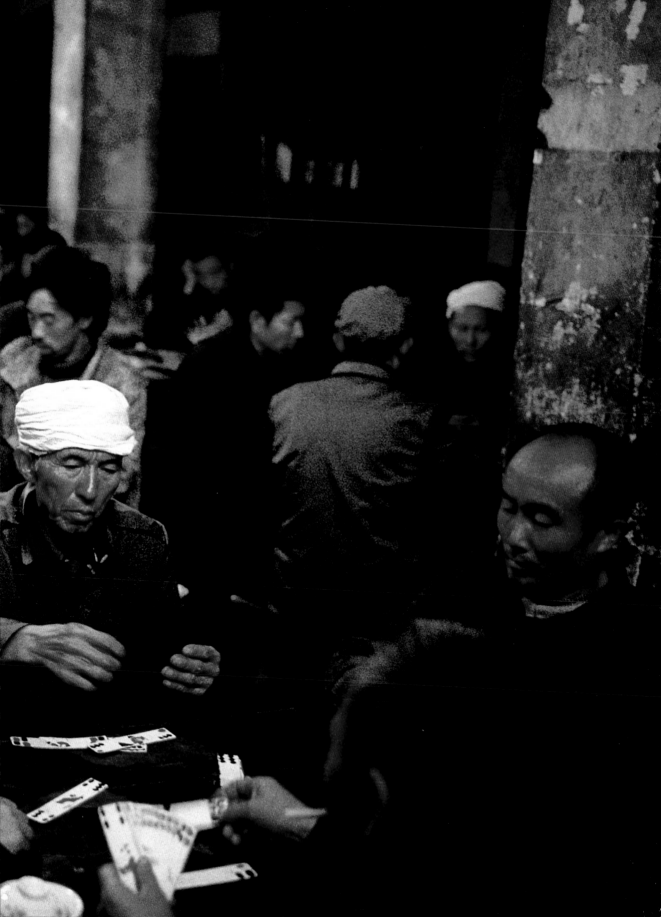

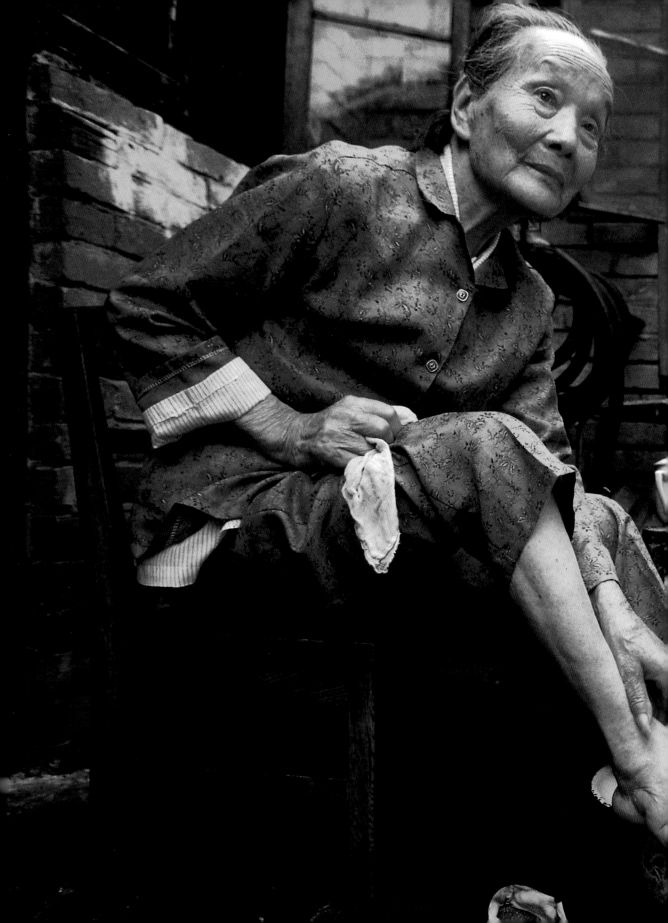

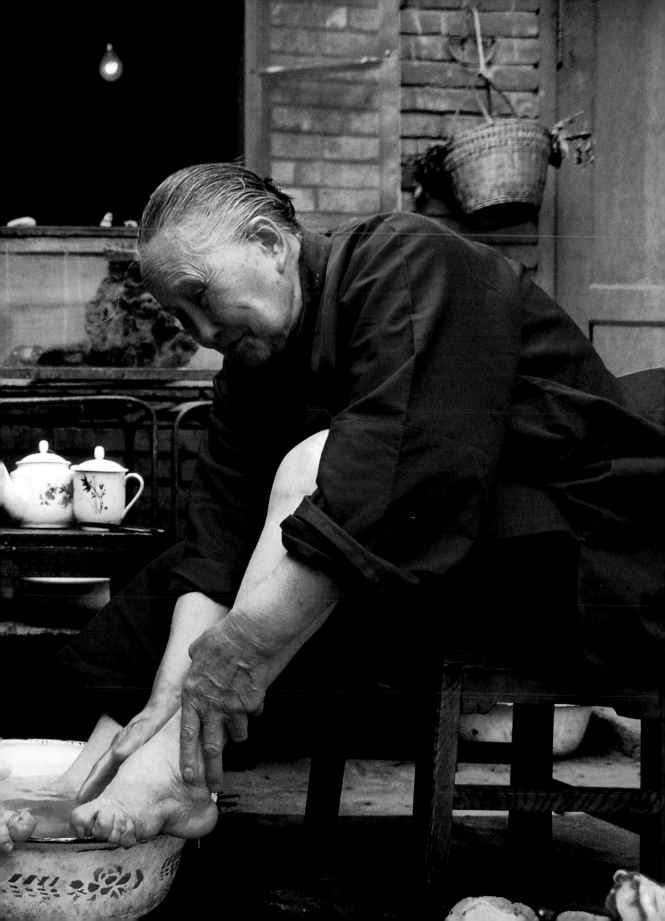

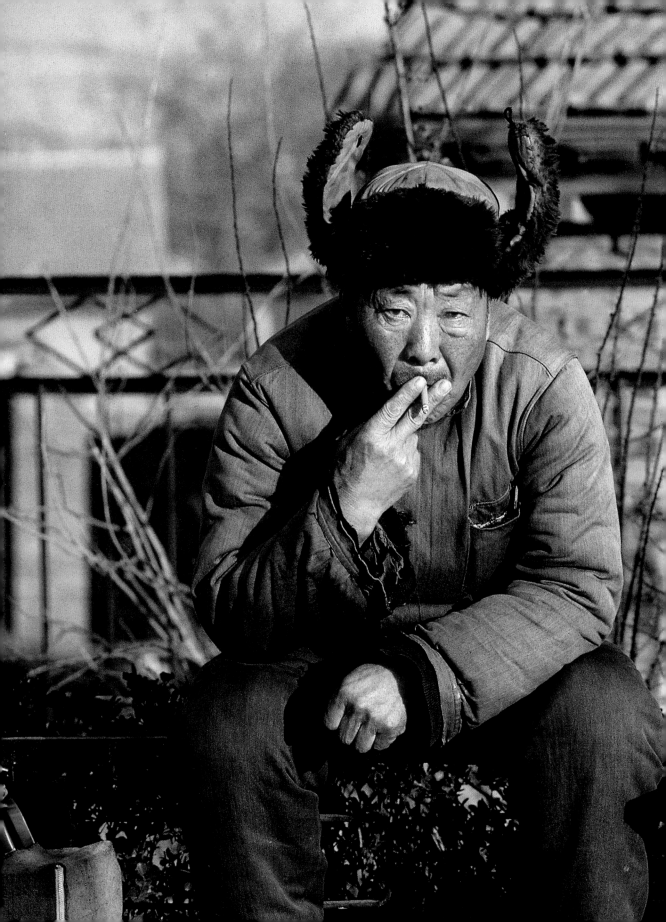

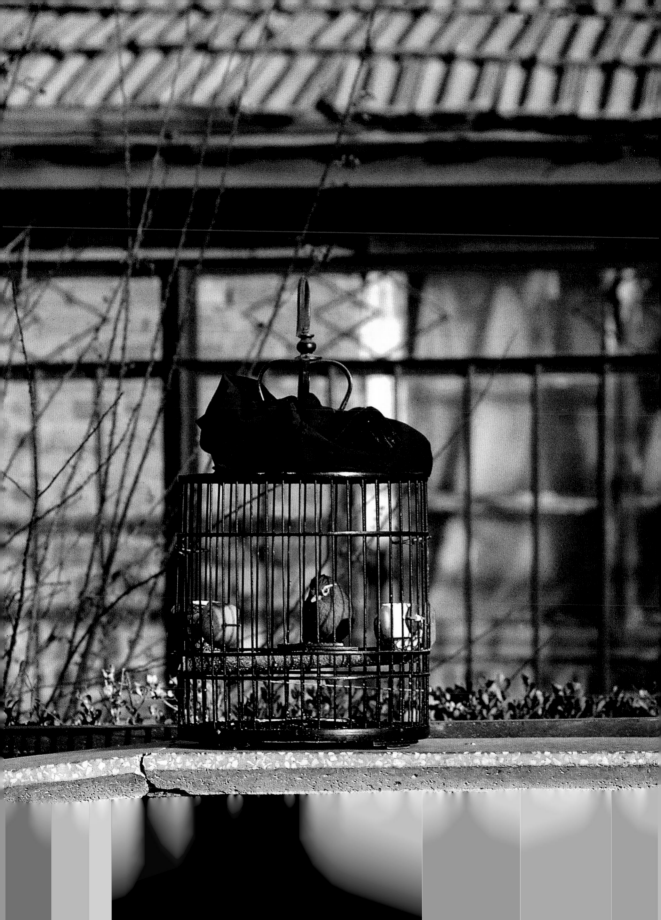

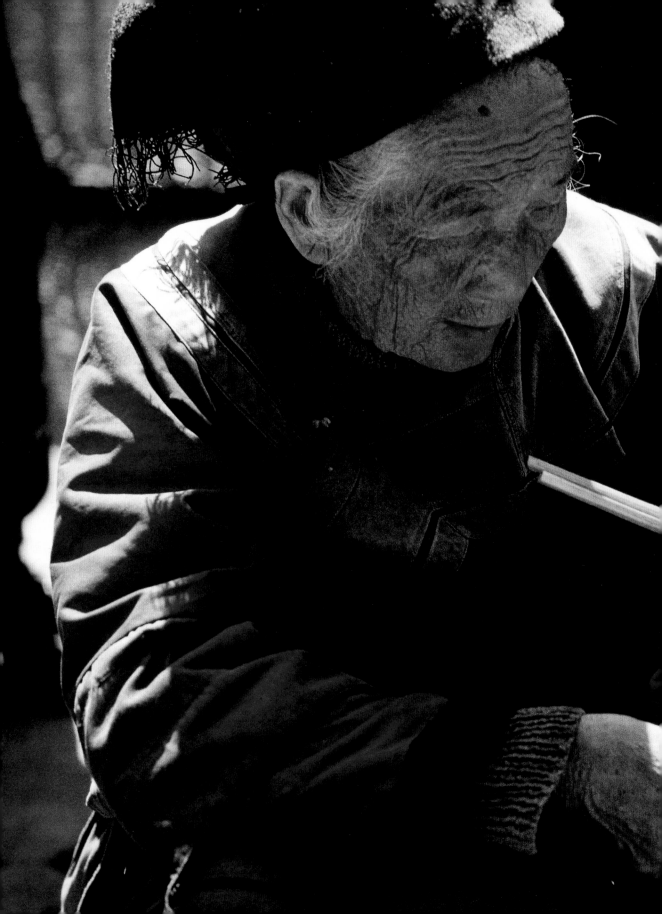

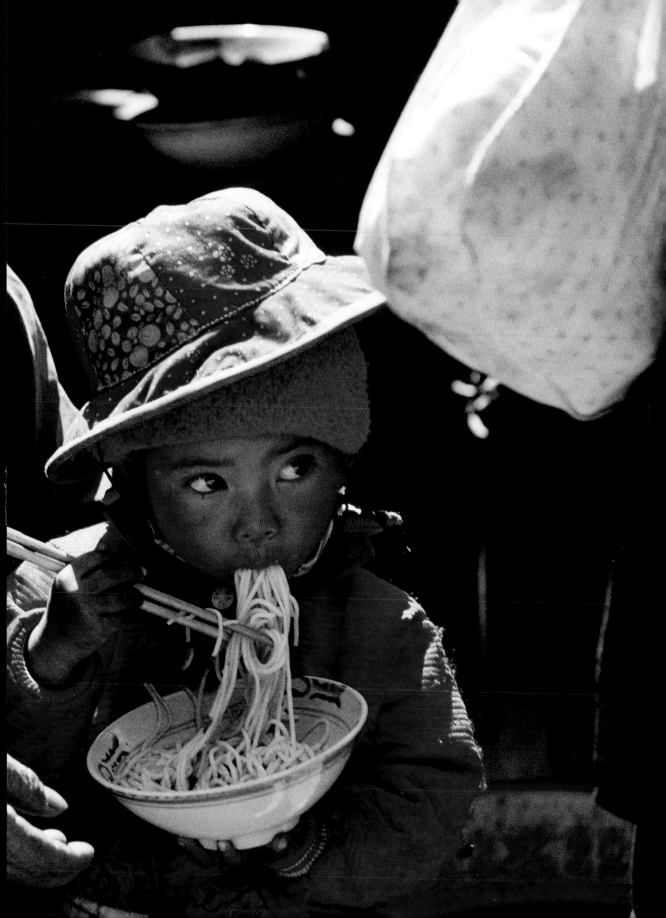

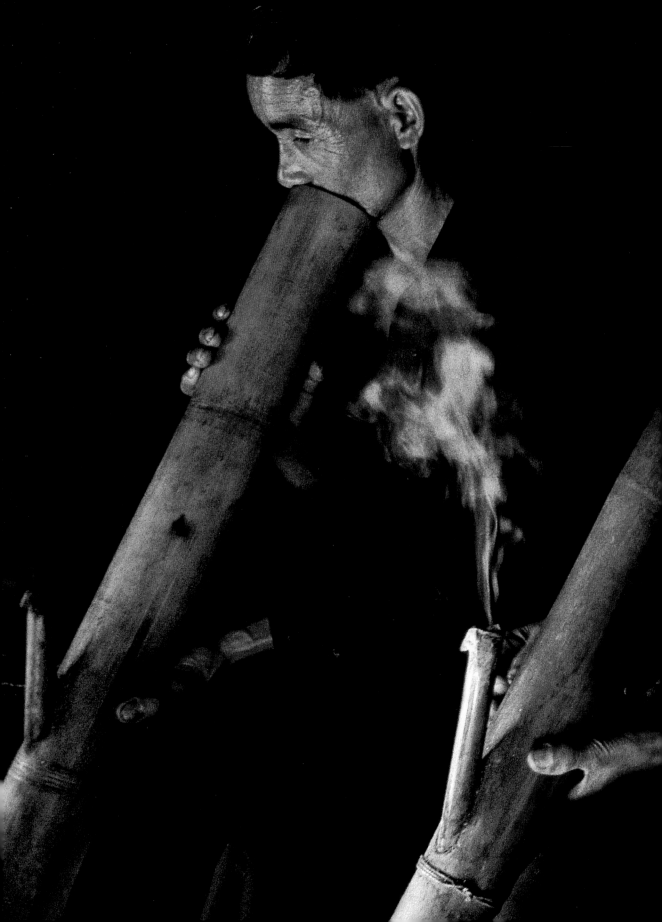

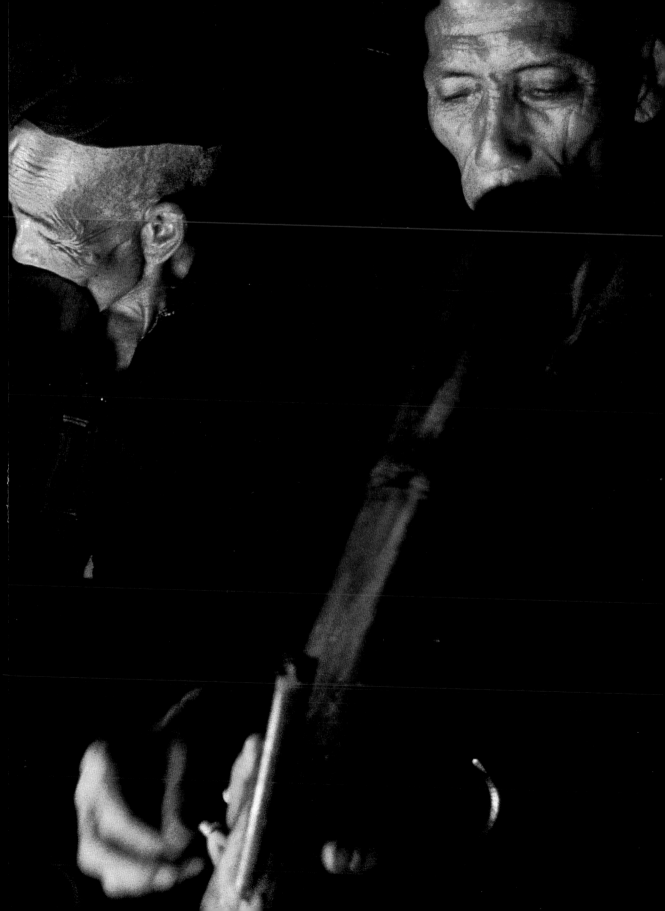

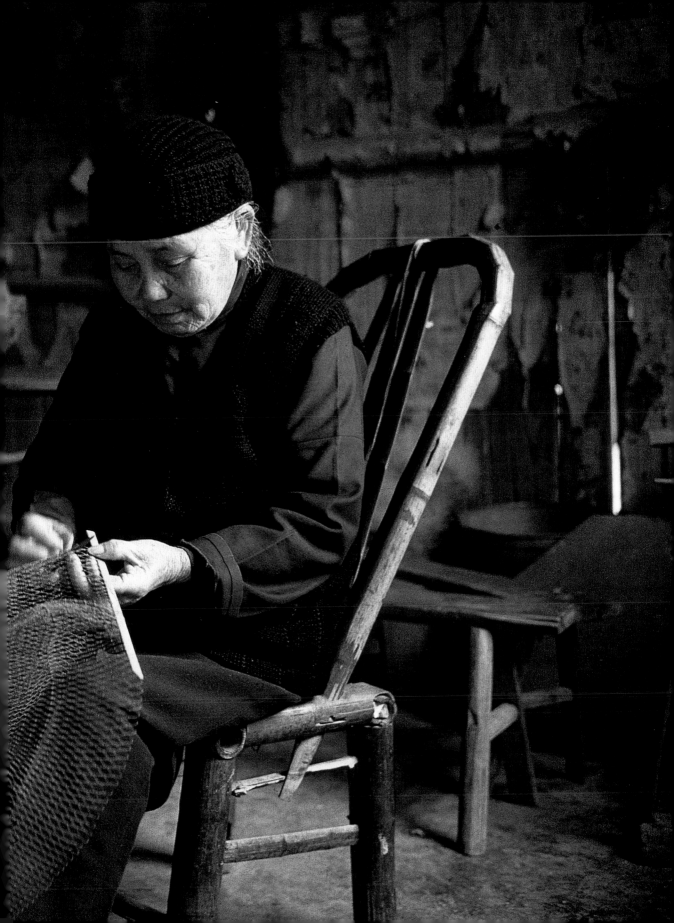

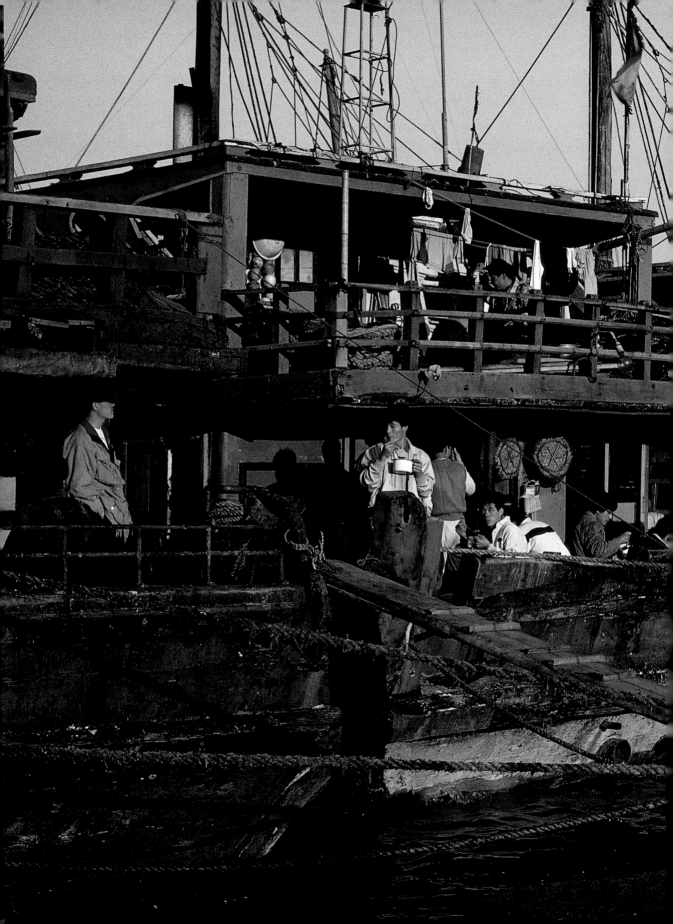

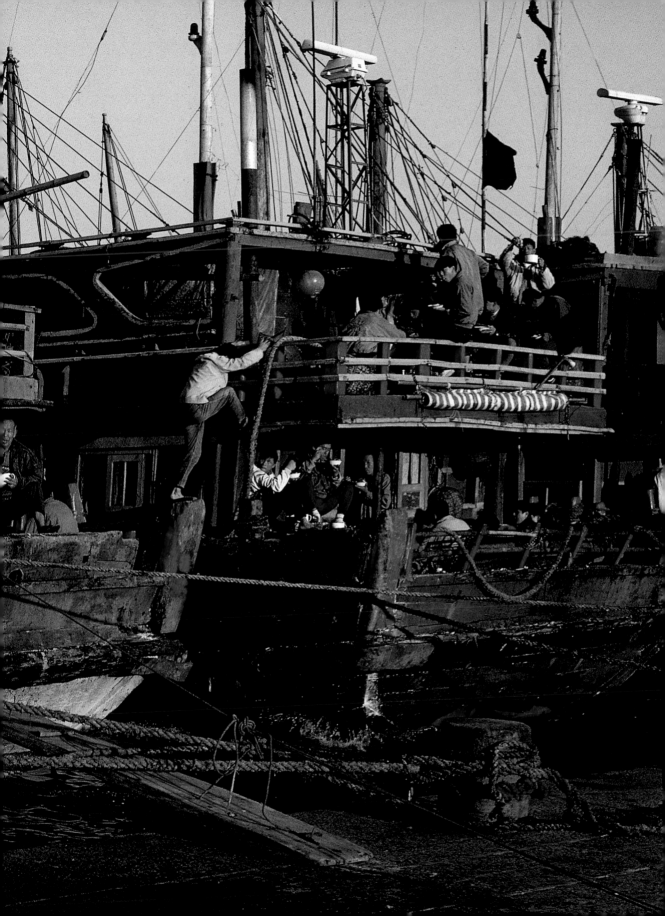

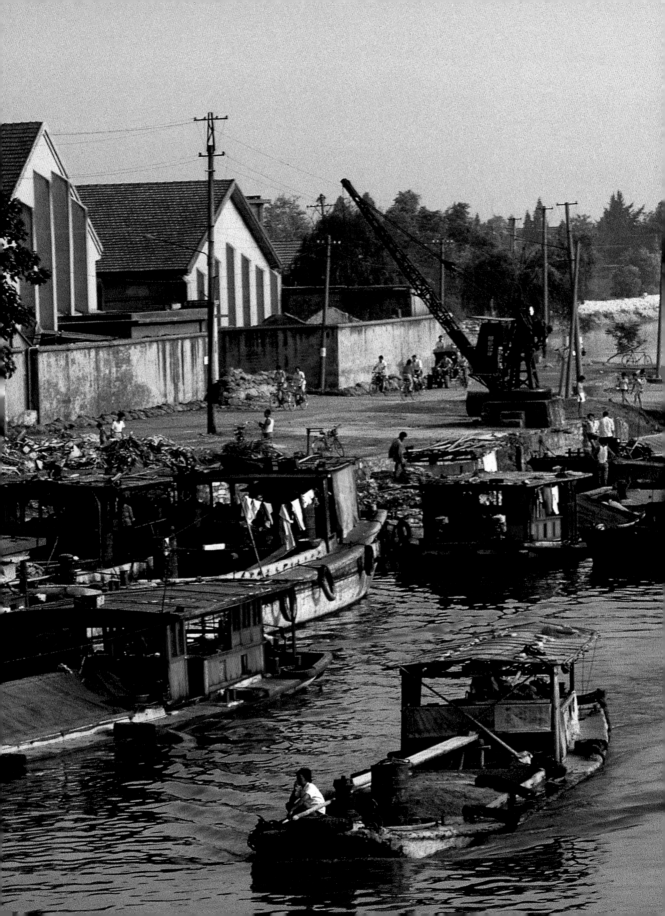

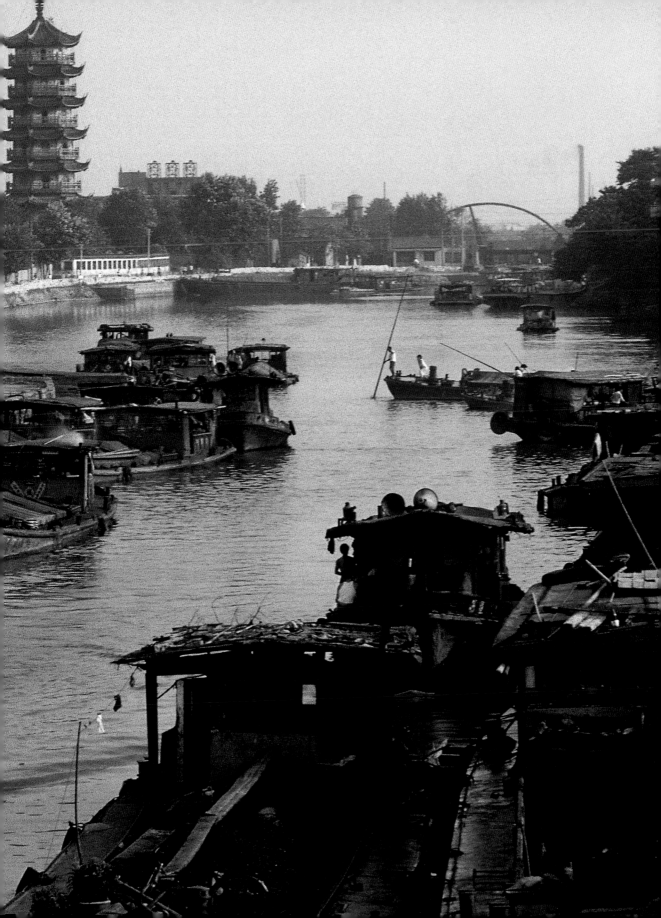

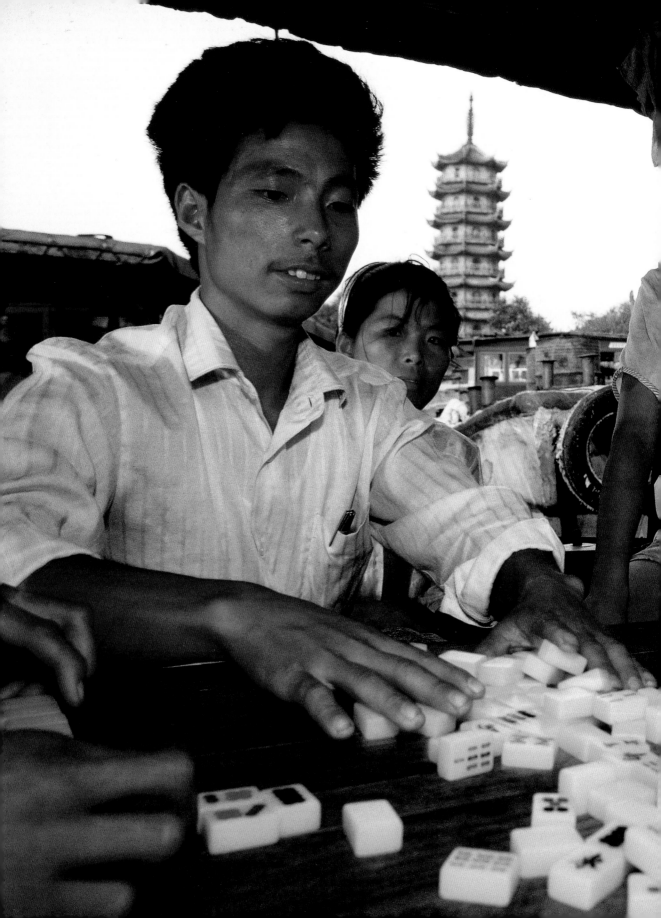

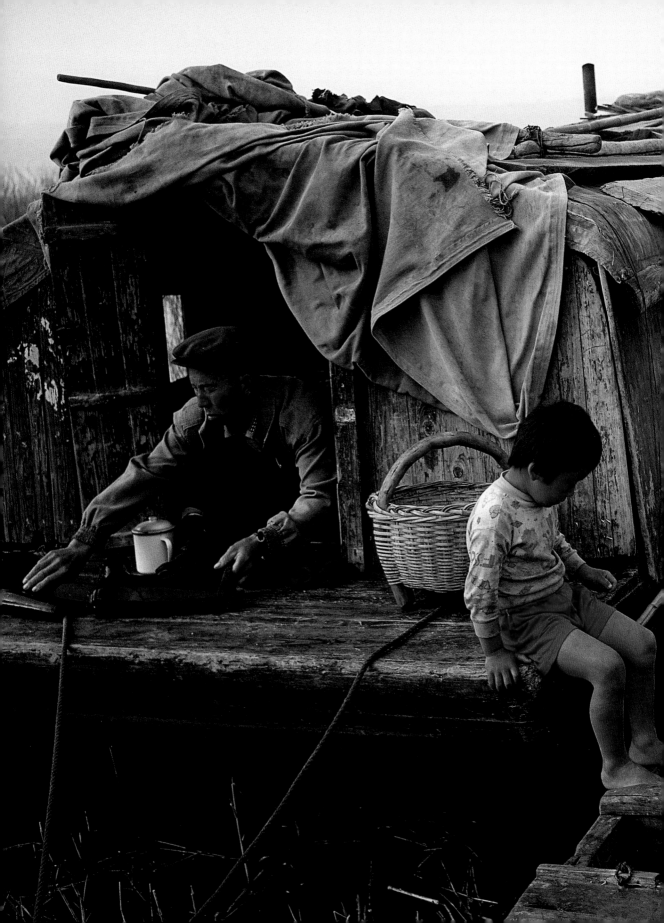

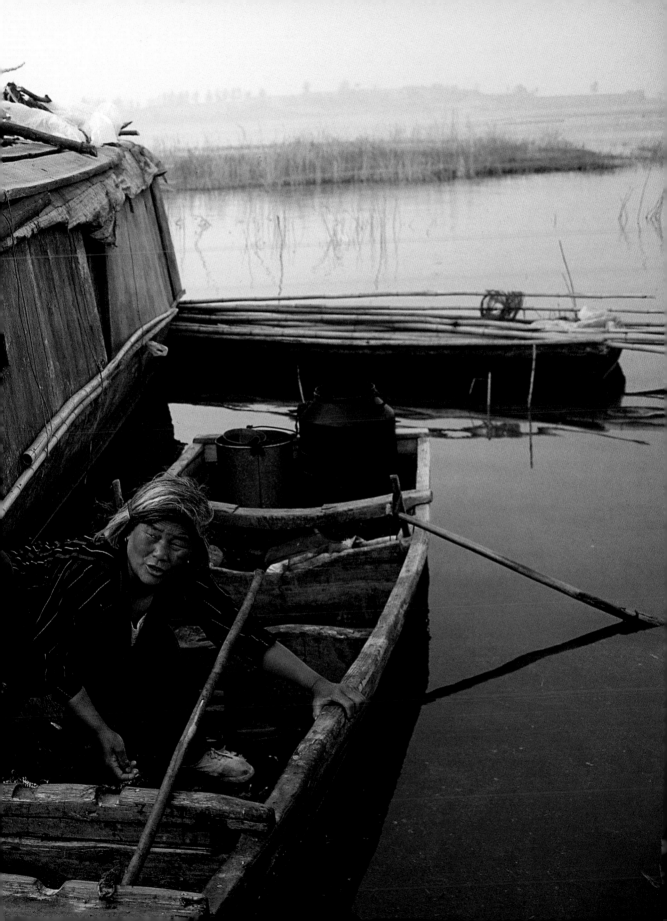

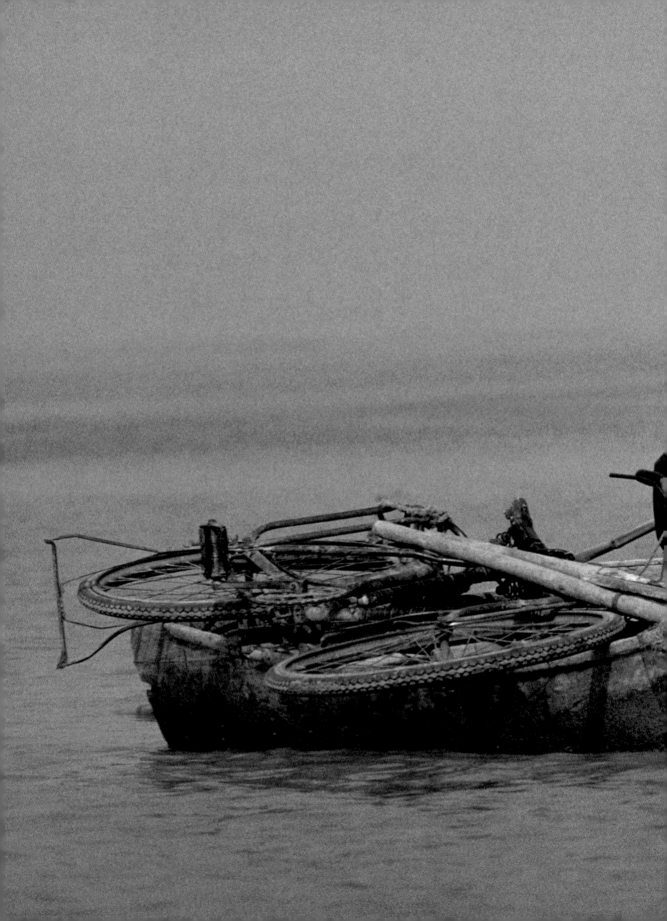

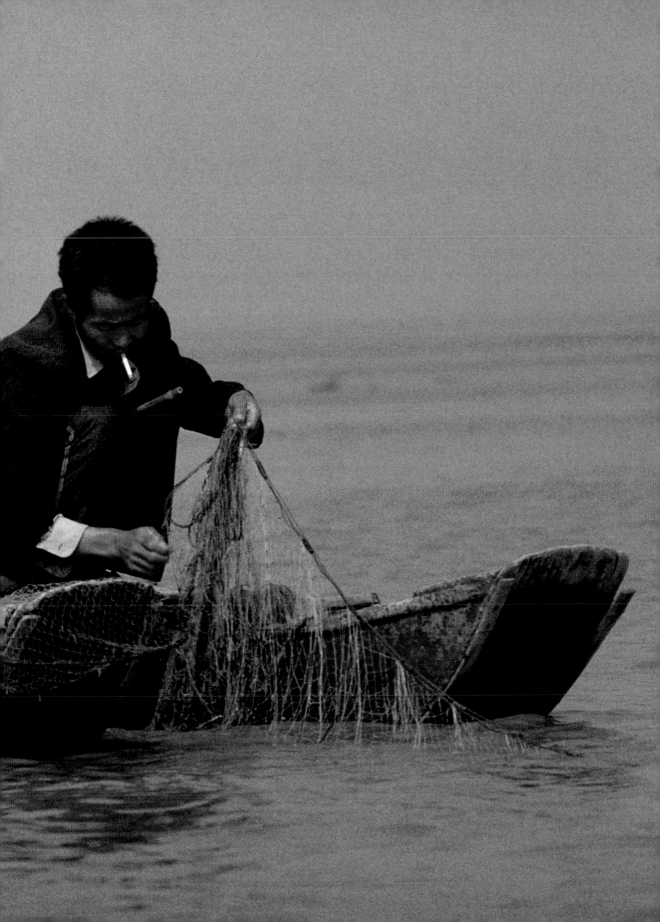

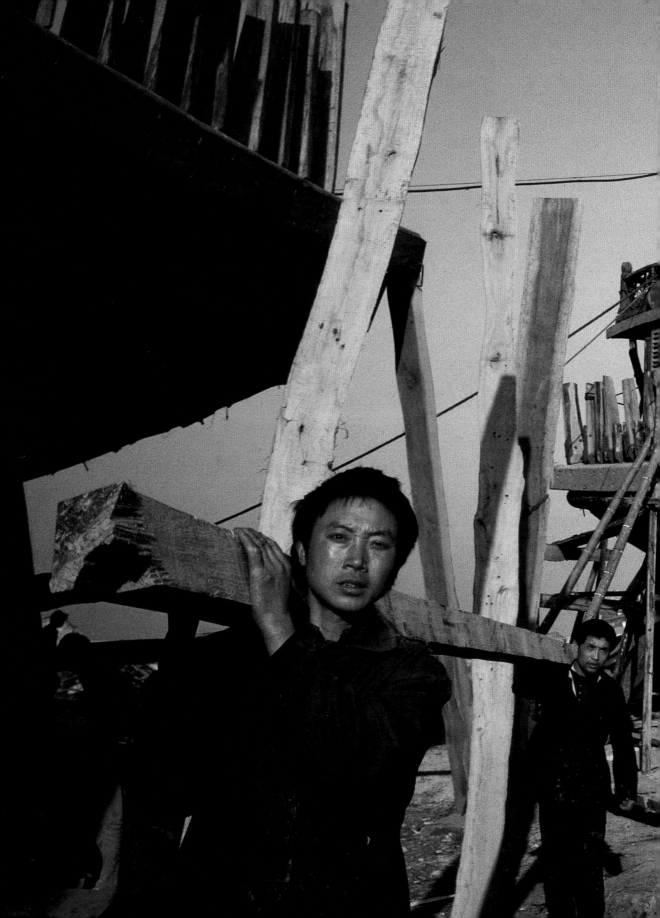

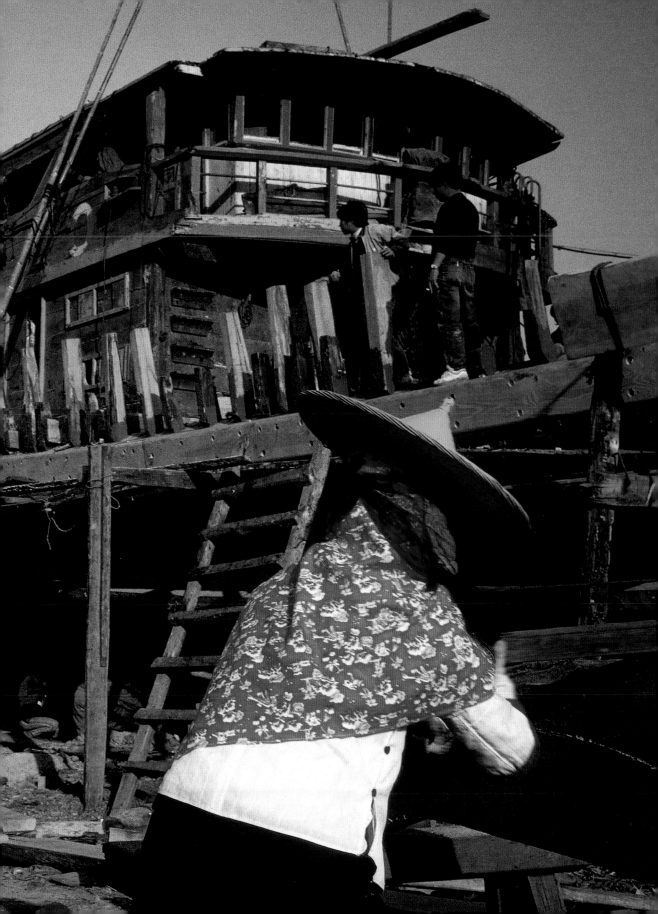

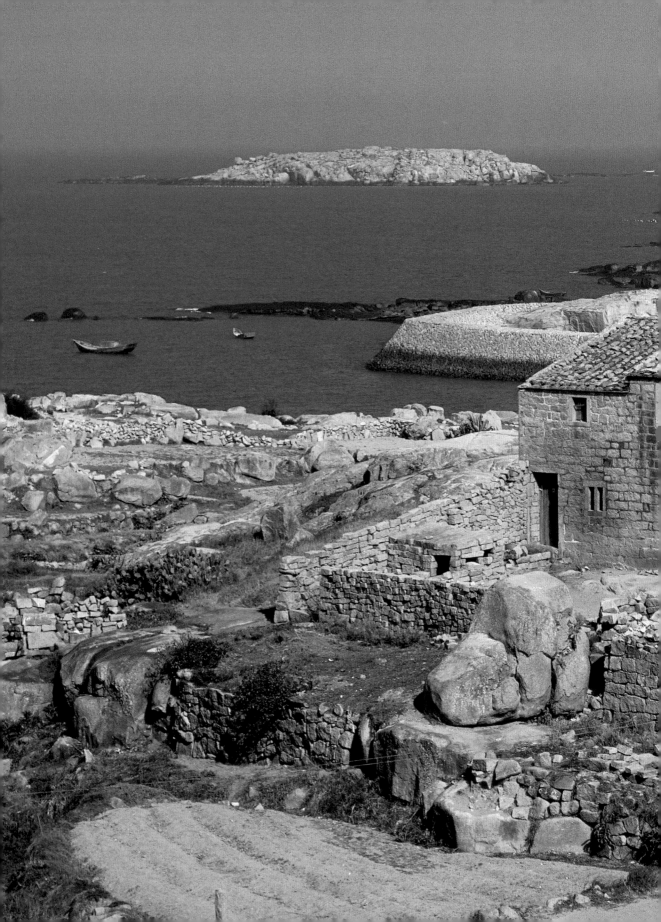

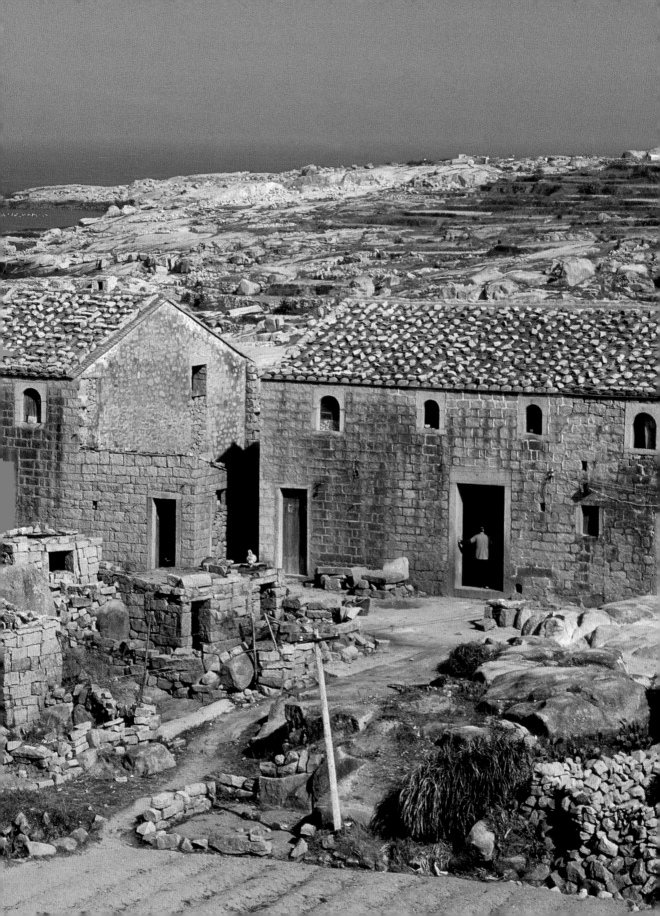

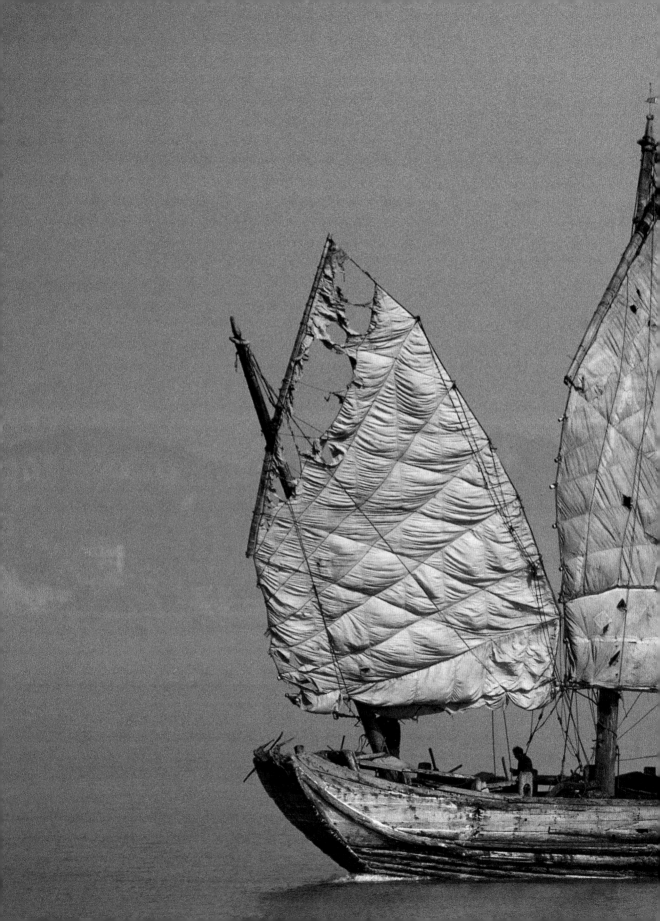

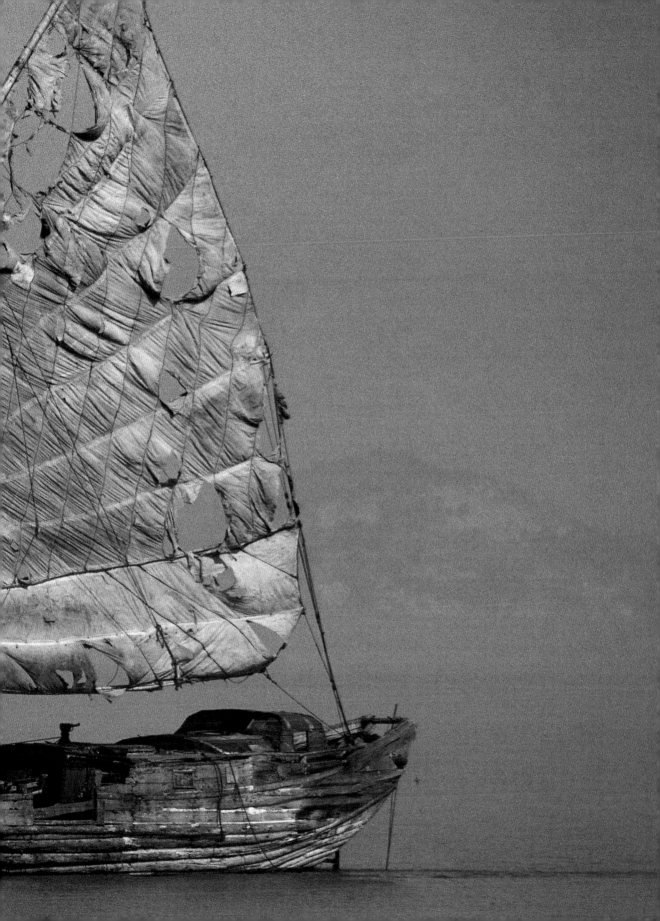

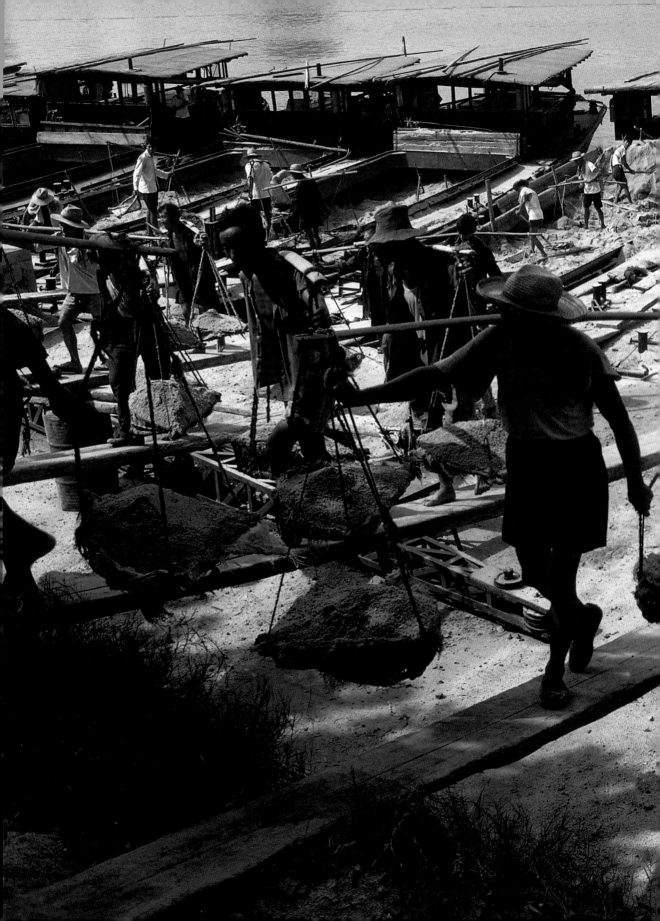

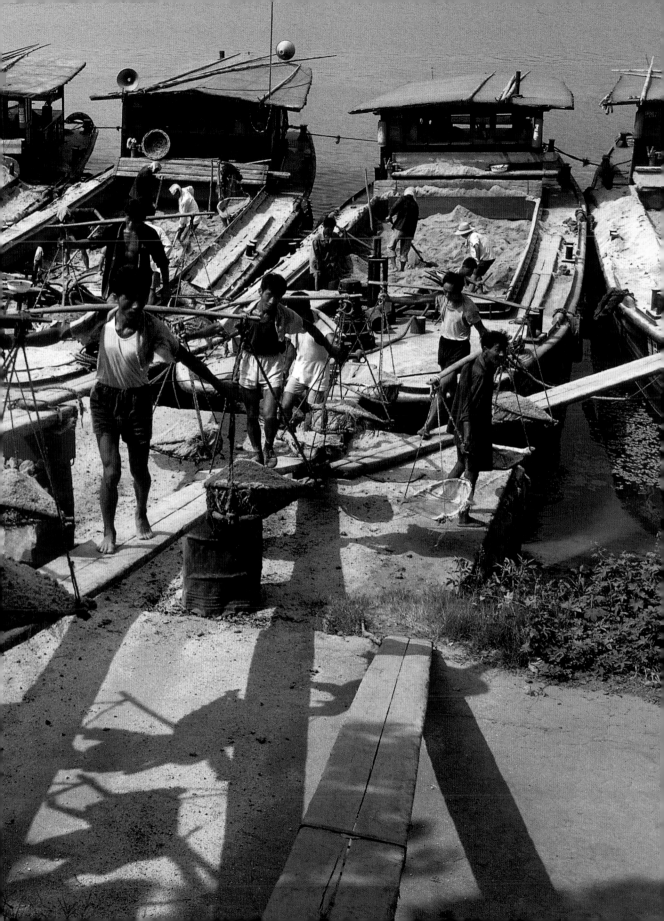

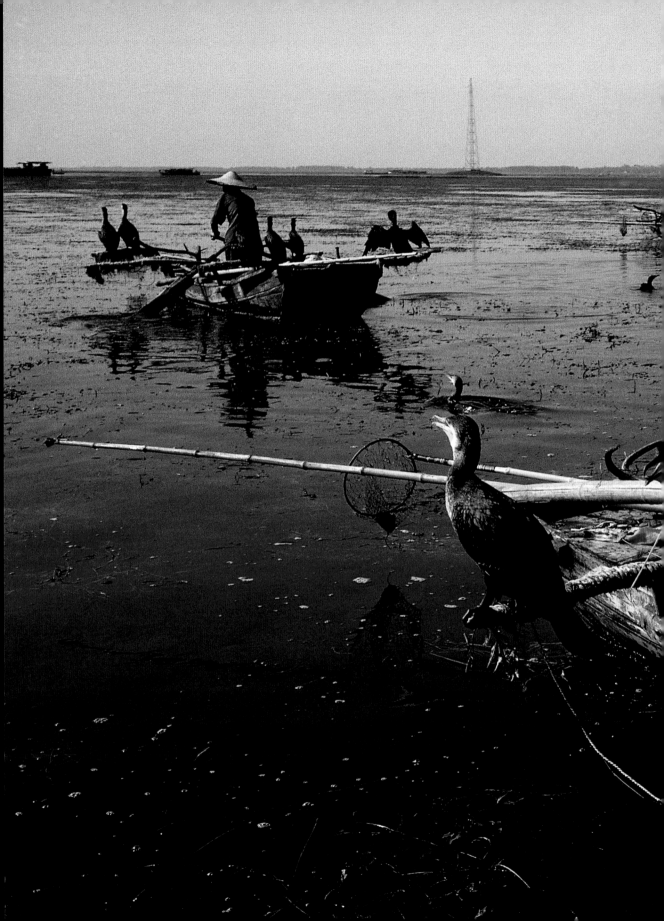

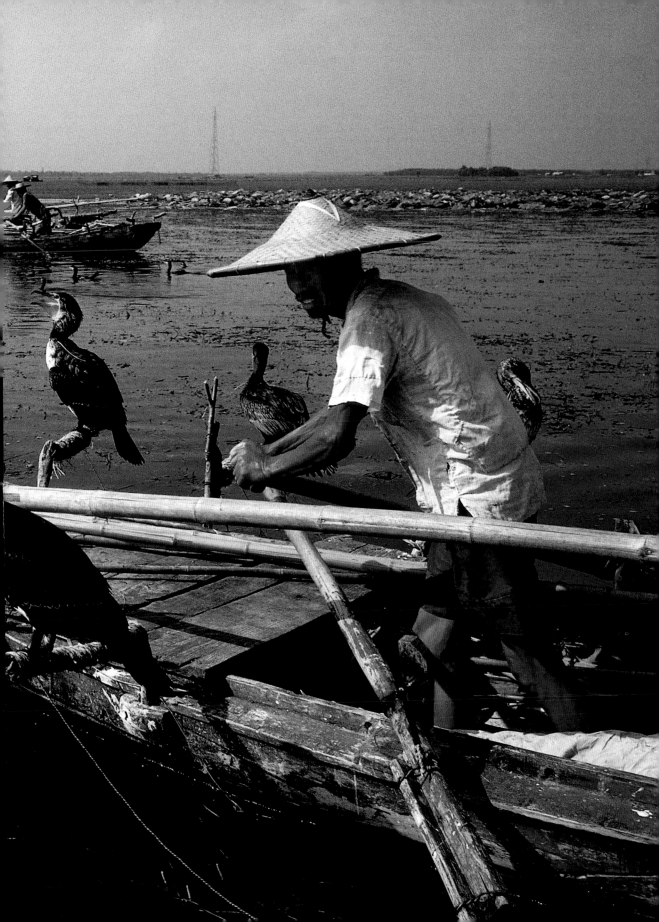

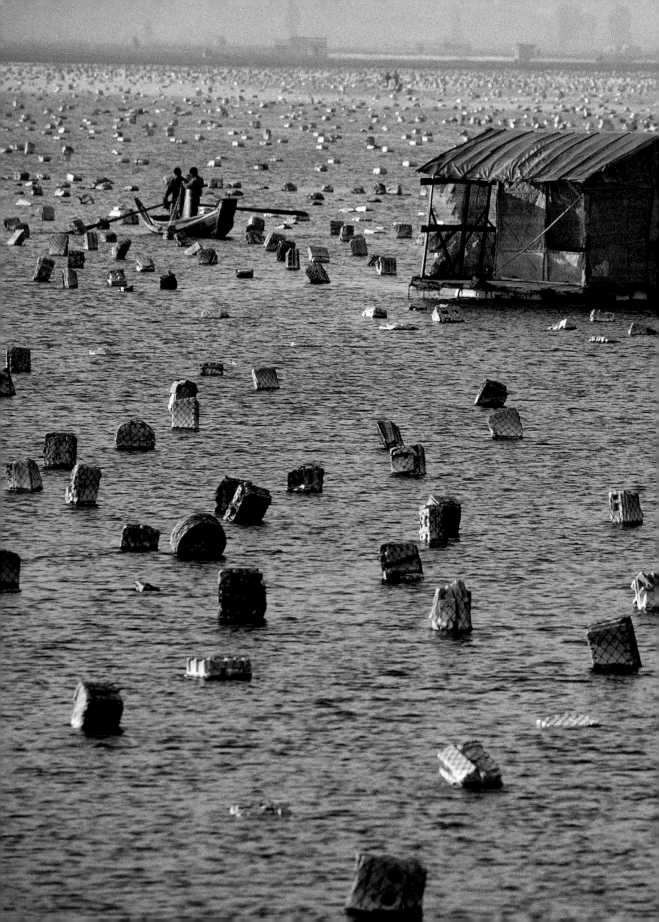

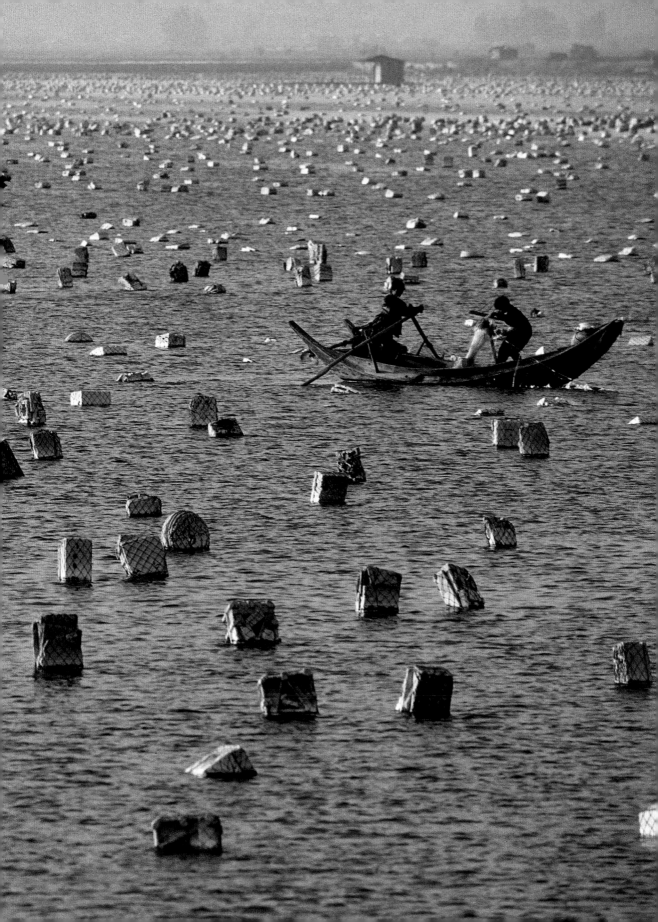

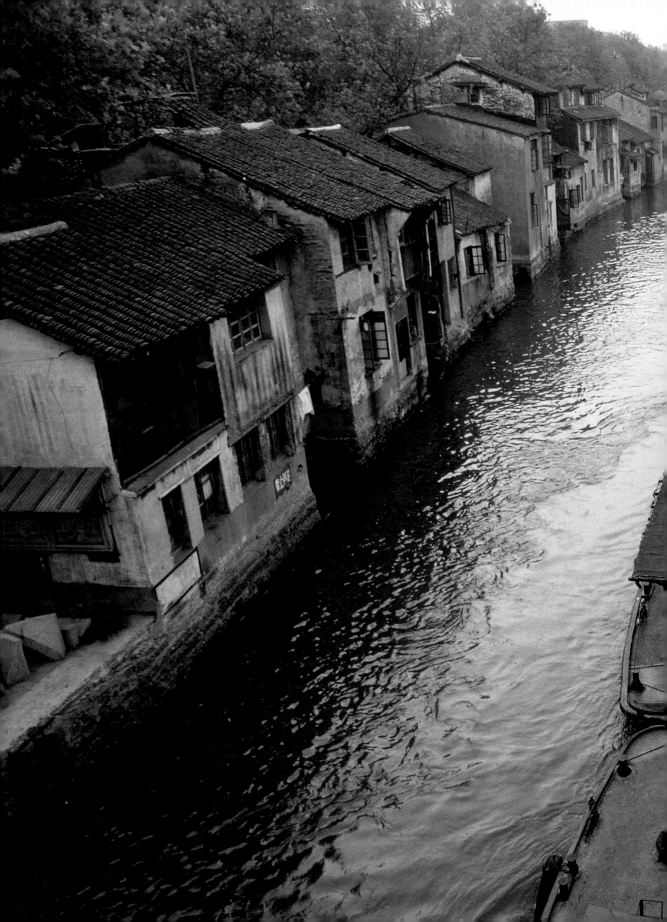

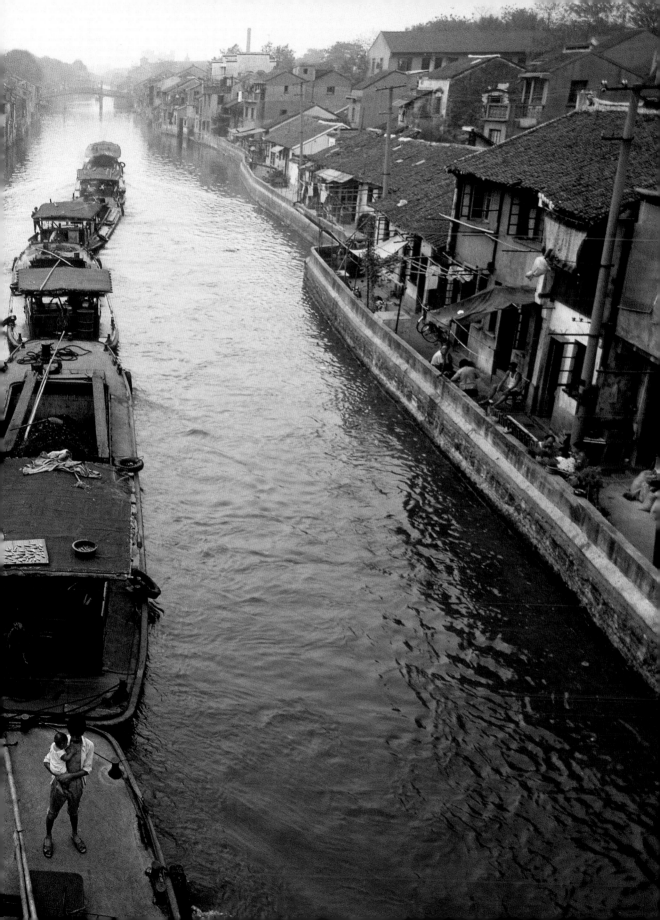

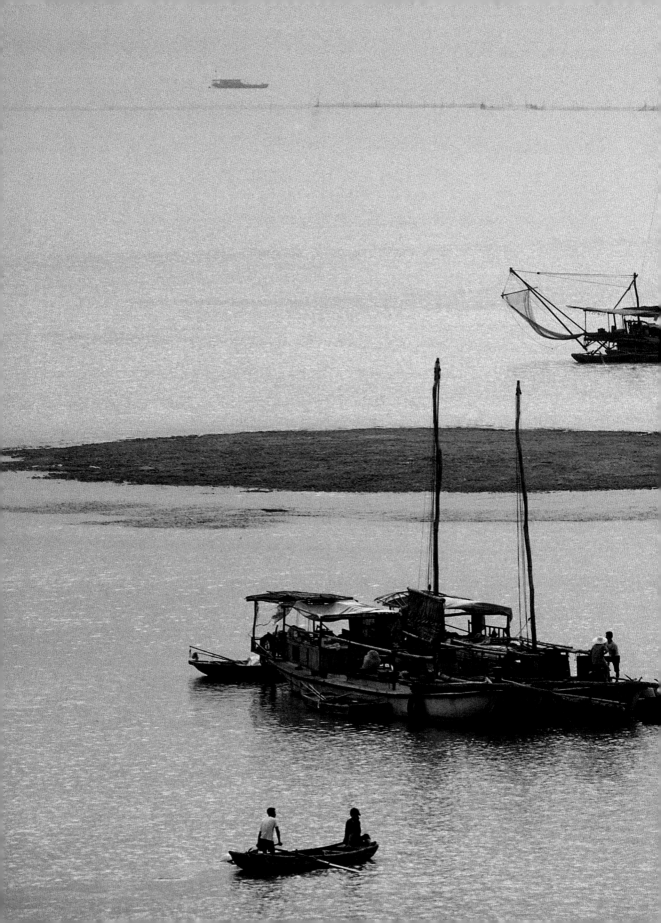

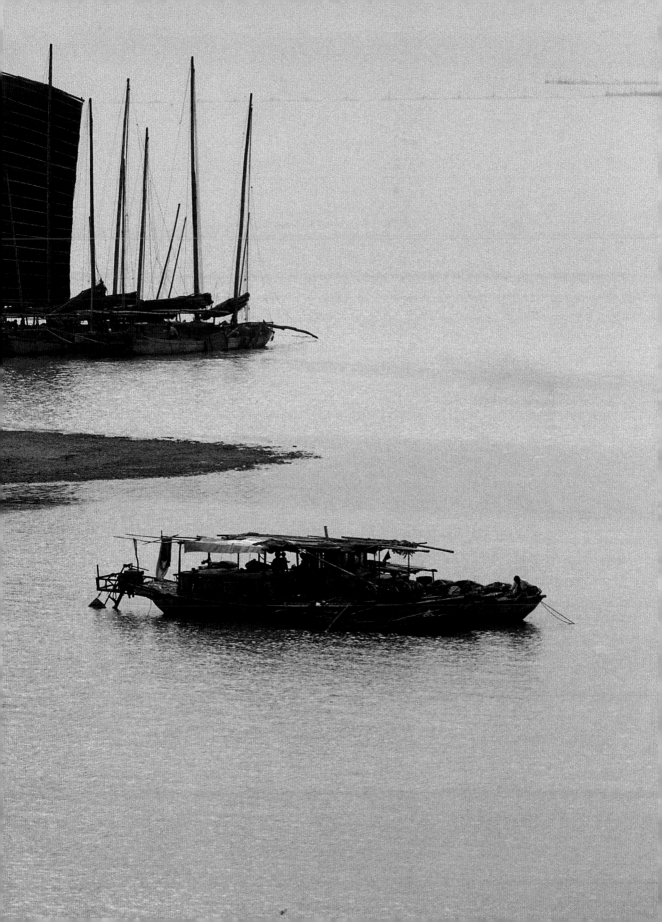

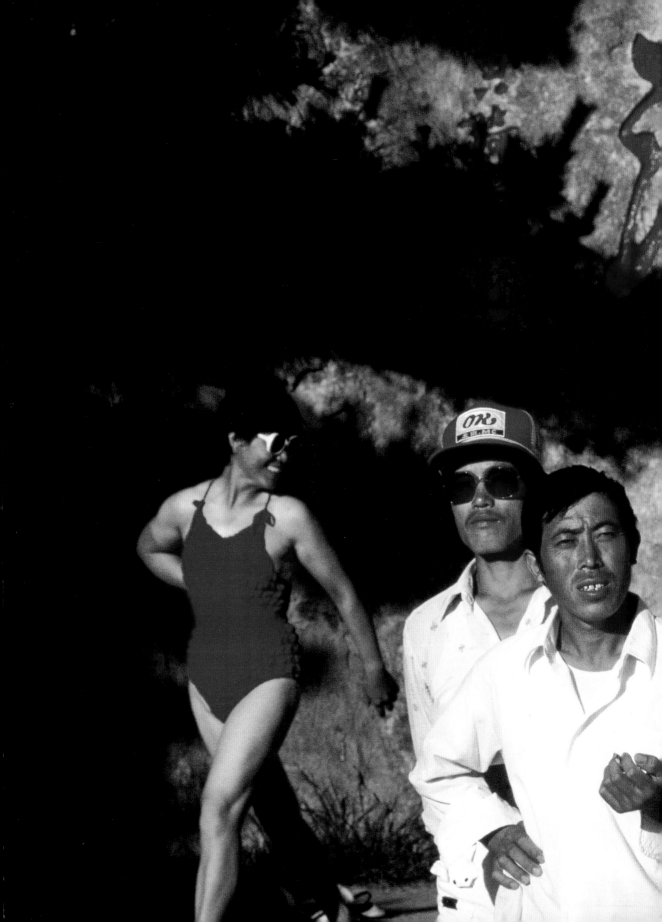

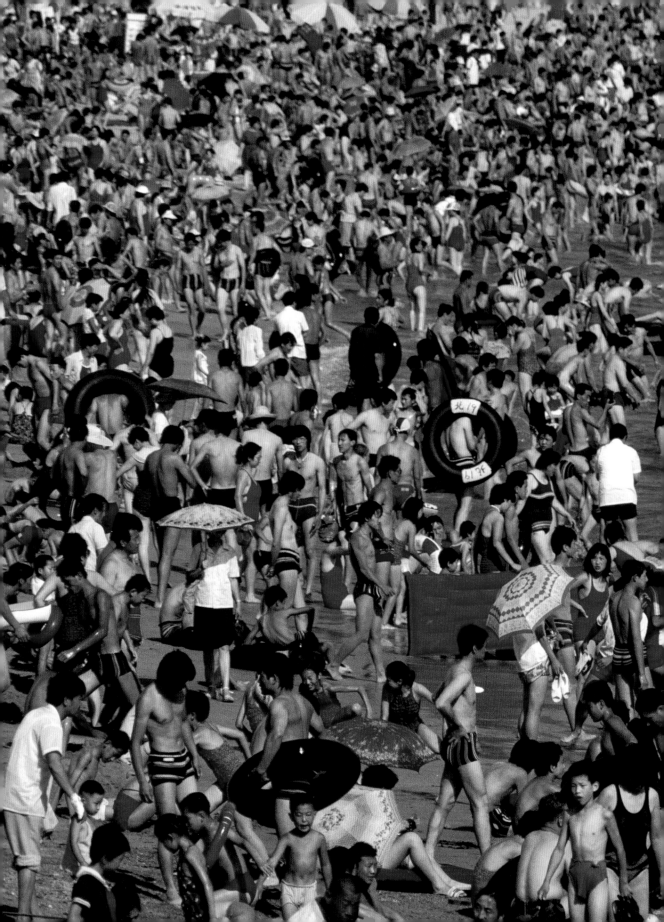

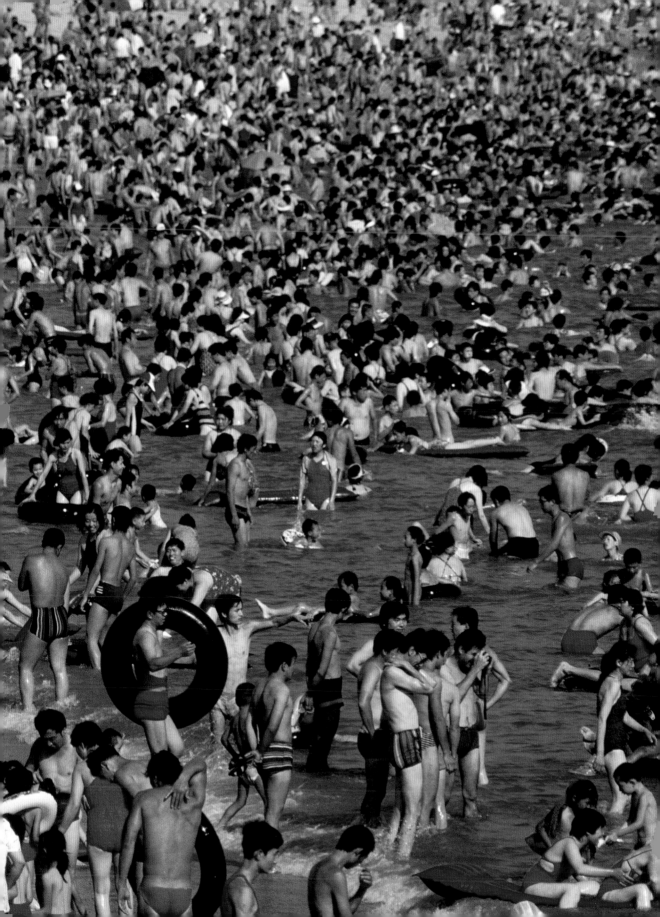

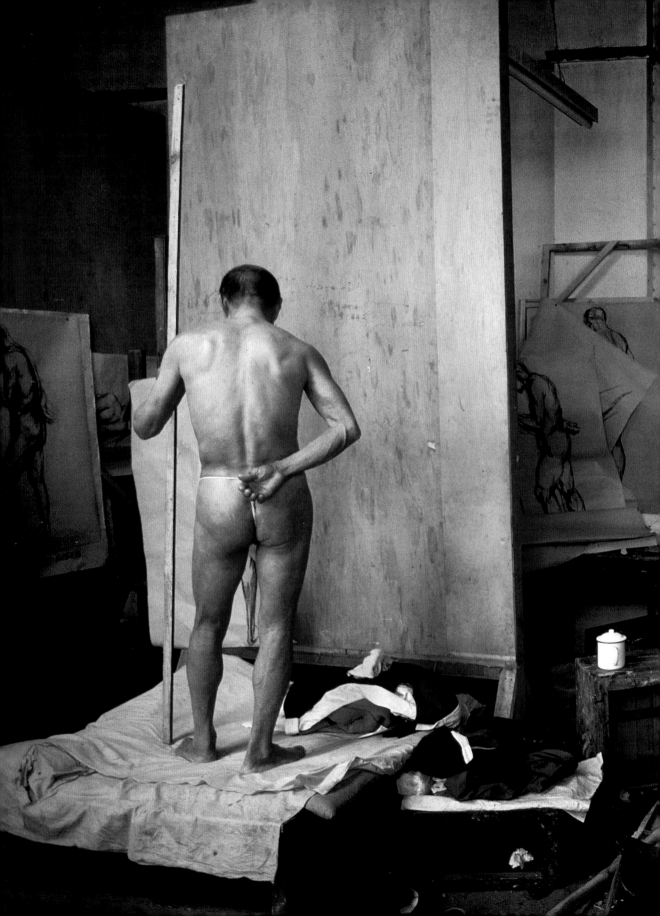

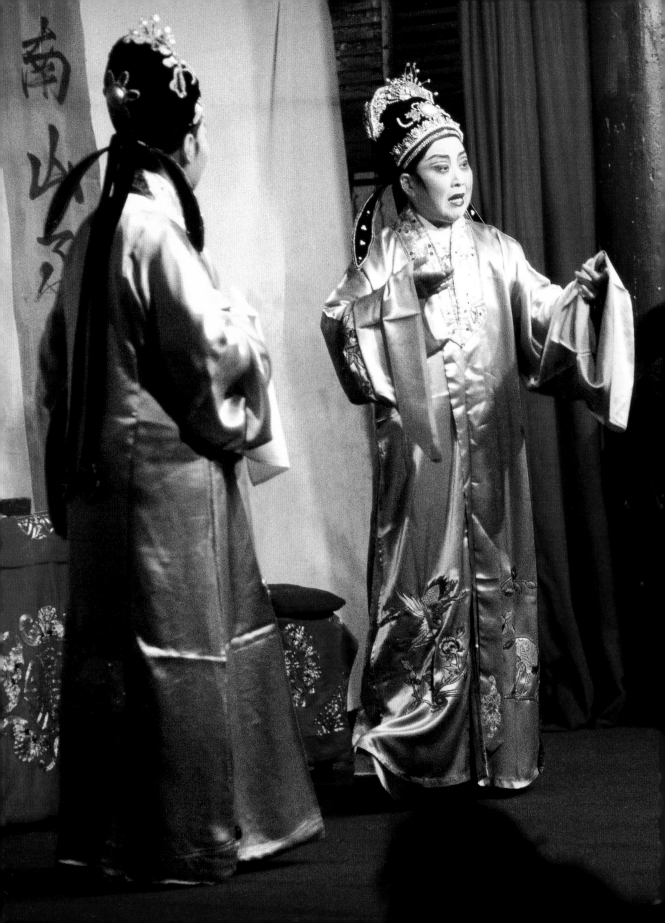

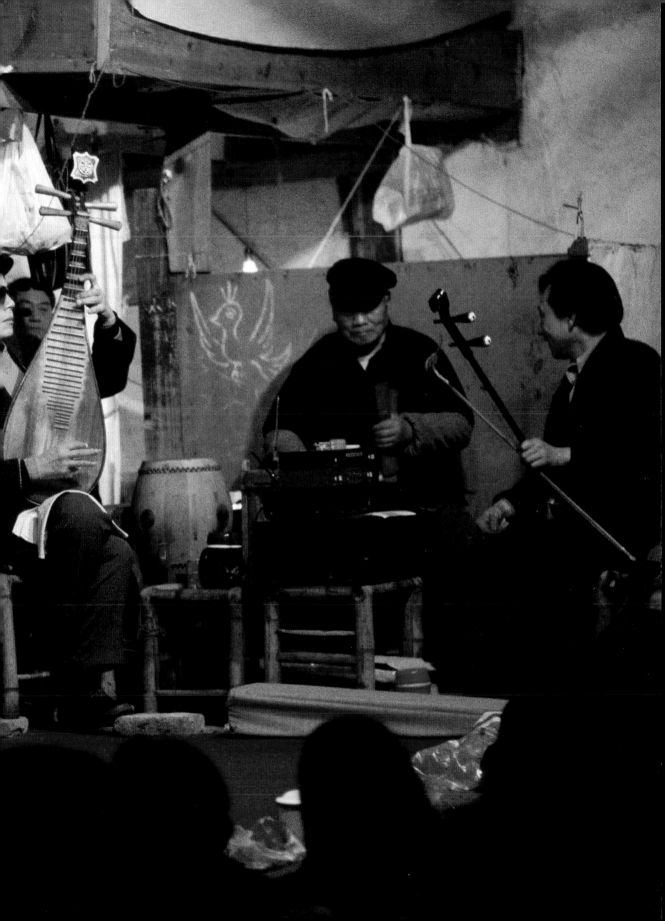

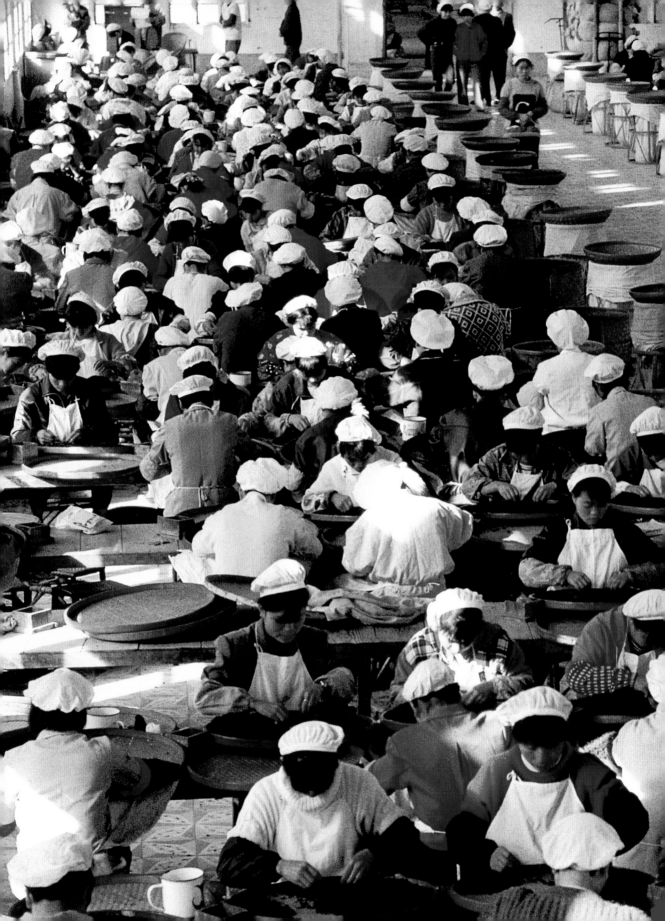

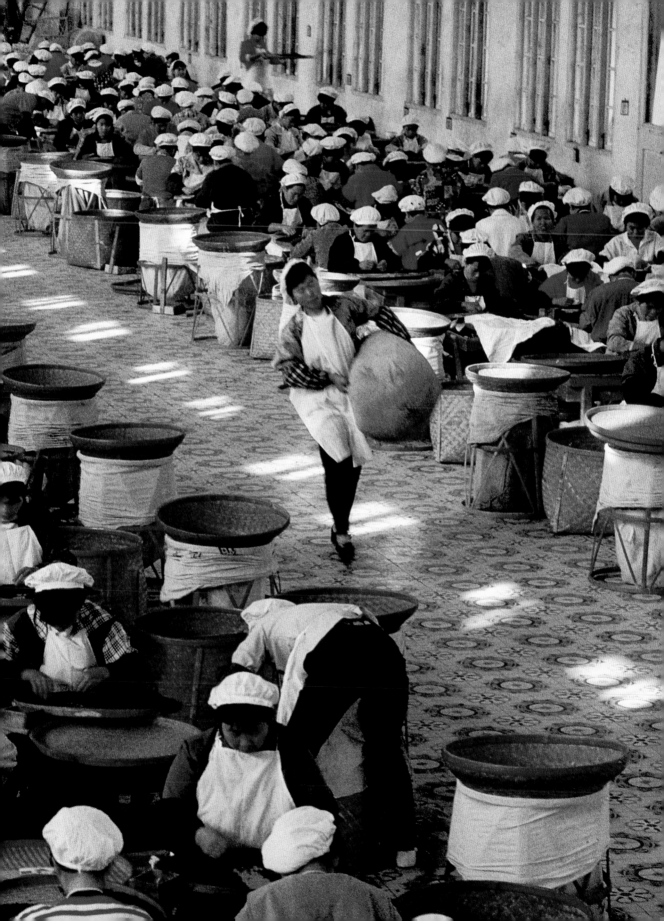

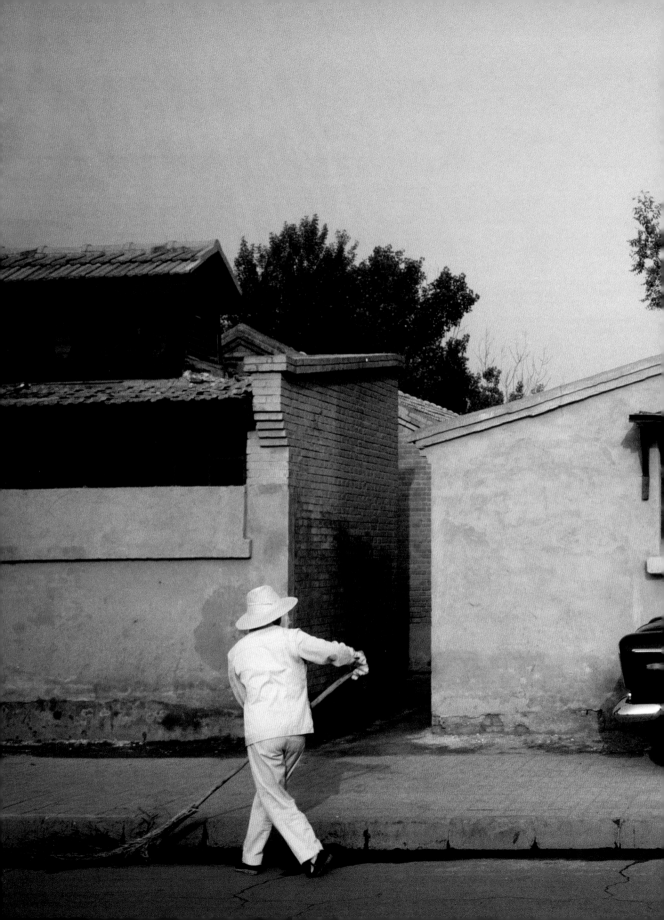

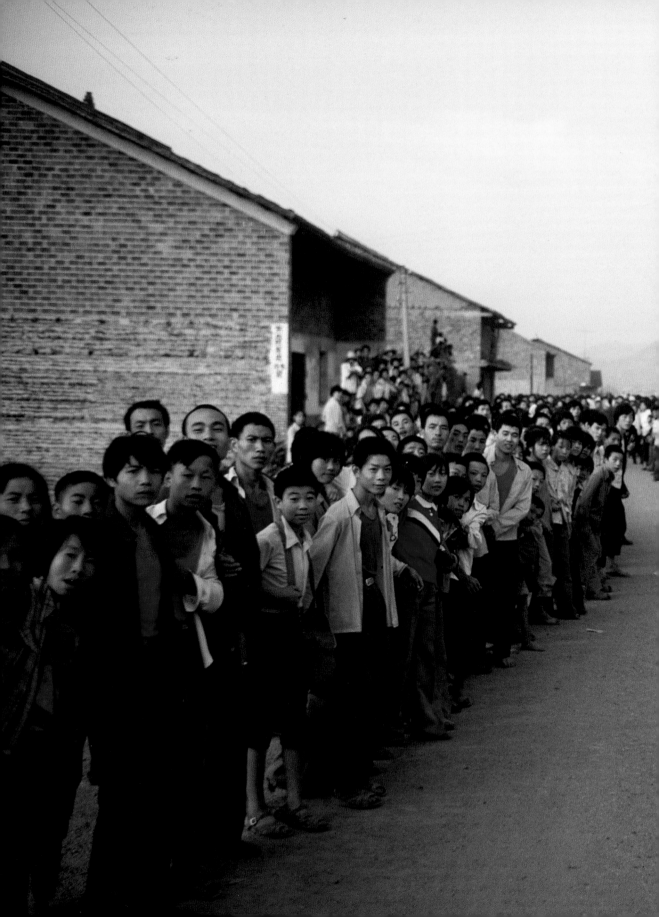

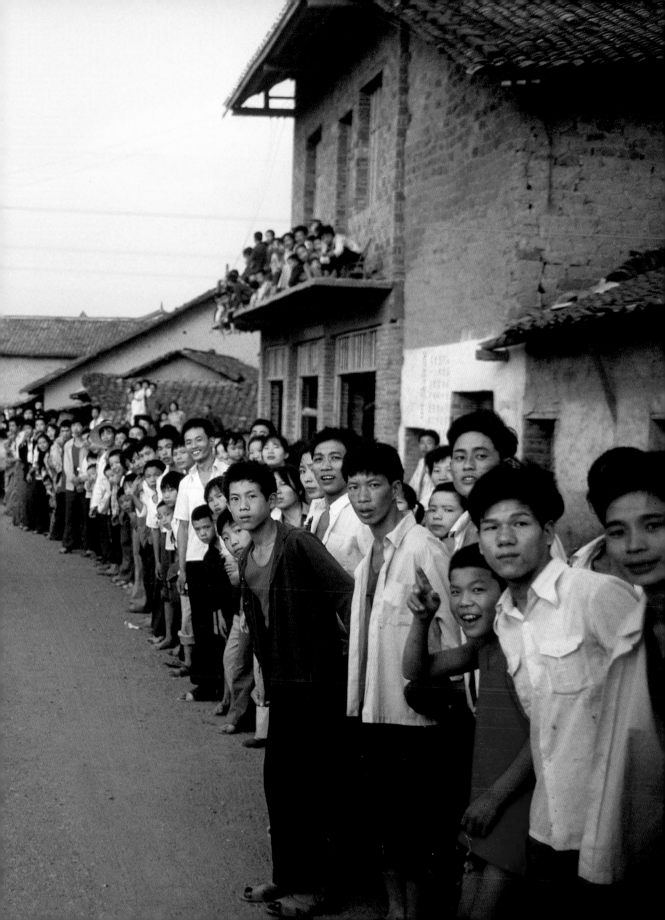

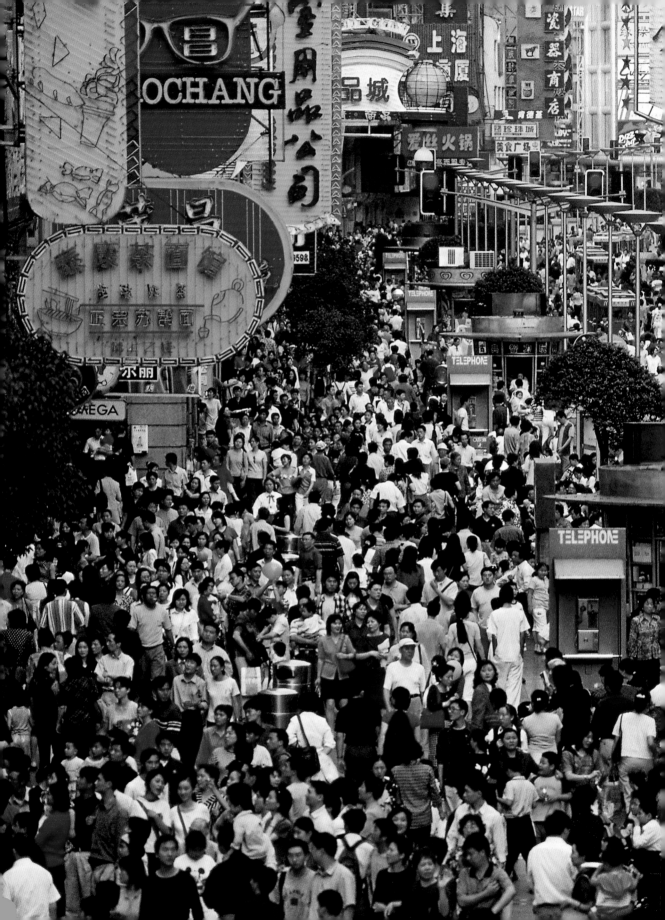

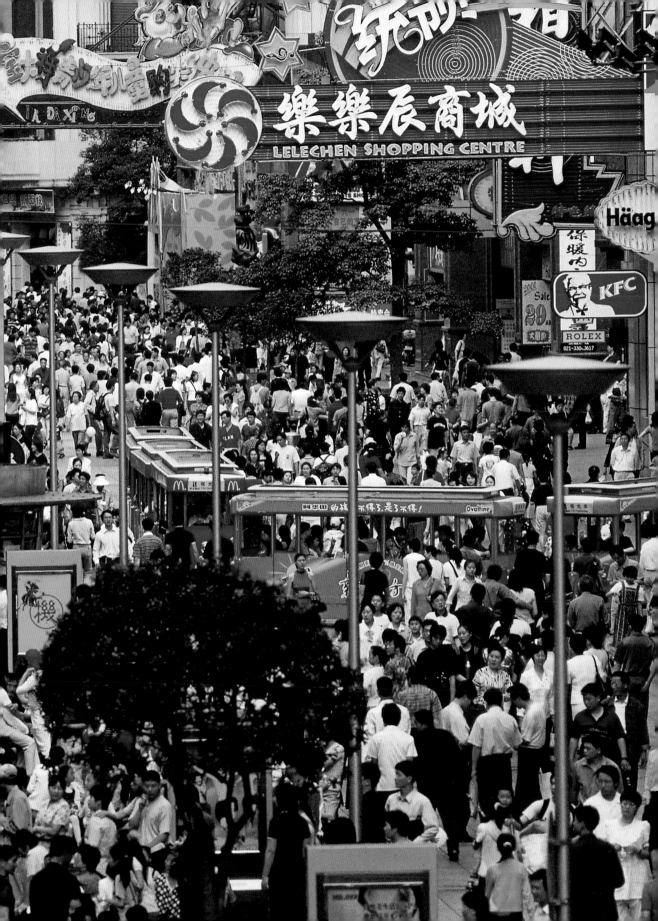

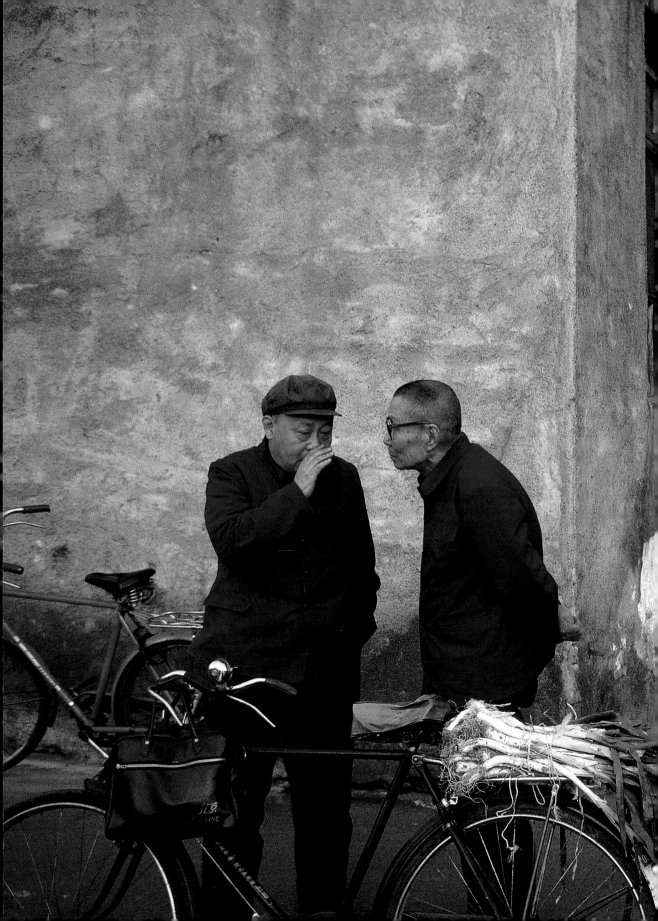

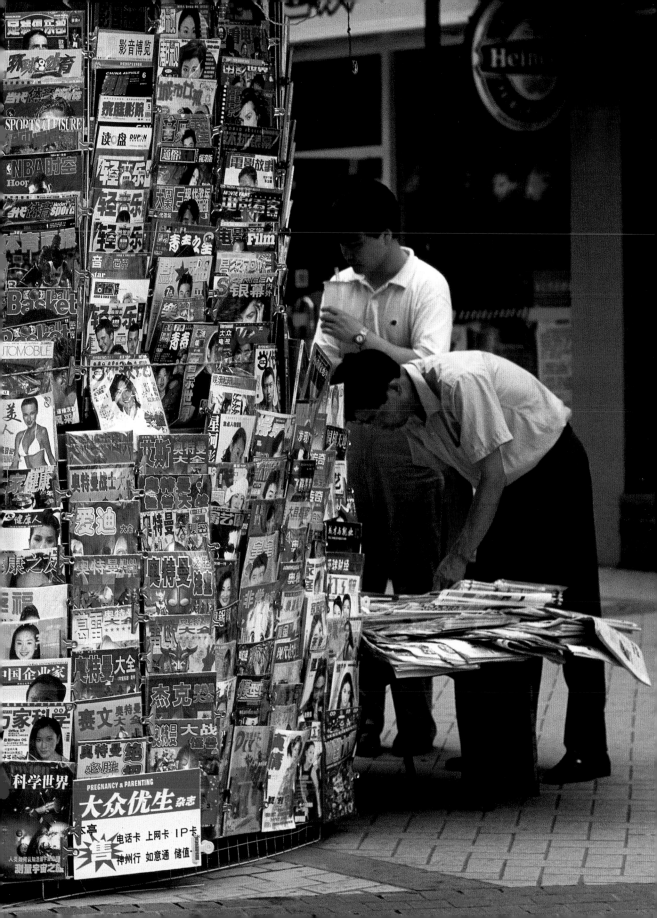

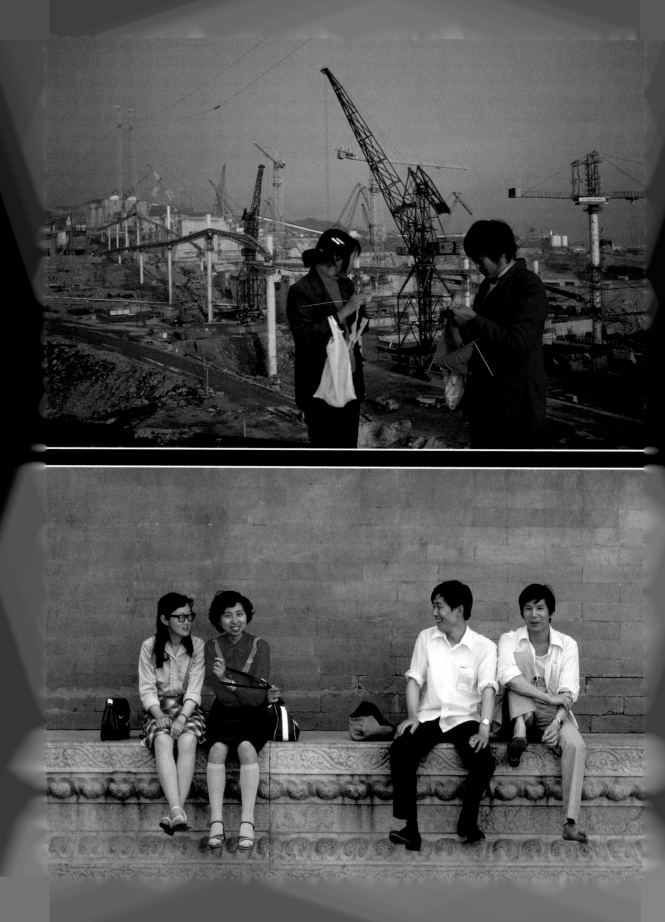

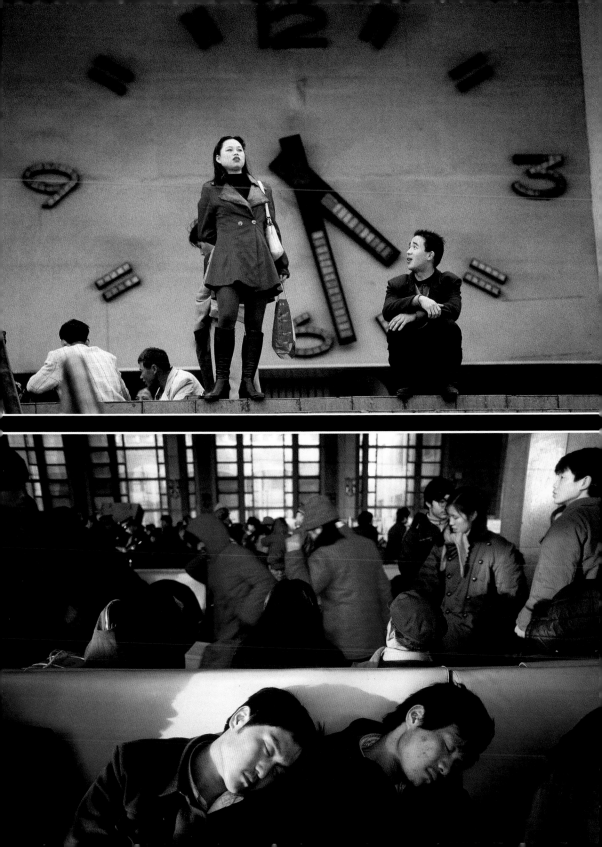

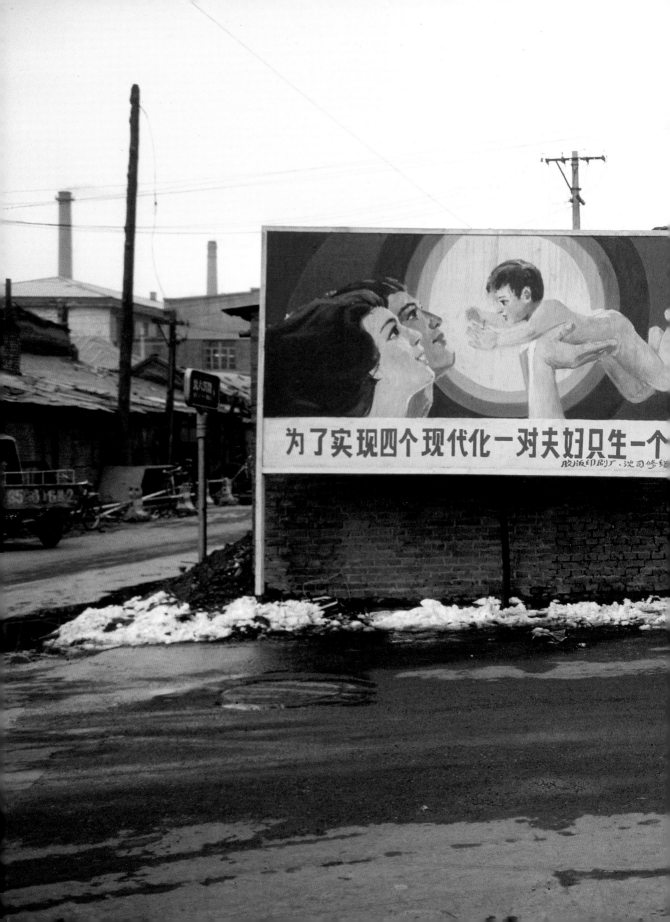

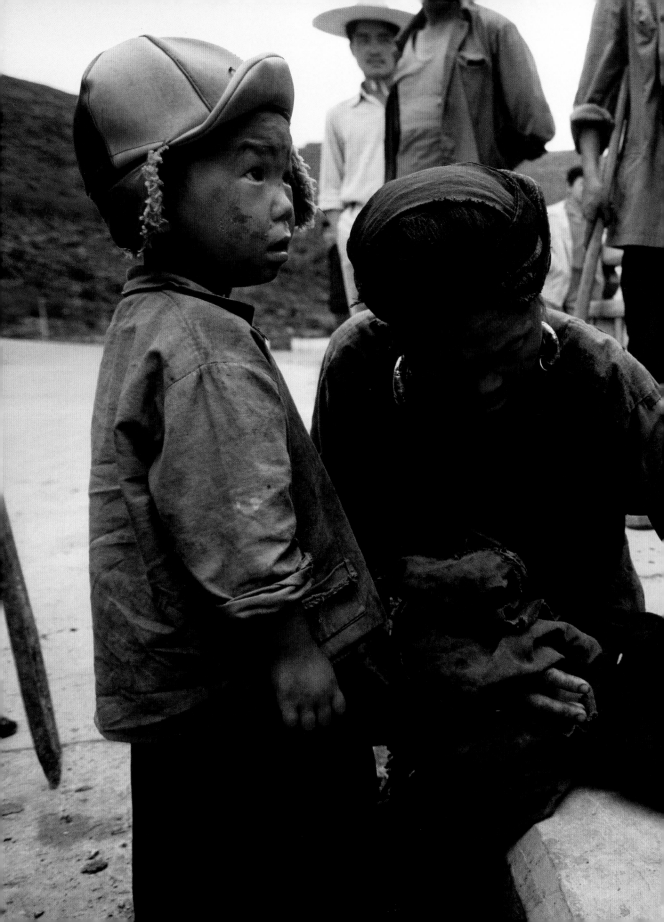

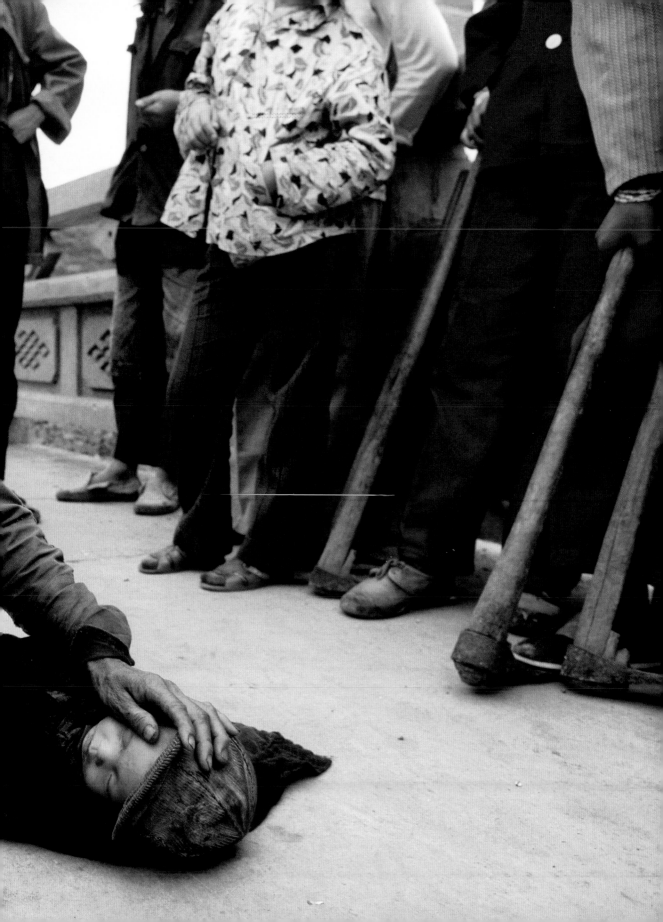

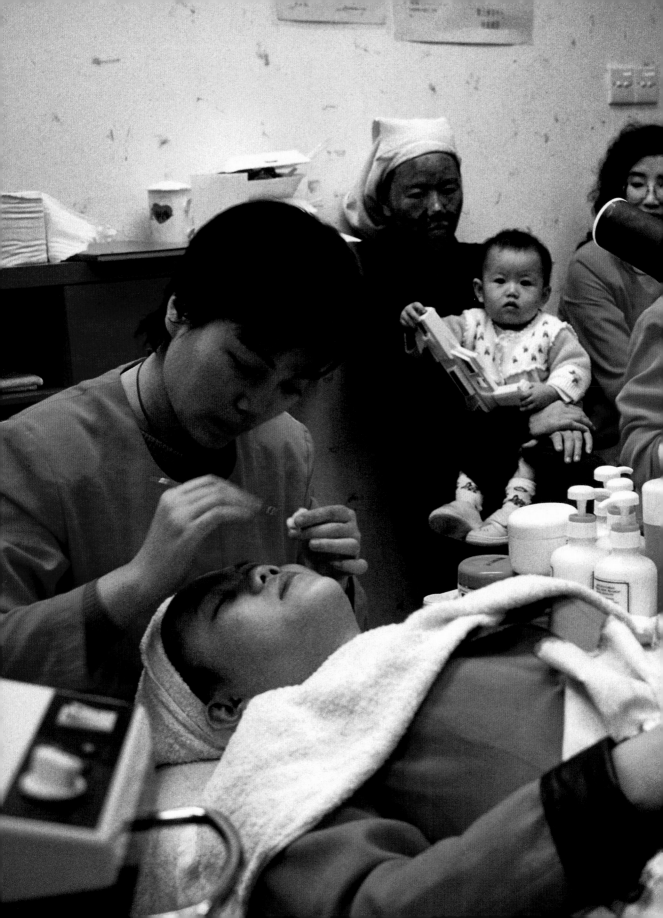

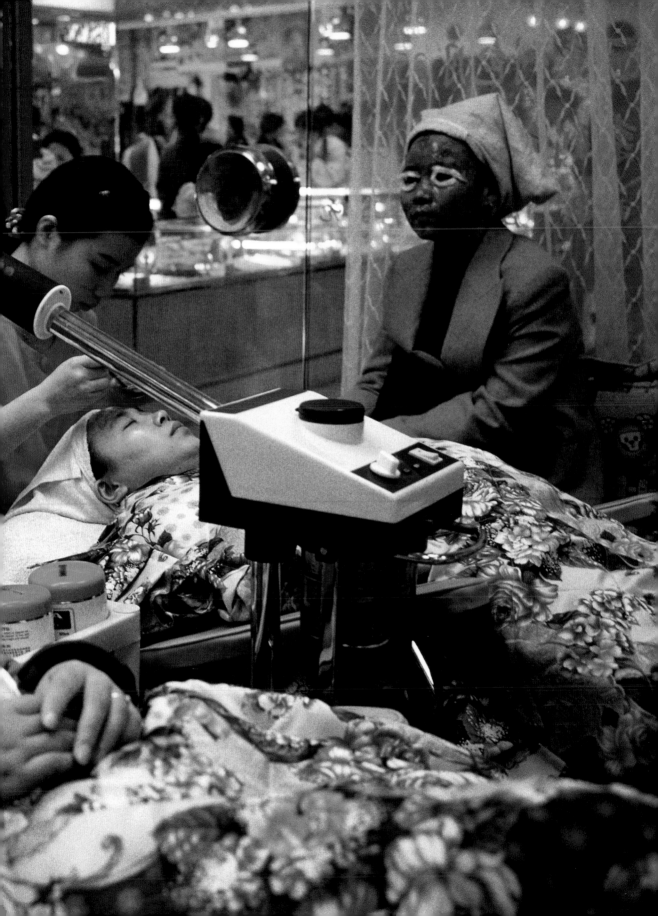

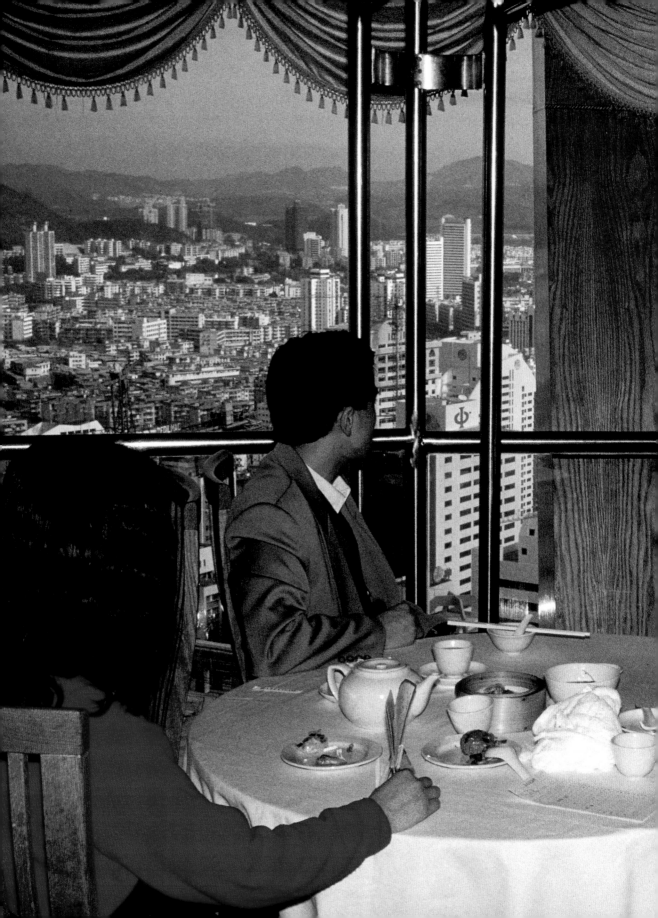

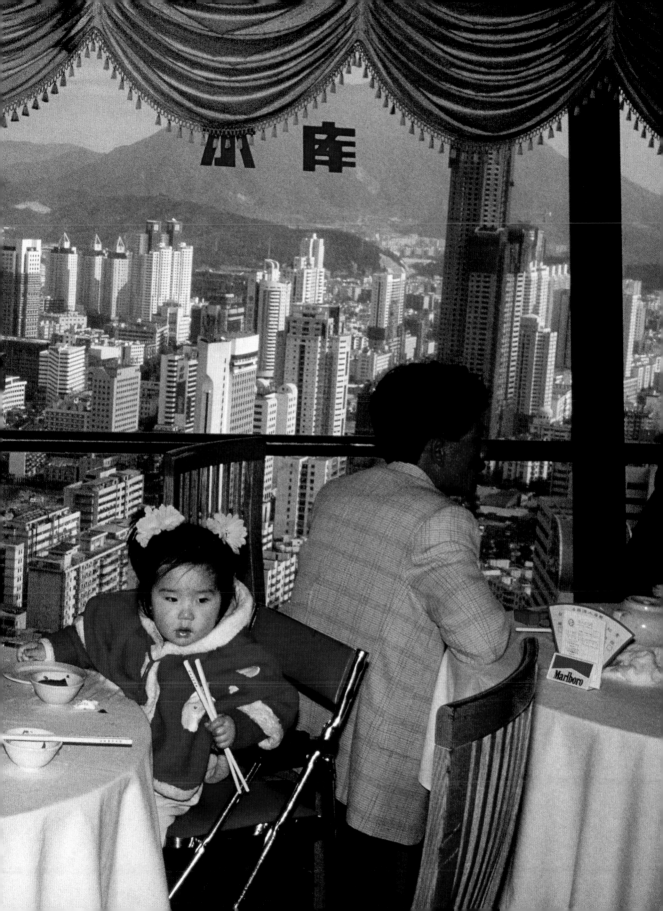

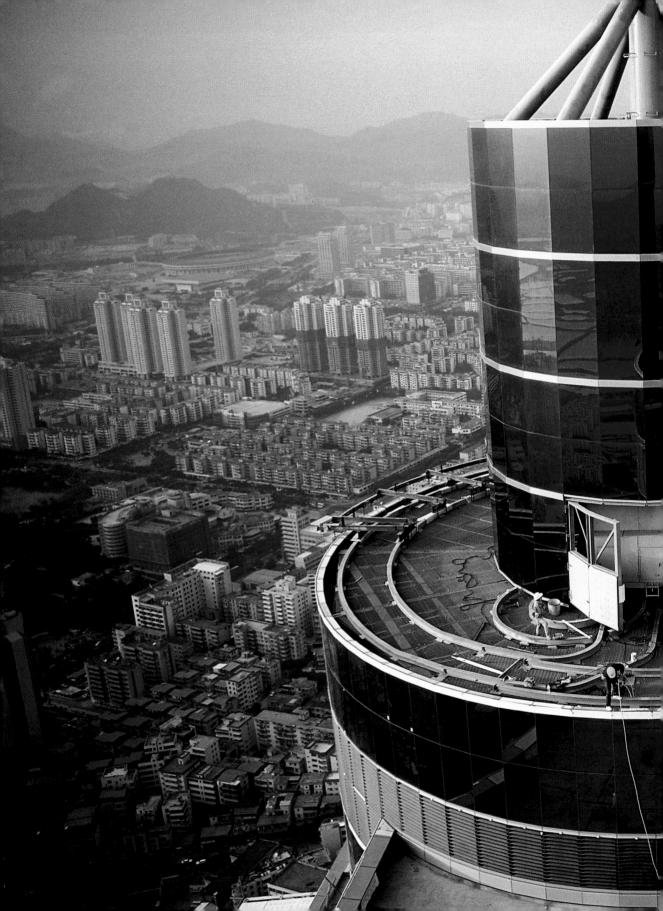

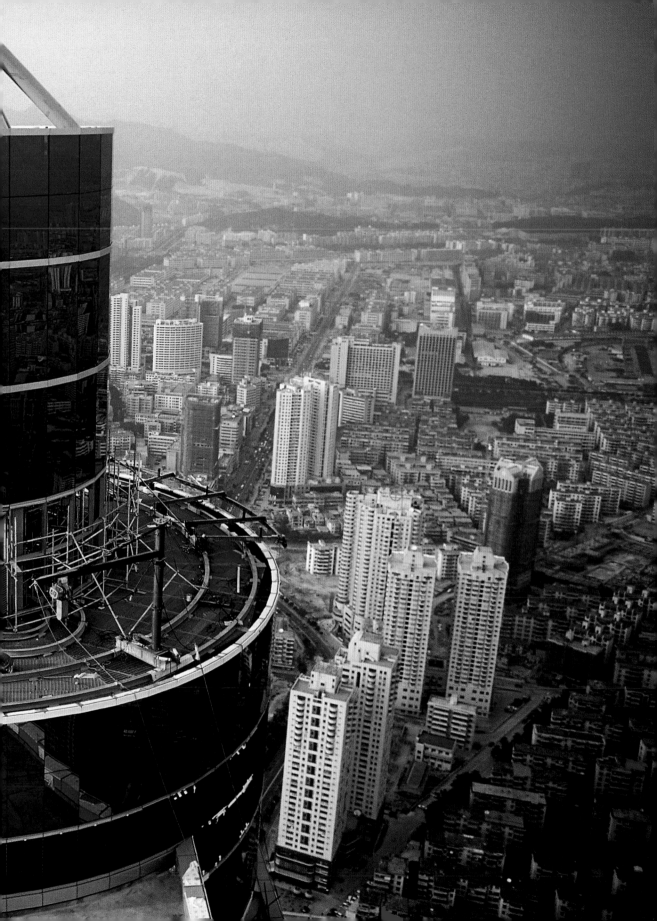

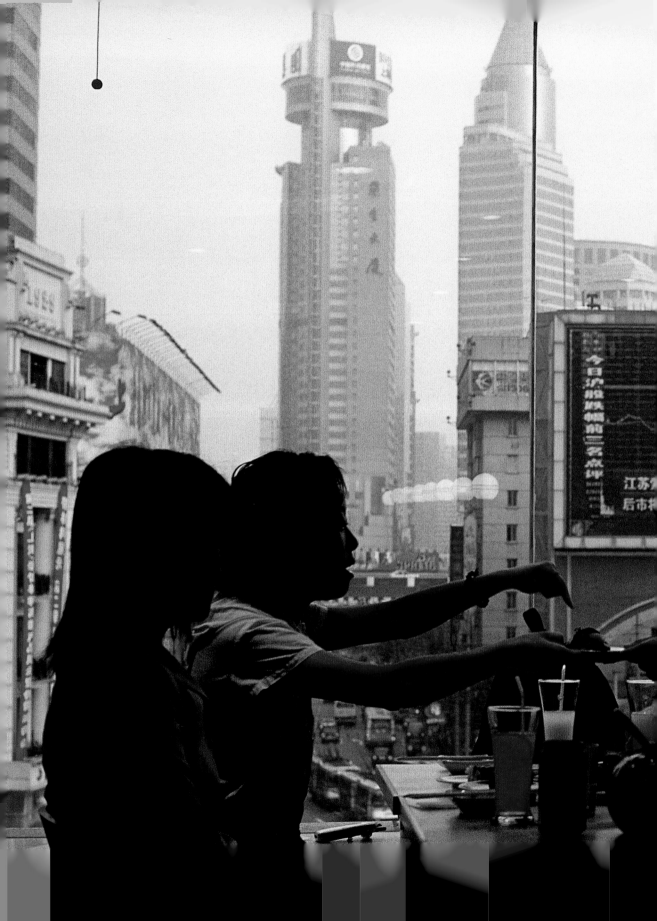

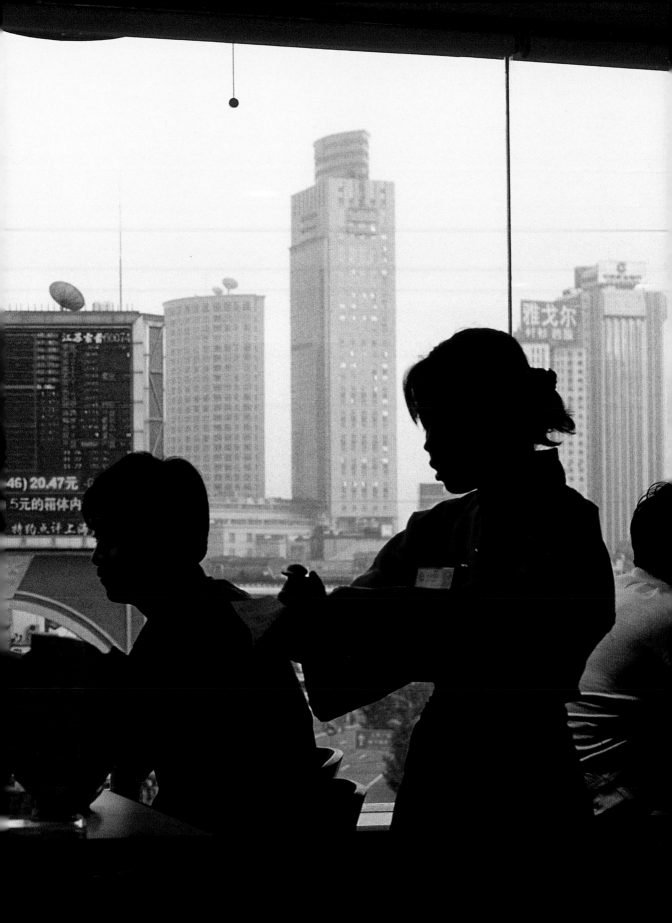

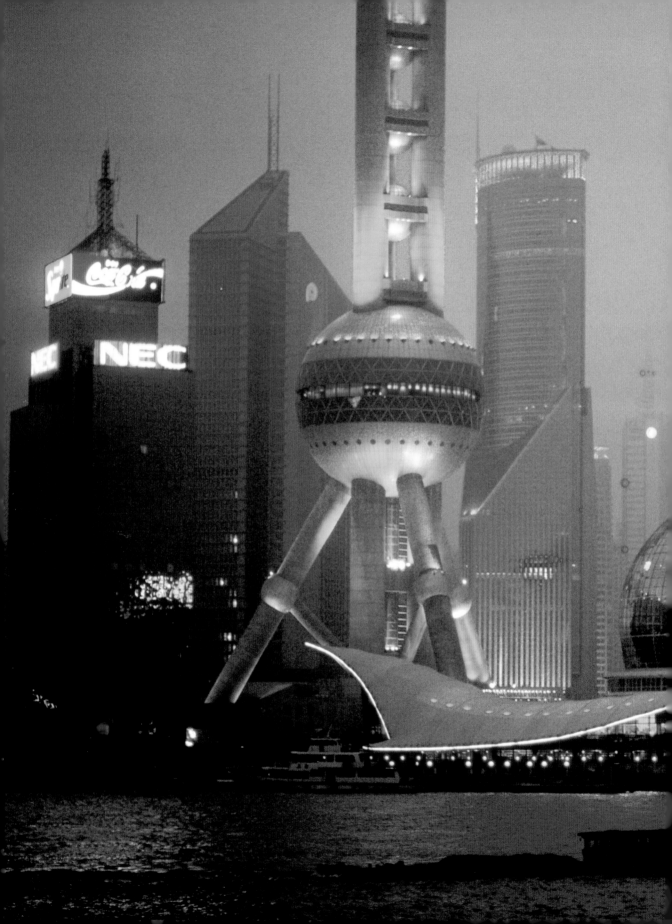

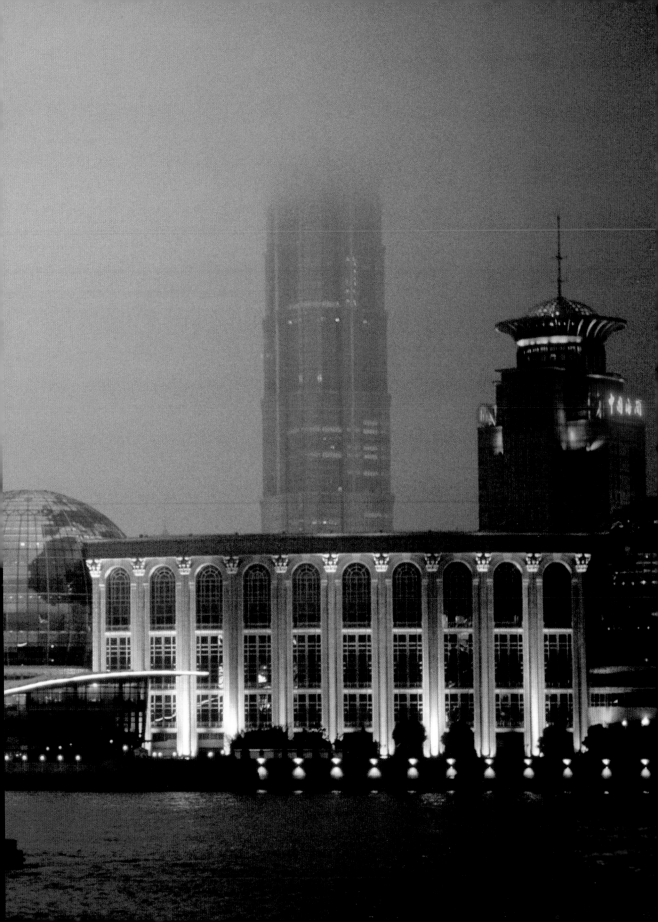

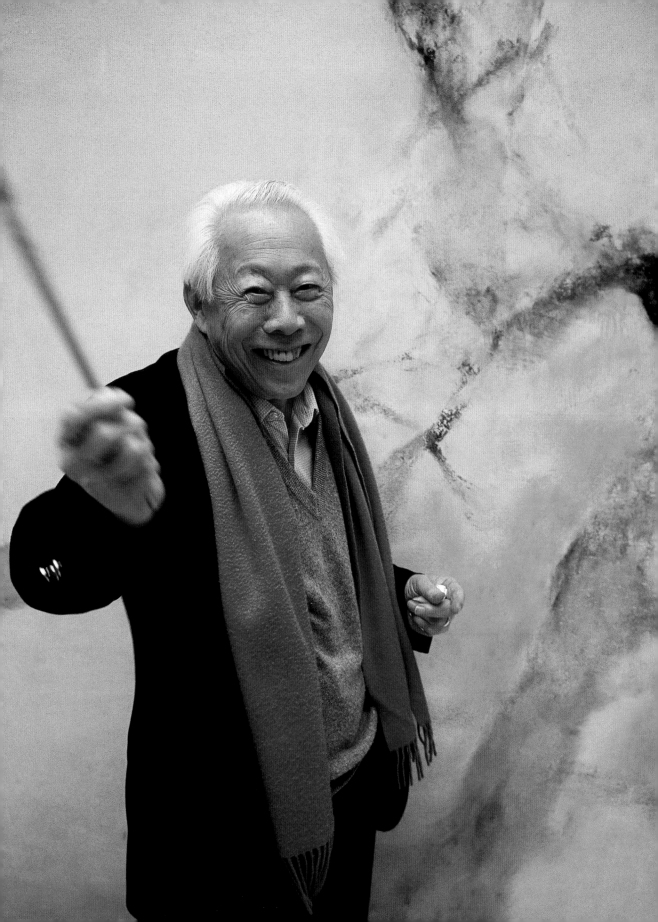

ZAO WOU-KI AND CHINA
A FREE DESTINY

Shanghai, 1930. He sits in an armchair in the milky atmosphere of the light in China. Bending over a book of pictures, he is filled with wonder as he turns the pages, stopping at a famous painting by Fan K'uan, *Travelers among Streams and Mountains*. Fan K'uan painted under the Song dynasty that ruled from the tenth to the thirteenth centuries. He was nine years old and had often heard his father and grandfather talking about the period.

This was the golden age of Chinese painting. A veritable effervescence inspired painters in the four corners of the country. They painted dragons and fish, mountains and streams, domestic animals and wildlife, bamboo and pines. In those days, landscape painting was an ascetic practice. A man would withdraw to the mountains and wait for a long time, watching, letting the rustling of the world pass through him, the curve of the wind, the call of the birds and dogs far down in the valley. As he waited, the hermit would be set free from himself and inhabit the things around him, becoming the wind, becoming the water and the mountains, the fog and the birds. Thus in every thing, the hermit would become part of strange dialogues between water and birds, between the fog and the mountains. This is *qi*, the body's spirit, the secret meetings between yin and yang.

His name is Tsao (later Zao) Wou-Ki. His family name in fact means Song, and his own name, Wou-Ki, a Taoist name, means limitless or boundless. He hopped from the big armchair, took another book from his father's collection in order to see once more, discover, rediscover, as later, filled with quiet enthusiasm, he would be fascinated by a catalogue of Chinese painting.

He worshiped Mi Fu, the painter-poet, a master of the Song school. His family used to perform a ceremony in his memory. Year after year, with bated breath, they would get out a painting by the master, as if they were handling something sacred.

In Wou-Ki's family, painting is a tradition handed down from father to son. His grandfather was a scholar of the last empire. He did nothing but paint, practice calligraphy, read, and spend his son's, Wou-Ki's father's, money. He was a banker. He was also a painter and was awarded a prize.

He is fourteen years old. On a trip from Shanghai to Hangzhou, the train moves through the Chinese countryside. The teenager sees the landscape pass by, looks at it through his dream, painting. To be a painter. This is what he repeats stubbornly to his mother. To be a painter is his path, Wou-Ki path, borne by the long, long tradition of the brush.

On the train from Shanghai to Hangzhou, he holds his father's hand; his father is a man with a pleasant, smiling face. Age has not changed his proud bearing. They share gratitude and complicity.

You couldn't have left without your father, without his support. Your mother didn't want to let you go.

Painting isn't a profession. He should become a banker, like you. And your father: *Wou-Ki, a banker! You want us to go bankrupt? Let him paint; he loves that. Whenever he does, if he succeeds, that will always be fine. Let him do what he wants.*

You were both stubborn. Your mother resigned herself.

On the way to Hangzhou, little white three-story buildings, market gardens. Father and son are both confident. Painting has held them for a long time; strong, it calls them, like the depths of certitude.

Shanghai fades into the distance. This allows you to appear.

You don't miss your life in Shanghai, caught between the Japanese and English occupations. The humiliation you suffered will be with you for a long time.

I have never forgotten it. The English concession on a garden on the Huangpu River. At the entrance, a sign: No Dogs or Chinese Allowed. I have never forgotten that. The Japanese concession that I also had to cross to go see my father at the bank. Soldiers, in their hands submachine guns that they would point at you. For a six- or seven-year-old child, it's terrifying. We were always afraid. They could shoot. We spent our lives like that. That was colonialism.

Things were better with the French. They didn't use the threat of power. The French occupation was more cultural. I lived in the French concession in Shanghai. There was a little bookstore with books on Henri Matisse, Pablo Picasso, more pretentious painters too. With my money, I bought books. That's how I got to know the Petit Palais and the Grand Palais.

Shanghai fades into the distance. The faces of those you are leaving come back to you. You laugh at the thought of your grandfather with his mischievous smile.

Thanks to my father, my grandfather got very rich. Then he did good things for the country. In China, it's very expensive to build a bridge; he built bridges everywhere. He promised bridges left and right with my father's money.

Shanghai fades into the distance, and pieces of conversations return.

Your father lecturing your grandfather: *You know, it's not easy to make money!* And your grandfather: *I build bridges for pleasure, for everyone. You'll benefit from it later.*

Hangzhou, southwest of Shanghai. Of course you know these sublime landscapes, this immense lake, these mountains surrounding it, majestic, like a lover's nest. Hangzhou. Of course you had heard about this legend of the white snake. Hangzhou. Above all, you return to the heart of painting. By long tradition, painters come from afar, to paint at the lake's edge the mountains as they play with the mists.

At Hangzhou, you will go to the School of Fine Arts. There is that nasty story, a crime of passion that tarnished the school's reputation. But your father brushes off the stories in the press.

Don't worry about that story. Work is what counts.

The father, with a stern face, approves of the adolescent. He won't think about girls, and then romance is forbidden at the school. He will work, a lot. Because that's where he wants to go, to the School of Fine Arts in Hangzhou.

There is also the School of Fine Arts in Beijing, but it's pretentious, academic. I wanted to go to Hangzhou. Hangzhou had the best school of fine arts. Painters from Hangzhou went to Paris during the Impressionist period. It influenced them. For the Chinese, Impressionists are still the avant-garde.

Suzhou, near Hangzhou. People say that the two cities are heaven on earth. The adolescent smiles at the images that come to him. His mother is sitting next to him. He would like to make her respect him. His grandfather teaches them both calligraphy.

In those days, a Chinese woman couldn't be educated. My mother learned to read and write Chinese with my grandfather at the same time I did. After school, we would meet to write characters; there are a lot, more than ten thousand. My grandfather painted fruit. He drew a watermelon and, on the back of the sheet, the corresponding character. I also began to draw. My grandfather was a Taoist. My name, Wou-Ki, was given to me by him. Wou-Ki means limitless, unbounded. It's a little pretentious, don't you think?

Hangzhou. Hangzhou. The train is arriving.

Hangzhou, the School of Fine Arts. Your father still encourages you. The admissions examination was a success.

When you go to the school, you choose a major, Western painting, traditional painting, sculpture. They have music too. I chose Western painting. I started classes, I drew with charcoal, like in France. Afterward, I went on to oil painting, because I was curious.

Hangzhou, study, work, wonder, perseverance. From time to time, news of your family. You paint your sister, mysterious and pensive. You paint your house on the edge of the Western Lake with a thousand bridges.

In Hangzhou, bridges are named after great writers and poets. A bridge is a name. Another bridge is another name. This way poetry is everywhere. In Hangzhou the School of Fine Arts is in a wonderful setting, right on the lake. There are places where you can drink tea, things like that.

Hangzhou. An adolescent is sitting on a hillside. People stroll and chat on the bridges that cross the lake. On the bank there, an old man is walking, slightly bent over his cane. Lovers, in small boats, draw away from the shore. The adolescent doesn't move. His gaze embraces the mountains there where they are blurred by the clouds. You can't tell where they stop, or where the sky begins. There, where the boundary is lost, infinity slips in.

In Hangzhou you study endlessly, discover Western painting in magazines, reproductions of J.M.W. Turner and Paul Cézanne, once again you find Matisse and Picasso. You are captivated. It doesn't look anything like Chinese painting. Here, the outlines of landscapes are blurred by the mist. Mountain and infinity merge. Here, mild and precious figures give the landscape all of its scale, its meaning. There, bodies are overthrown, transformed, dismembered. There, colors and daring.

Hangzhou, the School of Fine Arts. You also have to read all the treatises on Chinese painting, copy pictures by painters who bore you. You feel constrained. These long speeches on the art of painting bear down on your head like a lead weight. They impede the freedom to which you aspire above everything else. You can't bear the Four Wangs, four great masters of painting of the Yüan Dynasty.

The professor, a very well-known painter, asked us to copy paintings by the Four Wangs. I loathe them. I do whatever comes into my head. The professor complains to the director. "This student is impossible. He won't listen to me. I can't control him. We should expel him, right away." I beg the director. To be expelled would be terrible for my family. The director is on my side. For him I'm a model student. I can stay at Hangzhou.

Can you imagine what my father would have thought if I had been expelled?

Hangzhou. You're walking on a winter road. It's very cold. There the sun can hardly pierce the sky, the call of

the infinite. There the transparency on the bare branches, on the faded leaves, tints the crowns of the trees with pink and mauve. There, the snow reveals the summits. There are no bright colors in winter in Hangzhou.

Through these years, you learn the techniques of oil painting, tame color, amaze yourself with its arrogance. You daub canvases with blues and yellows without concession. Today, a day of anger, you spread a bright red on the canvas. That has never been done in your tradition. You like it. You like to cross boundaries, clear virgin territory.

I entered the School of Fine Arts when I was four-teen. Six years later the school said, "You're a good worker, you can stay as a young assistant professor." I improved paintings by students for the director of the school, and he explained to them why I did what I did. This went on for six years; I was fed up. The other students were about my own age, or even older than I. It wasn't much fun. I wasn't learning anything.

I told my father that I wanted to go to France, to Paris. He said, "You don't speak French, you speak English. Why not go to New York?" I said, "Because France has a much longer history of traditional painting." When I left in 1948, American Abstract Expressionism hadn't yet begun. André Masson wasn't there yet. Jackson Pollock came along in 1950. It was he who began things. You can imagine if I had left for New York, I would have become like them, an action painter. That wasn't my goal.

The young man leaves for France from the port of Shanghai. His family's there, some friends as well. Everyone says goodbye. Bearing introductions and encouragement, the young man boards the steamer. The crossing, thirty-six days at sea. The young man is discreetly attentive to his wife, Lan-Lan; thirty-six days at sea pass quickly. He is already in Paris, in the flesh of his dream. He wants to paint, learn, discover, obstinately.

As China fades into the distance, the faces of those he is leaving behind appear to him, sweet, trusting. His grandfather, the wise rogue. His father, radiant sovereign. His mother, stern and determined. His brother, who his mother thinks is a model child. But the young man is also visited by images, the scenes of horror that he witnessed.

I still remember, during the war under the occupation. We would hide. We were afraid of the Japanese, of beggars.

The army had lost the war, beggars did whatever they wanted, stole from wealthy families. Gangs of thugs would grab all the valuables and disappear. It was a terrible time. When the soldiers would catch a thief they would cut his head off in front of everybody. I was little. I don't know. I saw them cut the head from a man and hang it at the city gate. I had nightmares. This was China under the terror.

These atrocities haunted my nights, for a long time. Images, nothing but images and silence around them. You will come back to them in work to come, you will dissolve them in the great All of color. Later, they will fade away. One day very far in the future, when you tell the story, the traces of the child captured by these images will appear in a quiver in your voice; in a particular insistence.

Autoportrait,[1] in that beautiful dialogue with Françoise Marquet, your wife, you tell a story. Paris 1948. You check your bags and go to the Louvre, and carry your soul through the galleries as through a country of which you have dreamed for a long time. Here is a painting by Turner that was reproduced in a magazine in Hangzhou, and there is the *Mona Lisa* with her look of love. You rush to the Impressionists, discover Edgar Degas's dancers life-size, Cézanne's Provence.

Right away, you move into a studio in the rue du Moulin-Vert, where Giacometti is a neighbor. You barely speak French, but read the others' expression and tone of voice. An uncommon intuition bridges the linguistic gap. The beauty of Paris takes hold of you. The profusion of its museums is a marvel and an education. A few months for acclimation and you find the path of your work once again. While your brush follows the strokes of Cézanne, Paul Klee, and Cubism, you remember the inscriptions on Chinese bronzes from almost 2000 BC. The sign that names and the thing named become confused. You remember those stelae by the Han, the original people of China, engraved with spidery forms. Your, paintings secretly bear the trace of this double impregnation.

You discover the techniques of lithography. Henri Michaux, to whom your first lithographs are given, immediately writes eight magnificent texts.[2] Your painting is a poem. It summons the world within.

First encounters with Henri Michaux, phenomenal painter and poet. Michaux, enigmatic with his slender face, piercing eyes, and stern expression, enjoys the company of the young Chinese painter whose gaze is turned on a fabulous elsewhere. Zao Wou-Ki is not weighted down. His presence reveals itself in delicate touches. He doesn't threaten the painter-poet, who goes through life like a tightrope walker. On the contrary, he is welcoming and discreet, curious, courteous, and delicate.

Michaux had been visiting China for a long time. He had been all over the country when you were just ten years old. Then you came to France. You are escaping from an ancestral culture, and trying to break the bonds of the

1. Zao Wou-ki, *Autoportrait* (Paris: Fayard, 1988).
2. Readings of eight lithographs by Zao Wou-ki (Paris: Robert Godet, 1950).

forbidden in art. Michaux was searching for something fundamental in Asia, something related to freedom and grace. He read a lot, knew Confucius and the great Taoists, Chuang-tzu and Lao-tzu.

Together, you talked mostly about China, about Tang and Song painters, about the decadence of painting under the Ming dynasty.

After the sixteenth century, painters always did the same thing; they had no new ideas. And they filled up their paintings with calligraphy. In theory, there should never be words in paintings. A signature, that's all. By the Ming dynasty painting was no longer enough. They needed poetry to reinforce the space. That's excessive, don't you think? And the painter would write compliments to himself. He was unable to communicate through his painting, so he added to it. It's completely ridiculous. That's why in those days you had not only to be a good painter but also a very good calligrapher. Calligraphy is a separate art that has nothing to do with painting. You can be a very good painter without being a good calligrapher.

You had shows in London and New York. Michaux wrote the preface to the exhibition catalogue. "Wou-Ki is following his Chinese path, like the murmur of his maternal language, a path which leads to freedom from authority. The thin lines of his zigzag drawings, unfaithfully precise, capture the landscape without following it and bring the distance to life. To reveal by concealing, to break the straight line and make it quiver, to draw, reflectively, the meandering path and the spidery scrawl of the dreaming mind: this is what Zao Wou-Ki loves and, suddenly, with the same festive spirit that animates the villages and countryside of China, the painting appears, trembling joyously and strangely amusing in a garden of signs."

Michaux encourages you to reacquaint yourself with Chinese ink from 1973. "Why don't you do ink drawings?" he asks you. "That would let you say more." You avoid his idea with a discreetly annoyed look. No Chinese ink drawings. "Chinese ink is tradition. I don't want to fall into that trap. Chinese painting is already very limited." Michaux continues to encourage you. So much so that one day, with the end of your brush, you draw rings on sheets of rice paper, finer than silk, as he watches in amazement, alert as always. You follow your own idea. It is not what you have been taught. Nonetheless, the presence of the void and the impression of movement predominate. In China they're the essence of painting.

In those years, you traveled throughout Europe and brought back new paintings. Arezzo, Siena, Saint-Jeoire-en-Faucigny, where investigation of a new space is mapped out with childlike joy. When you returned to Paris, you spent your time at the school called the Grande

Chaumière and the Desjobert print works, where painters such as Viera da Silva, the Canadian Jean-Paul Riopelle, the Americans Sam Francis and Joan Mitchell, spent their time. They don't speak French. You communicate in English, and build the foundations of solid friendships.

Riopelle and I became very good friends. Unfortunately he died too early. He was buried out in the country, not far from my house. Viera da Silva was a neighbor. We would get together every day at 6:30 and talk painting. She was buried in the country, not far from my house. Arpad Szenes, her husband, said, "You don't work at night I never see any light at night your studio." It's true. I need daylight to paint.

These friendships, Paris, travel, painting, you avoid everything that is not essential. You stop going to the Alliance Française. Speaking French fluently isn't essential. At the Grande Chaumière, the professor tells you that you don't have to come every day: you already work very well. It's enough if you come from time to time to show him your paintings.

Something roars within you. The world is too narrow. You begin to associate with Hans Hartung and the Abstract Expressionists. You like Picasso. He hears about you. "Show me what that little Chinese painter has been doing," he says to the director during a visit to the Pierre Loeb Gallery. He likes your painting. The "little Chinese painter" intrigues him. He invites you to visit him at his house in Mougins. You hesitate. He must have so many people around. You don't want to disturb him.

You push back the borders, leave for America with your friend the painter Pierre Soulages and his wife, Colette, discover things never seen before. China returns to your painting. Signs, between calligraphy and the animate being, appear suddenly, making depth tangible; the space of Chinese painting, in which perspective opens upon the infinite on both sides.

Nineteen fifty-seven confirms the movement begun four years before. In your painting, forms become abstract, or rather are read from a thousand points of view.

One day you pay tribute to Michaux. On that canvas the reflections of night on the surface of a lake, traces of the moon, black transparency or an ancestor's face contemplating the reflections beneath it, under the lake near the banks sleeping under a veil of snow, whipped by the wind. But what shines and moves upon the lake: the feeling of diamonds, the reflections of a Sphinx that shifts with the speed of images in a dream?

Michaux suggests that you translate the Tao. Existing translations are mediocre. They don't capture the soul of Lao-tzu. You are enthusiastic. You talk about the Tao, and an image of your grandfather makes you laugh.

My grandfather was Taoism; he always found a way to escape. He thought, "I'm not mixed up in this." He was very shrewd. When he didn't like something, he would say: "I'm a Taoist." Taoism is not easy. Many things are not practical. It's especially about the dream. Michaux and I tried. We didn't succeed. Taoism, if you translate it too much, in reality, it's no longer Tao.

François Cheng is Chinese too. I arrived in France a little before he did. We got to know each other quickly after his arrival. I learned to sing, he did too. He didn't speak French. He really worked. It's impressive.

François Cheng has written a great deal about Chinese painting; he is a calligrapher too. You share your affinity for Tang and Song painters. Shih-t'ao painted later, in the collapse of the Ming dynasty, in the seventeenth century, under the Ch'ing, a decadent period. But Shih-t'ao ("Stone Waves") is an exception, one of the few men in each century who escape the mainstream to find their own path.

One day you suggest to François Cheng that he write a book about him. He takes your advice. *Shitao, 1642–1707: La Saveur du monde*3 is a very handsome work. In it we discover the work of the painter-poet. You remember this passage: "Now the Mountains and the Rivers have charged me with speaking for them; they are born in me and I in them. I have ceaselessly sought out extraordinary peaks, I've made sketches of them, mountains and flowers have merged with my soul, and their imprint has been metamorphosed there." Shih-t'ao also says: "It has been said that the perfect man has no rules, which does not mean that there is no rule, but that his rule is that of the absence of rules, which constitutes the supreme rule."

At the School of Fine Arts in Hangzhou, Chinese painting was a required course. You had to learn traditional painting. I worked with oils.

Freedom in art: if I knew what it was, I would make beautiful paintings; for the moment, not yet. You have to try to digest education, rules, everything that is imposed, to free yourself from five thousand years of tradition. Painters have written treatise after treatise on painting with precise rules. You have to forget them. If you think with each stroke of the brush what you could do, or what you have no right to do there, nothing happens. It comes or it doesn't come, that is the secret. When I work, I try to think about things as little as possible. When you eat good things, you shouldn't think that afterward you might be sick. I'm not saying that there should be no constraints. Freedom is made of them too. But if you stick too much to the rules, style becomes pretentious.

3. François Cheng, *Shitao, 1642–1707: La Saveur du monde* (Paris: Phébus, 1998).

With François Cheng you assess the breadth of the Chinese pictorial tradition. You examine color or its absence, landscape paintings, the status of the painter in tradition.

I prefer landscape painting. Tongwa (the Silk Road): I've never visited it. In the past, people went there for trade. People made paintings intended for the gods, so that they would protect and give good fortune. Since there wasn't enough room on grotto walls, they painted one painting over another. If you remove the first, you'll find a more ancient painting. Within the grottoes, there are things that are still more ancient.

In ancient China, the painter often lived in the mountains, as a hermit. Painting isn't a means to earn a living but to confide your thoughts, transmit what you have seen, delight in things experienced. Painting is a memory. The painter has no ambition; traditional painters didn't sell paintings, they gave them to friends. People painted because it made them happy, that's all.

In the Tang and Song dynasties, up to the Ming dynasty, painters used a lot of color. If they were painting landscapes, they would use green, blue. Today color is passé. What remains is mostly black. Painting on silk doesn't hold up. It yellows. It is very damaged today.

Beginning with the Ming dynasty, painting deteriorated, it became pretentious. The painters weren't very good. Then they cheated with calligraphy to complete their intentions. In every culture, there is the moment of decadence. Without decadence there is no innovation. Impressionists arrived at the point where there was no longer any means for self-expression. These things always work in cycles. It comes back, it comes back, it comes back. We painted abstractly. What does that mean? We transfigured nature. Abstract painting can be monotonous too, when there are too many rules. The best painters are always very free. Talk is easy, action difficult.

I don't know what to say about my own painting, I don't think about it. Spiritual, philosophical? It's not as complicated as that, I believe. In the end, I don't know anything. It's up to others to say. Yves Bonnefoy has spoken of my painting as a path toward the spiritual. I don't deserve that. It's too good. My painting is anything you want; nature, mountains and water, figures.

I don't understand Chinese painters today.

Are you talking about those painters of the moment, without depth, about their colors that are without nuances? Are you talking about this canvas, in which the figures look at you with their expressionless eyes? Are you talking about these performances in which the painter,

standing on a mountain in ceremonial dress, paints before an ecstatic audience?

Why do they call that attention to themselves? It just isn't done. Painters never used to work in front of anyone. Painters would hide in the mountains, at one with nature, far from society. Like the Tao. They painted for themselves, not for the public. Now they work in front of a bunch of people for entertainment, to show themselves off. Having all these people around changes the painter's attitude. How can he think with all these people around? These demonstrations go against everything in Chinese thought. I hate this exhibitionism, this bad taste. Why do you have to force people to understand what you're doing? It's pointless. If your painting is strong enough, there's no need to explain. Painting isn't something to be demonstrated, it's a thing in and of itself. It's like writing poetry, or singing. Painting is always an end in itself. When you're done, the painting leaves you. It goes to live with someone else. When I see the way that today's painters perform, I ask: is this sincere? I always work completely alone. I can't work if someone else is there. Something automatically slips in, something that wants to please, something whorelike. It lacks sincerity.

You give François Cheng two engravings to go with his collection *Rompre le cri*,[4] a series of magnificent poems. In it is the soul of the Chinese poem, which opens itself to the question, the heart of the void. Your engravings express the movement and the transfiguration of forms.

In all these years of work, exhibitions, and travel, China is present. You think about returning one day. But 1966 turns your world upside down. Mao unleashes the Cultural Revolution. Your country is closed to you. You will have to wait until 1972 to see it again, in a return that will leave you speechless.

My father was dead. I only saw my mother. She didn't want to leave the house, wouldn't even do her exercises in the garden. And then with my father dead, she was very unhappy. I saw my professor too. He was in hiding. He didn't dare work. It was against the regime. He said to me: "If you had been here, they would have shot you long ago." Because I am not someone who is very discreet. I think and say what I want.

By 1972, China had changed completely. It was horrible. Sons would denounce their fathers. Friends would denounce each other for imagined crimes. People were kneeling in the street, wearing those paper dunce caps. They would practice self-criticism. There was no more enthusiasm. Nothing was left of ancient China. It was terrifying. There was no

4. François Cheng and Zao Wou-Ki, *Rompre le cri* (Paris: Ecarts, 1994).

more thought; there was no more respect for the self. It was total demolition in order to find something new. In painting, is it necessary to destroy everything there is? No. I think tradition is beautiful, why would anyone revolt against it? They had no confidence in themselves.

Fortunately, it was a short period. It did enormous damage. It went beyond all bounds. In China when I was young, a child would never have dared to say things against his father. Respect and honesty were two qualities that were very important to the Chinese way of thinking. Whether or not China has found a new balance today, I don't know.

There was a first trip to China, after twenty-four years of absence. And then there were others: 1975, 1982, 1985, China attracts and surprises you. You come to know the unsettling strangeness of memories that come rushing back when you return to old haunts. One day your wife, Françoise, listens to your emotions with her heart. You're on the dock in Shanghai; she insists that you take her to the little garden in the former British concession where you couldn't enter as a child. The entry had been barred by a sign: No Dogs or Chinese Allowed. Arm in arm with Françoise, you're reunited with your father's soul. He allowed his eldest son to become a painter. An infinite gratitude to this man lives in Wou-Ki's heart.

My father protected me. Without him, I would never have become a painter. When I went back to China, I wanted to do something to thank him. That's why I went to China to give lessons at the School of Fine Arts. I was very strict. In those days, Chinese painting was influenced by Soviet art. Nudes had to be painted head-on, light always came from one side. Students didn't want to draw a woman in the shadows, they didn't know how. I told them what I thought of these ridiculous classes. I taught for a month and a half everyday, morning to night. I wouldn't let them pay me.

During these visits, you encountered Chinese nature, especially mountain landscapes, the essence of landscape painting. Nature appears and disappears to the rhythm of the mist, a milky light; forms materialize from the void and return to it. There is the presence in this movement of another realm, like a strange infinity. Not far from Hangzhou, on the yellow mountain, the Chinese come in pilgrimage to interpret forms in the movements of the clouds, in the silhouettes of the trees and the rocky outlines.

You can't do anything against nature. When I went to the yellow mountain, it was still impressive. You had to climb, one step after another, to cross every threshold and discover another nature. It's a life-size Chinese painting, with a foreground and then other image planes, one after another. You enter into the painting as into a landscape. It's

an incredible lesson. Everything is a lesson; a magnificent tree is a lesson. That day on the yellow mountain, I had white hair, another Chinese man came up to me and said: "Aged Sir, it's very tiring, you should ask for a porter, how old are you?" I replied, "Ninety-eight years old." This quickly sent him on his way.

Near Beijing, you went to the opening of the Fragrant Hills Hotel, designed by architect I. M. Pei. You like this place in the countryside, with low buildings to respect nature and silence according to Pei's wishes; a refined style. At his request, you painted four panels in the hotel in Chinese ink; gray, black, white, the shades of the Tao, in which the exquisite is born from emptiness, like the outline of a peak that can barely be seen in the clouds, a trace of the birth of matter.

Pei builds by following nature. He built a museum in Japan. But he didn't like the countryside. He's demanding. He wanted nature in relationship with architecture. He asked the owner to cut a hole in the mountainside to make it more beautiful. The view is magnificent. It's unbelievable!

Wou-Ki and Pei share their exile. They meet from time to time, in France, in America, elsewhere. They speak of their China, talk about their projects. Wou-Ki is enthusiastic, laughing, unleashes humor with the tip of his tongue. Both men still remember the extraordinary affair of the Louvre Pyramid. The story still makes Wou-Ki laugh.

I had put Pei in touch with Emile Biazini who presented him with the Louvre project. When Pei did the Louvre Pyramid he was attacked; it was terrible. And everyone said, "What! They found some little Chinese guy who lives in America to do this thing! The Louvre, the pride of France, made over by that little Chinese guy whose stuff is like Walt Disney." And Pei was very unhappy. He said: "It's OK to say I'm a bad architect, but not to call me Walt Disney." He said: "Wou-Ki, you really got me in a mess this time." I said to Pei: "Dig down, toward the Seine." He replied: "I can go down nine meters, no more. Otherwise we'll break into the metro lines. I have to go up." I said to Pei: "Don't go up, or you'll have nothing but problems." He compromised on the height. Now people understand better. But at the time it was hard.

The last time I saw Pei in New York, we talked about Tao. I said to him, "Listen, I think alone with myself too, and I think in painting. Of course, it's hard for you; think Tao in architecture and the building will fall down."

I don't feel alone; I'm surrounded by my work. I need to be alone to work. I can't do anything with people around me.

But one day, in early summer 2002, Wou-Ki is heartbroken. He can no longer achieve transparency in his painting. And he will do no more ink drawings. Someone copies his ink drawings, a copyist with no talent, who fills the space with inkblots. Nonetheless, by the end of summer the visitor to Wou-Ki's studio is welcomed by the odor of fresh paint, and by a large diptych. The two paintings tell the story of green and blue. The transparency is there, in the subject of water. Perhaps he will soon do more India inks on poems by Yves Bonnefoy. He still hasn't decided, in spite of the insistence of Françoise, his wife, companion, and accomplice. There is still so much to do with painting, enough to seek out. Each canvas should open up a new direction. In his fifty years of painting in France, step by step, one after the other, Wou-Ki has painted more than 1,500 oil paintings, without counting the watercolors and the drawings. One thousand five hundred paintings, which speak of the infinite and of the essence of things, of exile and China, of color and laughter. Turning toward the future with grace and laughter, Zao Wou-Ki receives the vibrations of the world.

—Catherine Zittoun

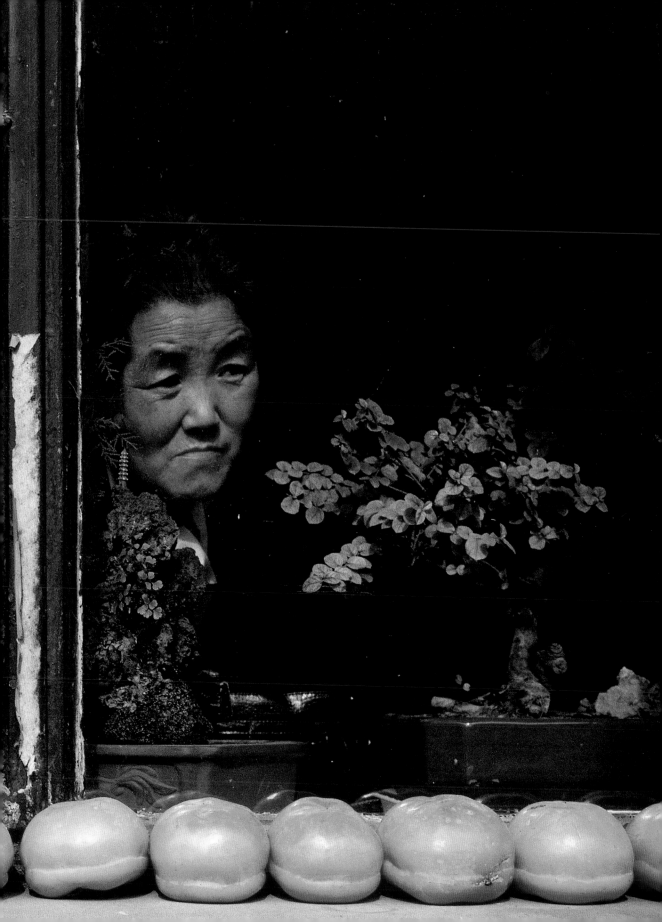

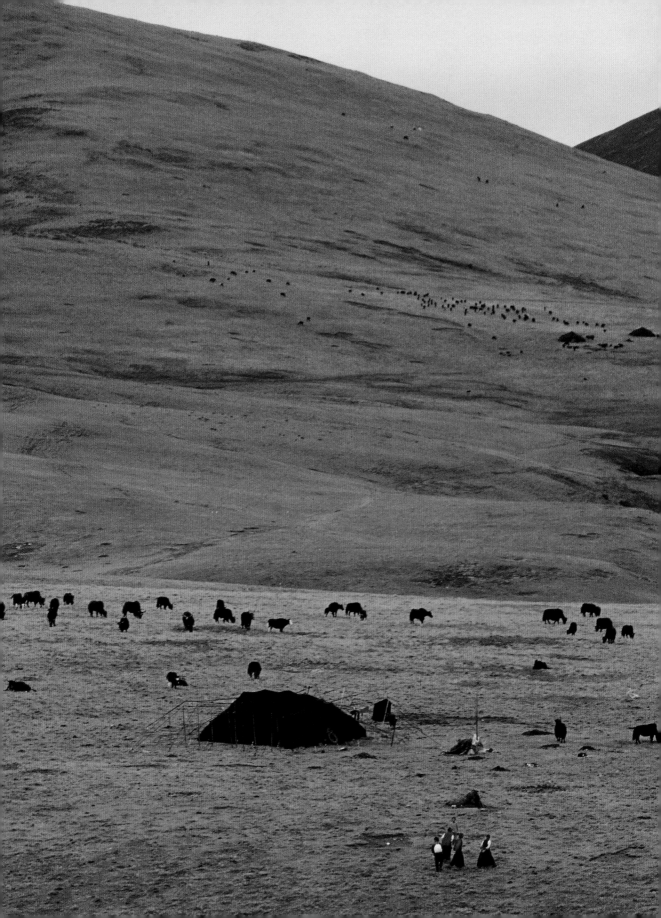

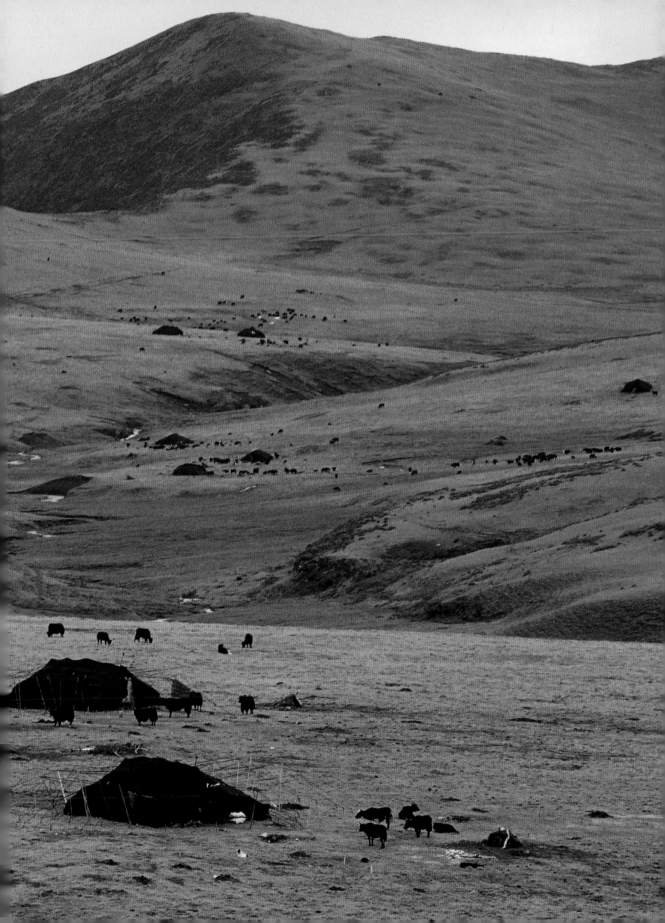

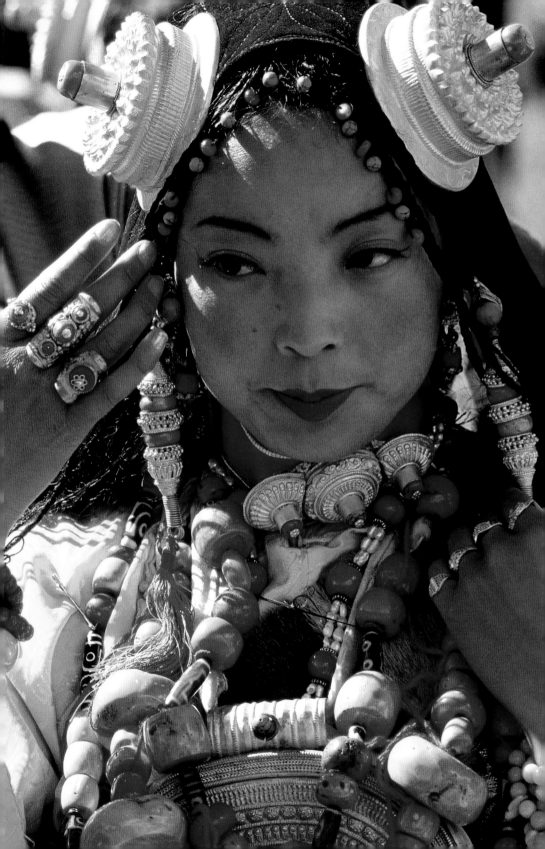

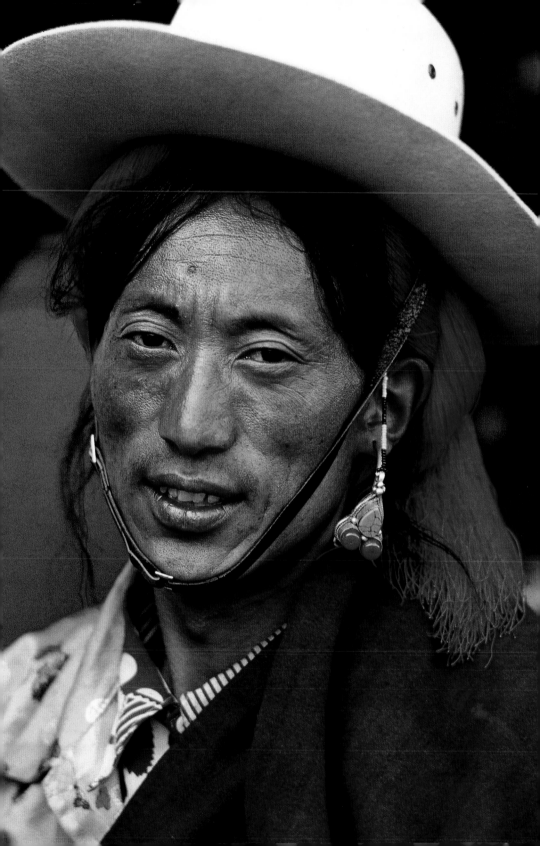

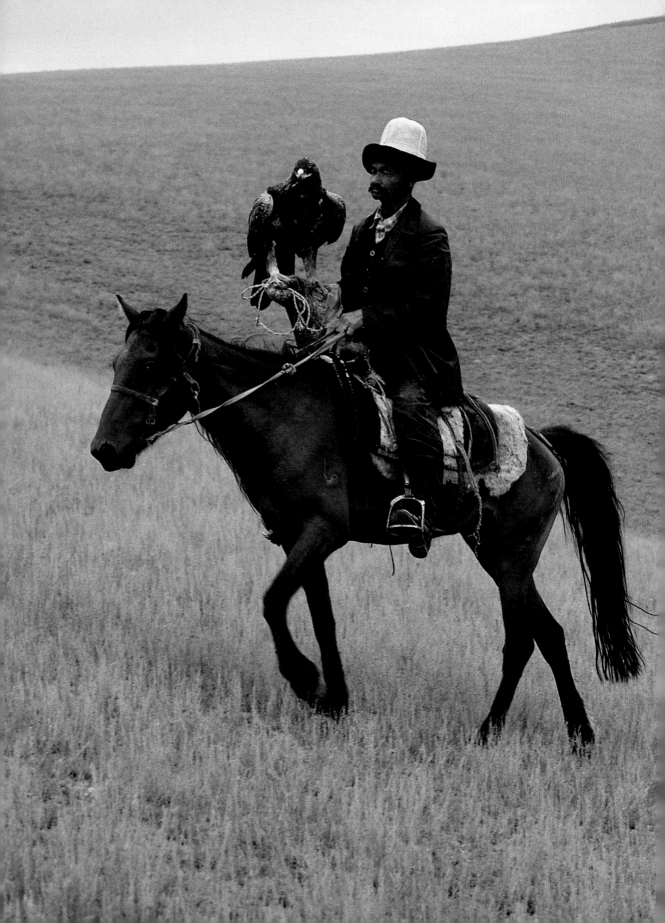

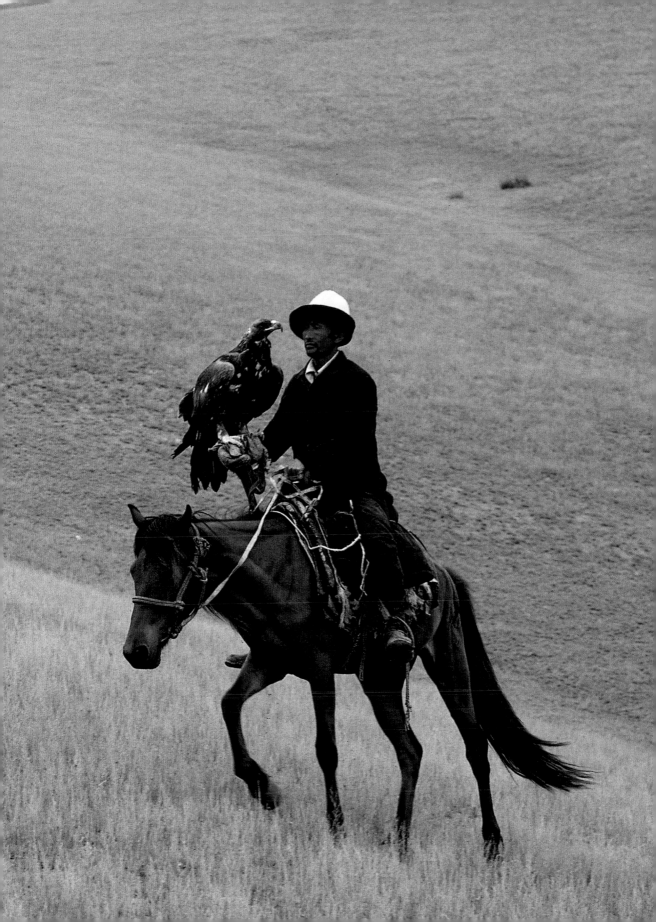

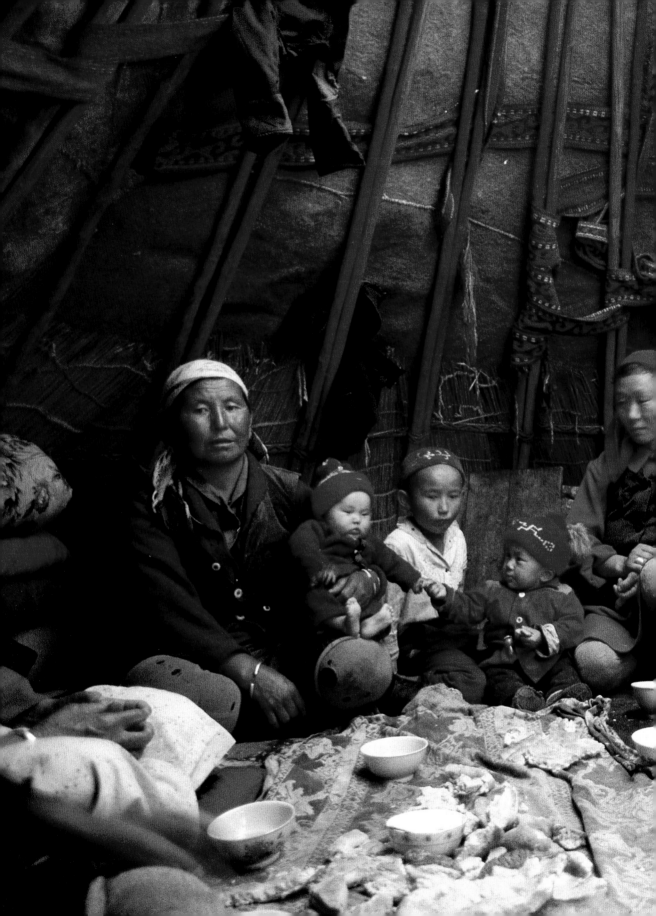

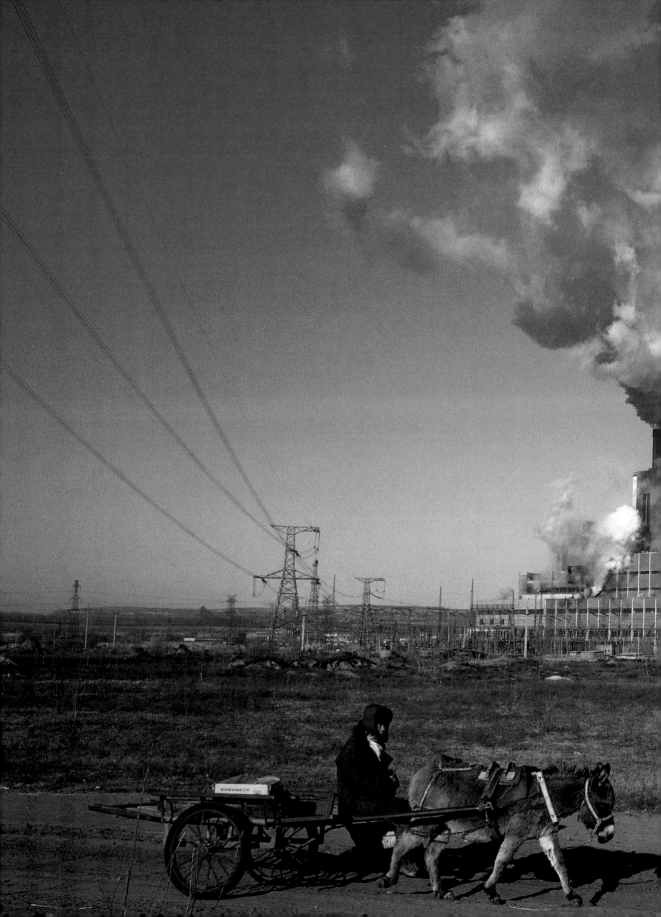

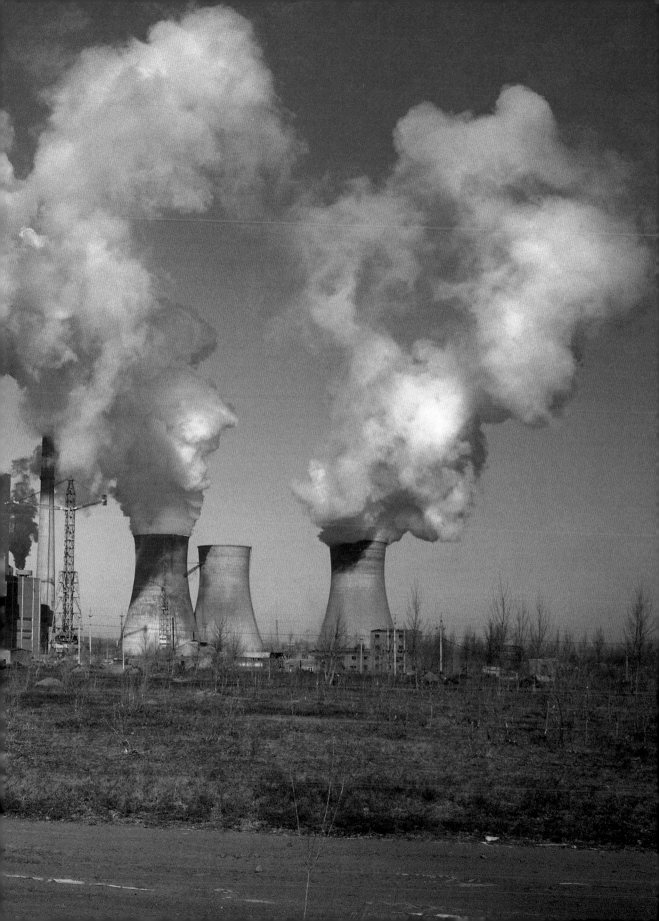

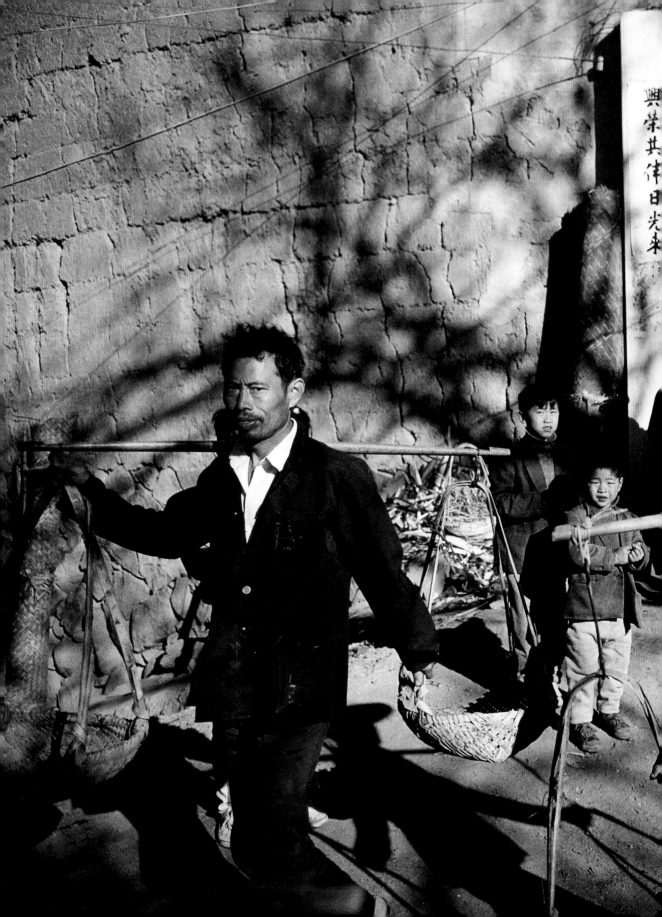

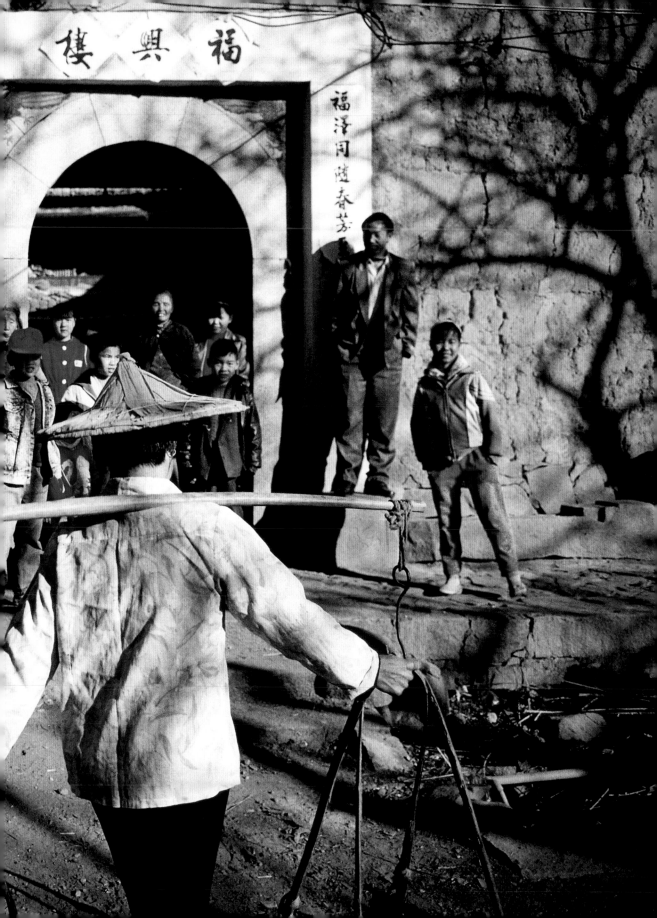

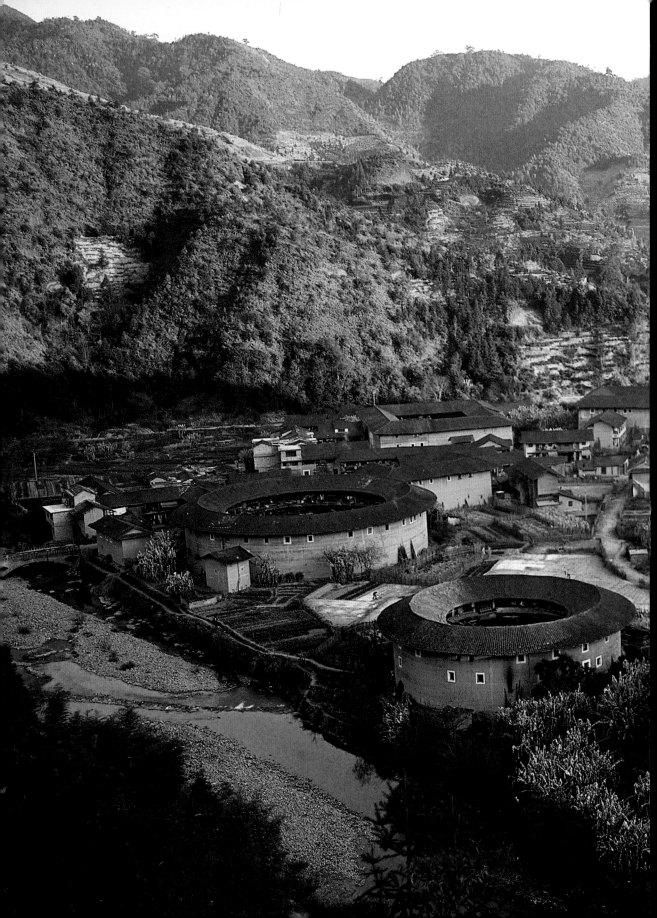

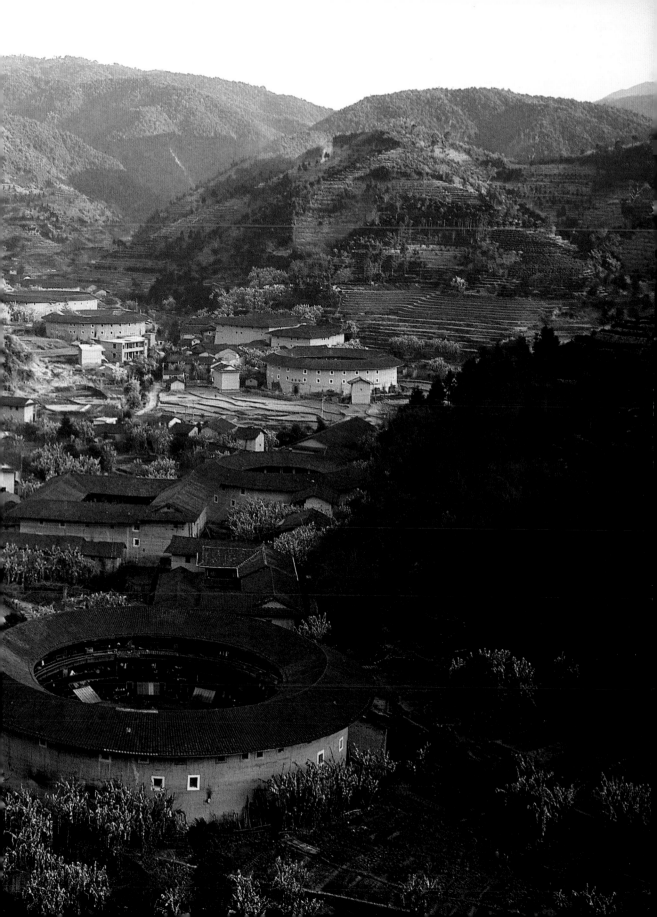

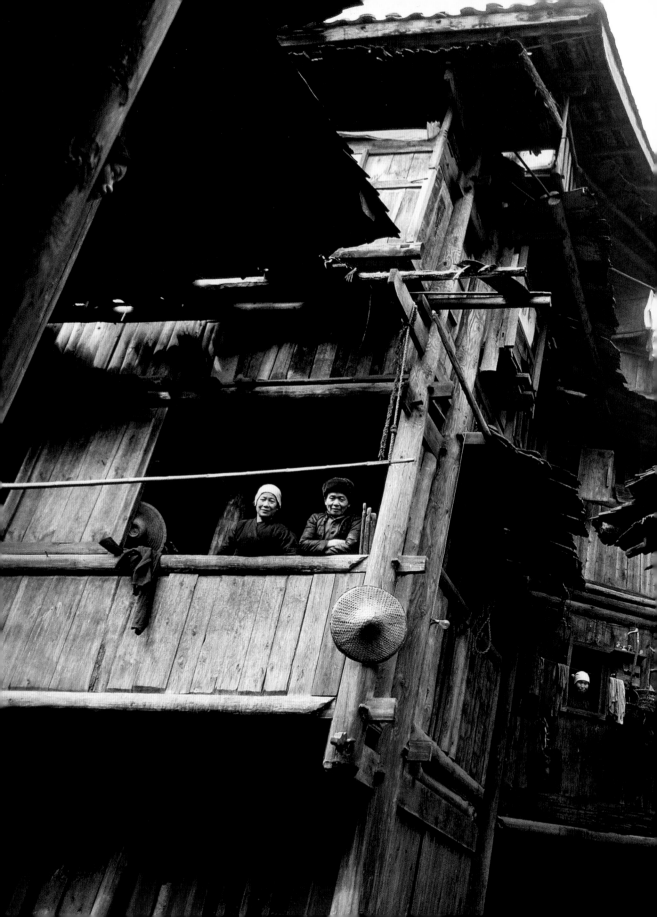

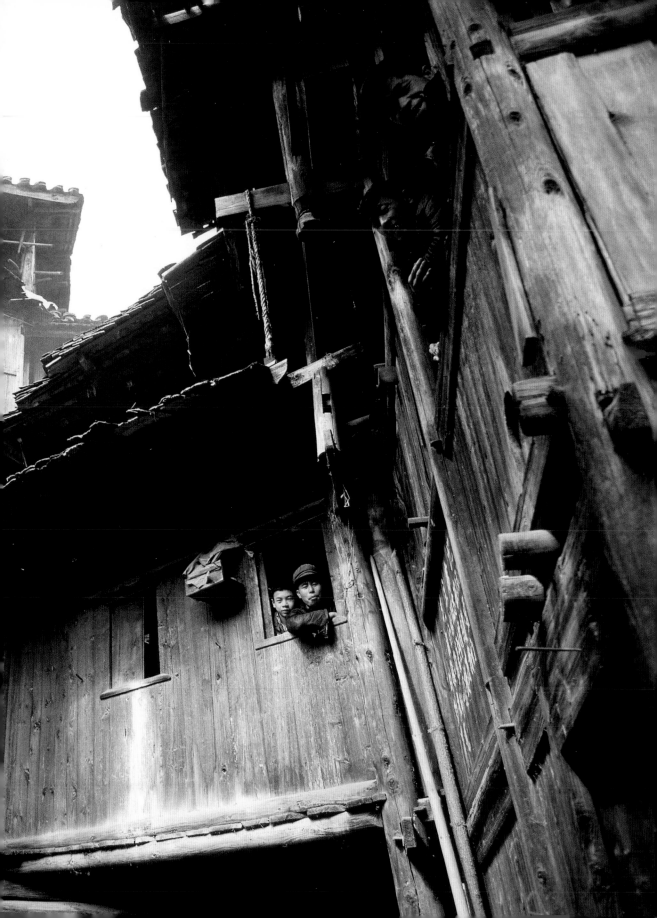

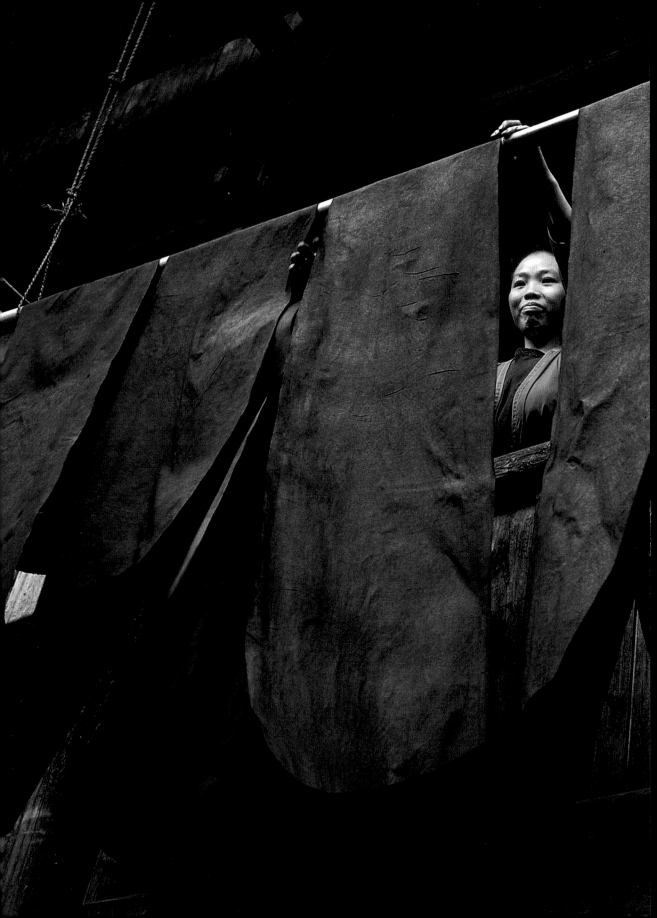

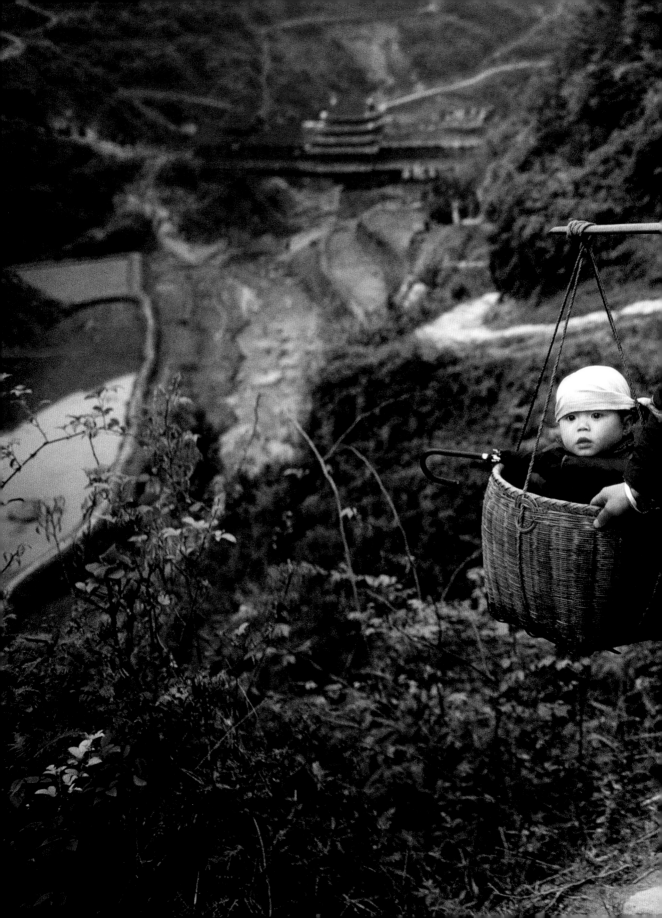

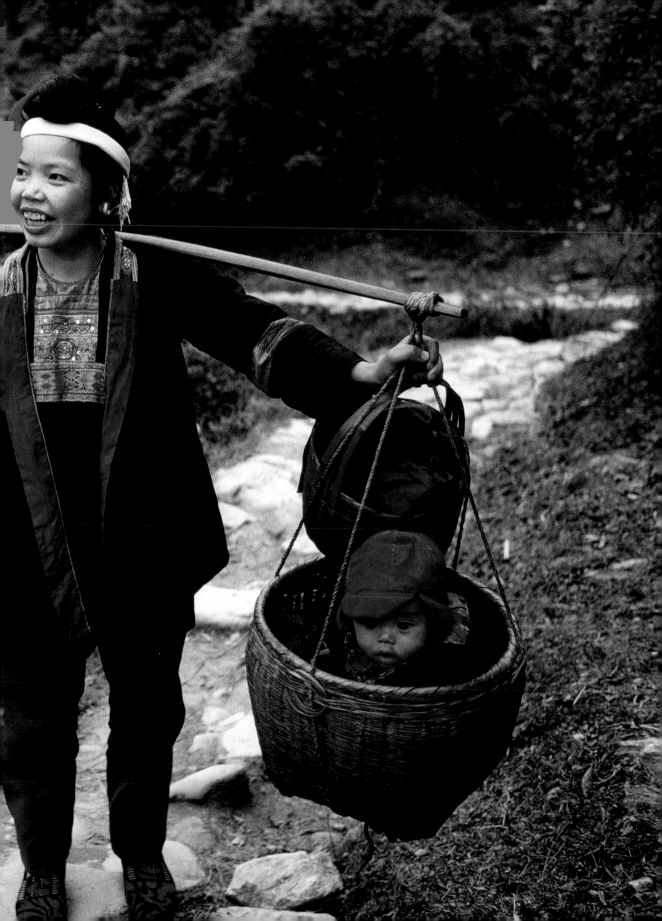

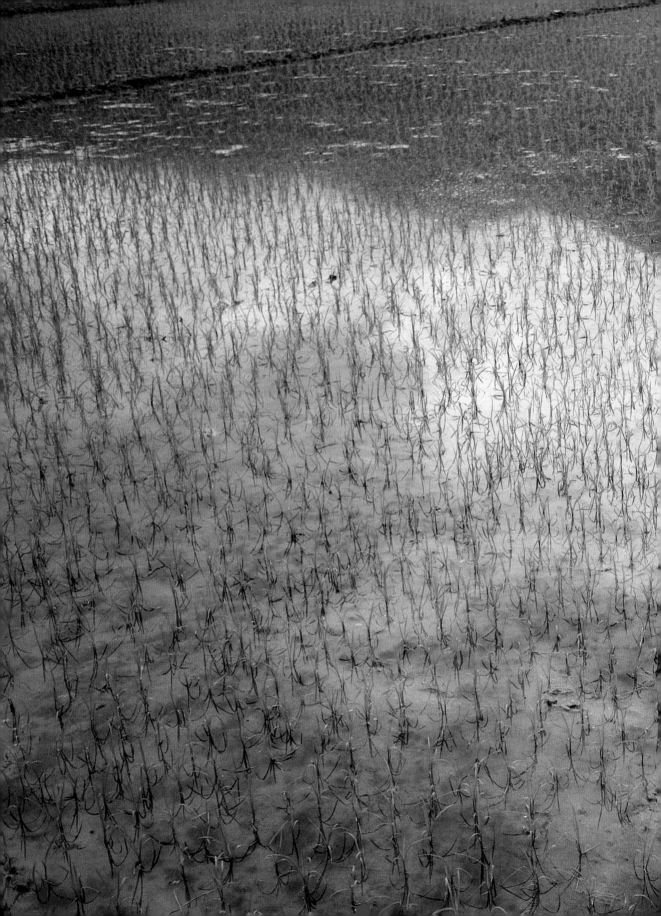

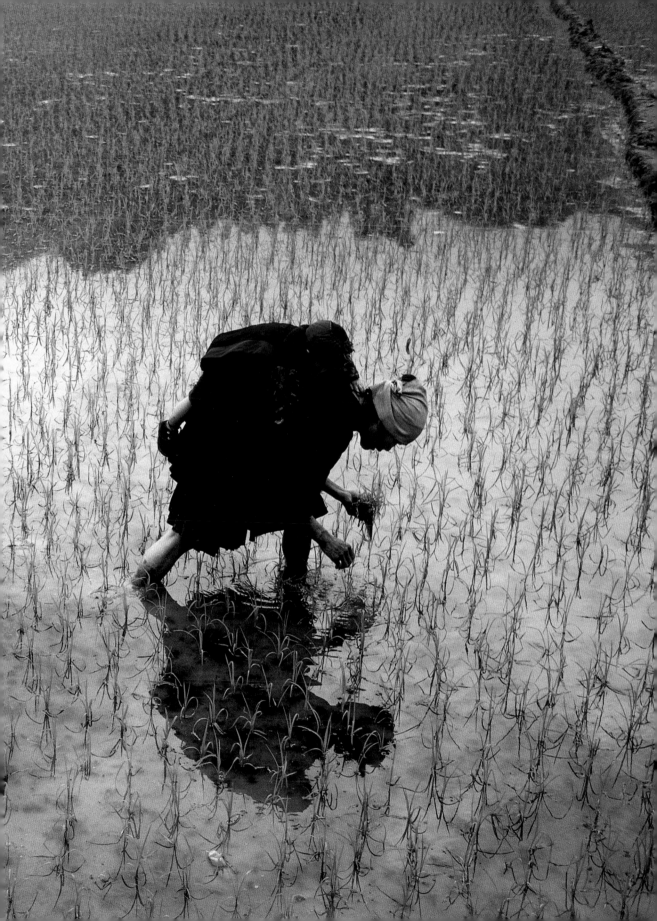

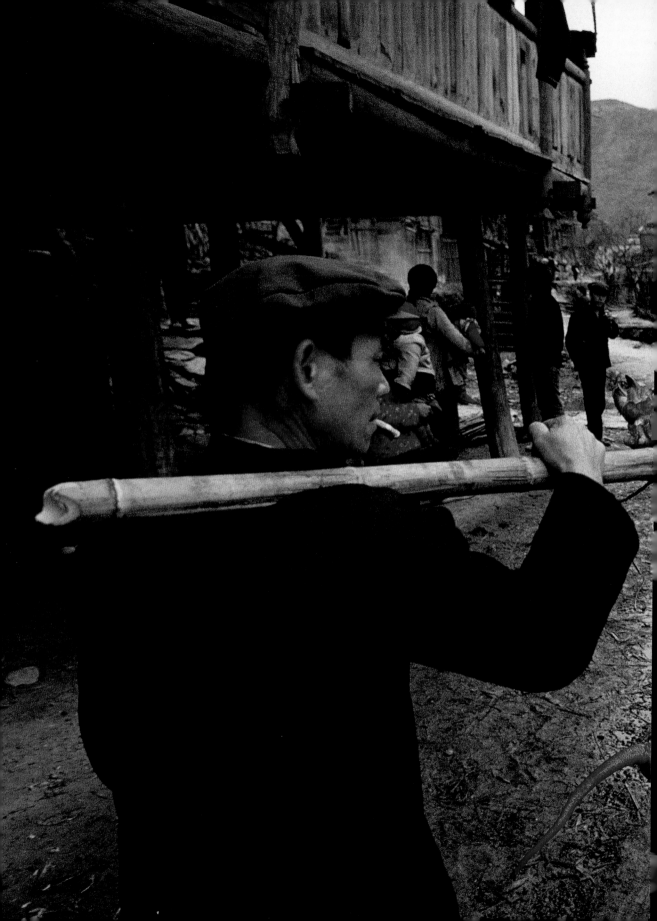

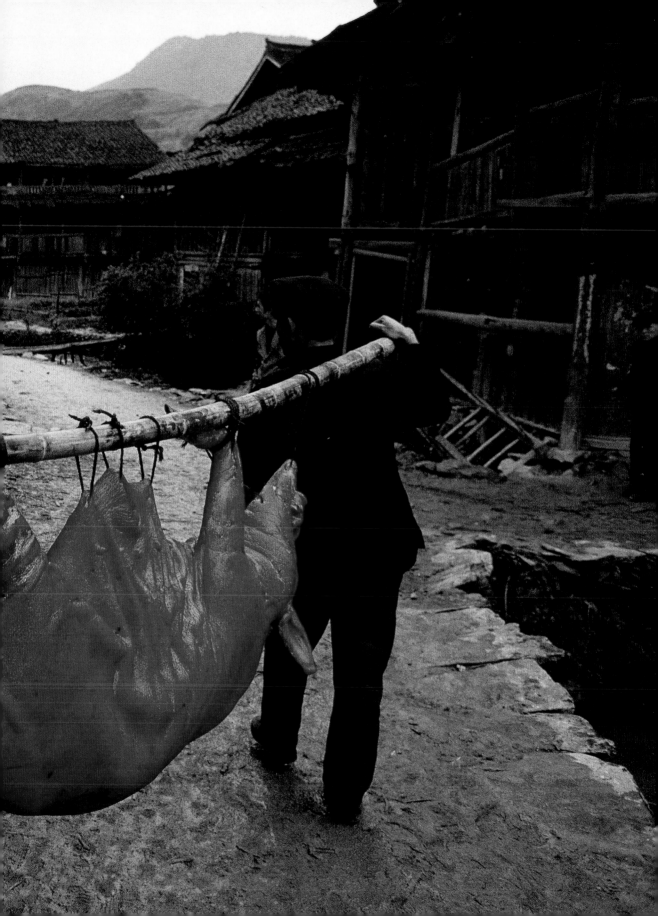

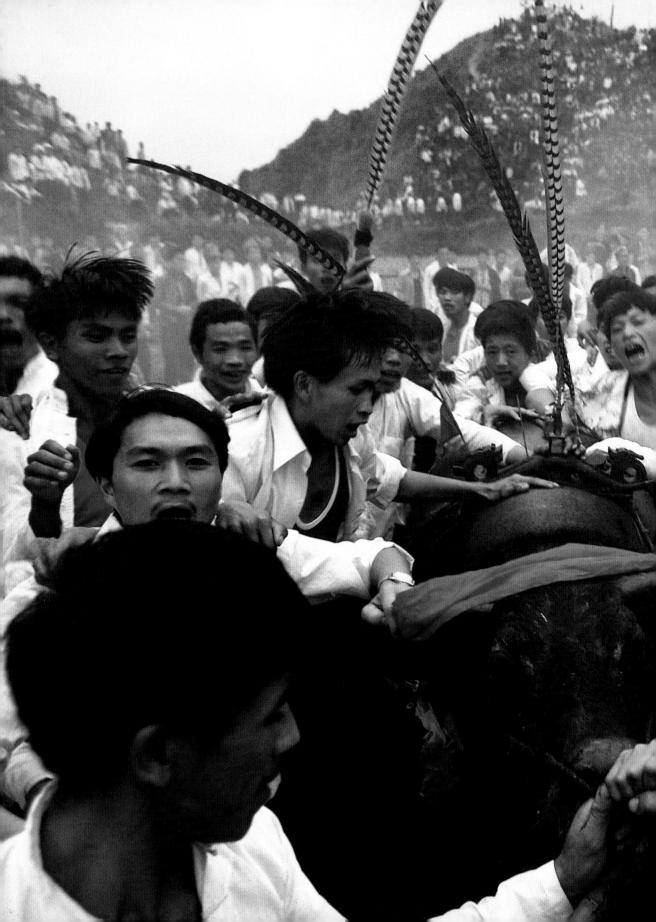

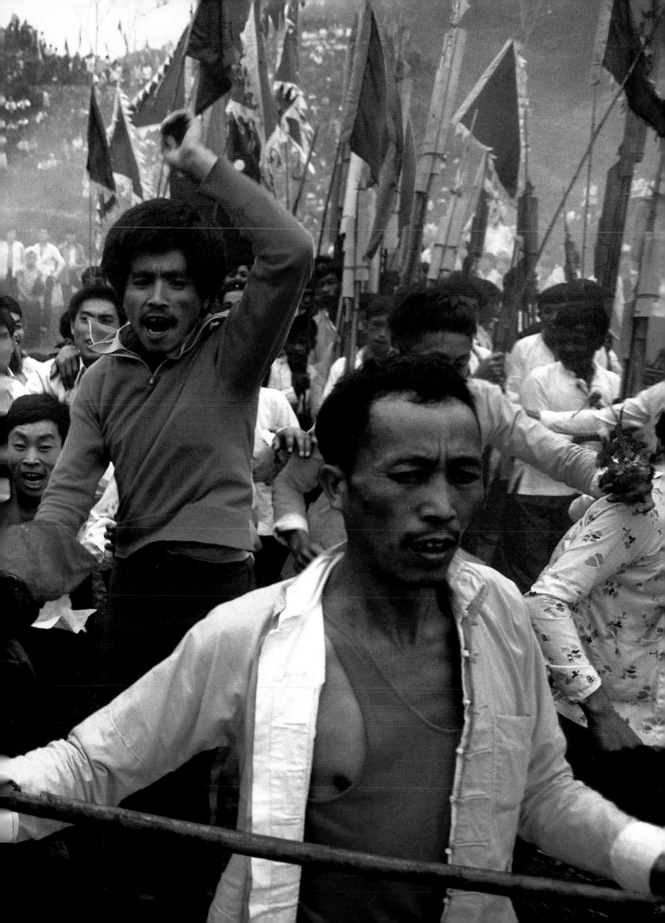

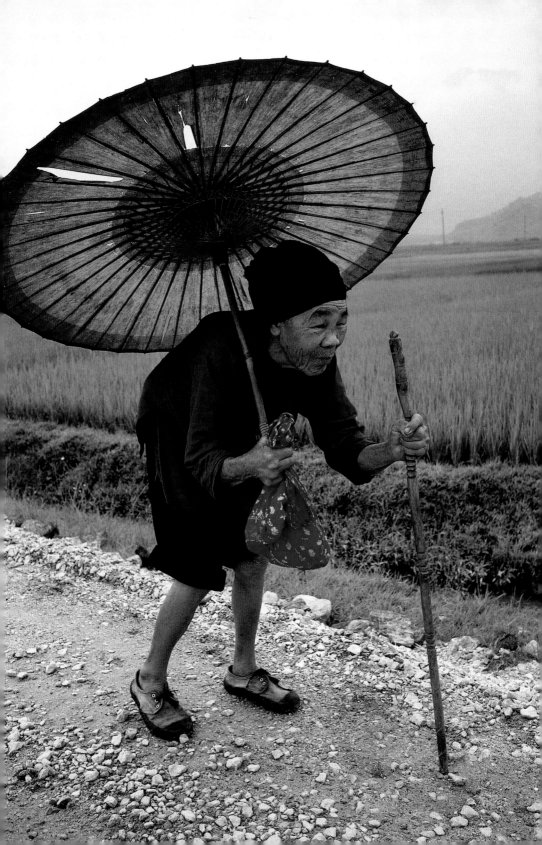

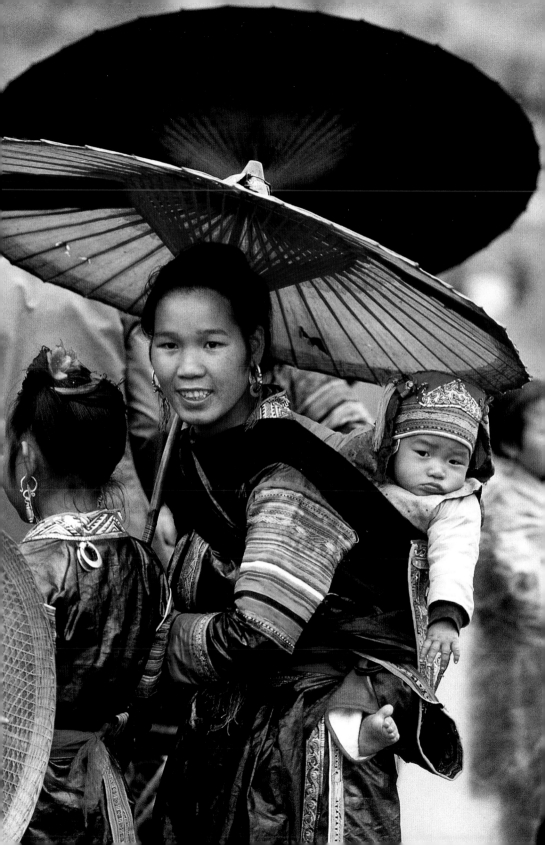

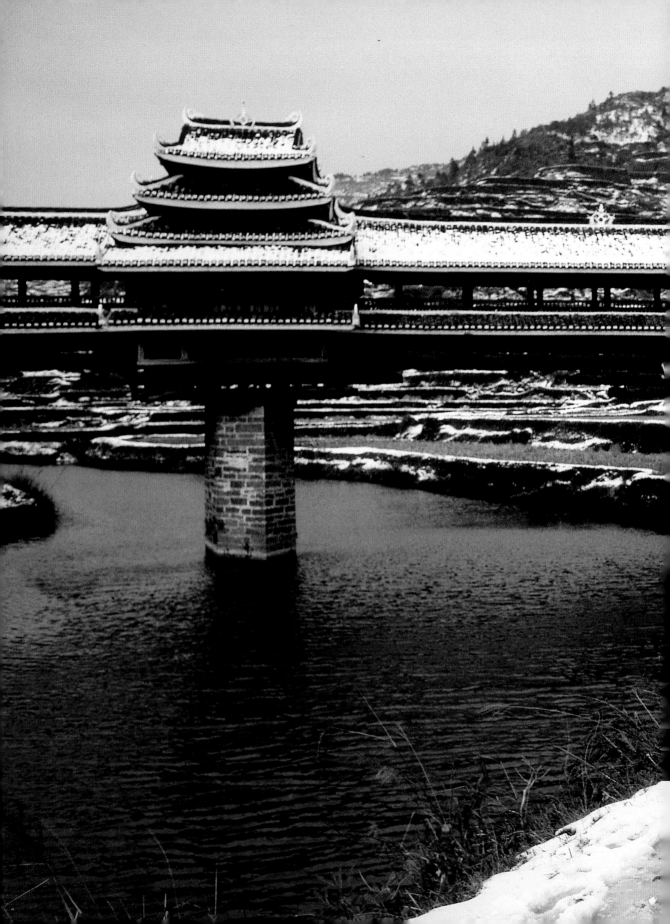

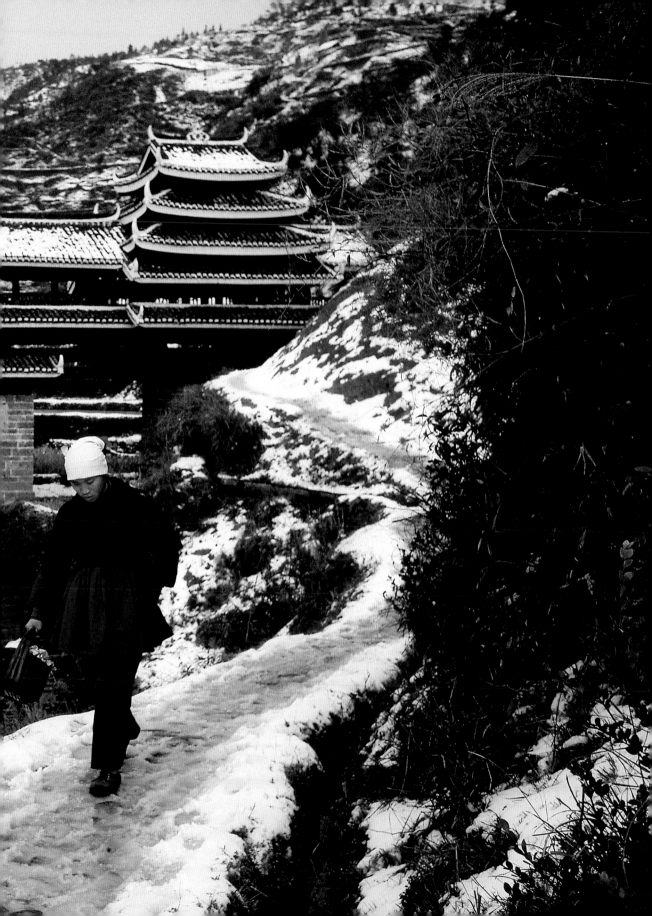

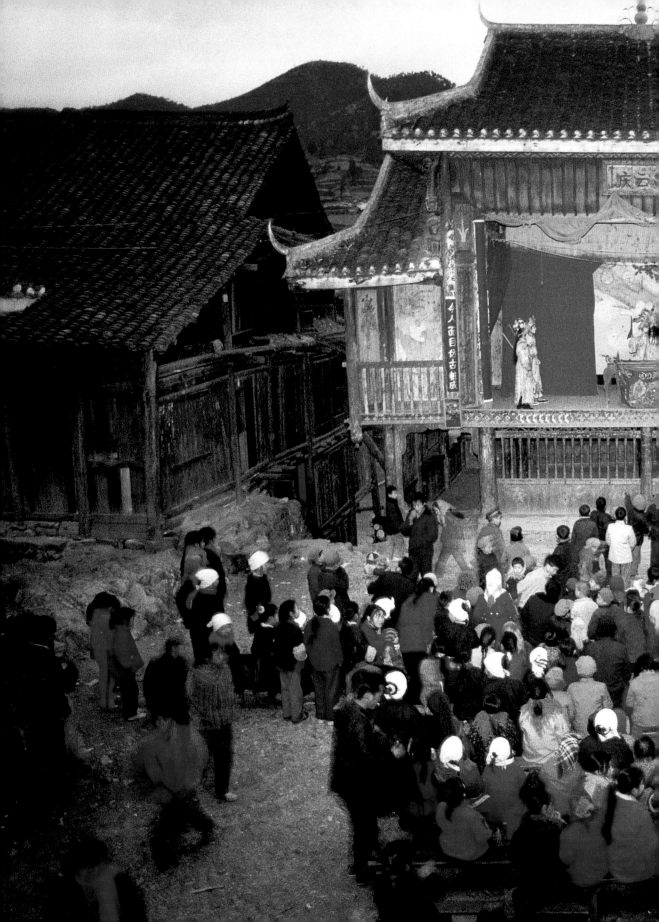

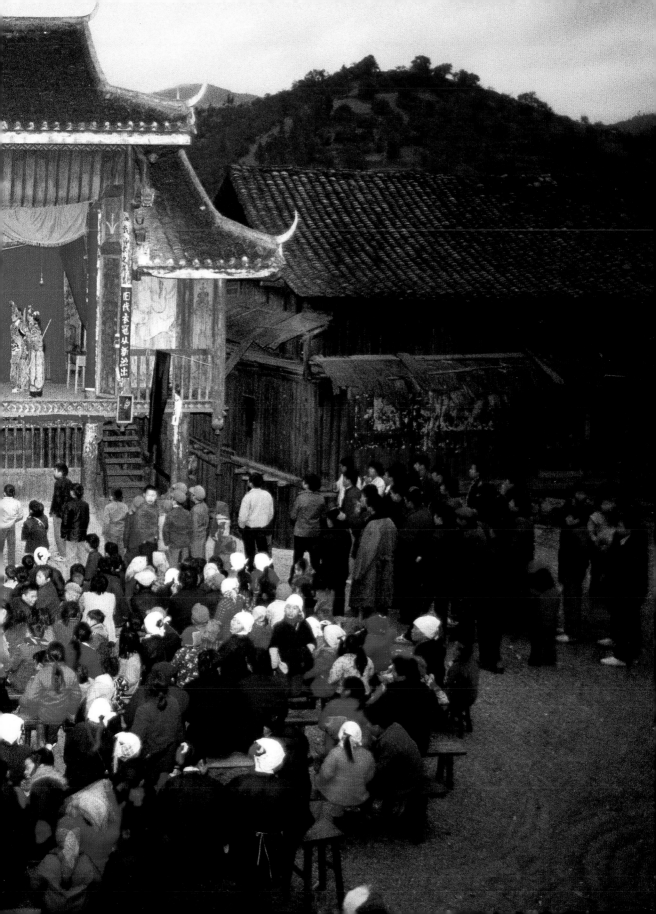

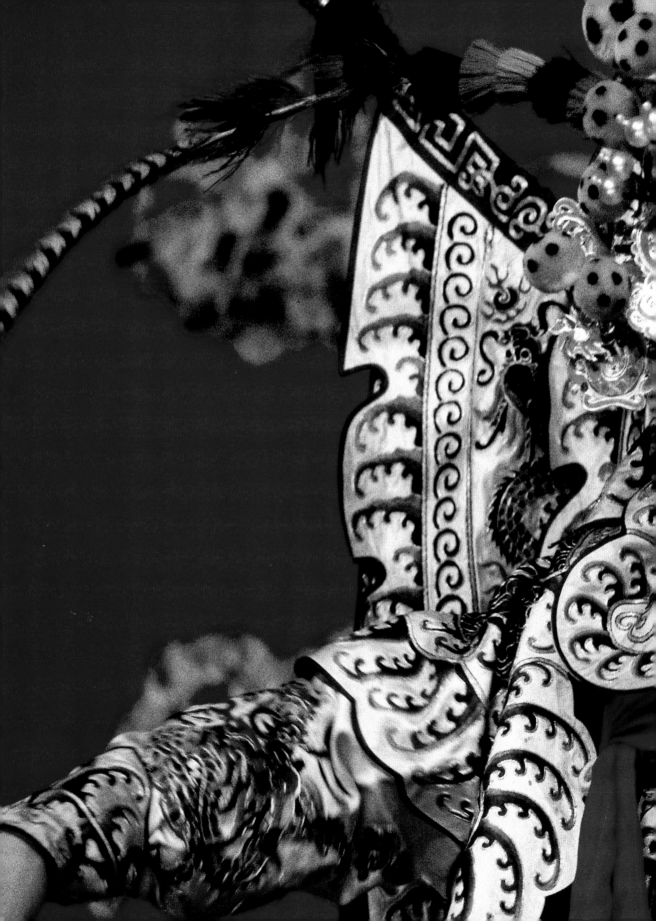

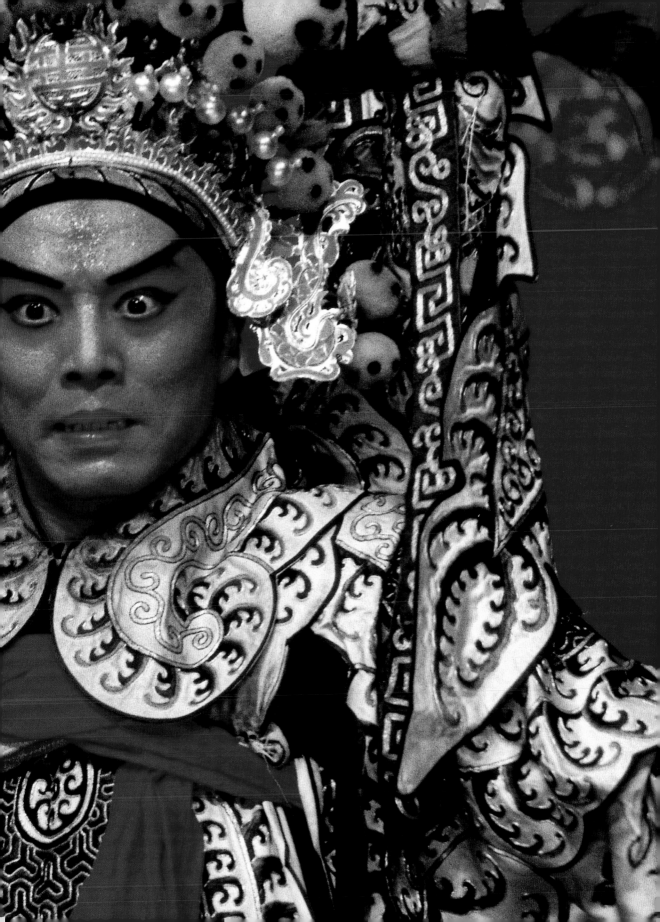

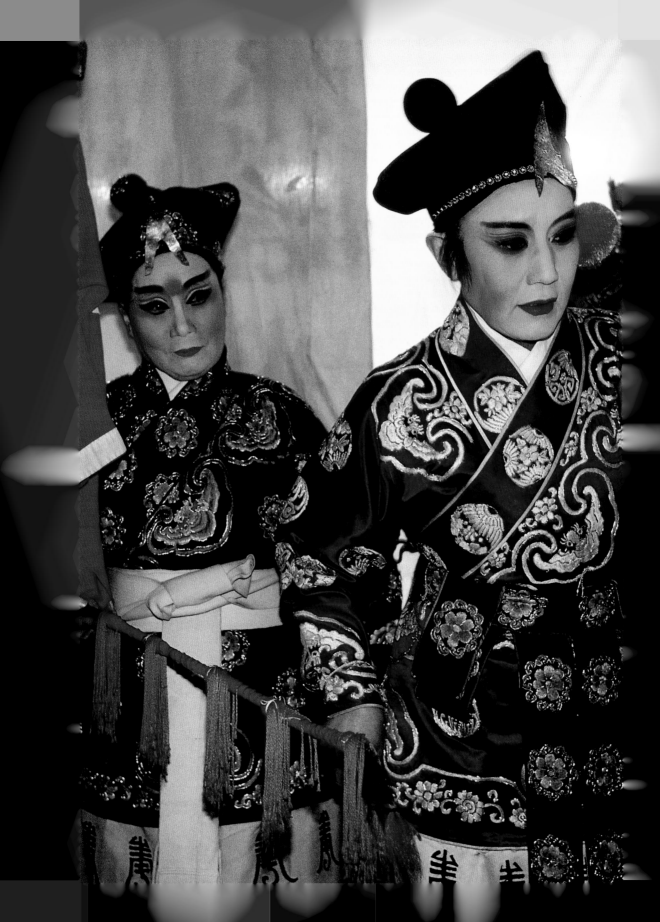

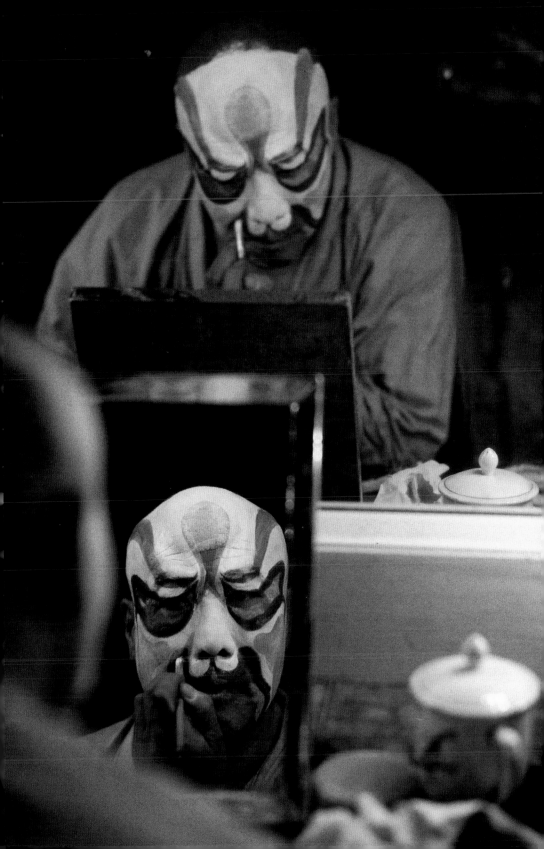

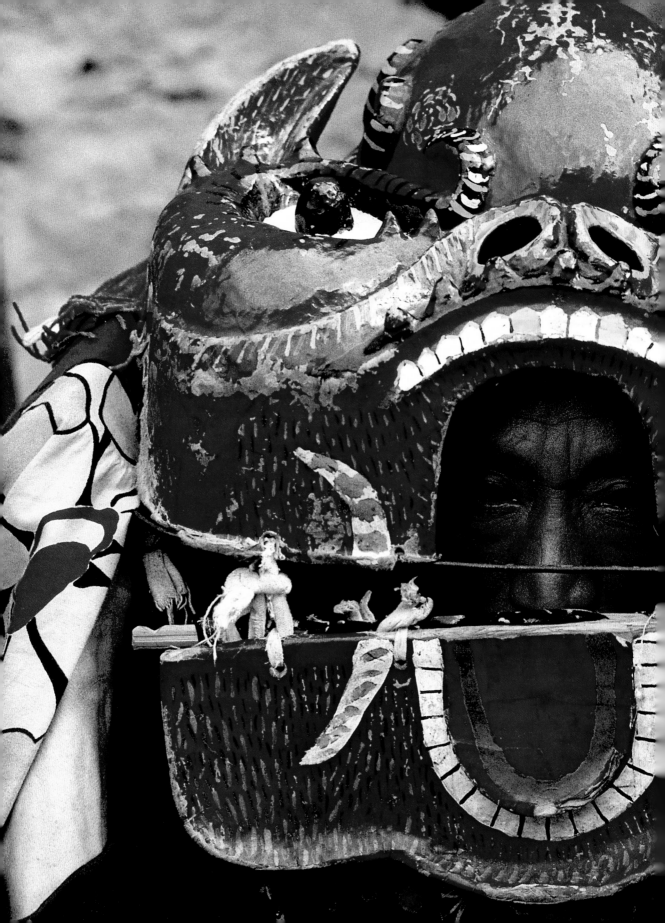

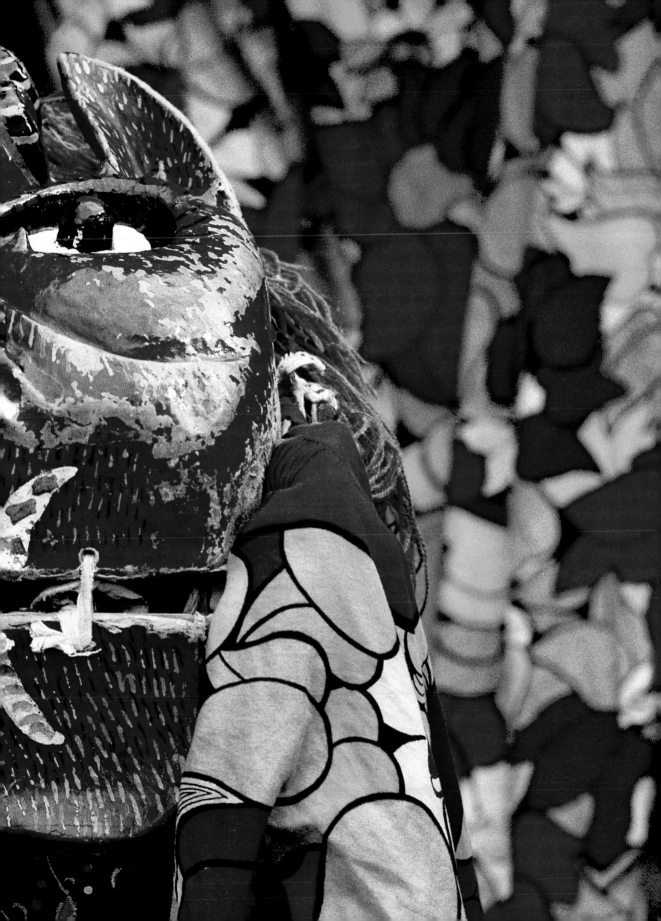

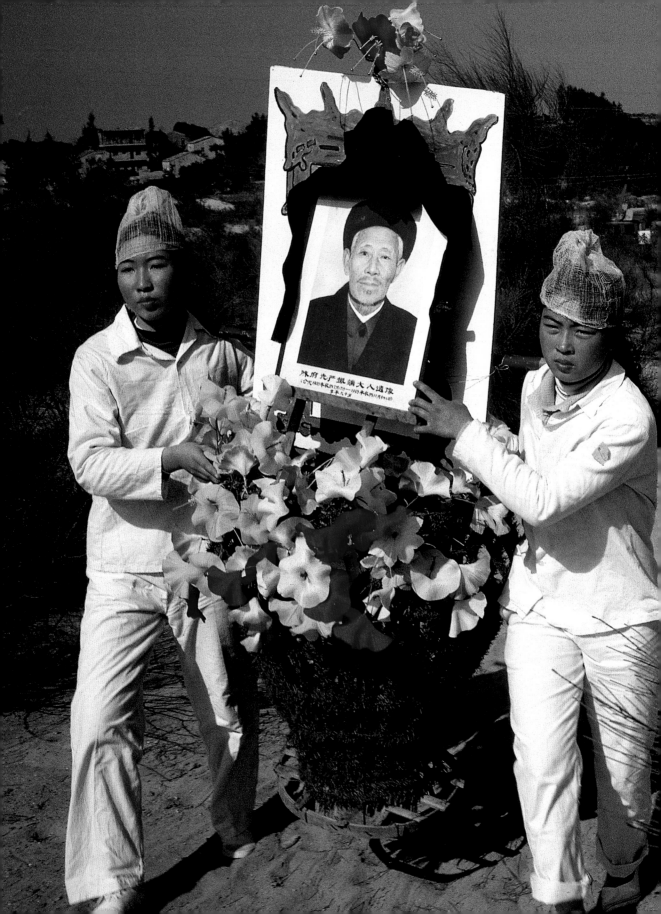

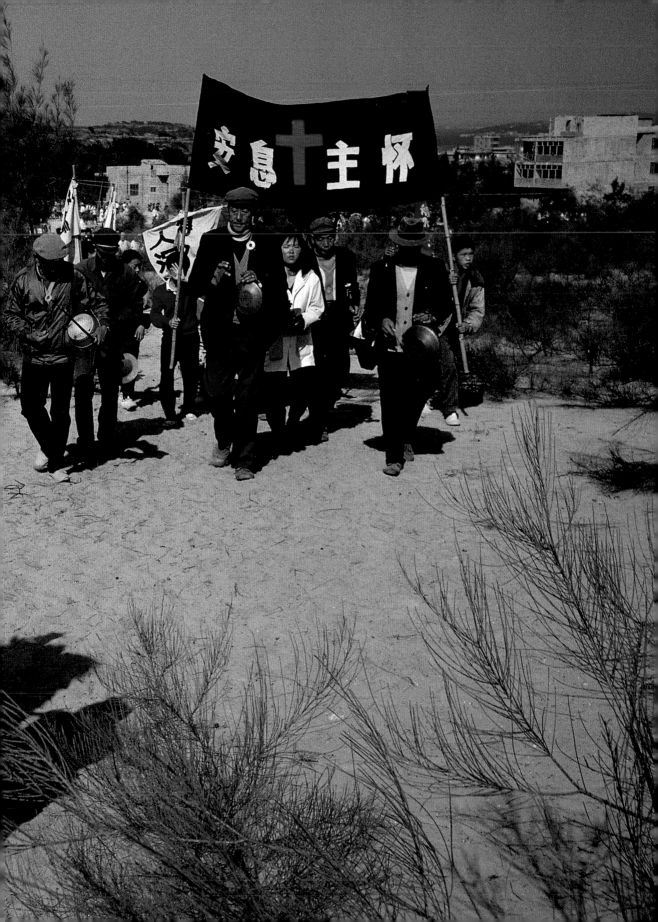

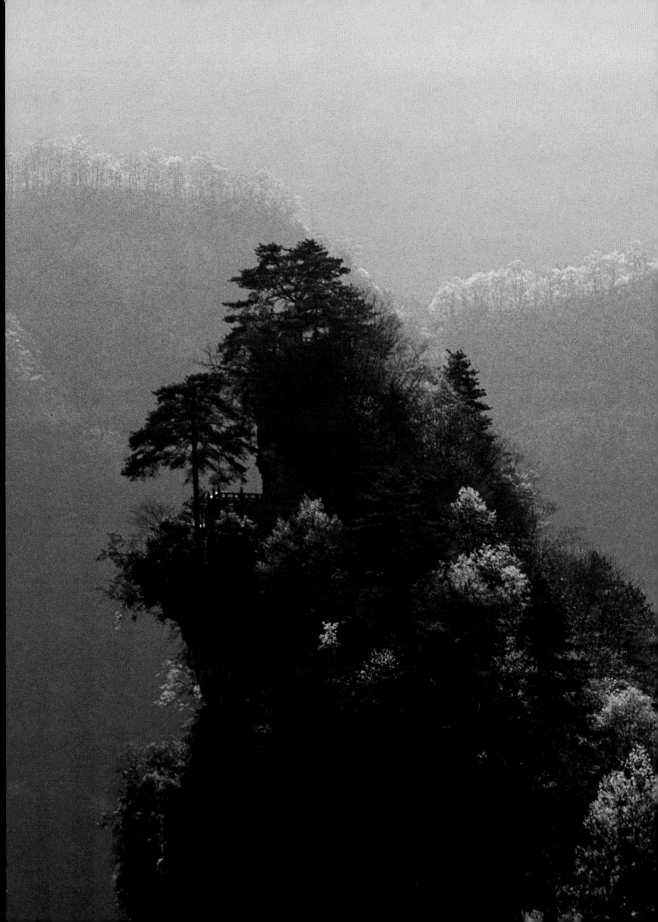

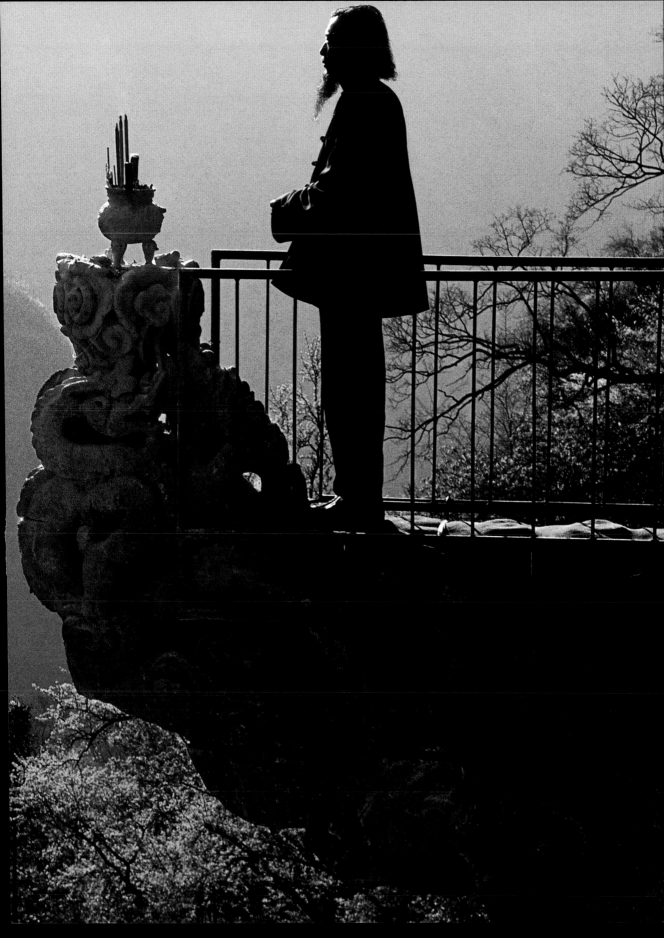

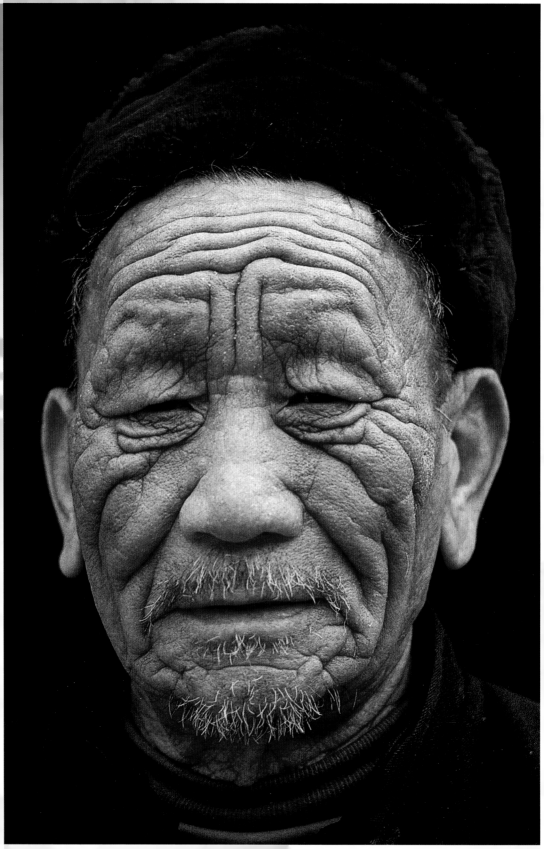

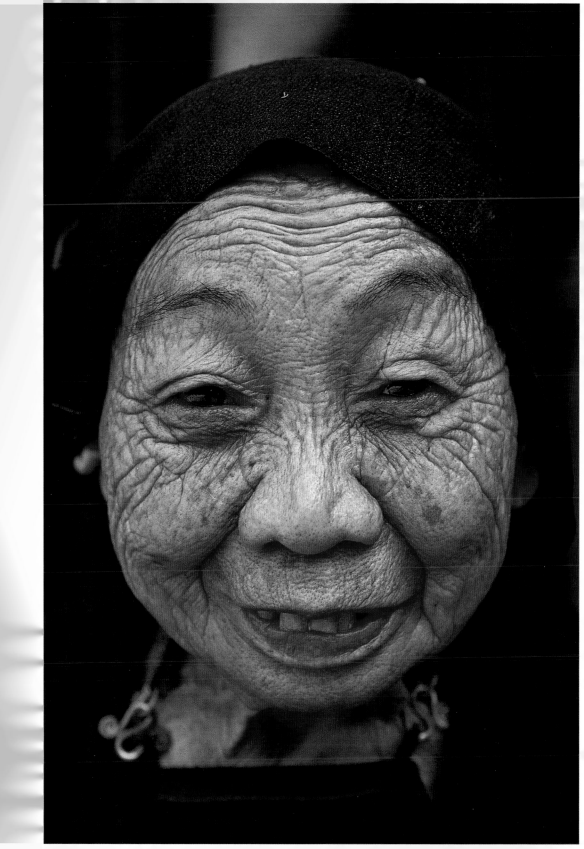

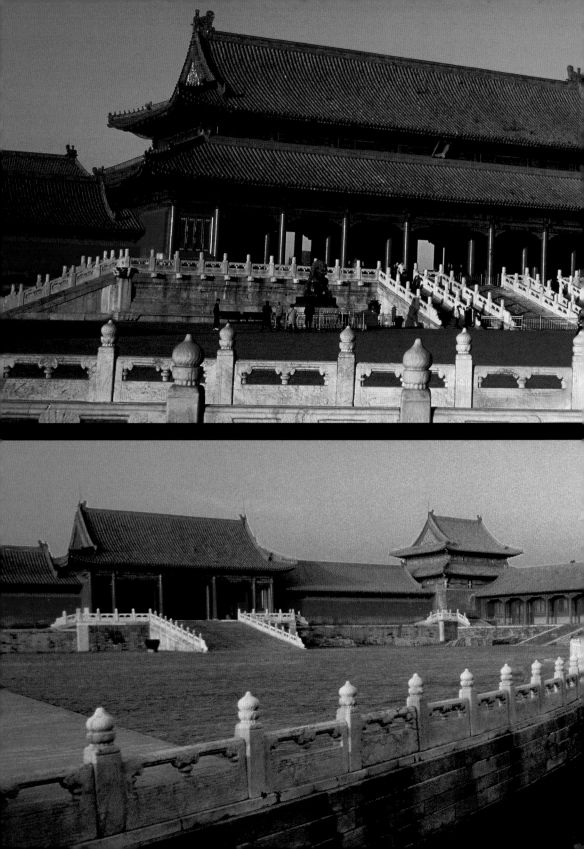

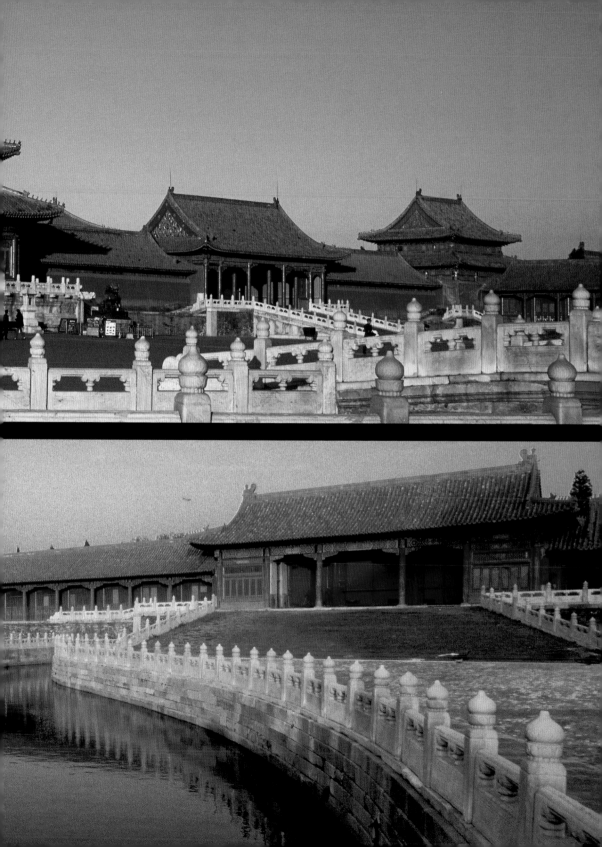

epths of the heart are farther than the ends of the world.

is joy in everything; you must know how to find it.

arn best when we learn with humility.

ledge, action, constancy, loyalty are the ways of the master.

urn to ancient things is to learn new ones.

ho makes of his passion a field to be cultivated takes the
se men as his masters.

ur faults through the eyes of others.

setbacks result from lack of self-knowledge.

willpower comes success.

the rising sun.

agnanimous with others, be demanding of yourself.

ot base your joy upon exterior things; do not give way to
ur own sadness.

ot rejoice at profit; do not be saddened by loss.

e drawing a bamboo, let it grow within you.

hat is not shown, hear what is not said.

te your life to humanity; do not take from humanity for
ur life.

spect others is to be respected.

r ages, laughter rejuvenates.

k anger once, avoid many regrets.

ing is learned at the expense of paper; medicine at the
pense of patients.

ving what knowledge cannot know is the highest knowledge.

lgence towards others and severity towards oneself inspires
iendship and respect.

nising too much is shameful for a superior man.

esty always, even if it wounds.

e for the best, prepare for the worst, and accept what comes.

ho lives without folly is not as wise as he thinks.

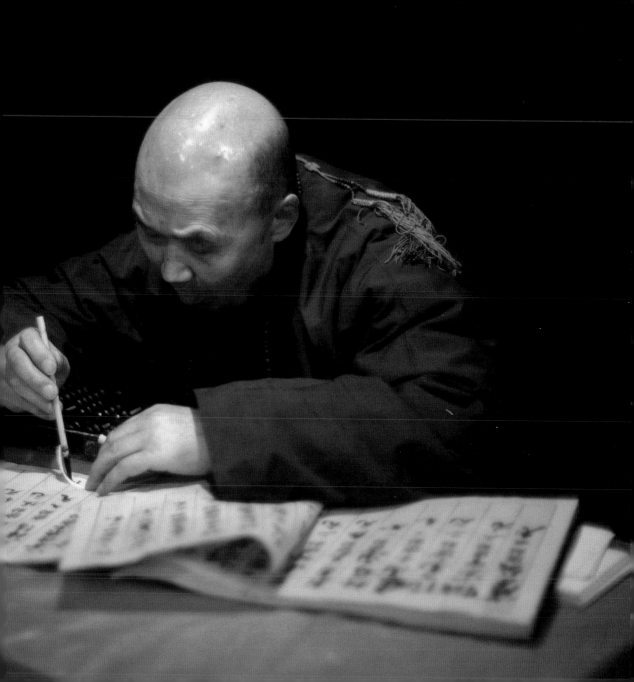

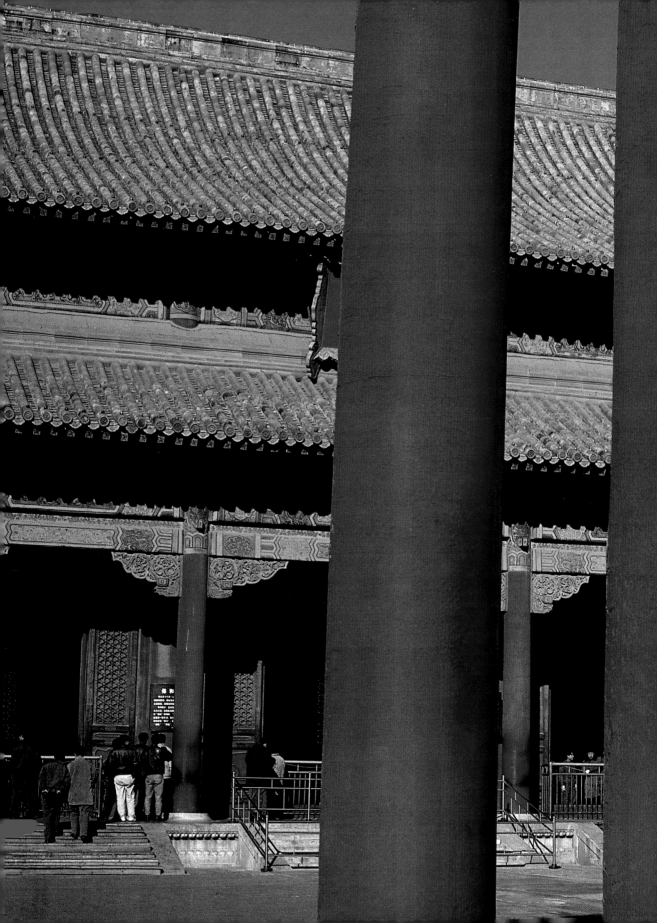

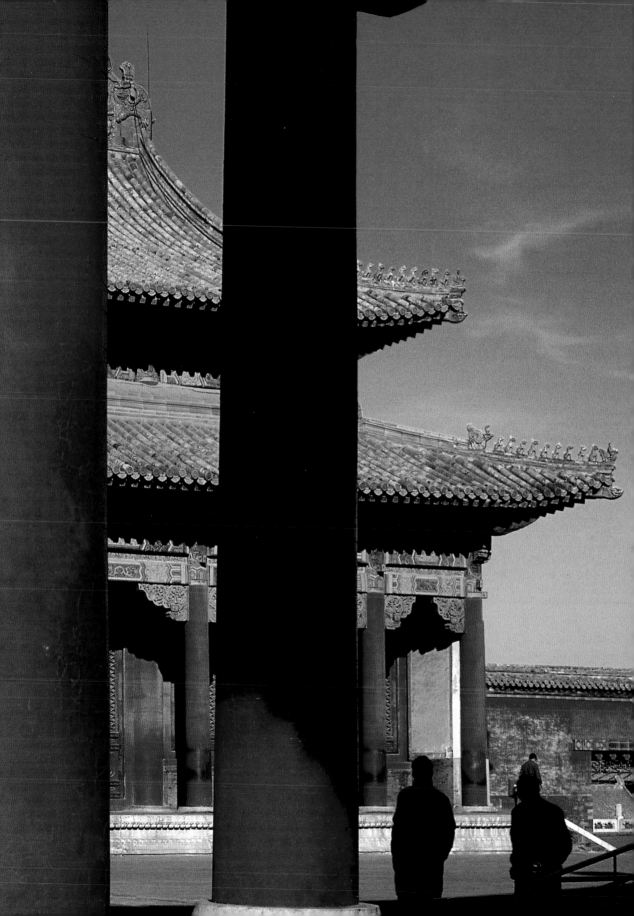

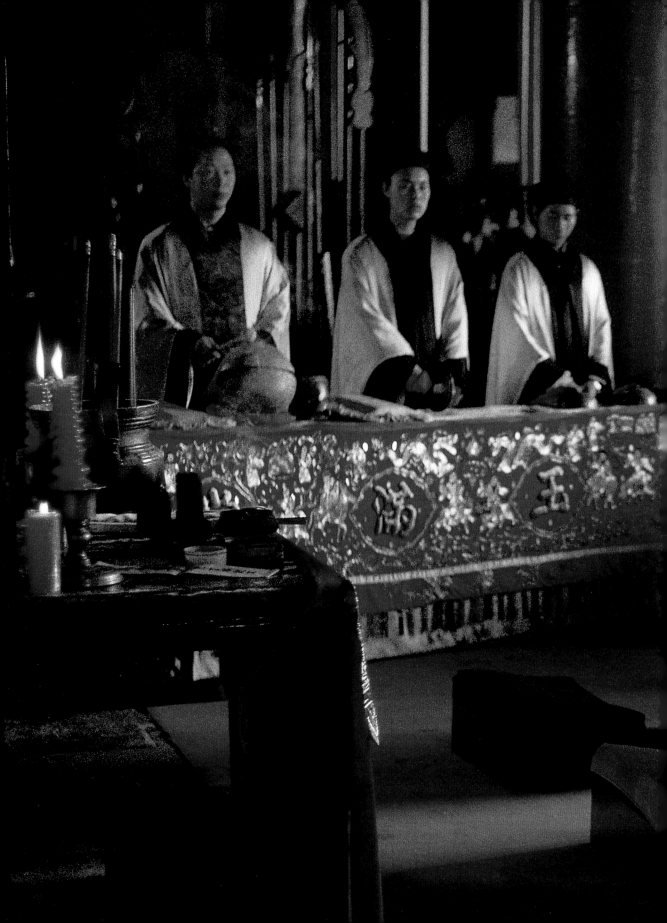

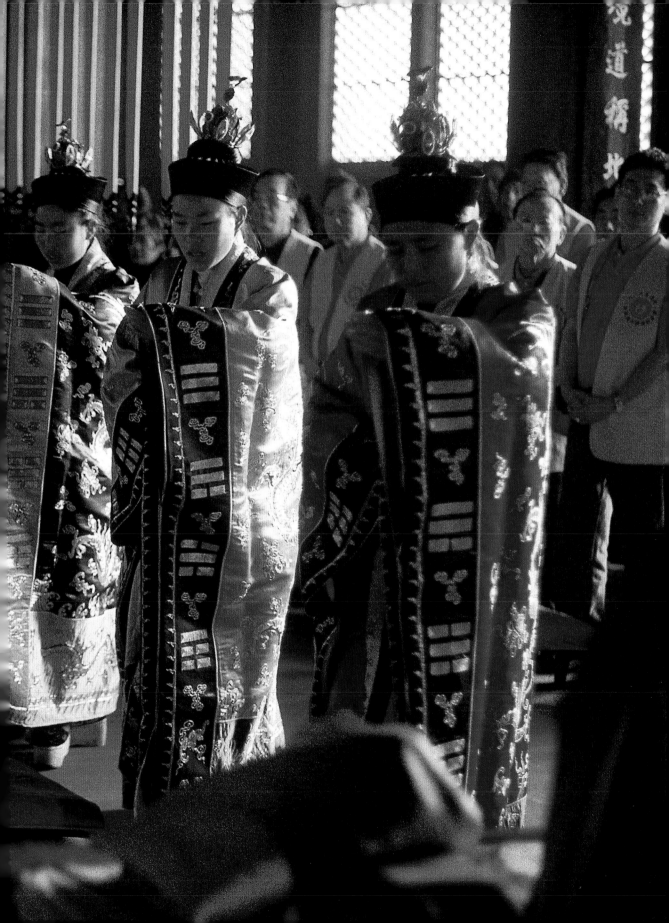

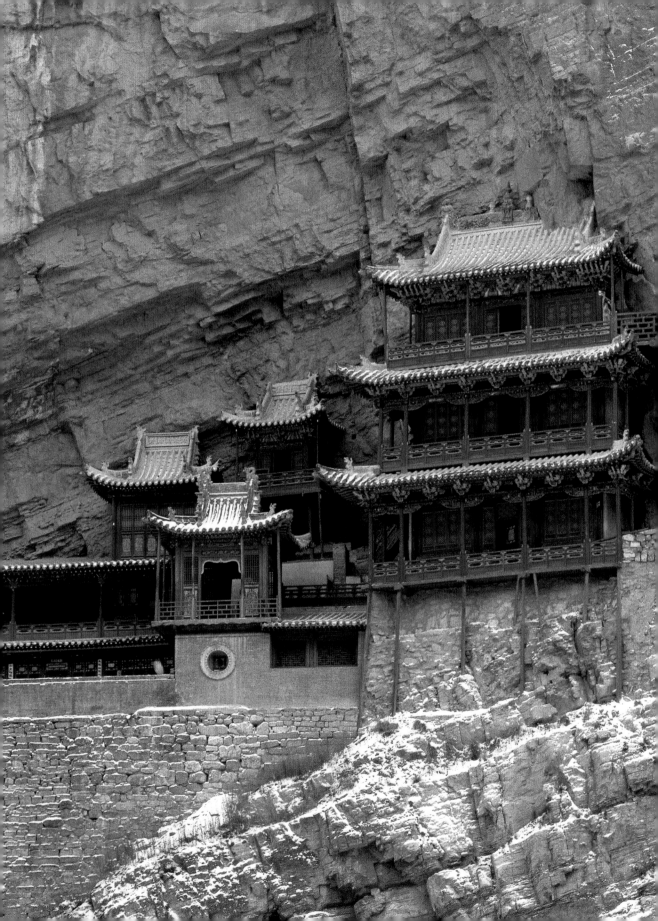

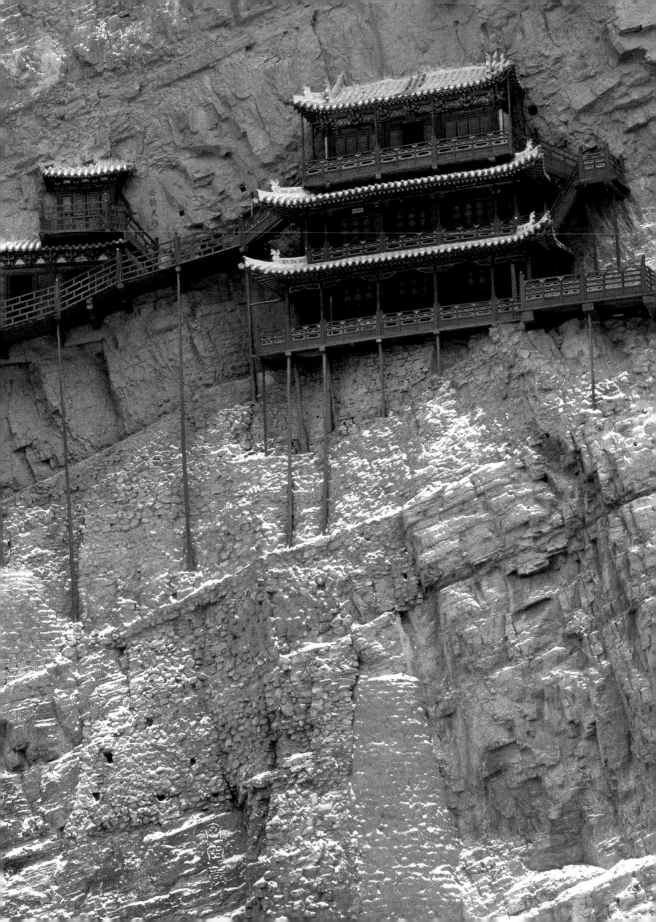

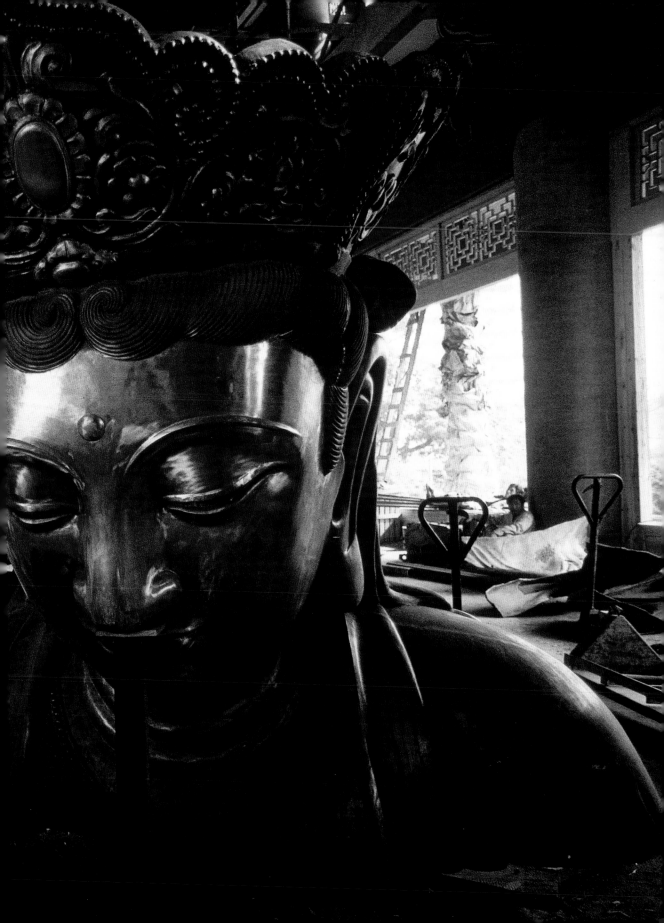

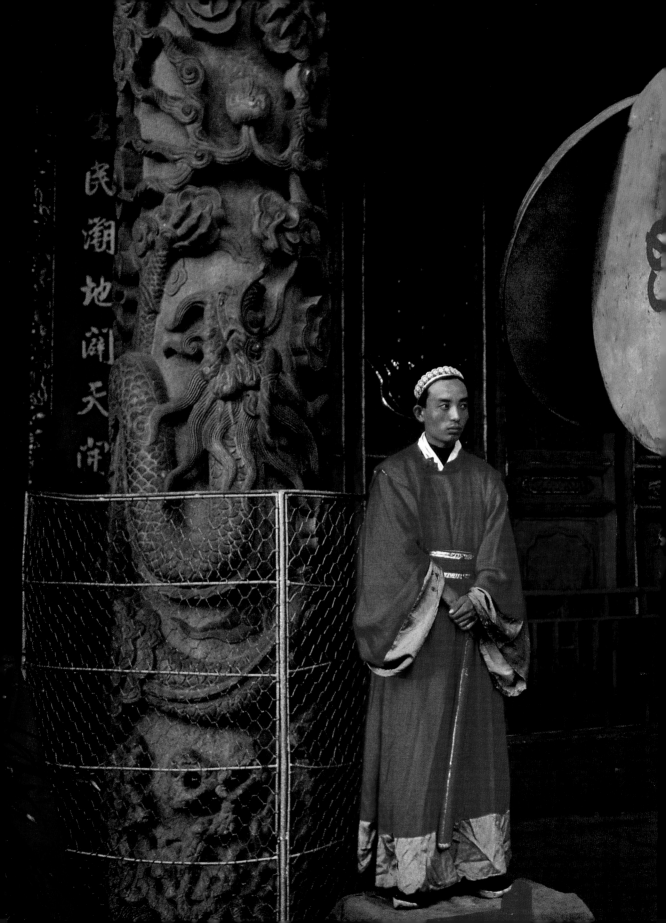

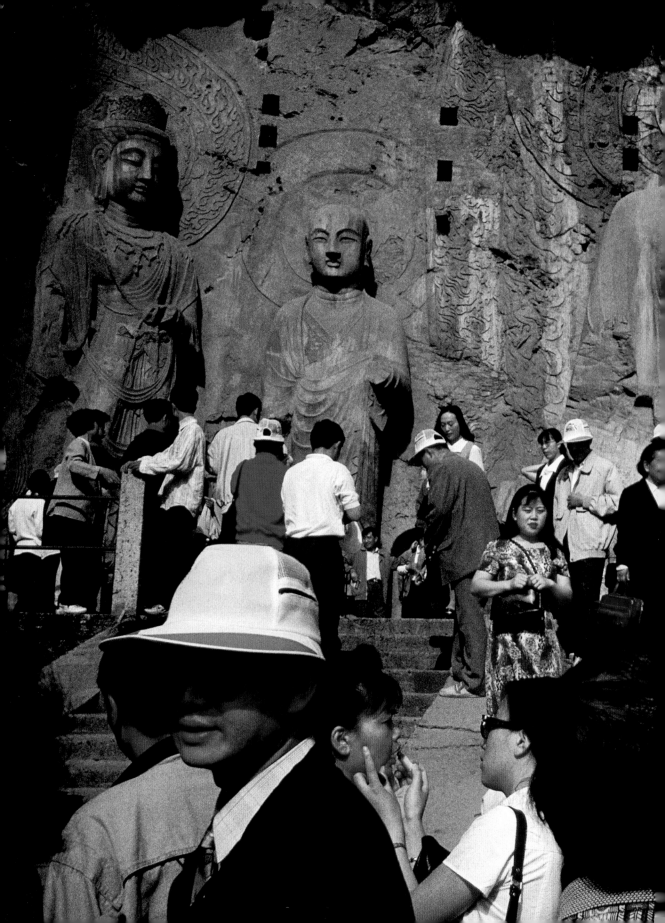

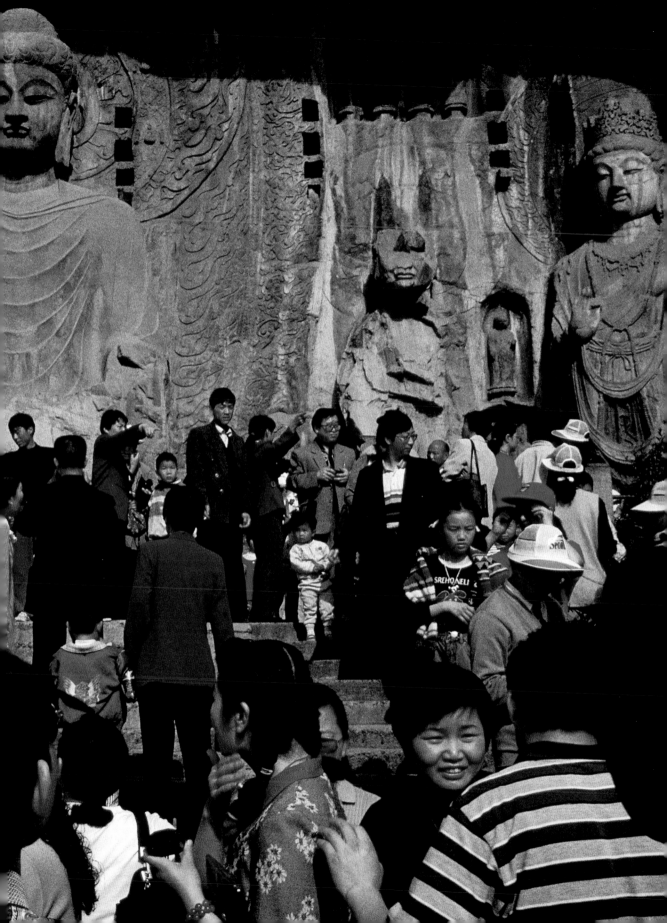

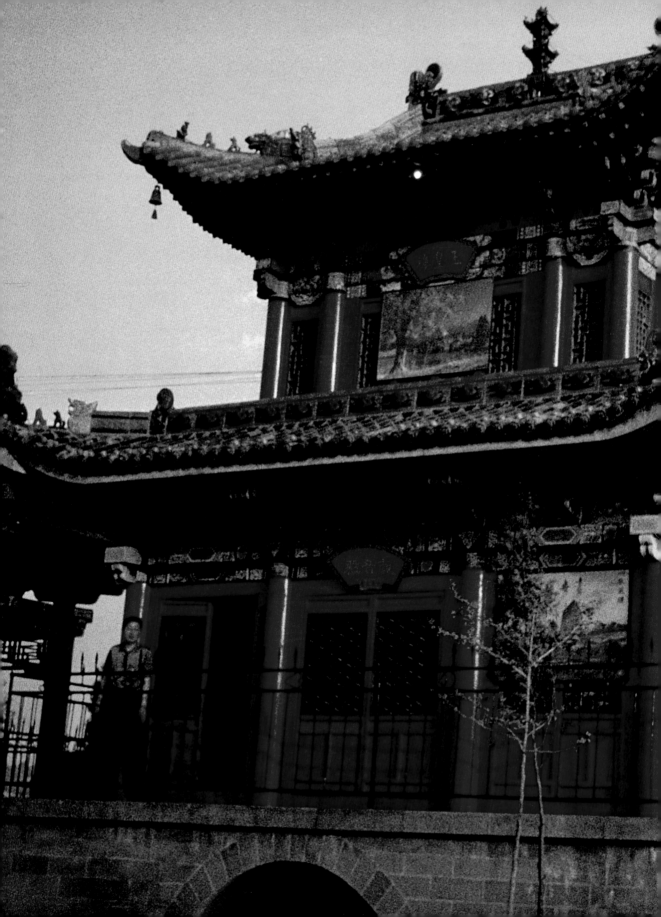

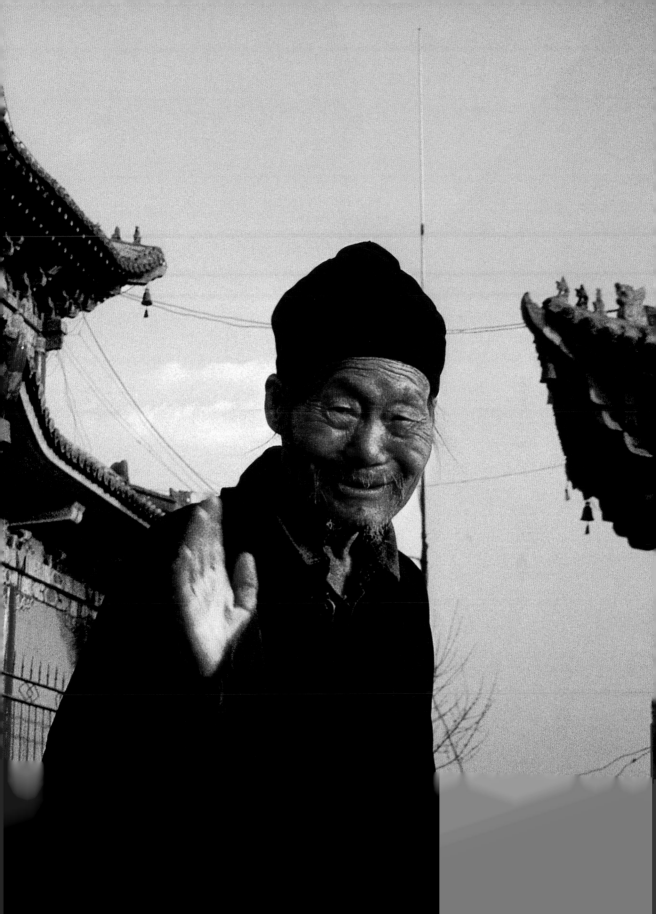

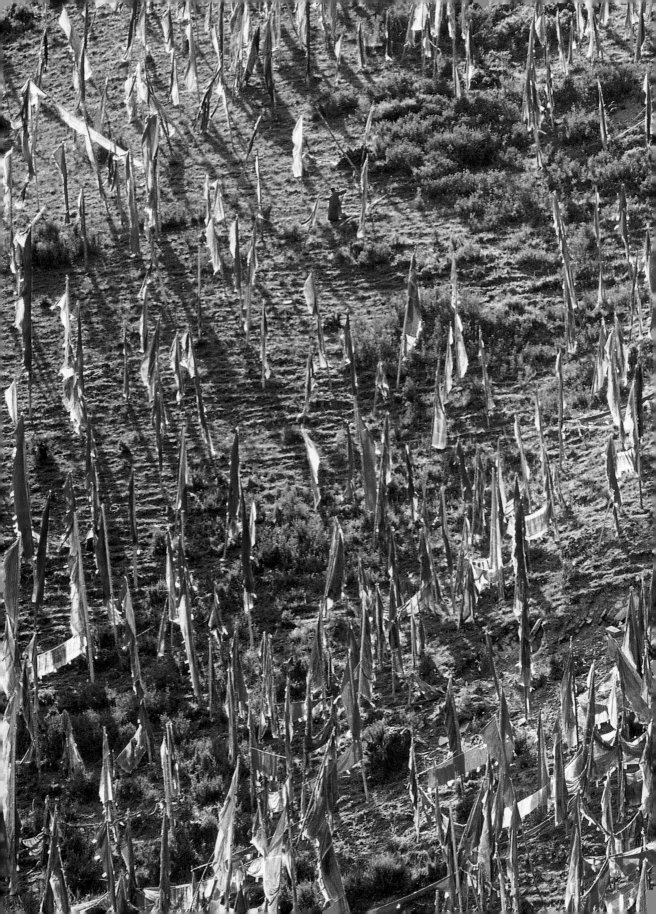

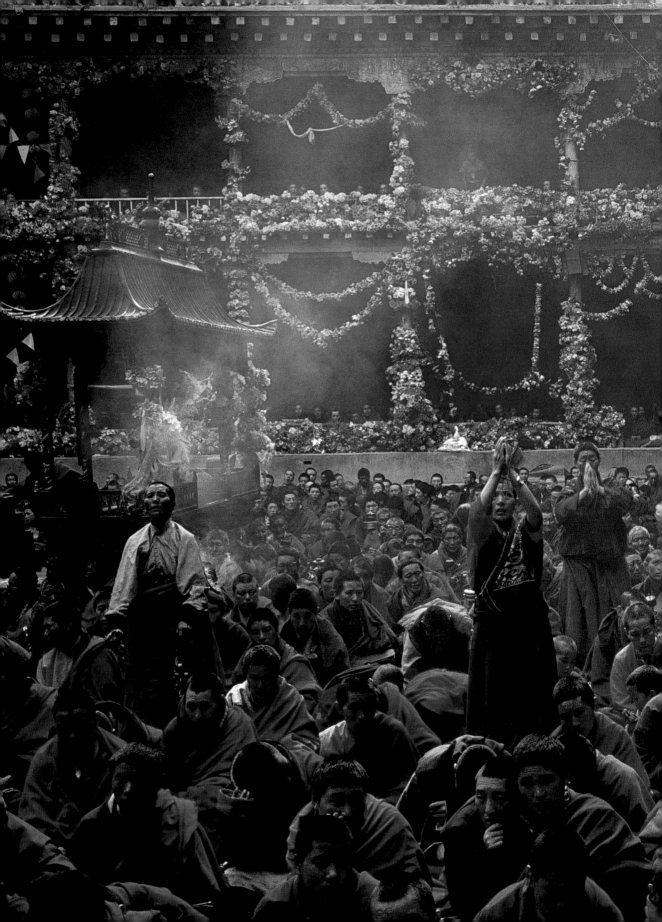

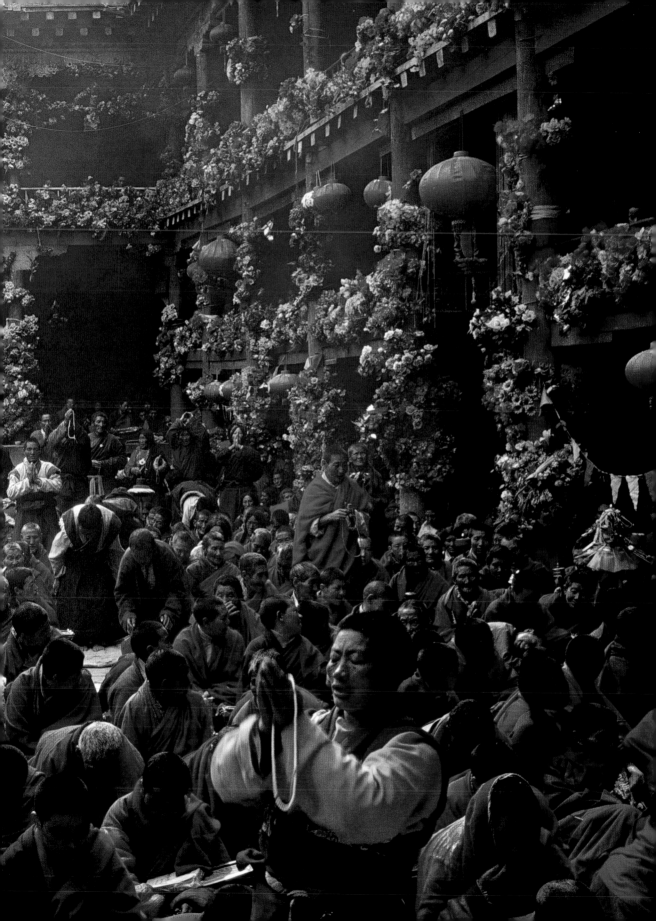

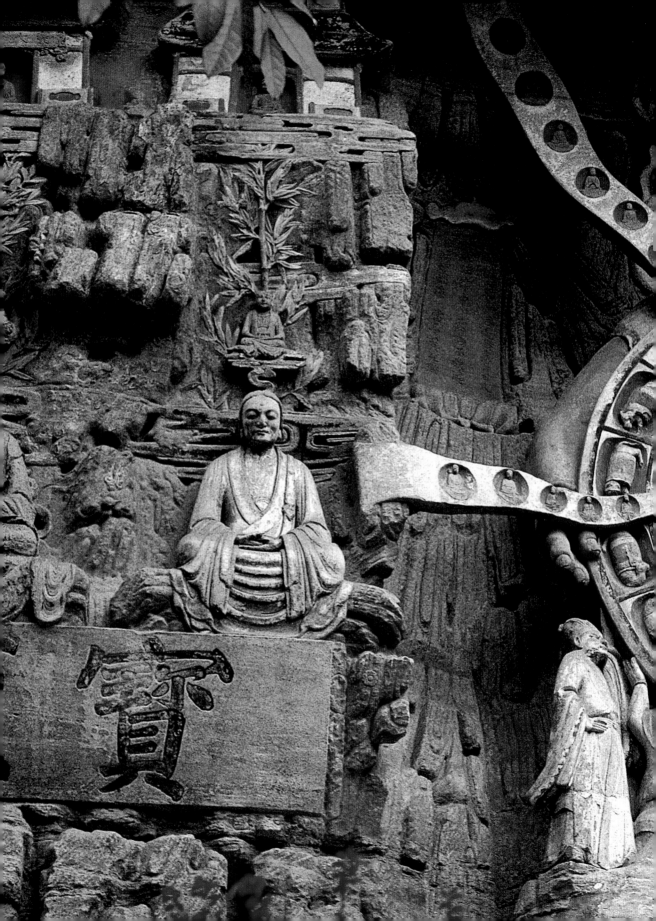

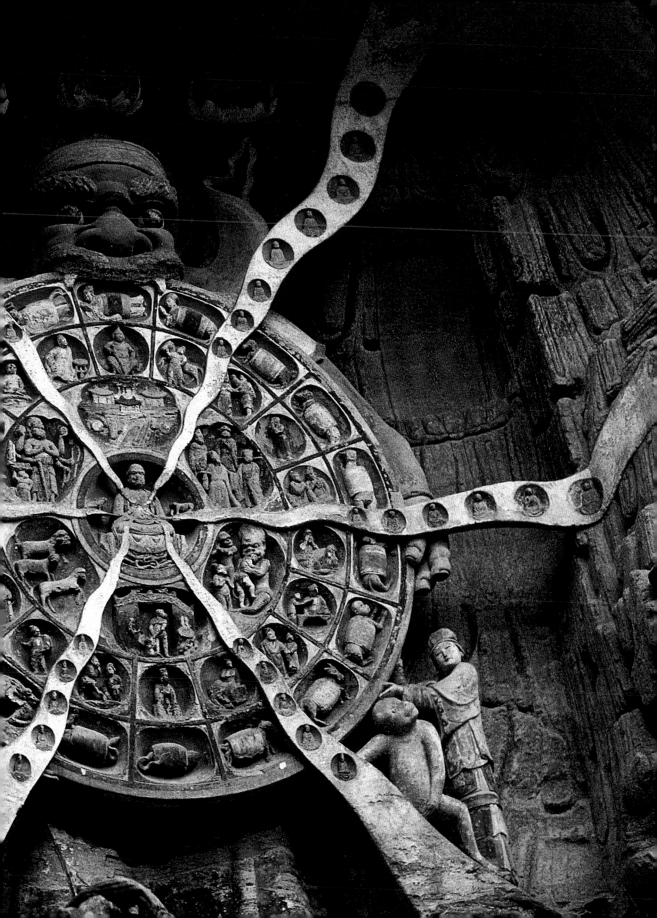

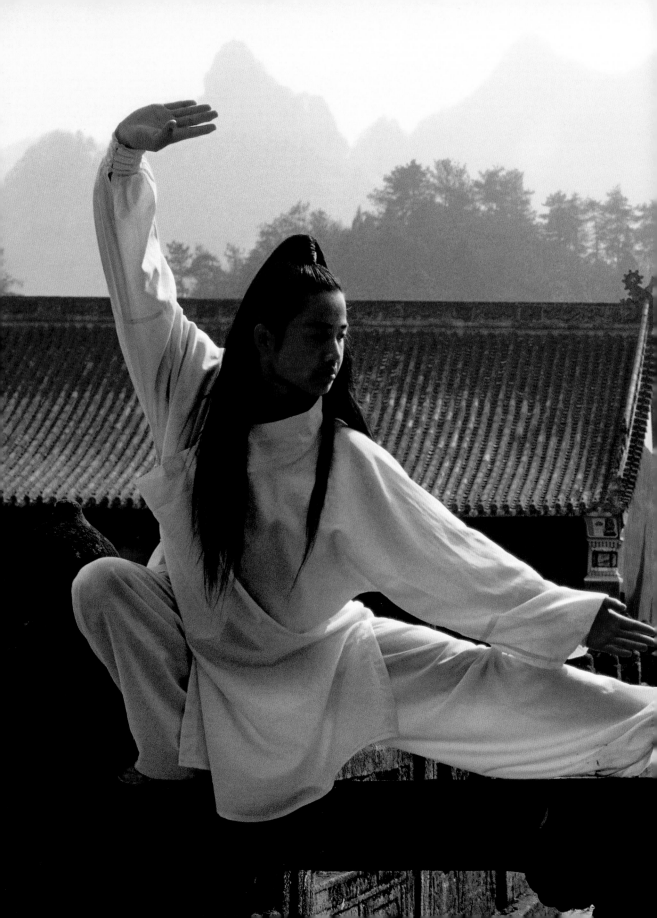

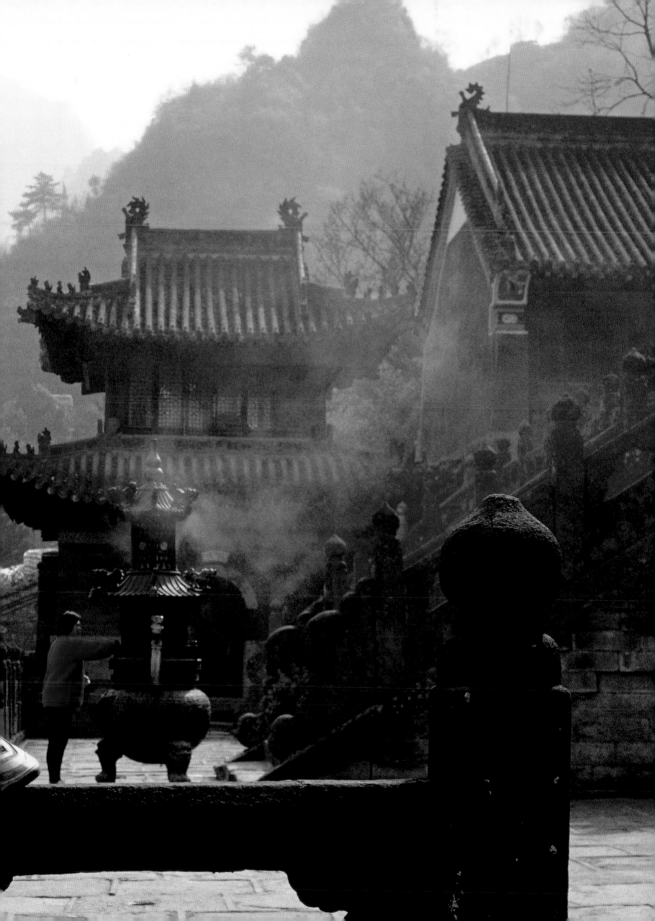

The true Way is the golden mean.

The journey of one thousand miles begins with a single step.

Great virtue is like water: it is good for all things.

Harmony is the universal law.

Too far east is west.

Without crossing your doorstep, it is possible to know the world.

Avoid the full, fill the void.

Use depends on the void.

The more the wise man gives, the more he receives.

Humility, greatness.

He who knows how to stop will never weaken.

If the heavens want to save a Man, they send him love.

Understanding others is wisdom.

Self-understanding is greater wisdom.

To be content with what you have is to be rich.

High Virtue is non-virtuous.

He who speaks a lot will be reduced to silence.

The name we give to the Way; the Tao, is not a name.

The Two in One is a mystery that opens the gates of the marvelous.

Do not flaunt things that make people envious: everyone will live in peace.

Concentrate the force of your breath, become as flexible as a child.

Purify your interior vision, make it crystalline.

If the powerful were wise, all would be better under the heavens.

Let the Way be the goal, Virtue the game, good the root, and the arts the relaxation.

A meeting is the fruit of heavenly chance.

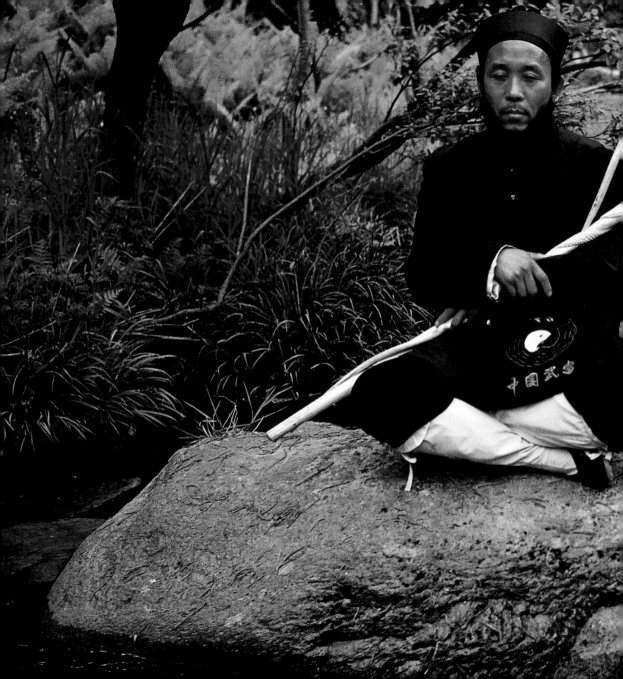

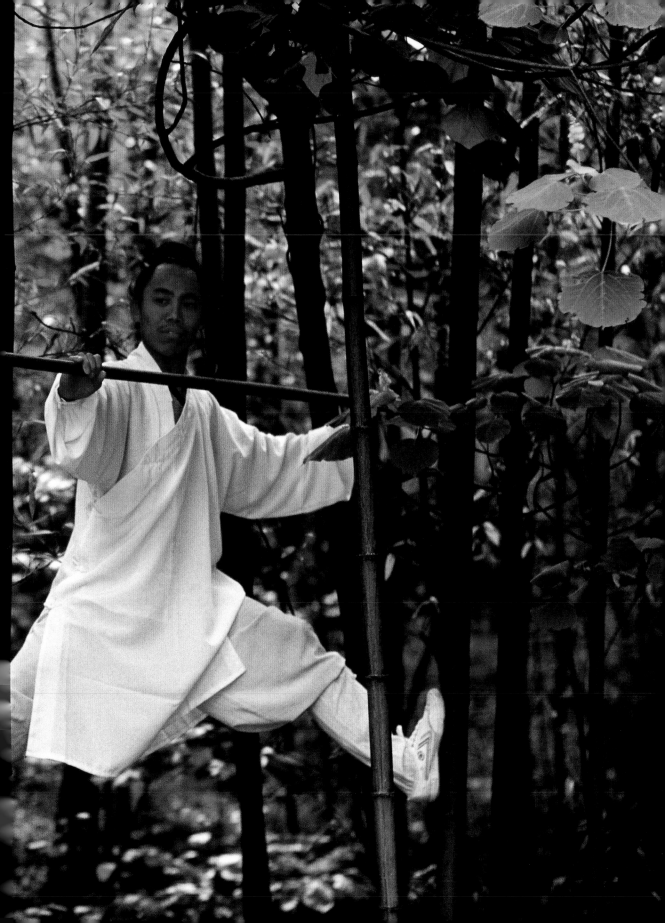

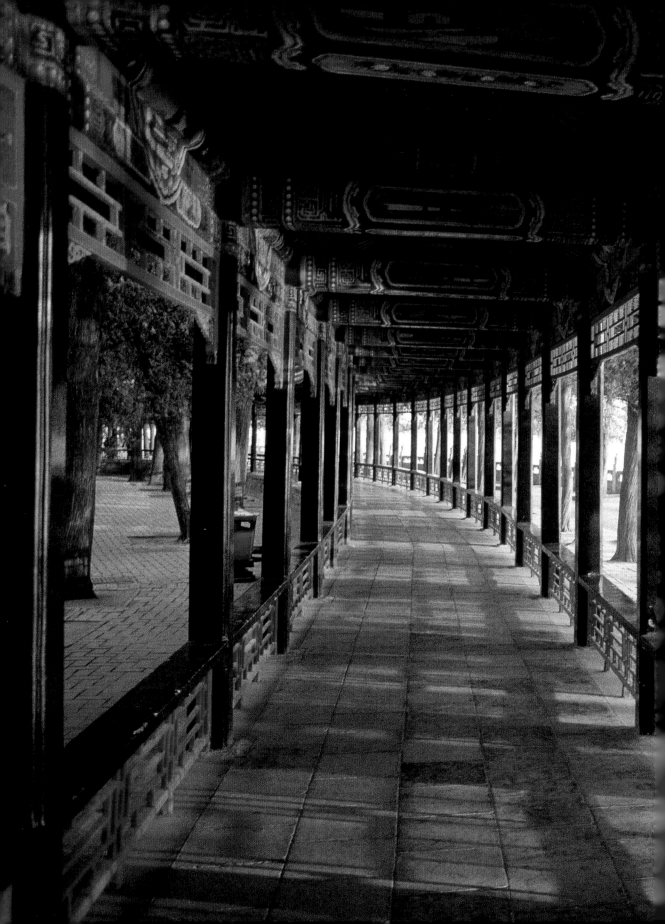

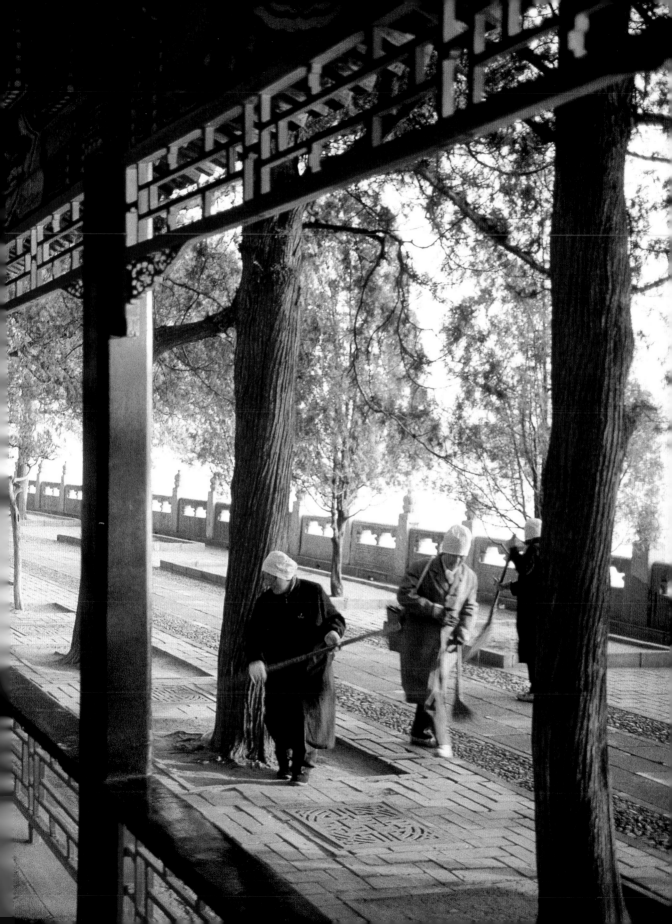

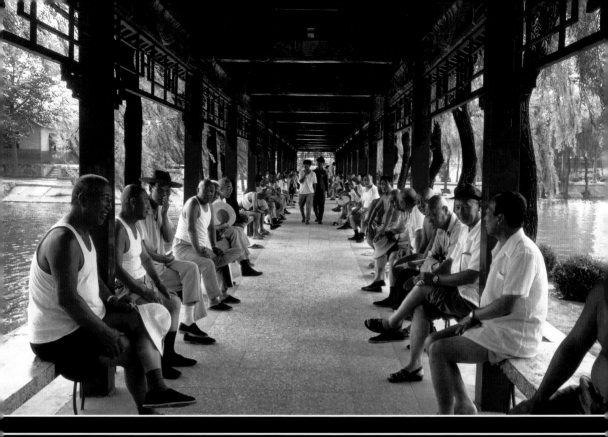
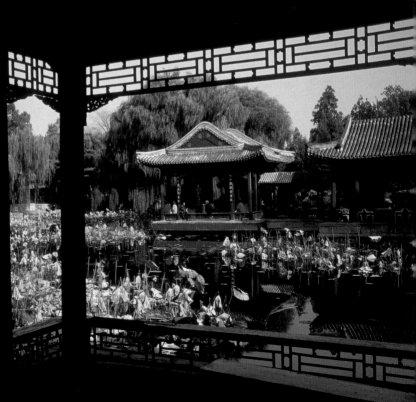

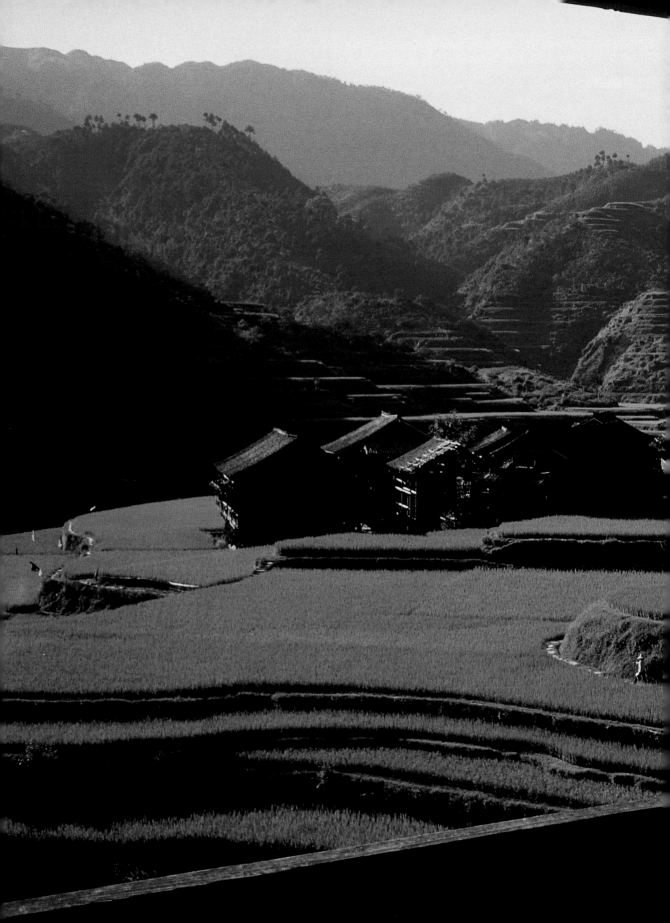

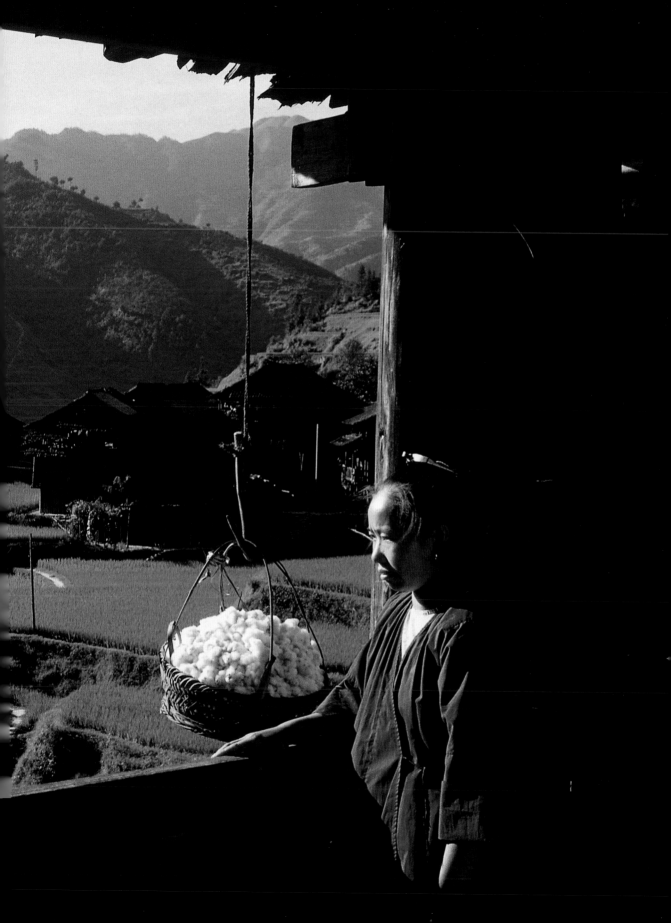

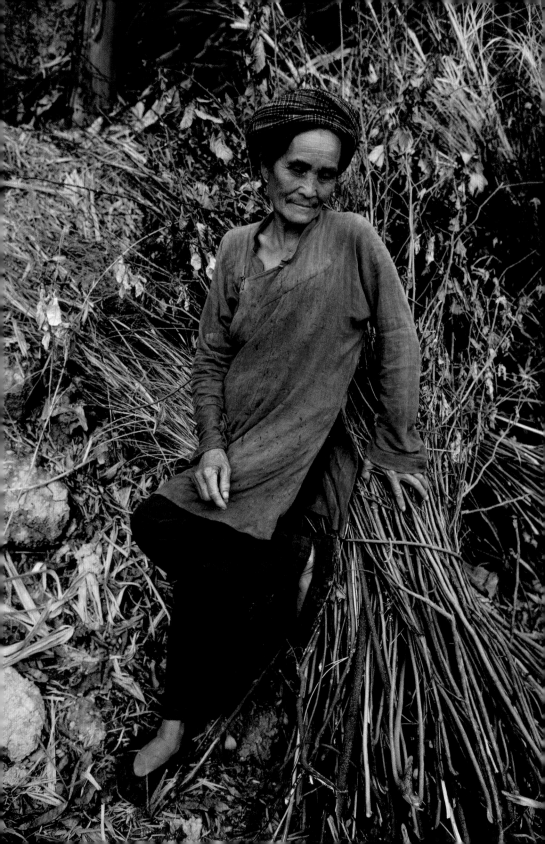

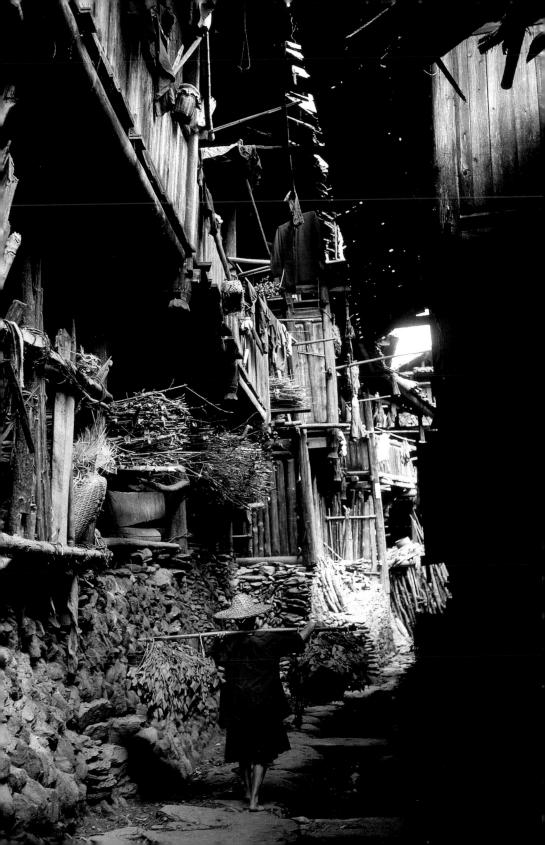

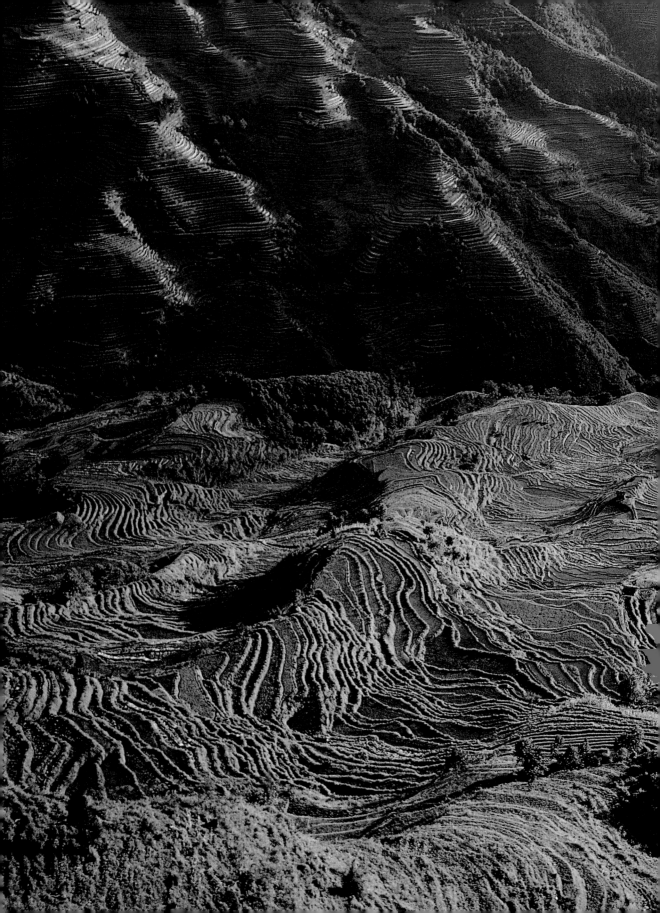

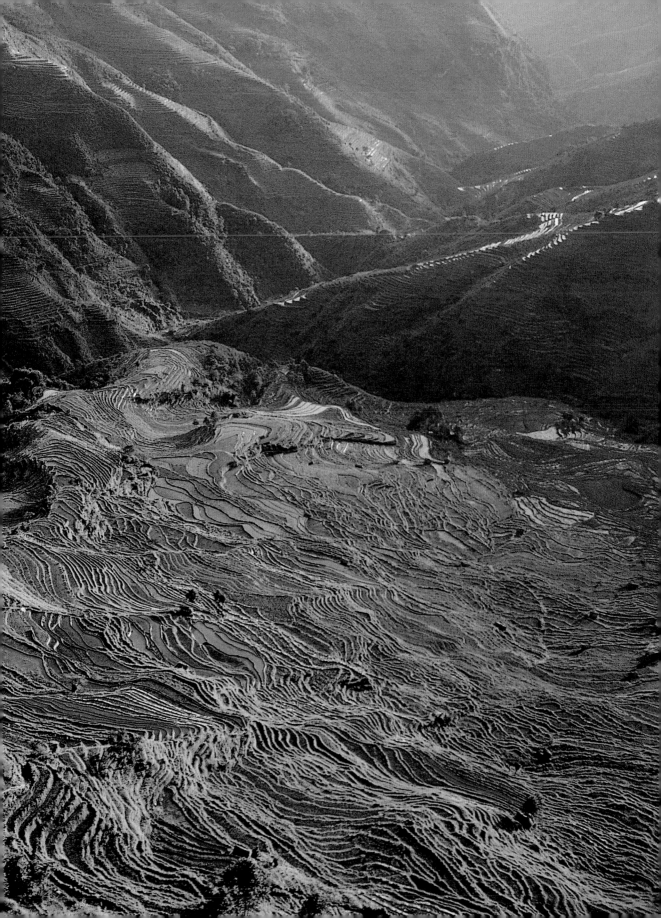

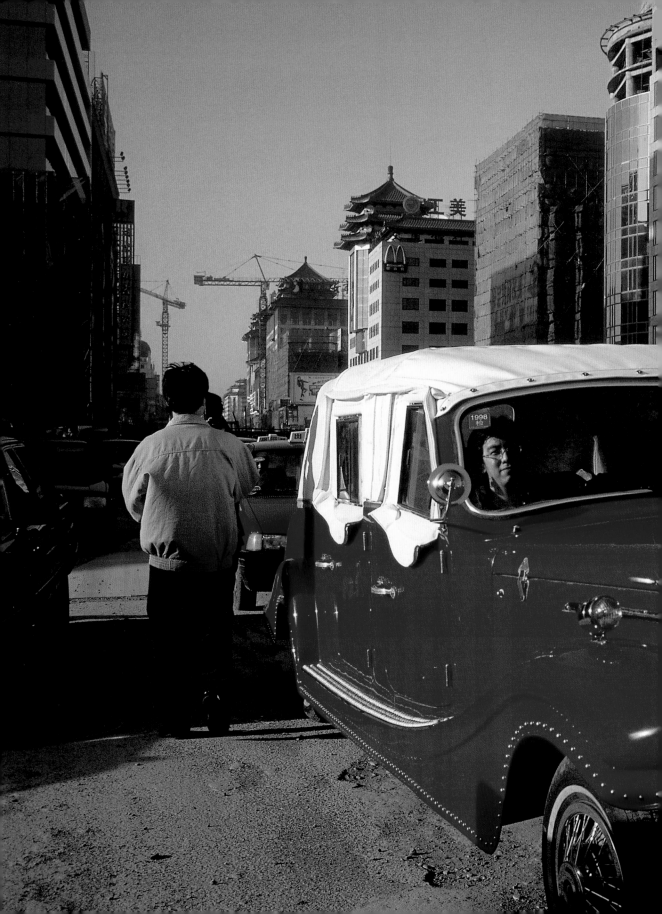

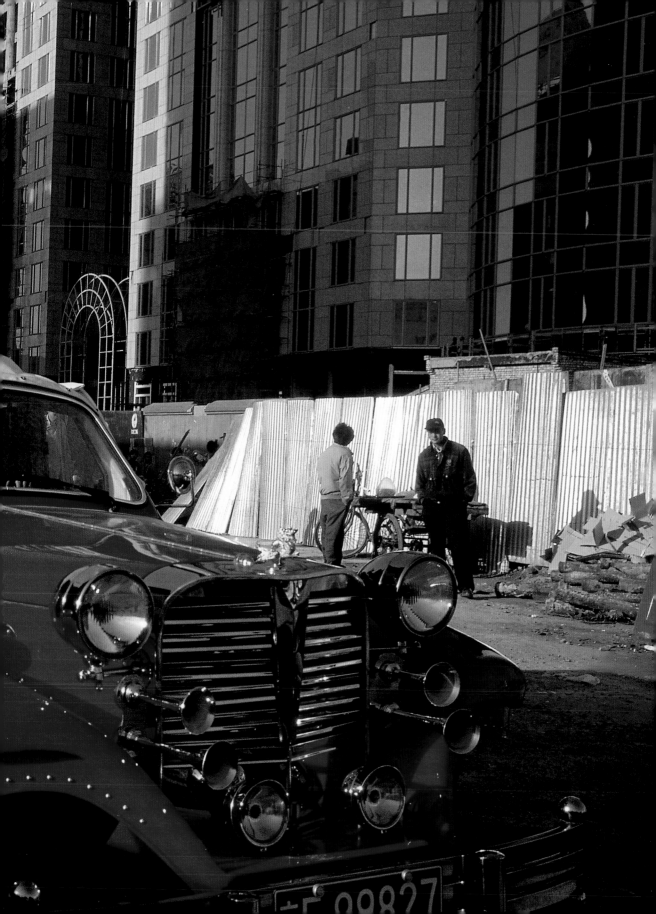

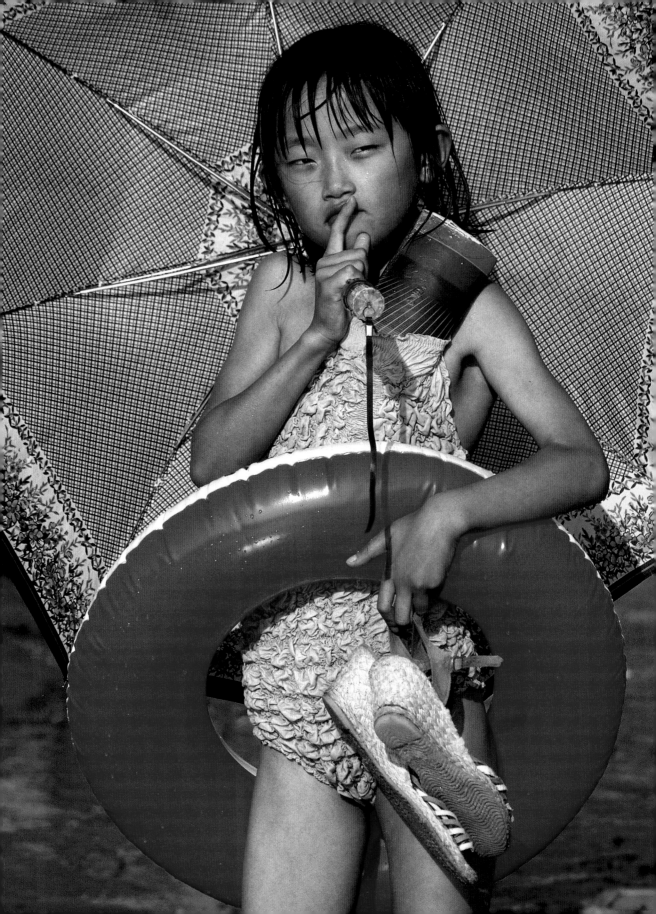

THE METAMORPHOSIS OF THE DRAGON

In those days in Beijing, automobiles were a rarity reserved for the Chinese elite. Pollution was unknown. Flies had been eliminated since there was so little meat to attract them. A favorite destination for strollers, a kind of proletarian Faubourg Saint Honoré, Wangfujing Street was lined with stores, but no one could tell what they sold, since their windows were all decorated with the same portraits and quotations from Mao Tse-tung, the same red flags, the same anonymous Red heroes. Consumer society was unknown, and so was competition.

Sexuality and emotions were hidden in the winter under the quilted canvas coats of the passersby, green, blue, or black uniforms depending on whether their wearers were members of the military, the proletariat, or the peasantry. In the summer, young women in identical pigtails or with bowl haircuts under their caps did not yet dare to wear dresses; potato-sack trousers were the rule.

Since the bird catchers, the instrument-playing pigeons, and the fortunetellers had been swept into the trash can of the "old things," there was a real need for a note of poetry. A little innocent half-note to dance at the winter solstice, when the sky was at its purest and the cold at its driest, to dance in the evening light, a golden shawl making that perennially gray capital sparkle, and for the moment daubed with red makeup. It quivered in the vocal exercises of a solitary cyclist escaped from the crowd of bicycles: *Let the red flag float everywhere in the world! / Even if to this end I must cross a mountain of swords and oceans of flames / I will fear no danger / As I would like to order the snow to melt / So that a new Spring would begin for all peoples!*

Thank you, Mao, for this taste of a new exoticism, for this utopian glimpse that thrilled, on our continents where "the West wind gives way before the East wind," the rising generation of academics, future planners, bankers, and technocrats fascinated; by the impossible dream of revolution. China must hide some secret treasure, otherwise what would be the good of this terra incognita, if it was only our poor mirror?

Mao, celebrated in the 1970s as a "beacon of world thought," was wrong nonetheless: he was certain that history began with him.

Thirty years later, Wangfujing Street no longer exists. It has fallen before the dollars of the Hong Kong palace-builders. Beijing, for so long a horizontal city, bristles with skyscrapers. There still aren't any flies, no doubt because of the air conditioners. But unknown concepts like competition and consumerism prevail over a capital, where the river of automobiles overflows, chasing away bicyclists and pedestrians. City maps and telephone books, once absolute state secrets, are superfluous now that the Internet predominates. And Chinese cities are breaking world records for their consumption of cell phones.

The new world is standardizing itself but, like a planet yet to be discovered, China is still like a dream. Now there are fewer intellectuals than capitalists. They marvel at this El Dorado. If they had a Chinese memory, they would remember the Imperial annals and their succession of dramas and farces, whose characters we may see crossing the stage of life. "The same passions, the same plot, the same ending; only the names change," the Jesuit Leon Wieger said at the beginning of the twentieth century, adding a sober note, "There can be nothing new among this antiquated people." A half-century before the fact he contradicted the prediction of Mao, who saw his country as "a white page upon which we will write the newest and most beautiful words!"

The walls of Beijing, city and palimpsest, stick to their word, they maintain their silent eloquence that, like the faces and the countryside of China, recite the lines of the endless Chinese world, of this long and heavy past that protects them and guides them from one upheaval to another. The name and the slogans of the Great Helmsman fade in the saltpeter, while the ancient precepts praising women of virtue and ministers of integrity still decorate the gates of the Summer Palace. You will no longer find Anti-imperialist Street, Red Sun Street, East Wind Street, Victory of the Masses Street, or Insurrection of the Autumn Harvest Street, since the labyrinth of old Beijing has rewritten the poem of its eternal life, returning to the names of its familiar itineraries: Magical Brightness Street, Black Tiger Street, Sweet Dew Lane, Pure Loyalty Lane, Intellectual Light Lane, Wine-cask Lane. But you have to hurry if you want to wander through them: modernization may swallow them up in their turn, and the city planners may have in mind a second-rate Chinatown in Beijing.

In the olden days, Beijing was a city of walls and gates, a city of prohibitions. I pushed open a heavy wooden gate, thinking that it opened on a temple courtyard. But

the caretaker refused me entrance with the excuse that the place was "being repaired." He couldn't admit that the temple was being used as a barracks. Today, as in the rest of China, the capital is hesitant to open itself to the curiosity of "people from outside" (*laowai*, or foreigners), who must get used to the chorus heard in every circumstance: "you have to find the man with the key." Without this refrain, Chinese ritual would lose its charm. Behind gates and walls the dust of the ages piles up, or is hidden in some "sage's kitchen garden." According to François Cheng, China is like the tree whose leaves fall toward its roots.

To celebrate the end of the Cultural Revolution and the arrival of the "opening," the painter Mao Lizi devoted his art to locks, less no doubt to lock up time or padlock the garden of old China than to mark the threshold of an era. It's no use forcing the faded red panels of the gates of the Shishahai quarter, the Lake of Ten Monasteries to the north of the city. In the middle of the year 2000, its iron or copper hinges decorated with lions, dragons, swans, or lotus flowers recall the enchantment of Beijing throughout the ages. The gates remain closed, and the action is in the bars and cheap restaurants on the banks of the Front and Rear Lakes, which meet under the Golden Ingot Bridge, not far from the Drum Bridge, under the balcony of the old Mongol restaurant Kaorou ji, whose famous grilled mutton was already a delicacy for foreign residents during the Mao years. Roger Darrobers, the former French cultural attaché and Beijing stroller in his soul, deciphered, on the pediment of a door, a distich dating back to Father Confucius, which shows how much, in its march forward, China has mastered the art or the illusion of moving ahead as it retreats: "Loyalty and generosity have lived long in the family, poetry and documents are handed down through, the generations."[1] Only the words "loyalty" and "poetry" have won the battle with time, but what a breath of air beside the rest of the Maoist whitewash!

We are only a few hundred *li*[2] from Beihei Park, a lakeside park arranged in the eighteenth century in honor of the former Dalai Lama, an ancient Summer Palace of Mongol sovereigns that became the favorite strolling grounds for Manchu emperors. There you could find Jiang Qing, Mao's official wife, trotting about on a black horse in the 1970s, when the lake and its gardens remained closed to that impenitent onlooker, the Chinese public.

And now today, once you cross the Avenue of Earthly Peace, you will rediscover, under the walls of the old princely houses, at the edge of the lakes, a mood that is somewhat elegant like Saint-Germain-des-Prés in Paris. There you can hear jazz played by the students of the conservatory, who have already converted from patriotic and revolutionary tunes to the music of Beethoven and other "venomous flowers" of the "bourgeois" repertory. "Today, the Chinese love Brahms," smiles Liu Yuxi, a professor at the conservatory. He had Isaac Stern and Yehudi Menuhin invited to China for his students. Other young musicians blithely tempt the great gap of centuries. They name their pop group "T'ang Dynasty," after the emperors who reigned from AD 618 until 907. Electric guitars and a clarinet tickle the nostalgia of the iced-coffee drinkers as they perform "The White-Haired Girl." It was a smash hit during the reign of Jiang Qing in the darkened concert halls. The diva of proletarian art had drawn the song from the peasant repertory, to adapt it to its operas and ballets with "contemporary revolutionary themes," the diet of a half-dozen pieces inflicted on the "masses" for the last ten years of Maoism.

General Wang Zhen, the companion whom Deng Xiaoping nicknamed "the Cannon," was right to worry about the new fashions followed by the inheritors of his Red China. "One day, they'll make the 'Internationale' swing!" he said indignantly in 1992. This warlord with a tiger's heart was no doubt unaware that he was in the presence of an underground culture. In 1970, Beijing was a termite mound: the entire population shoveled the earth every day to dig underground shelters that were supposed to protect them from an attack by the Soviets. Fifteen years later, when the country's leaders no longer spoke of "inevitable war," but of "the peace to be preserved," flower power was born in Beijing's bunkers, a place for the young to hide their loves, and to cultivate their rock music.

Of course, the West today has eyes only for the miniskirts of the punks and the techno din of the nightclubs, the rap or hip-hop groups, the generation with red or yellow hair for whom "thugs can always become models." But Wang Zhen should have had an eye on his contemporaries instead. Some older Beijing residents are the secret heroes of the resistance against the attempts at total domination. If the capital keeps some of its flavor and look in spite of the vandalism of thirty years ago and the great pre-Olympic public works, it's thanks to them.

1. Roger Darrobers, *Pékin, Au detour des rues et des ruelles* (Paris: Bleu de Chine, 2000).
2. 1 *li* = 328 feet (500 meters).

See them on the Western Bank of the Front Lake, playing cards or Chinese checkers, peacefully seated under the weeping willows on the tree-covered paths. I think that they are the real princes of Beijing. The victors over time, Victor Segalen wrote. You'd think that they had been sitting there, on their little stools forever, whatever the political climate. From the wrinkles of their faces, from the very freckles of their shaven monks' heads, from their sparkling eyes under the wrinkles, comes a glow, the knowing smile of the people who stand on an age-old foundation, impassive and tender. On the two strings of the *erhu,* the Chinese viol, they scratch a few notes, which are neither tears, nor cheerfulness, but perhaps both at the same time. This grandfather who holds the hand of his toddler to try to catch tiny shrimp in the lake, which will be dried to flavor their meals, is the ancestor who guides the child in the memory of Chinese good taste.

Fifteen or so years before, families would stuff their kids at the McDonald's, which moved into the space left by the big bookstore New China at the beginning of Wangfujing Street, I met a student there who already knew that the Marxist-Leninist Albania of Enver Hoxha, not long ago "united to China like lips to the teeth," was not the largest country in the world after her own. She was especially hungry for knowledge about the rest of the world. "They say that there are fields in the middle of Paris. What do you grow there?" For her, after two years of studying French, the Champs-Elysées was a golden triangle of French agriculture!

Mao had been dead for barely three years, and the plainclothes police hounded this young woman who dared to violate the prohibition on conversing with a foreigner, right in the middle of the crowd walking on Chang An Avenue, on the edge of Tiananmen Square. We went to hide in the groves of the Park of the Purple Bamboo, where the trembling of the leaves revealed the hidden lovemaking of young couples. Her limpid eyes reflected the eternal and troubling adolescents of China, the inheritors of forty centuries of oral history, always treated as though they had just been born. The thought police, still active at this time, had planted in this young mind warnings against the malfeasance of an outside world, whose great fault was that it was not Chinese. Her questions reflected her concerns: "Do all the young people take drugs in your country?" "Why do you import foreign workers?"

"Is it true that the hippies are vagrants who refuse to work?" she asked again. I told her about the performance of Glenn Cowan, the "hippie" of the American table-ten-nis team, who danced the twist to the tune of the hymn to Mao: "To navigate in open sea you need a helmsman, to make the Revolution you need the thoughts of Mao Tse-tung." A hero of the ping-pong diplomacy of the then-Prime Minister Chou Enlai, the year before the historic visit of Richard Nixon to Beijing in 1972, he amused the crowd in Tiananmen Square with his big hat and his flow-ered shirt. For the first time, the Chinese were allowed to laugh wholeheartedly. "With a little white ball, we will turn the heads of people throughout the world," said the head of the government, at the height of his charming elegance. But my student interrogator remained prac-tical: "What is the difference between a supermarket and a department store?" The answer came in the 1990s, when the stars of multinational commerce vanquished the main department store of the Mao years, the Bai-huodalou, the "store with a hundred kinds of merchan-dise," a required stop on a walk along Wangfujing. The young lady concluded, after a reflective silence, "What we Chinese need is freedom." The time when you could be arrested for saying, "There is a black spot in the sun" fades into the past along with the clicking of the hooves of donkeys and mules in the deserted Chang An Avenue where caravans carried cabbages, cans of soy, and sacks of flour, pumpkins, and sweet potatoes to resupply Beijing every night. The camels, which sometimes accompanied them, have withdrawn to the neighboring deserts.

Deng Xiaoping, the new master of the country, dared to speak the blasphemous phrase "Even the sun sets." Everyone thought of the twilight of Mao. He had appealed to the Chinese youth, and he had been heard on the campuses of America, Mexico, France, and even Japan: "You are like the sun at five o'clock in the morning, the future belongs to you!" A student without a univer-sity, Xiao Wei, appeared in the regiments at the height of their youth—fifteen to twenty million Red Guards—unleashed with their banners and their portraits of the "President" to discover their future. They marched on Chang An Avenue every evening, "going into the coun-tryside," as was said officially, to be "reeducated by the poor peasants." "What is socialism? No doubt, a model for us," he confided, leaning against the pale green wall of the minuscule apartment belonging to his parents, whom he had just visited clandestinely. A neon light lit an expression copied from a book by Lu Xun, a rebel writer who died before the foundation of the People's Republic: "The Chinese youth does not lack 'elder broth-ers' and other 'intellectual models.' " "Times change," dryly noted the theoretical monthly magazine of the

Party's Central Committee, *Red Flag*. More melancholic, the heroine of a Shanghai romance, she too in the half-pay of the Red Guards, who knows that the experience of an unexpected future awaited her, as it did millions of others: "Everyone is a child of the times, no one can choose his or her era."

China emerged hesitatingly, from the scales of frozen varnish, in search of its well-being. Rickshaw drivers, banned for twenty years as the shameful legacy of "feudalism," have returned with their laughter and their cries. Since the racket of the automotive civilization and the cries of the merchants have not yet invaded it, the capital enjoys the remains of the peasant silence. You can once again hear the celestial fugue of the flights of pigeons, the harmoniously designed whistling of the little reeds fastened under their wings. The four notes of the cuckoo's song confirm that spring is here. From the bottom of their little cage of leaves, or their box made of porcelain or colocynth (bitter gourd) bark, the crickets chirp away, providing a little summer music for the still-cool evenings. People were not yet talking about "market socialism"; nevertheless an immense curiosity arose in the suburbs, where the villagers set up their stalls to sell vegetables, frozen meat, and duck eggs. But the most popular markets were the bird markets. The old people were now free to walk through them with their reed cages. Shielded from the light by brown or blue cloth, the birds would sing as soon as someone opened their curtains, and their masters would "talk" with them by whistling.

From the balconies, a flashing glare heralds a new era, another kind of revolution: from 1980 to 1982, a hundred million Chinese equipped themselves with television. Previously, television sets had been seen only in official offices, for one or two hours every evening broadcasting edifying films on the achievements of socialism in the countryside and in the factories (people still didn't know that this was a fiction). A few years later, when color supplanted black-and-white, a poor peasant, whose daughter dreamed of a color television, glued sheets of colored plastic to the screen. At Da Xing, nineteen miles (thirty kilometers) west of Beijing, many houses have a television and a washing machine. It doesn't matter that electricity has been slow to arrive: the television sets serve as altars to the ancestors, and washing machines are used as tubs. It's the symbol that counts.

In the TV film *The Road,* the young male lead parades in front of his girlfriend. "If there were only hoods and cops to wear sunglasses and pointed shoes, life wouldn't be much fun!" The daily *Beijing Evening News* started a column of advice for the lovelorn. That forgotten trade of newspaper vendor has reappeared, and the publications' names compete to win their readers' hearts: "Find Your True Love," "Lovers' Needs," "Heartbreak!" In this China trying on new makeup, the official press congratulates itself. Next to its ideological calls to order are the booming sales of lipstick and beauty creams.

On the walls of Beijing and Shanghai are posters of Charlie Chaplin in *Modern Times*. But *Rickshaw,* the film adapted from a novel by Lao She, the eulogist of old Beijing who "committed suicide" during the Cultural Revolution, also draws crowds. Beijing residents are rediscovering their city. "You have to learn about the real old society, some people have exaggerated its dark aspects for propaganda purposes," says the director Lin Zifeng.

The genius of, ancient China was Confucius. In the beginning of 1970s, in keeping with the slogan "attack the acacia by aiming at the plum," people had to shout "down with Confucius!" to dethrone, in reality, the personal enemies of Jiang Qing, Mao's wife, the overly pragmatic prime minister Chou En-lai, and his acolyte Deng Xiaoping. Twenty years later, in the middle of its frenzy for modernization, the regime celebrates the old sage. In 1982, at Qu Fu, the village in the eastern province of Shandong where he was born 2,500 years ago, you saw neither television antennas nor the red flags found in other parts of the country. Noodles were drying right on the street, the tinsmith's hammer beat a rhythm while an ox turned around a grindstone, women bent over their labors and the men gave orders, and you could ask yourself if the Master wasn't about to appear around the street corner. So Mao or Confucius? The prudent answer of a young visitor, as if he still feared Mao's return, "Two great men, they both strove greatly for the country's progress."

If China was as the dreamer of the "clean slate" imagines it, it would be a land of forgetfulness, a country that would only survive because of its Great Wall, its Forbidden City, and a few temples, stelae, and stone animals. Ten years after I sniffed out the resurrection of Confucius in Shandong, I discovered in Fujian, another coastal province much farther south, the magical power of this earth: to be reborn from nothing. For more than thirty years, Fujian had been doing penance. The Communist Party didn't want to give the "bandits" of the Kuomintang (the Nationalist party of Chiang Kai-shek, defeated in 1949), in power on the island of Taiwan very nearby, the roads, railways, and factories, which they could have

used to reconquer the mainland. Obsessed by the threat of an "imperialist" landing, Mao had concentrated his industry in the more remote lands to the west, far from coastal China.

But now with the energy of those who are determined to make up for lost time, the Fujianese have transformed their province into a construction site, a sight that is amazing to anyone who traveled in this apparently changeless countryside a few years earlier, dozing in its rice paddies, its tea plantations, and its forests. On its bumpy roads, which had never been anything more than the place where they tramped from day to day, the barefoot peasants maintain an admirable composure in the face of the squadrons of trucks, luxury limousines, and homemade walk-behind tractors moving en masse. The cries of warning mingle with the coughing and banging of old machines bought from the scrap-metal dealers of the flea markets and returned to service in innumerable mechanical, carpentry, and pottery workshops. Whole families, including the children, work there day and night. The houses still have the look of seesaws between heaven and earth, with their concave roof tiling, curving in the middle toward the spirit of the earth and rising at the ends like darts pointed toward threats from the sky. These swallow-tailed roofs are no longer being built. "Labor has gotten too expensive," sighs a villager. Working men and women, joining together as families or even clans of several dozen people with the same name, are heading toward Fujian's new horizon, the giant cube-shape factories, and towers with blue-tinged windows that make the region look like an enormous bathroom. Everywhere bulldozers scrape the red earth, in spite of the plea from the local writer Chen Rishen, in his novel *The Blue Gulf,* "Do not disturb the sleep of the mountains." It must be said that at the other end of the country, in the heart of agricultural China, the Maoist legend made "the mountains dance." Today, they are sleeping with their peasant populations ignored by modernization.

The Blue Gulf of hills take their turn in the dance are to the south of Fujian, in the Minnan region that has an old rebel tradition. It begins before the city of Quanzhou and one thousand years ago it was one of the foremost ports in the world under the dynasties of the Sung and the Yüan (Mongols). It was "the most enormous," according to the Moroccan traveler Ibn Battūtah, and an "Alexandria of the Orient, where goods are piled up to the heavens," as Marco Polo marveled a century before him. Whether he was only dreaming or whether he really spent time in China, the Venetian remains an idol in Quanzhou, whose leaders maintain that he embarked there at the end of his Mongol-Chinese voyage. The south of China was then peopled by many Muslims and Quanzhou had an Arabic name, Zaytān. The city's museum displays the relics of its extraordinary cosmopolitan past; stelae, bas-reliefs, and statues composing a lapidary catalogue of its civilizations. Inscriptions in Arabic, Persian, Turkish, Sanskrit, Tamil, Tibetan, and even Latin sit next to Buddhist lotuses, Christian crosses, souvenirs of the passage of the Prophet Mohammed's first disciples, and the Franciscan and Jesuit missions, Khmer statues, and Hindu gods. This city of Angels and Dragons still bears a few traces of vanished religions, Nestorian ornaments, and a temple dedicated to the Persian Gnostic prophet Mani, no doubt the last in the world, with a lantern tower reddened by a flame that is still maintained.

In the ruins of a mosque, a poet wrote that "death is a cup from which all men drink." For Chu Yüan-chang, the former shepherd who became first a young monk, and then head of the revolt and founder of the Ming dynasty, everything had to be eliminated that stood in the path of his ambition to be worshiped as "a god of light," six centuries before Mao. Already, he wanted to break with the past. Quanzhou, the vibrant commercial capital favored by the two preceding dynasties, the Sung and the Yuan, ran aground for the, first time. For the new emperor the ports were nests of "pirates," as he called the merchants. The population emigrated to Taiwan and the coasts of the South China Sea (Nanyang), spreading the seeds of the Chinese diaspora.

The modern resurrection of Quanzhou begins in its cemeteries. Tons of granite bound for Taiwan, the countries of Southeast Asia, and Japan are piled on the quays, to be used for the last resting places of the "countrymen from beyond the sea" who cannot travel to die in the country of their ancestors. The "dancing hills" are incised with white wounds, from which is extracted Fujian's "gold," its granite. Along the roads, tens of thousands of women and children break and reshape it throughout the long days under the burning sun. This is a miraculous gold mine for small businesses that overshadow the state stores. They distribute motorcycles, Western perfumes, and Japanese knickknacks, as well as the religious and funereal paraphernalia such as incense, paper figures, and houses that disappeared under Mao.

Quanzhou is bringing back to life a world that seemed swallowed up forever by those who would extirpate the "old things": street singers and musicians, fortune tellers, portraitists of ancestors, and shamans—these

bearers of the "sorcery" condemned by the party. In carefully repaved lanes, the wandering souls of the unburied dead are chased back to the void with firecrackers, and each household has made offerings of rice cakes at the altar of the ancestors. At the far end of a rice paddy, a procession that is white because of the raw clothing worn by a family in mourning follows a casket, escorted by a brass band and mourners. As with all the forbidden rituals, the cult of the dead has risen again from its Chinese depths, disinterring the thread of history that the prophets of the New Man thought they had cut up and knocked out with their hammers and their sickles. "A clean break with the past? Don't even think about it!" the villagers seem to say around the sacred tree of the god of the earth, whose beribboned branches join the effigies of the ancient pantheon with a few generals, honored less for their rank in the Communist hierarchy than for their reputation as Robin Hoods, persistent righters of wrongs. "Never since the T'ang dynasty have so many monasteries been built," reports a sinologist returning from a long journey through the countryside. In many villages, the Taoist Master has become more powerful than the Party secretary. On summer evenings in Quanzhou, in a stadium built for socialist parades, thousands of spectators enjoy skits and mystery plays produced by the local theater, less rigid than the classic Beijing Opera. The municipal secretary of culture begs me not to write anything about the spectacle he presents, *Mulian*, in which there is a descent into the underworld, whose gates remain officially closed by the controllers of thought, who have been forbidden access.

The past emerges from the depths, as does modernity. The underground shelters of Xiamen, the local metropolis south of Quanzhou, have metamorphosed into endless commercial galleries. The commercial fever soon burst to the surface, where skyscrapers form the most improbable of horizons. The Chinese of the diaspora, often caricatured as poor coolies return in limousines from Taiwan, Malaysia, or Indonesia, back to their Fujian birthplace. They finance the abandoned moss-overgrown monasteries, as well as the reconversion of state factories into modern enterprises. At the museum in Quanzhou, conquering arrows mark the currents of emigration. It is time to reverse them, as the adventurers of the bygone centuries send the dividends from their exodus back to the country.

The ancestors of the millionaires of the diaspora preferred the risks of exile to the certitudes of the hopelessly immobile empire. If the overseas Chinese return to the motherland today, it is because in their eyes the country is changing. The dragon chloroformed, by the centuries now seems impatient to awaken. During the past thirty years, China has been said to be "changing" more, than any other country.

The Sleeping Beauty was Shanghai, whose rediscovered splendor was praised by a fashionable Paris magazine in 2002 that imprudently cited a supposedly "Chinese proverb," in reality entirely foreign to China, "To build the future, we must forget the past." The metropolis does not want to forget the impression it made on the journalist Albert Londres at the beginning of the 1920s, who likened it to a "goddess with twenty heads and a hundred and forty-four arms, her eyes are greedy, and her hands all finger the dollars!" It was just that feeling was forbidden, so the city cultivated its anesthesia. In 1970, it lay in a cold, greenish fog, as rusty as its streetcars, empty as its Bund—the legendary quay of the Huangpu River, where the Art Deco skyscrapers of world finance had been requisitioned and covered with garlands and red stars by its new masters. The guides droned, "The working class and the revolutionary people of the city have embarked upon socialist edification, the Great Cultural Proletarian Revolution has brought profound changes. The old ideas, with which the exploiting classes had poisoned the spirit of the people have been attacked."

Eight years later, less than eighteen months after Mao's call for a return to Marx, the little Shanghai dragon opened an eye. The young people let their mustaches grow, in the style of Lu Xun, the revolutionary but gloomy writer who died in 1936, the indestructible paragon of the independent spirit. The Elvis Presley hairstyle is quite popular. The women treat themselves to wavy hairdos, perms, their hair casually caressing their shoulders. A gust of romanticism envelops the café D'onghai, formerly Chez Sullivan, where the young patrons, forget the instructions about self-effacement toward foreigners recommended by the authorities: "We can finally have fun after work; for us, there can be no socialism without freedom." Curiosity and good taste revive with the need to speak out: "Come back tomorrow morning," a passerby advises a visitor, "when it's sunny, the corner is more beautiful, and there's an old tea merchant there who has just reopened his store."

In spite of its pretensions as sovereign of the Chinese spirit, Shanghai still lags behind in its understanding that "times are changing," as the official press claims. In 1984 on the Bund, the bell tower of the Customs Building was still ringing out the hours to the beat of "The East

Is Red." A confederate of the Gang of Four hangs on to the head of the municipality: "He doesn't understand that the time when they executed people for political reasons is past," whispers an old man walking by. The authorities set up a "Potemkin market" for the benefit of Deng Xiaoping, who was passing through the city, to prove to him that "things are changing." But the "patriarch" of the reform movement barks that "nothing has changed," and turns on his heel. In 1988, they wash the blackened walls of the city, to bring back the ocher tones of the granite, so as to present a worthy décor for the director Steven Spielberg, who is going to make a film, *Empire of the Sun,* about the 1937 attack on the city by the Japanese.

When the *People's Daily,* the most official voice of power, proclaims that the city has been "held back by the old system of planning, we have to move as quickly as possible to the market economy," Shanghai finally understood that it could shake off its torpor. A word that belongs only to this city, "*baxiang, baxiang*" (to have fun, in the local slang) came back into fashion. The municipal chapter of the Association of Chinese Women, the patronesses of the party, rented their premises to young Russian women who came to dance the French Cancan for a handful of dollars before a public with a taste for blondes. This is in 1992. The "Deng Xiaoping tornado" had just swept the south; to hell with the labels "capitalist" or "socialist," the important thing is to get rich! Before, people said, "look to the future," now they say, "look to the money"; the two expressions are homophones. The first stock exchange in the history of the People's Republic opens in the Astor Hotel, where Malraux had nursed his broken dreams in *Man's Fate.*

Formerly "the slave of the imperialists" that "harass its women," Shanghai opens its arms to foreigners. The municipality celebrates General Motors as well as Siemens and Krupp, who furnished the, city with the first magnetic levitation train in the world, a toy that even the Germans found too expensive. As local publicity indicates, the "maglev, a metaphor for Shanghai," can attain speeds of 267 mph (430 kph). The giant posters showing Mao surrounded by peasants and workers of all colors under the slogan "Workers of the world unite" inspires an American advertisement. The ad in the Anglo-Saxon financial newspaper sold in Shanghai shows the revolutionary leader decked out in a tie and suspenders, his followers bedizened with cell phones and computers, under red flags stamped with the symbols for the dollar, yen, and pound. They are assembled under a streamer: "Capitalists of the world, unite!" On posters, even in the

official terminology, the word "consumer" has replaced "comrade." Xintiandi, a formerly peaceful spot in the old French concession where Mao and a dozen accomplices founded the Chinese Communist Party in 1921, has become the most fashionable and the most expensive neighborhood in the city, with jewelers, boutiques selling the world's leading fashions, bars, Japanese or Italian restaurants, and nightclubs. The city proclaims in full-page advertisements purchased in the American press to support Shanghai's ambition to host the World's Fair in 2010 that it is the "latest fashion," "the equal of the Rive Gauche in Paris, or Soho in London," and "a superb example of the harmonious fusion of past and present." A bet won on December 3, 2002.

They predict in Shanghai that by 2010, a Chinese astronaut should be on the way to the moon. In the meantime, it is expected that in the autumn of 2003, China should be the third country in the world to send an astronaut, into orbit. Liang Qichao, one of the principal driving forces behind the reform program at the end of the empire, wanted to reach down to "the Chinese at the bottom." A good century later, China is looking "up."

—Jean Leclerc du Sablon

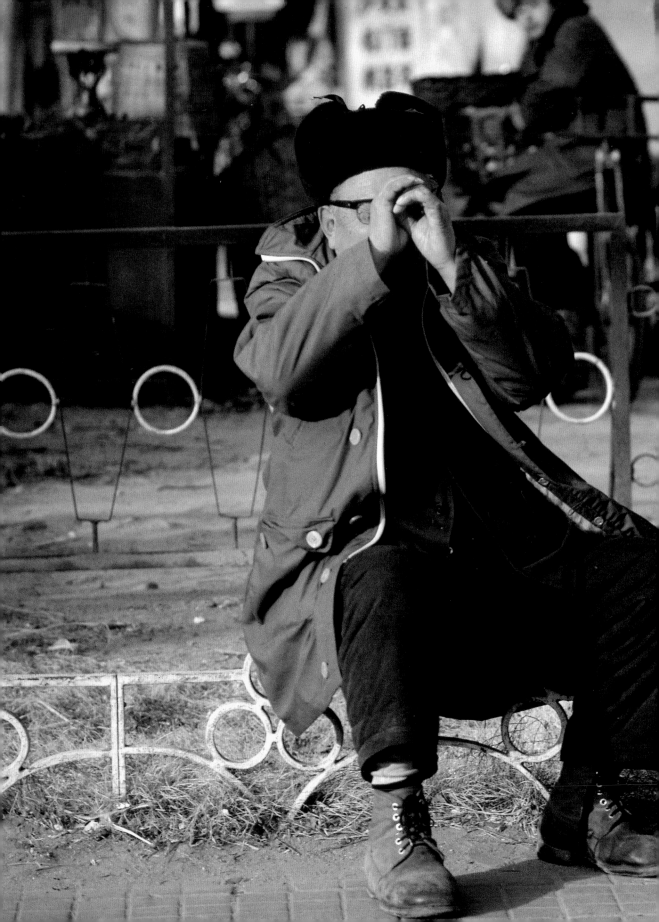

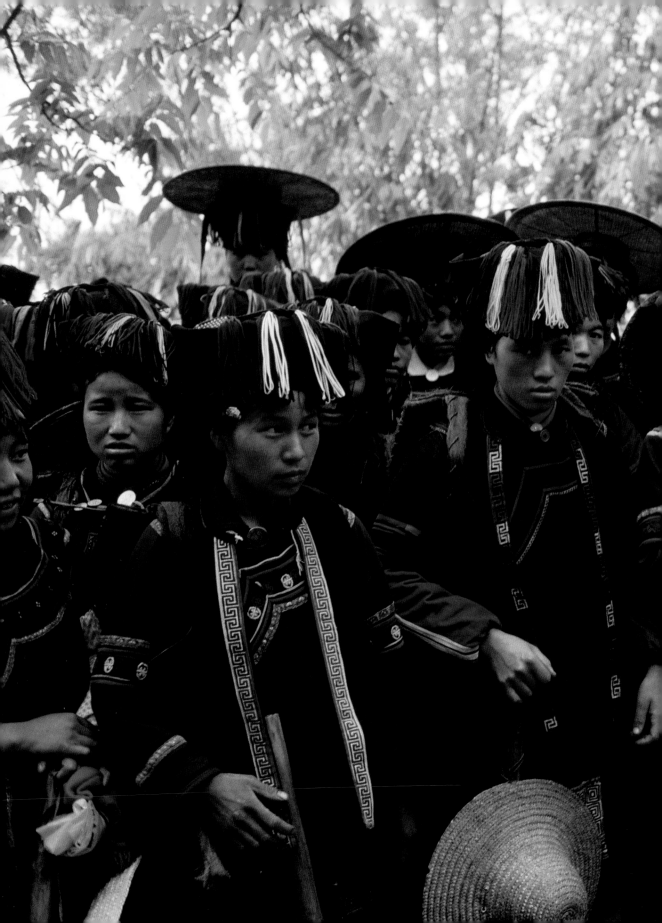

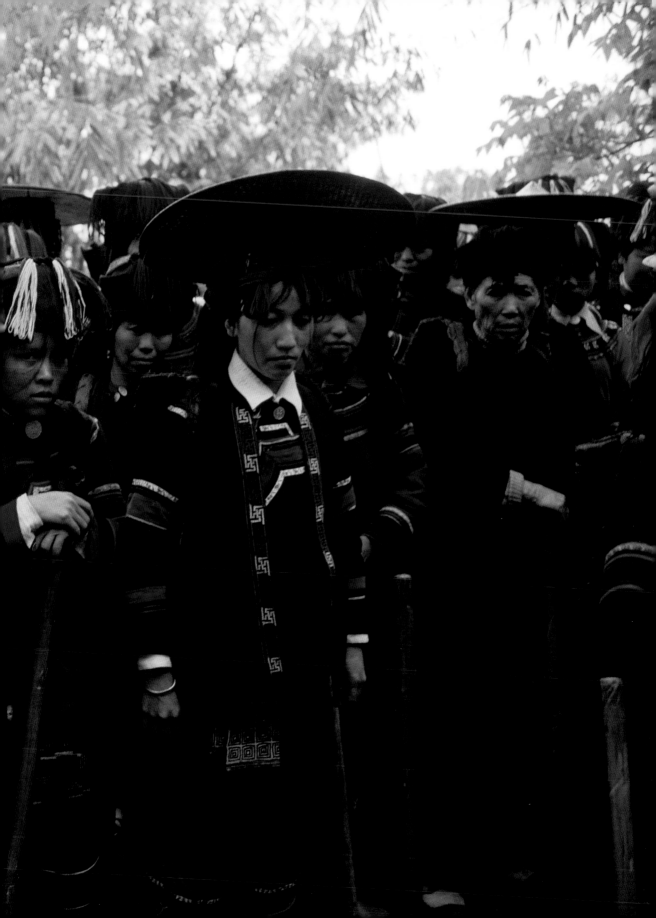

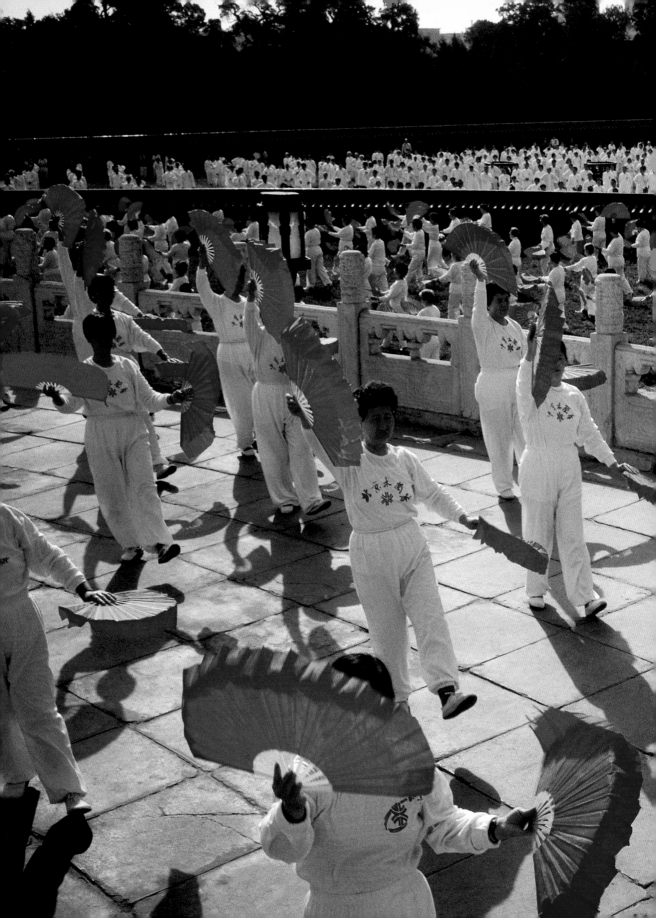

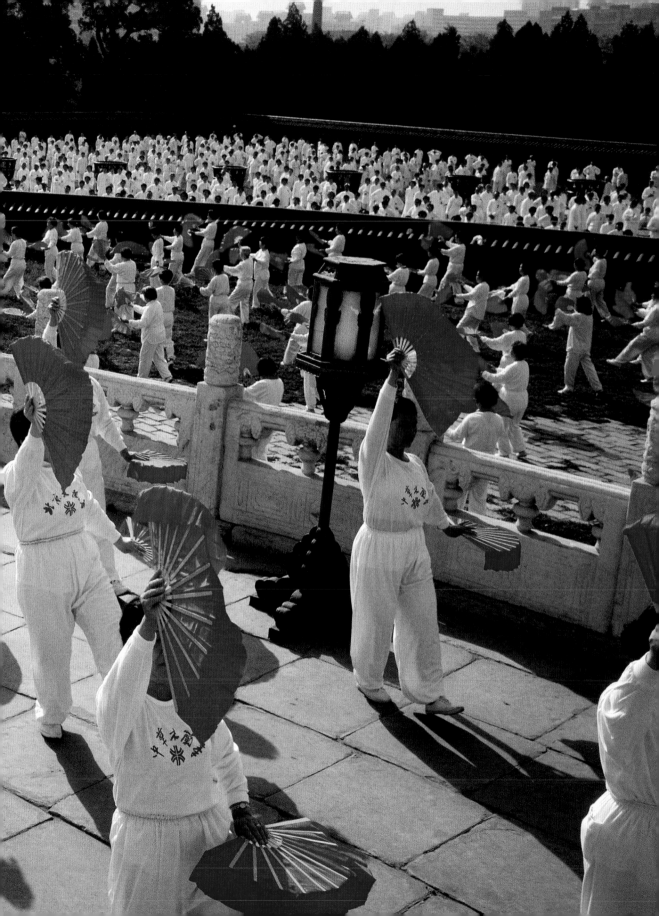

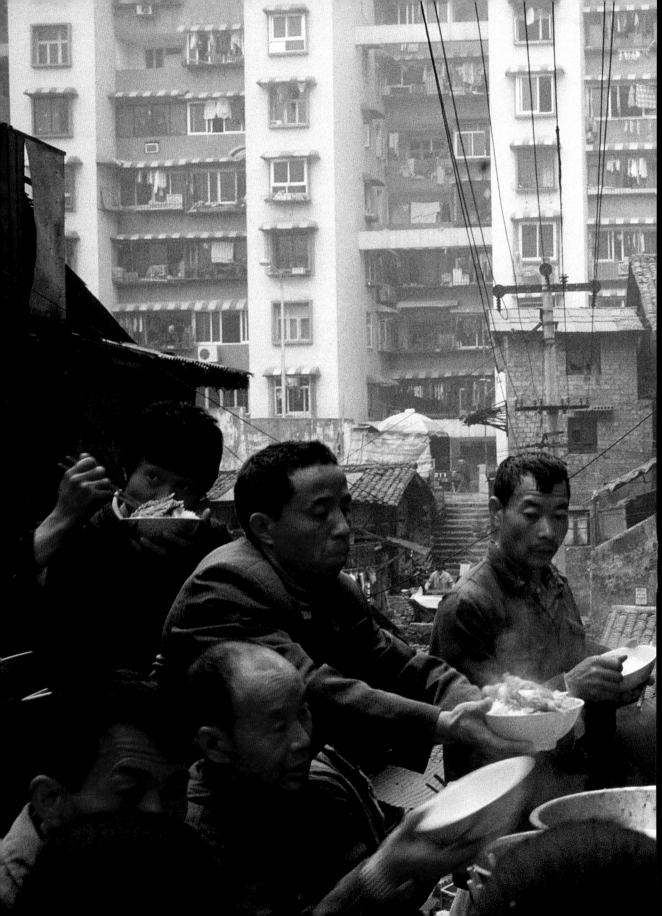

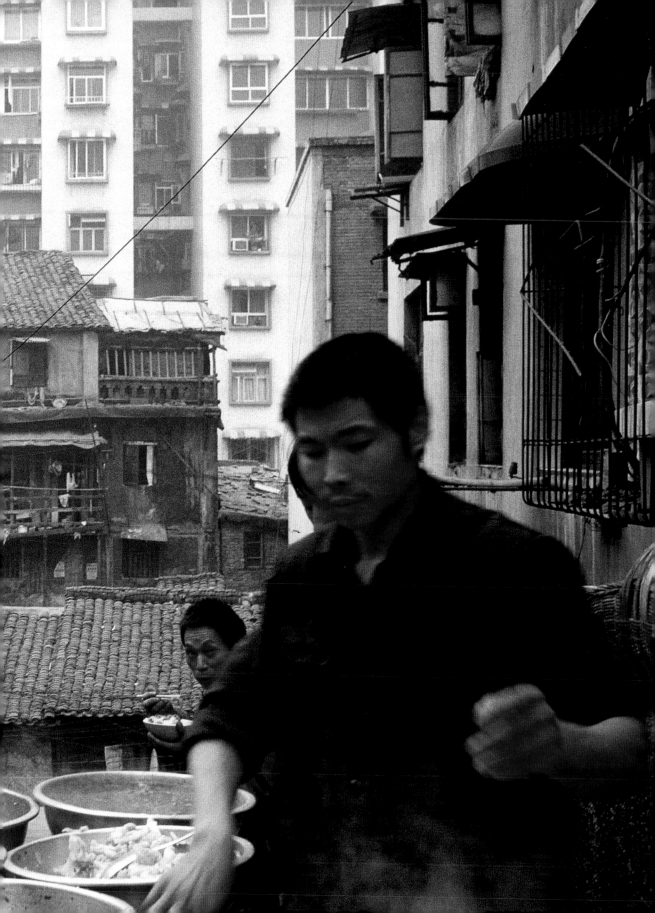

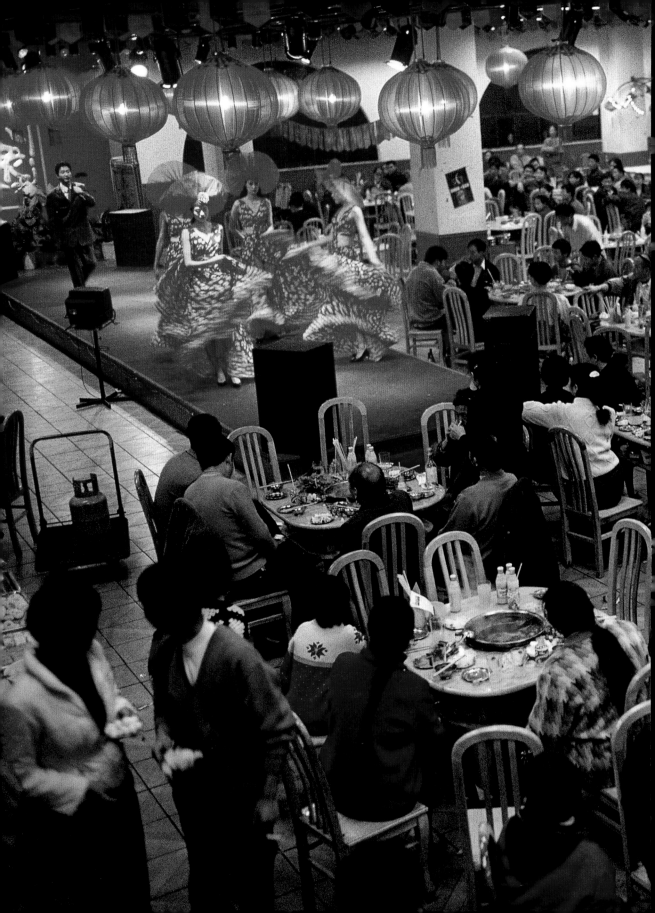

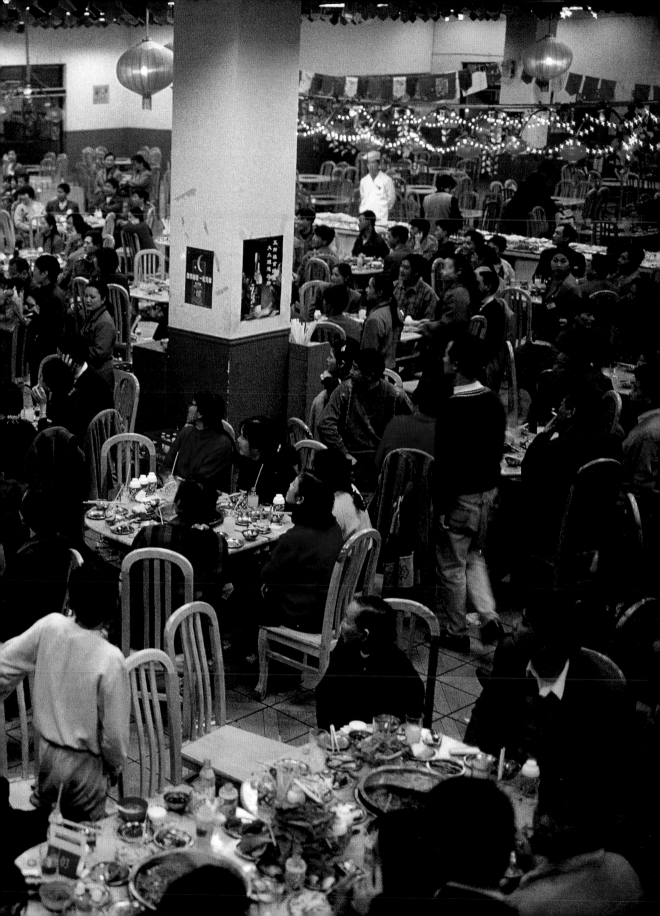

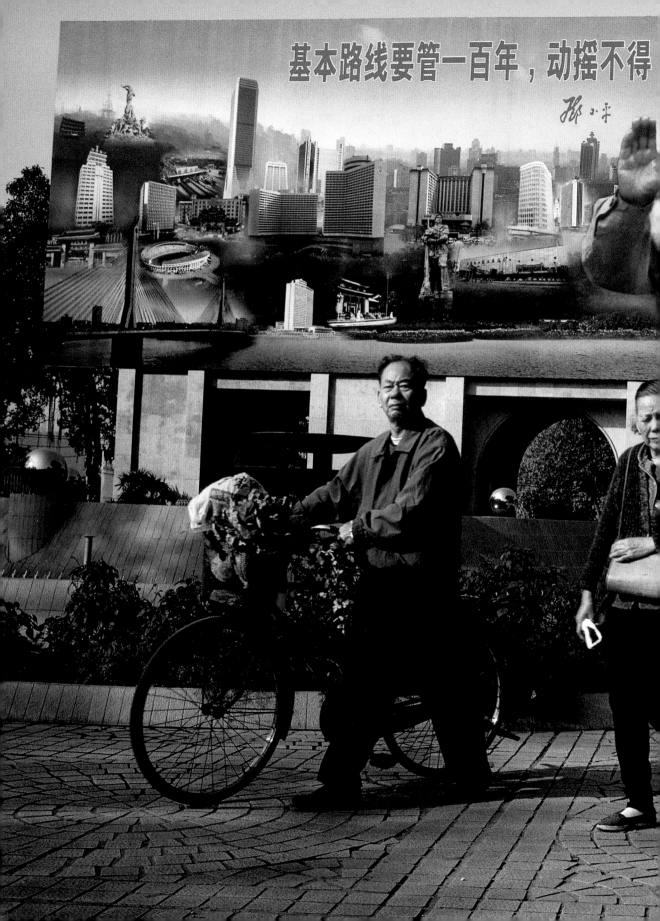

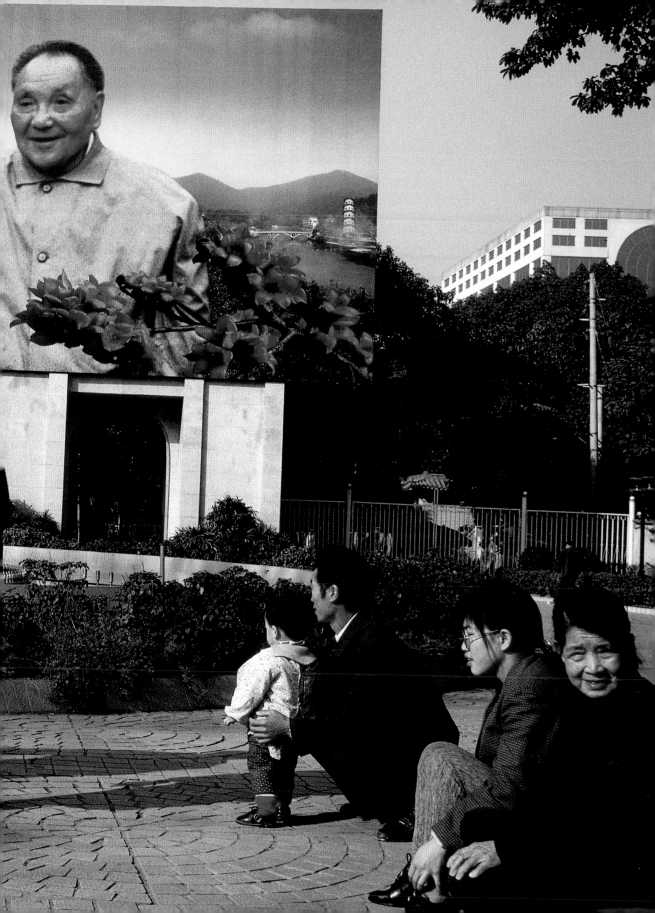

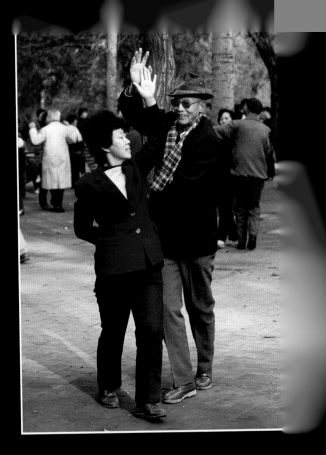
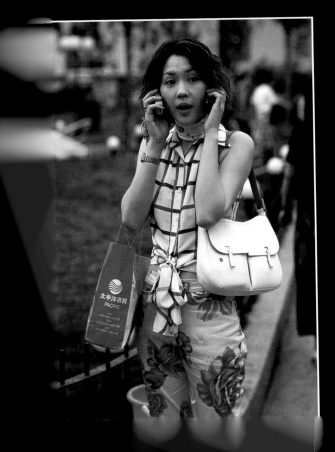
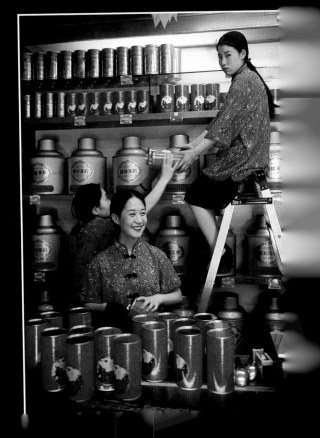

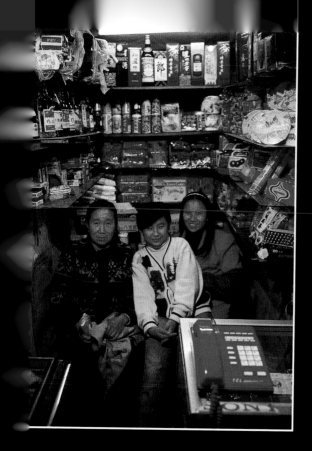
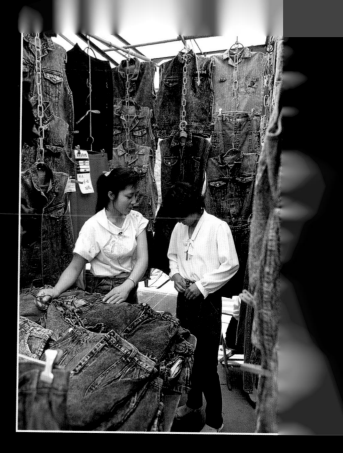
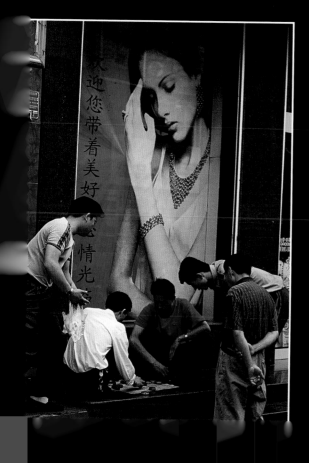
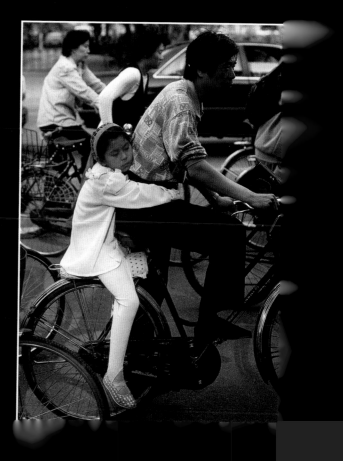

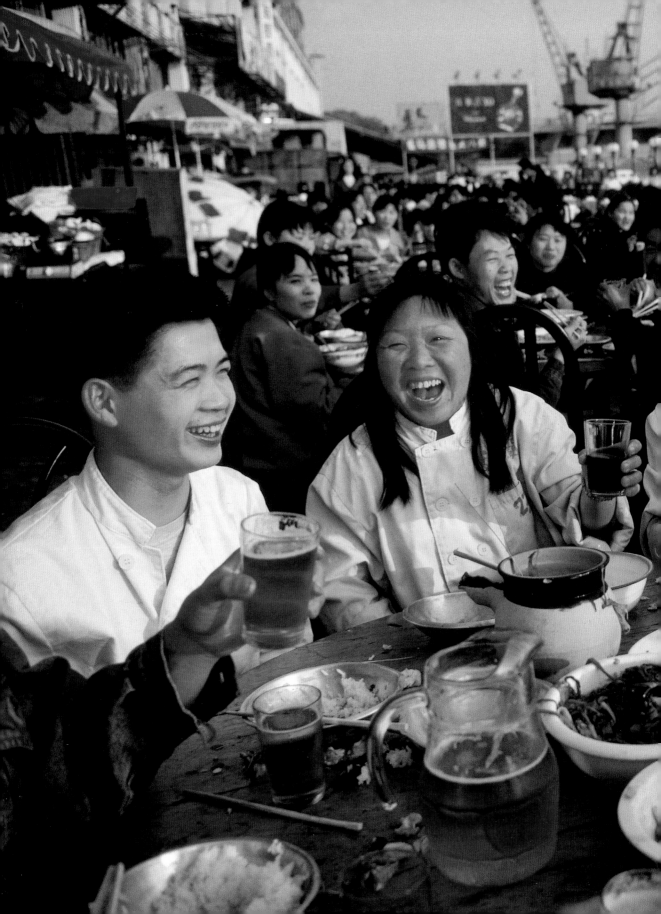

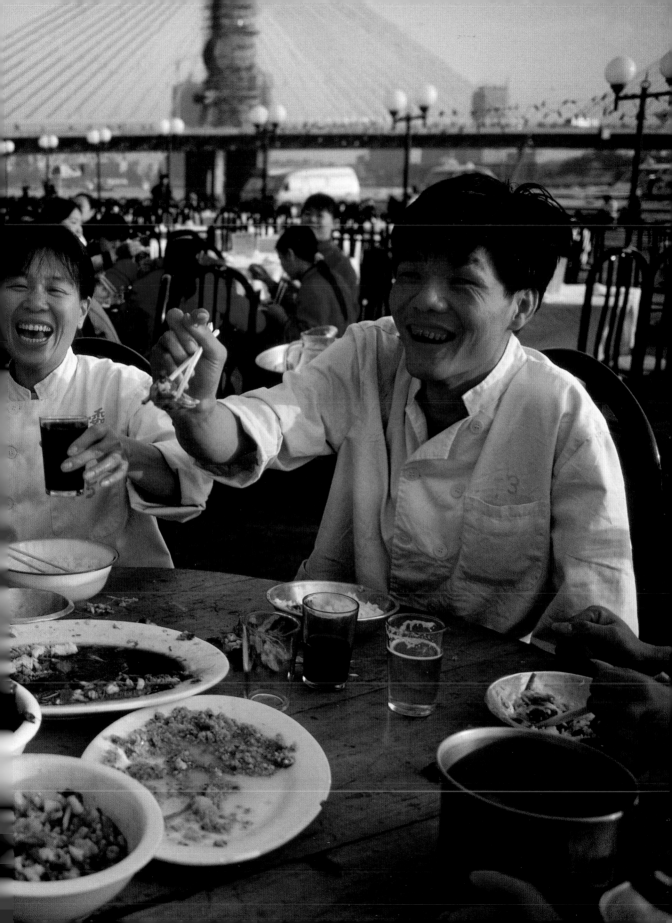

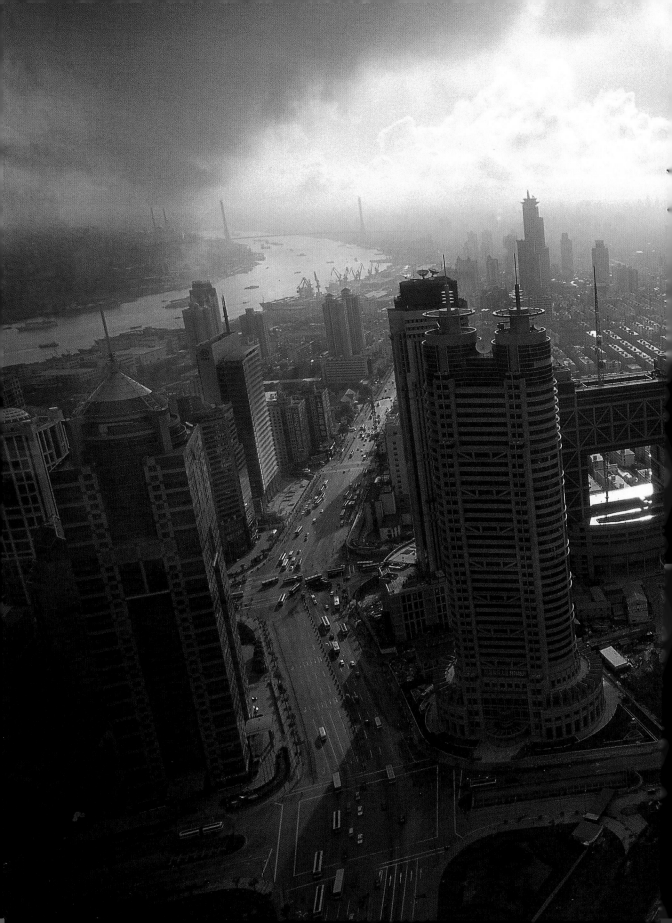

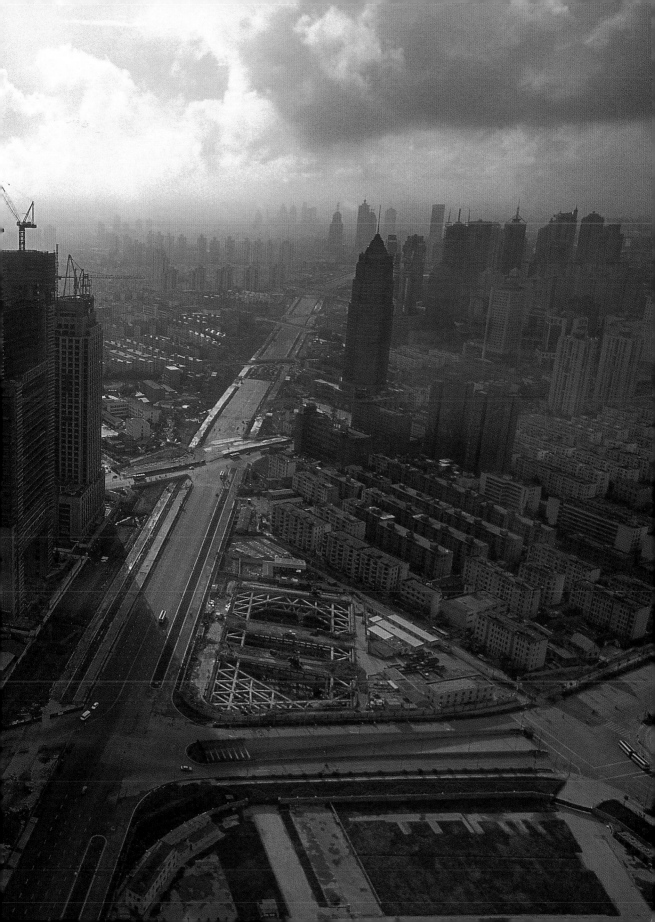

LAO-TZU, THE TAO, YIN AND YANG

Attributed by tradition to the philosopher Lao-tzu, whose life is known only through legend, the *Book of the Way and Its Power* (*Tao-te Ching*) is Taoism's most important text. The crux of the book, which is composed of aphorisms that can be taken both in the literal and the figurative sense, is the Tao (Dao), the principle of order that governs all things and beings and, by extension, the principle of total perfection and absolute harmony. It is through harmonizing oneself as much as possible with this principle of order that mankind attains its fulfillment and may aspire to immortality, especially by applying the essential principle of "non-action" (*wuwei*), as long as it submits to the regime and the appropriate discipline.

Yin and Yang (which must emphatically not be confused with Good and Evil) form the two antagonistic and complementary forces of the Tao.

In the Taoist universe, everything originates in Yin or Yang; the heavens and the sun, for example, are Yang, while, the earth and the moon are Yin. Yang is associated with everything masculine, and Yin, on the other hand, with everything feminine. Complementary, Yin and Yang are created to be associated with each other. From their union (or fusion) is born the supreme harmony that is the ultimate goal sought by every Taoist.

In spite of its sometimes somewhat esoteric character, the *Tao-te Ching* remains a unique attempt at a literary and poetic definition of the Tao, this fundamental axis of Chinese philosophy of nature whose premises go back into the nights of time.

The Tao that cannot be spoken of
Is not the enduring and unchanging Tao.
Having no name,
It is the Originator of heaven and earth;
Having a name,
It is the mother of all things.
We should rid ourselves of desires
If we want to observe its subtlety;
We should allow our desires
If we wish to see something of its manifestations.
Under the two aspects,
It is really the same, but as development takes place,
It receives the different names.
Together we call them the mystery;
Where the mystery is the deepest
Is the gate of all that is subtle and wonderful.

Not exalting the gifted prevents quarreling.
Not collecting treasures prevents stealing.
Not seeing desirable things prevents confusion of the heart.
The wise therefore rule by emptying hearts and stuffing bellies,
* by weakening ambitions and strengthening bones.*
If men lack knowledge and desire,
* then clever people will not try to interfere.*

The Tao is an empty vessel; it is used, but never filled.
Oh, unfathomable source of ten thousand things!
Blunt the sharpness,
Untangle the knot,
Soften the glare,
Merge with dust.
Oh, hidden deep but ever present!
I do not know from whence it comes.
It is the forefather of the gods.

Carrying body and soul and embracing the one,
Can you avoid separation?
In concentrating your breath can you become as supple
As a babe?
Can you polish your mysterious mirror
And leave no blemish?
Can you love the people and govern the state
Without resorting to action?
Opening and closing the gates of heaven,
Can you play the role of woman?
Understanding and being open to all things,
Are you able to do nothing?

Look, it cannot be seen—it is beyond form.
Listen, it cannot be heard—it is beyond sound.
Grasp, it cannot be held—it is intangible.
These three are indefinable;
Therefore they are joined in one.
From above it is not bright;
From below it is not dark:
An unbroken thread beyond description.
It returns to nothingness.
The form of the formless,
The image of the imageless,
It is called indefinable and beyond imagination.
Stand before it and there is no beginning.
Follow it and there is no end.
Stay with the ancient Tao,
Move with the present.
Knowing the ancient beginning is the essence of Tao.

The greatest Virtue is to follow Tao and Tao alone.
The Tao is elusive and intangible.
Oh, it is intangible and elusive, and yet within is image.
Oh, it is elusive and intangible, and yet within is form.
Oh, it is dim and dark, and yet, within is essence.
This essence is very real, and therein lies faith.
From the very beginning until now its name has never been
* forgotten.*
Thus I perceive the creation.
How do I know the ways of creation?
Because of this.

Tao abides in non-action,
Yet nothing is left undone.
If kings and lords observed this,
The ten thousand things would develop naturally.
If they still desired to act,
They would return to the simplicity of formless substance.
Without form there is no desire.
Without desire there is.
And in this way all things would be at peace.

In the pursuit of learning, every day something is acquired.
In the pursuit of Tao, every day something is dropped.
Less and less is done
Until non-action is achieved.
When nothing is done, nothing is left undone.
The world is ruled by letting things take their course.
It cannot be ruled by interfering.

THE INNUMERABLE CHINESE INVENTIONS

In his book *Science and Civilization in China,* whose first volume he began in 1948, the famous English historian and sinologist Joseph Needham was the first Westerner to systematically take stock of Chinese inventions since the beginning. They number in the hundreds, and include fields as varied as engineering, agriculture, medicine, transport, mathematics, and, of course, the art of war, with gunpowder being the most renowned of all its inventions.

In fact, when Europe was in its infancy during late antiquity and the Middle Ages, China had already invented everything—or almost everything—before anyone else. However, it did not reap all the benefits that its inventions could have provided in both the economic and military realms, as was the case in England after the seventeenth century. This characteristic way in which China would treat its innumerable inventions is a good illustration of how the Chinese think about China: land of the middle, center of the world, with no need for anyone else, safe behind the Great Wall—that great fortification, which was also supposed to curb any imperialistic impulses on its part.

Very often inventions we believe to be Western are really Chinese.

Let us begin, for example, with printing and paper. It was the Chinese, and not Gutenberg, who invented the first moveable type, which appeared in China by the seventh century AD, in the form of engraved blocks of wood used principally by Buddhist monks to ensure the distribution of their holy texts. This printing process had been preceded by the use of seals and stamps on stone. It is thought that the first book printed in China was the *Diamond Sutra,* whose colophon bears the date 868; it is reasonable to believe that several hundred copies were printed at that time.

We should also mention the stirrup, without which there would be no cavalry worthy of the name. Examples of stirrups cast in metal were found in China by the third century AD. They were later carried to Western countries by way of central Asia, through the intermediary of tribes such as the Avars.

Similarly, harnesses using collars that enable draft animals to pull heavy burdens without harm, found in depictions on bricks dating from the fourth century BC, were invented by the Chinese several thousand years before they were first used in Europe. Thus the wheelbarrow, which we know already existed in China by the first century of the present era, and that legend attributes to Guo Yu, a Taoist adept from Sichuan; while the builders of the cathedrals only developed it in Europe after the year one thousand.

In the list of materials invented by the Chinese, whose fame quickly passed beyond China's borders and became valuable commodities, we will cite first and foremost silk. Legend attributes this invention to the mythical Yellow Emperor. It was produced and woven in China by the Archaic Period, before becoming the object of intense trade with the West by way of the famous "Silk Road." Porcelain, which was invented by the third century AD under the Han dynasty, attained a considerable degree of refinement under the Sung dynasty (960–1279), before being mass-produced beginning in the Ming dynasty (1368–1644).

The decimal system, so essential to modern science, also had its origins in China before the fourteenth century BC, at a time when we already find traces, notably in the counting of the days using the calendar, and to which the system of the abacus is adapted, another Chinese invention and the ancestor of the first calculators.

In the realm of arms, China is the birthplace of the crossbow, invented about the fourth century BC. It was the essential foundation of Chinese armies for two millennia, before the invention of gunpowder by Chinese chemists about the ninth century AD. This explosive mixture of saltpeter, sulfur, and charcoal would be progressively perfected by those trained in alchemical practices such as the ones promoted by the Taoists. This invention would give rise to others, like illuminating rockets and fireworks that would rapidly reach Europe in their turn. European armies would not hesitate to use them against the Chinese during the colonial wars.

But other Chinese inventions are as fascinating as they are poetic. They include the kite, fishing reel, suspension bridge, equatorial astrolabe, mechanical clock, paddle boat, and even the canal lock, invented around AD 1000, that permitted the movement of heavily laden vessels on the network of canals dug throughout the land at the beginning of the Chinese Empire (third century AD).

IMPORTANT DATES IN CHINESE HISTORY

NEOLITHIC PERIOD (8000–2500 BC)

ARCHAIC AND PRE-IMPERIAL PERIOD

(2207–1765 BC) Xia or Hsia Dynasty

(1765–1122 BC) Shang or Yin Dynasty

(1122–770 BC) Zhou or Chou Dynasty

(722–481 BC) Spring and Autumn Period

(480–221 BC) Warring States Period

IMPERIAL ERA: ANTIQUITY

(221–207 BC) Qin or Ch'in Dynasty

(206 BC–AD 220) Han Dynasty

IMPERIAL ERA: MIDDLE AGES

(AD 220–264) Three Kingdoms Period

(AD 265–581) Six Dynasties Period

(AD 581–618) Sui Dynasty

(AD 618–907) T'ang Dynasty

(AD 907–960) Five Dynasties Period

IMPERIAL ERA: MANDARIN PERIOD

(AD 960–1279) Sung or Song Dynasty

(AD 1279–1368) Yüan Dynasty

(AD 1368–1644) Ming Dynasty

(AD 1644–1911) Qing or Ching Dynasty

REPUBLIC OF CHINA

January 1, 1912: Founding of the Republic of China.

PEOPLE'S REPUBLIC OF CHINA

October 1, 1949: Proclamation of the People's Republic of China.

1966–76: Cultural Revolution, ending with the death of Mao Tse-tung.

1979: Beginning of reforms and opening by Deng Xiaoping.

2003: Hu Jingtao becomes president of the People's Republic of China.

CONFUCIUS AND HIS ANALECTS

The Analects of Confucius are one of the
fundamental texts of Chinese thought.

Confucius was born in 551 BC in the land of Lu (present-day Shandong) and died there in 479 BC. Even if he did not attain his political ambitions, he elaborated the doctrine that carried his name to posterity.

The *Analects* laid the foundations of what would be as much a social morality as a political philosophy. Of the twenty books that compose it, the first nine are usually considered to be from the hand of Confucius himself. Confucian philosophy takes the form of instruction intended to restore an ancient, ideal order to avoid the chaos into which Chinese society was in danger of sliding in the period of the Warring States, the chaos that Confucius defined as the loss of the Way (*Tao*)—to which he gave the meaning of "celestial mandate"—which, depriving the sovereign of any legitimacy, prevented him from governing correctly. The loss of the Celestial Mandate, incidentally, became the main fear of the emperors of China. The ideal as proposed by Confucius is that of the Superior Man (*Junzi*) defined in opposition to what he called the Small Man (*Xiaoren*). The moral training of the Superior Man is essential if he wants to attain the principle of benevolence (*Ren*), that virtue of supreme humanity, which, according to the philosopher, is indispensable to society's harmony. Based on respect for ritual and ancient texts, Confucian morality also cultivates a sense of hierarchy and concern for moderation ("the golden mean") in judgment and point of view.

Confucianism was rejuvenated in China in the 1990s. From that time on, it has been the subject of international symposia, held in order to make it known and to develop it. It inspired many Asian state formations, at the top of the list being Singapore.

Playing on the sound "*zheng,*" which means both "to govern" and "to rectify," Confucius emphasized a sense of rectitude, necessary, according to him, to the "virtuous" sovereign, who alone is capable of governing correctly.

The following selections from the *Analects* will give a better understanding of Confucianism.

In learning and straightway practicing is there not pleasure also? When friends gather round from afar do we not rejoice? Whom lack of fame cannot vex is not he a gentleman?

The young should be dutiful at home, modest abroad, heedful and true, full of goodwill for the many, close friends with love; and should they have strength to spare, let them spend it upon the arts.

Not to be known should not grieve you: grieve that ye know not men.

In governing, cleave to good; as the north star holds his place, and the multitude of stars revolve upon him.

The superior man is catholic and not partisan. The mean man is partisan and not catholic.

Without truth I know not how man can live. A cart without a crosspole, a carriage without harness, how could they be moved?

The student of virtue has no contentions.

Wealth and honours are what men desire; but abide not in them by help of wrong. Lowliness and want are hated of men; but forsake them not by help of wrong. Shorn of love, is a gentleman worthy the name? Not for one moment may a gentleman sin against love; not in flurry and haste, nor yet in utter overthrow.

Those who are guided by nothing but their own egoism will attract hatred and spite.

Gentlemen cherish worth; the vulgar cherish dirt. Gentlemen trust in justice; the vulgar trust in favour.

Men of old were loathe to speak; lest a word that they could not make good should shame them.

Who contains himself goes seldom wrong.

The highest goodness is to hold fast the golden mean. Amongst the people it has long been rare.

The four things the Master taught were culture, conduct, faithfulness, and truth.

The Master was friendly, yet dignified; he inspired awe, but not fear; he was respectful, yet easy.

You have to show the people the Way to follow, without thinking yourself obligated to explain to them the reasons why.

Study as though the time were short, as one who fears to lose.

He is clairvoyant whose thought is not influenced by slanderous insinuations, nor by the cutting sword of blind accusation. Much more, clairvoyant is he who sees farther than the others.

What is kingcraft? The Master said: Food enough, troops enough, and a trusting people.

Fairness is the principal quality of the Superior Man. In basing himself upon ritual, he puts it into practice and by his discretion, he puts it forward.

What are the five graces? The Master said: A gentleman is kind, but not wasteful; he burdens, but does not embitter; he is covetous, not sordid; high-minded, not proud; he inspires awe, and not fear.

CHINESE BUDDHISM

Born in India in the sixth century AD, Buddhism, a religion of salvation with a universal mission, entered China around the beginning of the Christian Era, by the Silk Road. There it found particularly fertile ground. Its very rapid acclimation to the Chinese world would quickly make Buddhism one of the great religions of China, and would have a profound effect on the way the Chinese think. It harmonizes easily with the social morality of Confucianism and the taste for meditation and retreat extolled by Taoism, as well as with literature and the arts in general (murals, pagodas, and multistory commemorative towers derived, directly from the Indian *stupa,* sculpted and painted grottoes, statuary, works in gold, etc.). Buddhism gave the Chinese a sense of the infinity of time and space, as well as a taste for ornamentation and luxury. In contrast to its ideology, which is based upon the renunciation of wealth and material goods, Buddhist religious practice does not reject the grandiose and the theatrical.

Even the Chinese economy would be affected by this religion of salvation, in which each person is responsible for his or her actions. Nirvana is attained through ethical behavior that involved giving a part of the wealth gained by its adepts to monastic communities, which became numerous and powerful. Indian practices such as secured loans, as well as the redistribution of a portion of personal wealth to the most needy through the medium of the monasteries, was a significant contribution to the Chinese taste for commerce and the work ethic, contributing to the economic rise of China under the T'ang Dynasty (AD 618–907).

Parthian (An Shigao, active in Luoyang from AD 147 to 170), Indo-Scythian (Zhu Fahu, active in Dunhuang from AD 265 to 313), and especially Kāchan (with the famous Kumārajīva from AD 344 to 413)

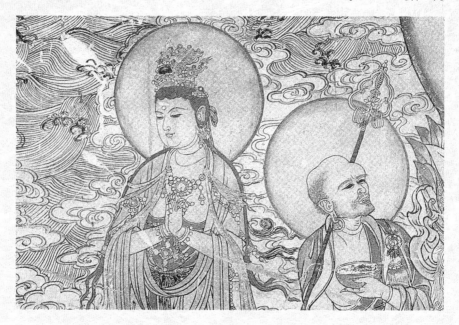

monks, working in monasteries located in the heart of the most important oases on the Silk Road, provided Chinese translations of thousands of sermons (sutras) in Sanskrit, supposed to have been spoken by the Buddha. This enabled his teaching and doctrine to be widely distributed throughout all the cities of China.

During the first four centuries of our era, the implantation of Buddhism would occur by assimilation of and adaptation to the Chinese way of thinking, with the intention of becoming not a substitute but rather a complement. During the following four centuries, Buddhism triumphed and attained the status of official religion. The emperors of China henceforth endeavored to defend it and to promote respect for it.

The Chinese way of thinking did not include the idea of retribution for past actions, belief in multiple reincarnations, in the magical effects of spoken, written, or traced symbols or texts, or in the fundamental interpretation of the world based on the notion of suffering, as was propounded by the Buddha, Siddhārtha Gautama. In this sense, the introduction of Buddhism to China may be considered a true social and religious revolution, since the characteristics of Buddhism are a priori remote from those of China's two other great religious and ethical currents, Confucianism and Taoism.

One of the symbols of the sinicization of Buddhism in China is evident in the changing of the sex from male to female of the Bodhisattva Avalokisvarha, who would become one of the most popular female Chinese divinities, under the name of Guanyin.

The Buddhism of the "Great Vehicle" (*Mahayana*), where the stress is placed on meditative reflection, was spread thanks to sutras such as the *Lotus of the Good Law,* which made it more influential than the Small Vehicle (*Hinayana*), which places greater emphasis on ritual. Under the influence of the legendary monk Bodhidharma, the most Chinese form of Buddhism, Chan (Zen in Japanese), derived from the Sanskrit term *dhyana* (equivalent to "meditation"), would become enormously popular beginning in the sixth century. Perfectly adapted to the Chinese way of thinking and to its Taoist aspect, Chan Buddhism emphasizes the intuitive character of the adept's approach, who in order to achieve illumination must, by means of appropriate meditation exercises, attain complete emptiness of mind through the total absence of thought (*wuxing*), which is nothing but the spiritual counterpart of "non-action," as extolled by Taoism.

Specific divinities would appear through Chinese Buddhism, which makes its pantheon one of the richest and most complex in existence. Among the most important are the Buddha of the Future, Maitreya (Mile in Chinese), whose coming will bring to the world the Great Peace (*Taiping*), as well as the Buddha of Infinite Age, Amitabha, who will reign over the western paradise.

In today's China, after an eclipse of several centuries, Buddhism, which began a slow decline about the first millennium, is far from absent, and the pagodas are, for the most part, open once again for religious purposes. They are always filled with the faithful, who perform their devotions in front of the religious statues.

It is probably in its moral aspect (evil actions lead to unrewarding reincarnations, which move the individual a little farther from "paradise"), as it was in the past, that Buddhism has its greatest impact on Chinese society; nevertheless, the authorities keep a very close eye on the sectarian developments to which certain millenarian practices may lead some of the faithful.

In Tibet, on the other hand, Buddhism has taken a characteristic form, Tantric Lamaism, and has never ceased to be the state religion since the seventh century. The inconclusive attempts at subjugation by the central Chinese authorities in this country (set up as an autonomous region) is explained by the historic permanence that makes Tibet, even today, one of the essential homelands of religious Buddhism.

WRITING AND CALLIGRAPHY

In China, writing and language are separate. It may be said without exaggeration that there is an oral Chinese language and a written Chinese language, each having no relationship with the other. This characteristic explains the difficulty of learning Chinese, which requires as much visual as auditory memory. This same dichotomy is the greatest obstacle to an understanding of Chinese civilization and thought.

In the beginning, in the written language of China, the sign, called an ideogram, was intended to represent directly the object it designated. This graphic language appeared in the Shang dynasty (eighteenth to twelfth centuries BC) on turtle shells or bones burned in the flames for divination. The cracks produced in this way (*jia gu wen*) were thought to be written signs from the gods, which could be deciphered to predict the future. This divinatory language, which consisted of writing suitable commentary on the divinatory instruments in relationship with the *jia gu wen*, formed the basis for the Chinese graphic language, i.e., the first written Chinese.

The ritual origins of writing explain the importance of the act of writing, and the essential place of calligraphy, a true discipline of the entire body as well as the mind, and its elevation to the rank of one of the most important arts by the Chinese.

The first characters of Chinese writing were used to decorate ritual bronzes. They might concern the donator of the piece, its date and place of manufacture, or even a legal text, which thereby—and without any play on words—became cast in bronze. Beginning in the twelfth century BC, at the start of the Zhou (or Chou) dynasty, the written language achieved its maturity with a particular style of writing (*da zhuan*). One of its characteristics is that it is perfectly legible and very easy to understand. Next, thin pieces of bamboo were used as a writing medium in China until the invention of paper.

With a gradual political centralization that led to the empire, the scribes promoted the emergence of a style of writing that is more easily executed, and especially better adapted to the use of the brush, which slowly replaced the graver. This new style of calligraphy, also called "chancellery" or "official style" (*li shu*) will mark a decisive turning point in comparison with archaic and ritual writing. It is from this style of calligraphy that the three great styles of writing, still in use today, emerged: the "regular" or "formal" (*kai shu*) style and the "semicursive" or "running" (*xing shu*) style, which already reveals a great concern for aesthetics and, finally, the "cursive" or "grass" style (*cao shu*), which is most closely related to free-hand drawing, and whose mastery requires very long practice, great self-control, and an intimate knowledge of the language.

The use of India ink and brushes of very different sizes and materials reinforces the emblematic character of calligraphy, this art of writing that in China dates back to China's origins.

The development of calligraphy went hand in hand with the emergence of the class of "scholar/civil servants," who for centuries formed the principal framework of Chinese institutions. The greatest masters of calligraphy would be those who, while respecting the conventions of writing, succeed in emancipating themselves enough to create their own style, based on elegance and balance, as well as an almost supernatural perfection. This explains why in China painting, poetry, and calligraphy are always inextricably linked. The greatest poets were always immensely talented calligraphers; the same is true of painters. Calligraphy was thought to be an art unto itself, but which handily completed a painting and often recounted a poem. The act of calligraphy, in Chan Buddhism, is itself an authentic form of meditation. Mao Tse-tung himself was always eager to give his visitors demonstrations of his talents as a calligrapher, just as the Chinese elite, since antiquity, has never ceased to practice this discipline steadfastly and relentlessly.

Writing is a poetic and artistic act, independent of the message it carries, and which it transcends.

Today, in the cities and villages of China it is not rare to see an itinerant calligrapher practicing his trade on the sidewalk, under the attentive eyes of a group of bystanders who critique, in their own way, the techniques of calligraphy by the appreciation of a particular ideogram drawn with virtuosity and elegance, or even comment on the scribe's way of holding the brush, and controlling every movement of his arm.

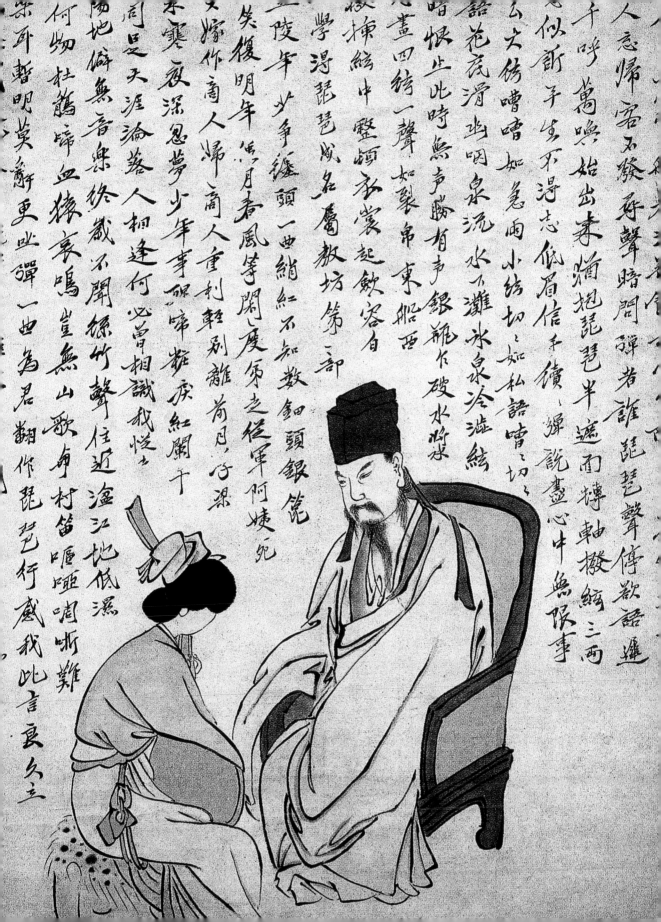

人忙歸客石發孤聲暗問彈者誰琵琶聲停欲語遲

千呼萬喚始出來猶抱琵琶半遮面轉軸撥絃三兩

似訴平生不得志低眉信手續續彈說盡心中無限事

聲花底滑幽咽泉流水下灘冰泉冷澀絃

暗恨此時無聲勝有聲銀瓶乍破水漿迸

大絃嘈嘈如急雨小絃切切如私語嘈嘈切切

棟絃中整頓衣裳起斂容自

盡四絃一聲如裂帛東船西

學得琵琶成名屬教坊第二部

陵年少爭纏頭一曲紅綃不知數鈿頭銀篦

笑復明年無月春風等閒度之徒軍阿姨死

又嫁作商人歸商人重利輕別離前月浮梁

本寒夜深忽夢少年事夢啼妝淚紅闌干

同足天涯淪落人相逢何必曾相識我悅士

陽地僻無音樂終歲不聞絲竹聲住近湓江地低濕

何物杜鵑啼血猿哀鳴豈無山歌與村笛嘔啞嘲哳難

柴耳暫明莫辭更坐彈一曲為君翻作琵琶行感我此言良久立

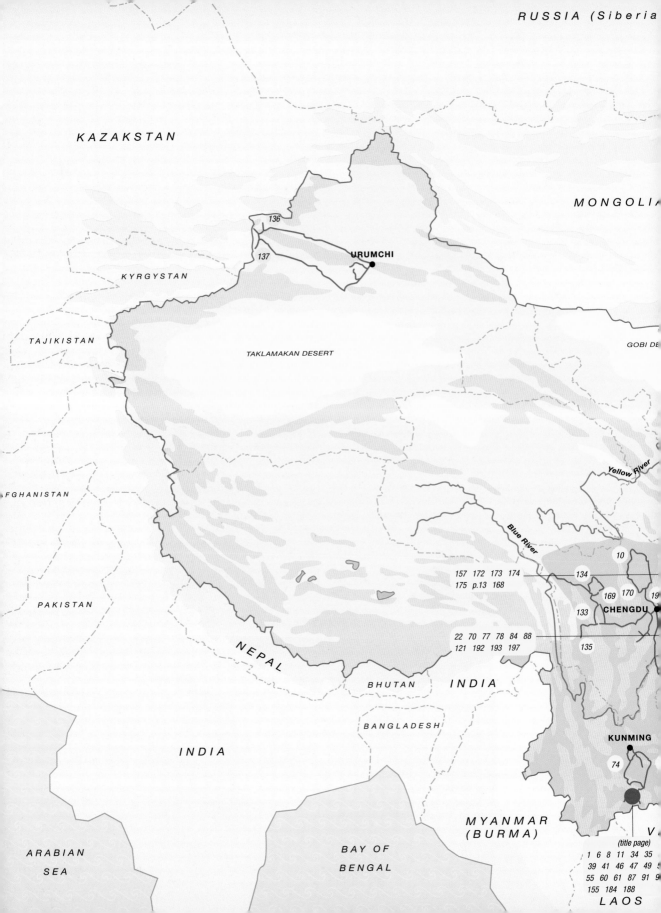

RUSSIA (Siberia

KAZAKSTAN

MONGOLIA

136

137

URUMCHI

KYRGYSTAN

TAJIKISTAN

GOBI DE

TAKLAMAKAN DESERT

FGHANISTAN

Yellow River

PAKISTAN

Blue River

10

157 172 173 174
175 p.13 168

134

169 170 19

133

CHENGDU

22 70 77 78 84 88
121 192 193 197

135

NEPAL

BHUTAN

INDIA

BANGLADESH

KUNMING

INDIA

74

MYANMAR
(BURMA)

V

ARABIAN
SEA

BAY OF
BENGAL

(title page)

1 6 8 11 34 35
39 41 46 47 49 5
55 60 61 87 91 9
155 184 188

LAOS

SHENYANG

4 26 27 56 124

SEA OF
JAPAN

*NORTH
KOREA*

JAPAN

138

32
31 2
BEIJING

24
30
28 164 109
59

9 17 20 23 63 75 83 90 92 114
117 119 122 123 132 139 152 154
160 162 176 177 179 185 187 189
191 196 200 202 204

*SOUTH
KOREA*

QINGDAO

21 110 186

168
51
190 45

99
LUOYANG
98
X'IAN
76 167

3

Yellow River

82 85 166
QU FU

104 25 161

103

97 96

SHANGHAI

19 66 67 72 79 80 106
116 118 129 130 199

Wudang Mountains

Blue River

120

WUHAN

15 111
HANGZHOU **NINGBO**
108
SUZHOU 5

69 112 126 170 153

73 107 178 180 7

WENZHOU

94

18

158

195

PACIFIC OCEAN

16 57 100

QING

115

113

105

XIAMEN
140 38 102

101

194
13 **GUANGZHOU** 64
203 **SHENZHEN**
HONG KONG

65 156
95

TAIWAN

68 71 81 127 128

147

*Ailao
Mountains*

HAINAN

12 14 29 40 42 43 44
54 58 62 141 142 143
144 145 146 148 149
151 181 183

DONG COUNTRY

CAPTIONS

1. Yuanyang District (Yunnan), 1993.
Between two small posters depicting protective warriors, this young Yi woman welcomes the visitor with a smile as she opens the door to her house. The doorjambs, as in most Chinese houses, are decorated with a poem in two stanzas. Here it reads:
The fragrances of the flowers that emanate
from here mingle and harmonize.
This year, the songs of birds
spread peace here.

2. The Great Wall near Beijing,
in Jinshanling (Hebei), 2000.
China, *Zhongguo,* means the "land of the center." The Great Wall shuts it off to the north to protect it from foreign incursions. This "Great Wall," which was unified by the First Yellow Emperor (259–210 BC) from elements built by the preceding dynasties, stretches 3,850 miles (6,200 km) from east to west. It is actually made out of a discontinuous network of more than 3,200 miles (50,000 km) of fortifications, ceaselessly improved or rebuilt by all the successive emperors.

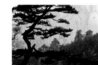

3. The sacred Taoist mountains
of Hua Shan (Shaanxi), 2000.
Located some 62 miles (100 km) from Xi'an, which was the Imperial capital for centuries, these mountains are venerated for the beauty of the mysterious alliance of peaks, trees, and clouds. Since the Tang dynasty (AD 608–907), they have been celebrated by the greatest Chinese painters, who have found them to be an inexhaustible source of inspiration. The final ascent takes place by a vertical stairway cut into the cliffs that can only be climbed by hanging on to chains.

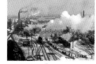

4. Railroad yard in Sujiatun (Liaoning), 1988.
In temperatures of -40° F/C, the engines of the locomotives, which transport lumber and grain throughout the country, must be kept warm at all times in Manchuria's main railroad hub. In order to take this photograph it was necessary to climb a factory chimney 131 feet (40 m) tall, using a ladder and wearing gloves of steel mesh, to the great alarm of the railway workers who shouted with fear. Because of the intense cold it was impossible to look through the viewfinder; skin would have frozen to it.

5. East Lake in Shaoxing (Zhejiang), 1996.
Located about 3½ miles (6 km) from the "Chinese Venice," whose canals extend beyond its walls, the East Lake has become a real "Silicon Valley" over the past ten years. Here it is said that the First Emperor liked to come to meditate before its beauty and harmony. East Lake represents the quintessence of the Chinese aesthetic of gardens. It very rarely snows here.

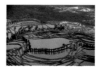

6. The rice paddies of Yuanyang (Yunnan), 1993.
No Westerner had ever gone into the Ailao Mountains to see the greatest rice-paddy landscapes in the world. Each spring, the villages of the Hani and Yi tribes join forces to sculpt new rice paddies from the mountain slopes, in order to give them to young married couples. A council of wise men linking all the villages is in charge of distributing water among the terraces.

7. Master Yu's traditional garden, Shanghai, 2000.
Standing next to one of the walls of this famous walled garden, the two "dream stones," one shaped like a mountain peak, and the other sculpted by wind and water, symbolize chaos and harmony. The aesthetic of gardens in China always makes reference to the Four Elements: water, stone, plants, and architecture. A subtle spatial organization, when the garden is observed from different angles, turns it into a true landscape, which shifts with the point of view.

8. Young boy near Yuanyang (Yunnan), 1993.
This young boy, inspecting the novelties of the weekly market in his village, no longer wears the traditional costume of the Yi minority. Like all the young people his age, he wears Western clothing.

9. Government slogan, Avenue of Celestial Peace
in Beijing, 1985.
The character *Jian,* which this man has just painted, means "to enlighten" and "to build." Drawn from a Maoist slogan, it was one of the catchwords of the political reform led by Deng Xiaoping at a time when struggle raged between conservatives and reformists.

10. Multicolor Lake in Jiuzhaigou Park
(Sichuan), 1992.
In the park of the "Valley of Nine Villages," declared part of the heritage of humanity by UNESCO, the water from the seventy-two lakes arranged at different heights, which overflow in wide falls or in slow torrents, is among the purest in the world. Filtered by the miles of moss and underbrush they cross, you can see the bottom of the lakes 98 feet (30 m) below. Today, the park is the biggest giant panda preserve in China.

11. Mourner at a Yi burial in the
Ailao Mountains (Yunnan), 1993.
The use of professional mourners in China goes back to the most ancient antiquity. Here, the women, who must come from a neighboring village, have put on their ceremonial costume of embroidered silk. They hide under an umbrella in order to feign weeping better while keeping a vigilant eye on the funeral ceremony.

12. Dong farmers in front of a "Bridge of Rain and
Wind" in Baxie (Guangxi Zhuangzu), 1990.
Among the Dong, a people who express themselves in songs, the "Bridges of Rain and Wind," like all the rest of their architecture, are thought to be divine. These works of art, always covered with wooden pagodas built without pegs, rest upon pillars whose stones are stacked without mortar. They cross the river outside of the village, where the spirit of the bridge "feels best." In the foreground, locals take advantage of the first rays of the spring sun to dry their rice.

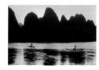

13. The Li River in Guilin (Guangxi), 1995.
On bamboo rafts, cormorant-fishermen perform the same unchanging gestures that have fed their families for centuries. This natural setting has been the source of inspiration for countless great Chinese painters and poets.

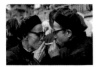

14. Shaoxin Village (Guizhou), 1990.
Two members of the council of elders of this Dong village, dressed up in round fake glasses chosen for their comical look, celebrate the "Festival of Laughter," which takes place in the beginning of spring a few weeks after the New Year. On this occasion, everyone dresses up in disguise before parading from village to village singing. The "laughter songs" are one of the forty-four types of songs used by the Dong to communicate among themselves.

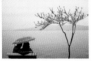

15. Young couple gazing at the East Lake in Hangzhou (Zhejiang), 1986.
Two gaze at the evanescent spaces of this famous lake, the symbol of Hangzhou. It was dug from a lagoon in the eighth century by the governor, and enabled the Imperial Canal to connect Hangzhou to Beijing. Here, it took a certain degree of audacity on the part of these lovers to dare display their affection in this way in the 1980s.

16. Market at Chongwu (Fujian), 1996.
It is not easy to take up mercantile activity once again after years marked by the complete prohibition of private commerce. This meat-seller counts her ten-yuan (one-dollar) bills in a makeshift cashbox.

17. Portrait of the "Great Helmsman," Mao Tse-tung, facing Tiananmen Square, Beijing, 2001.
This painted icon, under which thousands of visitors to the Forbidden City pass every day, and before which parade the Army and the Chinese Communist Party, is maintained in perpetuity.

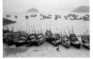

18. Fishing village in Zhejiang Province, 1996.
Trawling is the only resource of this little village on the poor coast. Ports here were once prosperous in the seventh and eighth centuries, at a time when maritime commerce began between China and India. Today, its wooden trawlers carry on a clandestine commerce with the island of Taiwan.

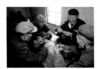

19. Fisherman's teahouse, Port of Shanghai, 1985.
These elderly fishermen in Shanghai, who warm their hands by holding them near the boiling-hot teapots, wear Mao jackets like all Chinese at the time. The Chinese love to gamble, anywhere, anytime. The traditional Chinese pantheon includes divinities who help gamblers to win. Foremost is Caishen, the God of Wealth, who is welcomed every year on New Year's Eve. As part of the celebration, people refrain from sweeping their homes for two days so as not to chase away his good influence.

20. Avenue of Celestial Peace, along the wall of the Forbidden City, Beijing, 1986.
In the early morning, an elderly man devotes himself to the most popular of Chinese martial arts, Tai Chi Chuan, which means "supreme ultimate point" and improves flexibility, circulation of the blood, strength, and balance. It is by developing the internal spirit *Qi*, which is used both in struggle and healing, that people increase their longevity.

21. Bicycle parking lot in Qingdao (Shandong), 1987.
In China, the bicycle remains the principal means of transportation despite the appearance of luxury cars reserved for the wealthy. In the 1980s, bicycles were all manufactured in the same model, which made identification difficult when they were left in the immense parking lots created for them. This poor man, searching through the inextricable jumble of bicycles, will probably spend more than an hour to find his own.

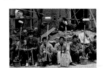

22. Men looking for work on a street corner, Chongqing (Sichuan), 1998.
The population of the town of Chongqing, which extends over an area comparable to that of Austria, has grown to more than thirty-two million inhabitants since it was separated from Sichuan Province. Workers coming from the countryside offer their services to individuals and companies. Black-market work is often the only way for the poor to improve their living conditions, and the only way for the numerous building sites throughout China to keep working day and night.

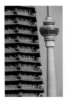

23. Pagoda and television tower in Beijing, 2000.
The "Pagoda of the Birds," which stands in front of Beijing's 1,500-foot (450-m) television tower, is one of many buildings of its kind in the capital. To obtain the effect of this contrast between the two buildings, more than five centuries apart, five years of stubborn research were necessary, finally culminating with the use of a telephoto lens set on the roof of a school.

24. Steam locomotive factory in Datong (Shanxi), 1988.
Under the omnipresent "Safety First!" poster plastered all over China, some of the 20,000 workers in this immense State factory that produced one "Liberation" locomotive a day, busy themselves with soldering the belly of the monster. The factory closed its doors in 1992. The Chinese railroad system has been partially electrified in recent years. On the rest of the railroad, diesel locomotives have slowly replaced the glorious "Liberations."

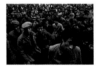

25. Waiting area in the Xuzhou train station (Jiangsu), 1985.
An anonymous crowd, amazed by the presence of the foreign photographer who has come to witness the opening of a tomb containing earthenware soldiers of the Han period, discover a new kind of face while waiting for their train. Since the 1990s the Chinese now willingly approach foreigners with a big smile and a "Hey! *Laowai*!" or "Hey! Foreign friend!"

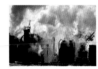

26. Railroad yard in Sujiantun (Liaoning), 1988.
From steam escaping from steel monsters into the icy atmosphere of Manchuria to Chan paintings of shadows and clouds in monochrome ink, there is only a single step in spite of the total lack of connection between the two worlds.

27. Same location.
This elegantly made-up young girl removes
the ice from a trench that mechanics use to
go under the trains to deice the axles.

**28. Steam locomotive engineer
in Datong (Shanxi), 1988.**
This engineer, a very cordial man and father of
two children, was happy to earn less than 100
yuans ($12) a month for this difficult work.

32. A sleeper car on the same train.
The reverie of an elegant young woman in the Spartan
atmosphere of the "hard sleeper" cars available to
the common people. The "soft sleepers" are reserved
for the well-to-do and for Party executives.

33. An only child on the same train.
A Shanxi farmer holds his only child in his arms. He has
a hard time hiding his unease as he travels to Beijing,
since this is the first time he has ridden a train.

38. Elderly Hakka man in Fujian, 1996.
The Hakka people, whose activity is essentially restricted
to agriculture, live in Fujian as well as Guangdong. This
elderly man wears the traditional hat of woven bamboo
and proudly displays a mustache and a beard carefully
trimmed to a point, which give him the look of an aged
scholar. It took no less than four hours of fierce negotiation,
with the active participation of the whole village, to obtain
written authorization from him to use his photograph.

39. Terraced rice paddies in Yuanyang (Yunnan), 1993.
For thousands of years the Ailao Mountains, which
peer out of the clouds, have been sculpted by the Hani
and Yi ethnic minorities to plant rice. The mountains
and the water, wisely harmonized by the hand of man,
represent the ineffable quintessence of nature.

**29. Bus station in Dong country (border of Guangxi
Zhuangzu and Guizhou), 1990.**
In 1990, a single bus made only three trips a week
between the Dong country and China. The bus
stations represented a door opening up another
world for the inhabitants. The travelers, seated in
a makeshift restaurant, smoke as they wait for the
bus, which will arrive either that day or the next.

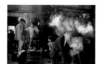

**30. Engineer and locomotive mechanic
in Datong (Shanxi), 1988.**
The engineer has just climbed into the locomo-
tive and casts a last look outside in the direction
of his house before unleashing the thousands
of horsepower from his machine of steel.

31. Second-class car on the Datong-Beijing train, 1988.
Around the New Year, trains in China are even more
crowded than usual. The travelers who chat, play cards,
drink beer, and eat sunflower seeds have all been searched
before boarding the train to be sure that they aren't
carrying any fireworks or firecrackers. The Chinese
railways carry more than a billion passengers every year.

**34. Farmers of the Yi ethnic minority
in Yuanyang (Yunnan), 1993.**
Dressed in their hand-embroidered traditional costumes,
these Yi women actively participate in the large annual
gathering of the villages, during which they sculpt the
mountains in order to transform them into terraced
rice paddies. In China, since the most remote antiquity,
women have always worked on construction projects.

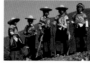

35. Same location.
The ritualization of this work, which consists of sculpting
the rice paddies to give them to young married couples,
appears both in the strict organization of the villagers,
who hoe the earth in battlefield formation, and in the
difference between the blue Hani clothing and the
multicolored Yi dress. These two ethnic groups, which
coexist in this region, join together for this event.

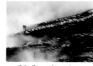

36. Same location.
The work of the sculptors of the mountains is laid out in ter-
races at an elevation of 6,500 feet (2,000 m) above the clouds.

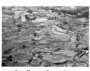

37. Same location.
The little green spots reveal parcels of land where the Hani
and the Yi sprout the rice grains before transplanting them.

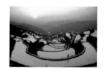

**40. Terraced rice paddies in
Dong country (Guizhou), 1990.**

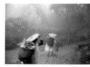

41. Hani village of Luopu (Yunnan), 1993.
These two Hani women, wearing the characteristic
hat of southern China, carry their vegetables to the
spring above the village to wash them. This heavy
load is carried twice a day, in both directions.

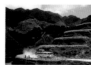

42. A bus in Dong country (Guizhou), 1989.
On one of the rare roads that crosses the Dong country,
we see villages of wooden houses perched on the
hilltops. The farmers wave to the passing bus as they
harvest their rice. This road is still the only way to go to
Guilin, the main city, located a day's travel from here.

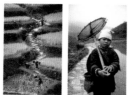

43. Rice harvest in Dong country (Guizhou), 1989.
The steep slope of their plantations requires the Dong to carry out all the work of the rice harvest without any mechanized equipment, from threshing to baling straw and transporting it using shoulder poles. At the time, these farmers were unfamiliar with the concept of money and used their silver necklaces for barter.

44. Young Dong girl (Guizhou), 1989.
This young Dong girl wears a white hat, used in winter by the women of this ethnic group, and carries on her shoulders a net to fish for the crabs, shrimp, and fish raised in the rice paddies. Her traditional vest made of twisted cotton has been lacquered and beaten with bamboo.

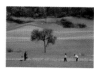

45. Work in the fields near Yan'an (Shaanxi), 1999.
Without irrigation the loess, with its characteristic yellow color, is a very dry, sandy soil, periodically swept by the winds that blow from the Gobi Desert. Plants will only grow here if they are immediately irrigated and the surrounding earth is protected with strips of plastic to retain moisture. These climatic conditions are responsible for the region's very low standard of living.

46. Rice mill in Yuanyang (Yunnan), 1993.
These two Hani women pour the rice into a circular depression through which the millstone travels. It is powered through wooden axles by a waterwheel located outside the mill. After several turns of the millstone, the rice is reduced to flour. The Hani are also called "the rice people." Rice is stored in the attic, while its flour is carefully kept in a jar that will be stored in the main room of the mill throughout the year.

47. Hani farmer near Yuanyang (Yunnan), 1993.
This farmer, like all the members of his ethnic group, is paired with his buffalo for life. The plow he carries is used five times a year to turn the soil of the few hundred rice paddies belonging to his family. The man, who is returning to his village, shows surprise at meeting what is called in China a "long-nose," or foreigner, no doubt for the first time.

48. Farmers beating rice straw near Kaiyuan (Yunnan), 1993.
The Chinese countryside still has a look of peace and serenity, which has been the distinctive feature of agrarian civilizations for thousands of years.

49. The Hani "Great Dragon" wizard near Yuanyang (Yunnan), 1993.
"In spite of the fact that we were born on opposite sides of the world, I discover that in the end we are alike, and that we have everything to learn from each other," said the Great Dragon, who serves in his village as an intermediary between man and the gods, after having sought to determine if there was a "good heart" in the face of his interlocutor, and that this was the case. The Great Dragon, seated on his buffalo named Immense Knowledge, contemplates the work of his ancestors, the sculpting of the mountain. Every Hani man can cite the names of his ancestors going back fifty-six generations.

50. Near Yuanyang (Yunnan), 1993.
Bundling the sprouted rice plants before planting takes up most of the spring days for these Yi farmers, which doesn't prevent an elderly man from smoking his bowl of tobacco in a traditional bamboo water pipe. This work, which extends over a variation in height of 8,200 feet (2,500 m), is divided between the men, who plow the fields, and the women, who do the planting.

51. Courtyard of a farm near Yan'an (Shaanxi), 1998. This family of truck farmers has a welcoming smile for the foreigner, before offering him red tea and burning-hot dumplings in the cave house dug into the loess where they live. The mother declared that the family only earned 500 yuan ($60) a year, the cost of an ordinary bicycle in Beijing at the time.

52. Stabilization of sand dunes in the Gobi Desert near Yinchuan (Ningxia Huizu), 2002.
In an attempt to slow the advancing of the sand in the Gobi Desert, the women bury straw. It looks like a gigantic checkerboard and will retain enough moisture to help a few thorny plants grow. By constructing this new "green barrier," which extends over more than 1,250 miles (2,000 km) and is situated a few steps from the Great Wall, the Chinese make a desperate attempt to halt the spread of desertification.

53. Dong man smoking his pipe in Baxie (Guangxi Zhuangzu), 1989.
This man is a member of the village council of elders that meets every day in the Tower of the Drum, a pagoda shaped like his clan's totem.

54. Schoolchildren in Dong country in Shaolidong (Guizhou), 1989.
Elementary schools were still very rare in Dong country at this time. Some of these children traveled more than 12 1/2 miles (20 km) on foot to get to school. Boys and girls, wearing the traditional costume of lacquered cotton, learn Han Chinese. Education has been a means of introducing this ethnic group to the world outside of which it has lived for centuries.

55. Elementary school in the Yuanyang district (Yunnan), 1993.
These young girls of the Yi minority from the village of Luopu, wearing the usual turban, learn to write in Chinese characters. Just like all the little schoolchildren in the world, they exchange secrets and smiles surreptitiously, for fear of being caught by the teacher.

56. Recess at an elementary school in Shenyang (Liaoning), 1986.
A game of Ping-Pong, the true national sport, on a concrete table whose net is often made from a row of bricks, is the favorite activity of these schoolchildren. They wear the red neck scarves of the Young Pioneers, the Communist youth group.

57. Schoolchildren at the beach in Chongwu (Fujian), 1996.
A weekly walk, which brings together all the schools of the region at the edge of the China Sea, is compulsory. This physical activity is interspersed with lectures on civic duties. Since it takes all day, the children bring a picnic. Each class is led by a student carrying a red flag decorated with a yellow star in the center.

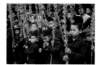

58. Ceremonies following the New Year near Baxie (Guangxi Zhuangzu), 1989.
Among the Dong, some children begin to smoke at the age of two. These children are holding strings of firecrackers—that can be as long as 6 1/2 feet, or 2 meters—which they are preparing to set off. Every major Dong ritual celebration includes huge fireworks. The New Year's celebrations take place over almost two weeks. During this time, contests in singing and playing the bamboo mouth organ alternate with ritual Dragon dances and the ceremony of the "flowery cannon." This enormous firecracker, which weighs almost 22 pounds (10 kg), shoots an iron ring into the sky that they try to catch before it falls to the ground. The winner is crowned the "king of the Dong" for a year.

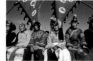

59. On the outskirts of Beijing, 1986.
At this time, it was still officially prohibited to celebrate the ancient traditions of the Chinese New Year. Defying the authorities, the inhabitants of this village on the outskirts of the capital dress as actors of the Chinese opera and climb upon enormous stilts, preparing to accompany the palanquin of the Moon Goddess. After disappearing with the foundation of the People's Republic of China in 1949, it was not until the middle of the 1980s that traditional culture and beliefs began to reappear.

60. Hani ritual for the Spring Festival near Yuanyang (Guangxi Zhuangzu), 1993.
The participants dance with fans around a makeshift altar topped with pigs' heads and rice wine. These offerings to the spirits of the mountains represent the abundance sought from them before planting the rice crop.

61. Hani woman nursing her baby, Yuanyang (Yunnan), 1992.
This woman nursing her baby wears the traditional Hani costume and headdress. As this photograph was taken, the husband of this young woman appeared, displaying a rage bordering on madness. He then locked his wife in the house. This attitude is very rare in China.

62. Dong baby in a Yellow Mountain village (Guizhou), 1990.
The row of miniature protective deities, which border the silk bonnet of this little Dong boy, is supposed to ward off illness. From their earliest days, Dong babies are taught their singing culture through the rhymes of their parents.

63. Park of the North Lake in Beijing, 1994.
The political policy of having only one child, in place since the end of the 1970s, has profoundly transformed Chinese society. China has become the land of the child-king and, sometimes, nothing is spared to satisfy his smallest whim. It is not rare to witness the disparity in the elaborate infrastructure intended for children and the small numbers who use them.

64. Palace of a "concrete king" between Shenzhen and Guangzhou, 1995.
This man, who made his fortune in five years in public works, had a gigantic living and leisure complex built for his own personal use. Three 115-foot (35-m) statues representing the Gods of Luck stand in the middle of the complex. These monumental statues are tiled and decorated with the character *Fu* (Good Luck). He leaves through the back of this monument, from whose summit he loves to contemplate his life's work every day through the open mouth of the God Lu.

65. Road construction site in Shantou (Guangdong), 1996.
Public building sites in China are perpetually decorated with flags as if they were the indisputable sign of the radiant future that economic development will bring to the people. The economic boom of the southeast coast of China has attracted nearly one hundred and fifty million workers in the last ten years.

66. Elevated highway under construction in Shanghai, 1995.
Behind the steel rods of reinforced concrete, the ultramodern office building of the public television of Shanghai is visible. Today, the network of elevated highways in Shanghai exceeds a couple of hundred miles in length. Shanghai's population is around eighteen million, and some twenty-three thousand buildings have been built.

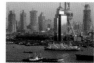

67. View of Pudong, the port of Shanghai, 1995.
Built on the marshy land on the other side of the Huangpu River, which boats cruising the Yangtze River use to sail upstream, the new financial district of Pudong is beginning to look like Manhattan, Tokyo, or Singapore. The telecommunication tower, one of whose three balled tops here, is called "the Pearl of the Orient." Like the Jingmao office building on the right, it is more than 1,300 feet (400 m) high.

68. Skyscraper window-washers in Shenzhen, 1995.
Twenty years ago the little fishing village of Shenzhen, located across from Hong Kong, had a population of no more than twenty thousand inhabitants. Today, because it was the first "special economic zone" decreed by Deng Xiaoping in 1981, it has more than five million inhabitants. This megalopolis has profited from the extraordinary changes its new status made possible.

From left to right and top to bottom:

69. Receptionist in Ningbou (Zhejiang), 1996.
This young woman, wearing a receptionist's uniform crossed with a red sash, has left the countryside for the city, where she works in a luxury department store. She seems frozen in a reverent pose, which bears witness to the respect in which she holds the clients. She seems somewhat intimidated by this new environment, which will be hers from now on. Chinese consumers, who only had State stores to shop in until this time, had just discovered international brands and the joys of shopping.

70. Poster-seller in the streets of Chongqing, 1998.
Marilyn Monroe, Rita Hayworth, and other Hollywood stars coexist with official calendars and the portrait of Deng Xiaoping.

71. Models in the streets of Shenzhen, 1995.
A fashion show is organized for the opening of a department store. Presentations of fashion shows and beauty pageants have become a real cultural phenomenon all over, in large restaurants, theaters, and stores.

72. Optical shop in Nankin Street, Shanghai, 2000. Luxury, fashion, and Parisian style attracted the Chinese so completely that Shanghai has long been called the Paris of the Orient. Today, this kind of store is very common in China.

73. Three generations of women in the streets of Sunzhou (Jiangsu), 1991.
These three women from the same family create the intimate atmosphere of a living room in the street. Their bearing reveals the manners of a nobility whose day ended with the foundation of the People's Republic of China. In summer—the season when this photograph was taken—it is customary for the Chinese to move into and live in the streets, where they play, drink tea, eat, and sleep.

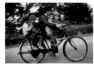

74. On a bicycle on the way to kindergarten near Kunming (Yunnan), 1992.
This man is taking four children to kindergarten at seven o'clock in the morning. Three of them are wearing military uniforms, a familiar sight in China. Chinese children love to dress up like little soldiers.

75. Bird walkers on Avenue of Celestial Peace in Beijing, 1986.
The habit of taking birds to sing in the parks, prohibited during the Cultural Revolution, gives passionate bird-lovers the opportunity to meet at sunrise in all the parks in China. They are often the elderly, who get a taste of nature in this way. Here, a child with a sparrow learns the age-old gestures of this cultural practice from the older man, who has a mynah bird.

76. Food cart in Luoyang (Henan), 1998.
This little mutton market is run by merchants from the Hui Muslim minority, recognizable by the Arabic inscription and the distinctive shape of the teapot. Until 1983, it was forbidden to run a business in China. Today the whole country is covered with these little markets.

From left to right and top to bottom:

77. Photographer's promotion in Chongqing, 1998.
In the center of town near the department stores, a model dressed and hatted in red, displays to the stunned onlookers a photograph demonstrating the quality of the work of the studio she is promoting through the distribution of business cards.

78. Departure of cruise ships in Chongqing, 1998.
An eighteen-year-old girl, who is getting ready to leave Sichuan to go to Shanghai by boat on the Chang River, makes herself beautiful before going on board. When she arrives 1,200 miles (2,000 km) downstream, she will work as a hairdresser in her cousin's beauty salon.

79. Street scene in Shanghai, 1995.
In a lane in old Shanghai, in front of a wall of posters of Chinese stars for sale, the look of this passerby reveals the astonishment experienced at seeing a Westerner.

80. Lovers in Shanghai, 2001.
In the major commercial street of Nankin, young people in China today are like their peers throughout the world. Like them, they also wonder about the ultra-rapid changes taking place in society.

81. Department store installation in Shenzhen, 1995.
On bamboo scaffolding the owner of a new store, who comes from Anhui Province, finishes installing the neon tubes that will form the ideogram *Zhong* on the typical façade of his store. *Zhong* means the center, the middle, the basis, the reference, i.e., China. Everything happens very quickly in the evolution of society, even in the construction of a small store, a symbol of the buzz of excitement in China today.

82. Raising the flag during the Confucius rehabilitation ceremony in Qu Fu (Shandong), 1994.
This military procession, witnessed by sixty thousand people gathered in a stadium, hides a ceremony in honor of the anniversary of the birth of Confucius, whose rehabilitation took place after a prohibition of eighty years. For centuries, September 28, the birth date of Confucius, was considered a national holiday.

83. Military parade in Tiananmen Square, Beijing, October 1, 1999.
On the fiftieth anniversary of the People's Republic of China, the Chinese army marched in front of the Politburo of the Communist Party, located above the door of Celestial Peace in front of the Forbidden City, for the first time in fifteen years.

84. Fashion design contest in Chongqing, 1998.
These young women introduce avant-garde models before the committee of the town's Office of Culture. This is one of many contests of this type, whose finalists will participate at the grand finale in Shanghai.

85. Confucian scholars participating in the Confucius rehabilitation ceremony in Qu Fu (Shandong), 1994.
Assembled from all over China and throughout the whole world, these Confucian specialists prepare to participate for three days, under a burning sun, in commemorative demonstrations celebrating the anniversary of the birth of the great Chinese sage in the village where he was born.

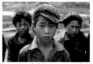

86. Three country children west of Guizhou, 1986.
When this picture was taken, these children, whose faces reveal a certain seriousness, didn't go to school, but already worked in the fields all day long under harsh conditions.

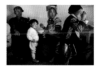

87. In a cheap roadside restaurant in Yi country, Yunyang (Yunnan), 1993.
Surprised by the passing of a vehicle, this Yi family eats lunch in a cheap restaurant at the weekly market. Attached to her belt and falling over her bottom, every Yi woman wears two squares of cotton embroidered with designs, one of which symbolizes the sun, the other, the moon.

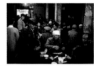

88. Gambling house in Dazu (Chongqing), 1998.
Card players in a teahouse in Dazu, including one who is wearing the white headdress of mourning, get together no matter what the time. Chinese society has always been animated by a passion for games of luck and betting. Since the 1980s, when it was not well looked upon to play for money, places like this have continuously proliferated.

89. Two elderly women near Chengdu (Sichuan), 1987.
The custom of binding the feet of upper-class women, who were supposed to represent the height of refinement, was abolished toward the beginning of the 1930s. To reach the desired stage of deformation, it was necessary to rebind the feet every day with strips of red or white cloth, which were continuously tightened until marriage and worn for life. Today this practice has entirely disappeared, and only a few women over ninety years old, who have very rarely been photographed, still wear the bindings.

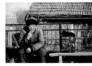

90. An elderly man and his bird in Beijing, 1985.
The elderly man chose to sit on the narrow iron guardrail, leaving the stone bench provided for strolling walkers for his bird.

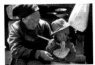

91. In a market near Yuanyang (Yunnan), 1993.
A Yi grandmother feeds a bowl of noodles to her grand-daughter, who no longer wears the traditional costume.

92. Elderly Beijing resident, 1985.
This man with the warm and welcoming look has agreed, with some amusement, to allow himself to be approached by the Western photographer. In the 1980s, it was forbidden for the Chinese to have a conversation in the street with a foreigner without having express permission.

93. Three Hani wizards smoking, Yuanyang (Yunnan), 1993.
Hani wizards meet to reapportion the water resources fairly between the various rice paddies, and prepare ceremonies between villages. During these meetings, they always smoke their *Bangs* and it is also their custom to exchange live piglets.

94. Fisherman's house near Pingyang (Zhejinag), 1996.
A grandmother and her daughter make nets for trawling. This dying trade is slowly being supplanted by industrial fishing and fish farms located further south, along the coast.

95. Trawlers on Dongshan Island (Fujian), 1996.
The trawlers of this rich island, near the coast of Guangdong, go on two-week fishing trips beyond Taiwan. Every ship is equipped with the most modern technology, but also has a little shrine covered with red cloth and dedicated to the God of Fishermen, Guanglong.

96. The Great Imperial Canal in Yangzhou (Jiangsu), 1992.
The Great Imperial Canal serves to transport merchandise from southern Shandong to Zhejiang. In the distance, the Buddhist pagoda called the Semaphore of Writing can be seen.

97. Mah-jongg game on a Yangzhou barge (Jiangsu), 1992.
Mah-jongg, which is played for money even within the family, is a game like poker that involves finding the most powerful possible winning combinations before your opponents do. This game is popular throughout the entire Chinese world.

98. Fisher-folk on the Yellow River near Sanmenxia (Henan), 1998.
The closer the Yellow River gets to the sea, the greater its flow. The water, however, has been diverted so much to irrigate the arid soil that the river is slowing. These fisher-folk, who live in deplorable conditions on their fishing boat, are the last holdovers of a bygone activity, in the very place where the earliest Chinese civilization developed.

99. Fisherman on the Yellow River near Sanmenxia (Henan), 1998.
What is there to fish in 12 inches (30 cm) of muddy water loaded with loess on this minuscule boat whose two floats are joined by a simple plank?

100. Boatyard near Chongwu (Fujian), 1996.
A "butterfly woman" (*Hui'An Nu* in Chinese) wears a transparent piece of gauze covering her whole face, under a yellow-painted conical hat of woven bamboo. The Christian "butterfly women" are skilled in stonecutting and building wooden boats.

101. Pingtan Island (Fujian), 1996.
These islands in the Taiwan Strait, long closed to foreigners because of their military bases, are swept by winds and typhoons, creating a desolate landscape. The granite coasts seen in the photograph shelter several fishing villages, whose houses are oddly reminiscent of Celtic architecture. By tradition, the fishermen who live here have been Catholic by faith since the seventeenth century.

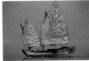

102. Junk near Pingtan Island (Fujian), 1996.
It has become extremely rare to see the distinctive shape of a Chinese seafaring junk. This traditional boat has been abandoned for more modern vessels. This one, the holes in its sails giving it the look of a ghost ship, sails near the boatyard of a new deep-water port.

103. Unloading barges in Baoying (Jiangsu), 1992.
Men with shoulder poles unload sand transported by barge along the Great Imperial Canal. Balancing on the narrow planks under the burning sun requires great skill, especially when moving such heavy material.

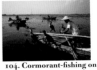

104. Cormorant-fishing on Lake Weishan (Shandong), 1992.
The cormorant, which some fishermen begin to train while the bird is still an unhatched embryo, is capable of responding to its master's commands and capturing its prey under the water. It is unable to swallow its catch because of a ring that grips the base of its neck. As he passes, the fisherman collects the most beautiful lotus flowers, which may be seen growing on this lake in the distance. Lake Weishan is crossed by the Great Imperial Canal.

105. Crab farm near Xiamen (Fujian), 1996.
Crabmeat is highly revered by the Chinese, and is exported as far as Japan. The crabs are raised in crab pots hung from blocks of polystyrene. The floating house is inhabited by the guardians of this farm, which covers a few thousand acres.

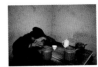

106. Sleeping fisherman in a teahouse near Shanghai, 1985.
It is so cold that the elderly sailor has fallen asleep holding his boiling teapot.

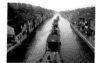

107. String of barges on the Great Imperial Canal in Suzhou (Jiangsu), 1992.
This photograph was taken from one of the traditional bridges shaped like a half-circle (this explains its height) that cross the canals of this city, nicknamed the "Chinese Venice." The old houses seen in this photograph, whose bricks are painted white while the roof-tiles are painted black, have practically all but disappeared today. There is a saying: "In Heaven there is Paradise, on Earth there is Hangzhou and Suzhou."

108. Lake Tai near Wuxi (Jiangsu), 1996.
The fishermen live on flat-bottomed junks, characteristic of this part of China, and they sail the lake at the whim of the winds. Pollution here is so bad that the water has been recently declared unfit for "industrial consumption."

109. Chinese tourists at the seaside resort of Beidaihe (Hebei), 1987.
Located 186 miles (300 km) from Beijing, Beidaihe, whose name is cut into the granite behind this group of "new tourists," was a seaside resort reserved for the upper echelons of the government and the Communist Party for forty years.

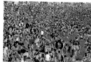

110. First paid vacations at the beach of Qingdao (Shandong), 1987.
As they discovered the joys of vacations, Chinese from the north flooded the beaches of Qingdao, a former German trading post until World War II known for its beer. Loud-speakers ordered the return of rented bathing suits at 6 PM, halting the waves of heads created by the overcrowding.

111. School of Fine Arts of Hangzhou (Zhejiang), 1986.
The School of Fine Arts of Hangzhou is one of the most famous in all China. Notably, it trained the great Franco-Chinese painter Zao Wou-Ki. When this photograph was taken, it was particularly daring to pose nude for the classes in figure drawing. In the nineteenth century, Chinese artists began to adopt the canons and models of Western painting, very different from those of traditional Chinese painting. Hangzhou has been one of the most outstanding centers of Chinese painting since the Sung dynasty.

112. Yue Opera in the working-class neighborhood of Ningbao (Zhejiang), 1996.
There are more than three hundred styles of opera in China. Before the 1949 revolution and the creation of the People's Republic of China by Mao, the Yue operas of Zhejiang were traditionally played only by men. After forty years of prohibition, it is exclusively women who have taken up this tradition once again. The elderly musicians play string instruments, the *Pipa* (Chinese guitar) and the *Erhu* (two-stringed Chinese violin). In the hall, the spectators drink tea and chew on sunflower seeds.

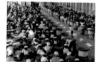

113. Oolong tea factory in Anxi (Fujian), 1996.
While exchanging gossip in the hubbub, eight hundred workers in this hall sort by hand the best tea leaves grown on the neighboring mountains. Green Oolong tea, among the most refined in China, is exported throughout the world. Tea-sorting is passed down from mother to daughter, and a daughter will fill in when her mother is sick.

114. Traditional house in Sanlitun, the embassy district in Beijing, 1985.
This house, originally gray, was painted pink by the town to try something new and to "spruce up" the neighborhood. The Shanghai parked outside was the only car made in China at the time. It was almost exclusively reserved for Communist Party members. In Beijing, the light is particularly soft in spring, when the sun pierces through the mist. Today, one of the biggest techno clubs stands in its place.

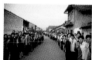

115. Farmers in Henan watching the first car rally from Hong Kong to Beijing, 1985.
This was the first time that foreigners were allowed to cross China by car. For the event, nearly ten million spectators, supervised by 50,000 policemen, assembled along the route. In this village, as everywhere, the astonished and respectful crowd formed what looks like an honor guard.

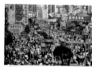

116. View of Nankin Street in Shanghai, 2000.
This image has become typical of the major commercial thoroughfares of today's China. The curious are jam-packed in little trains decorated with billboards promoting the surrounding stores. The shops are marked by enormous signs.

117. Lane in an old neighborhood in Beijing, 1985.
In front of a sign advertising the presence of one of the first "free stores," two elderly Beijing residents catch up on the latest news. What can they buy? Produce from the fields, which the peasants are allowed to bring to town to sell. This photograph has become historic, since ultramodern skyscrapers are inexorably replacing the traditional neighborhoods of *hutongs,* lanes that gave Beijing its charm.

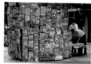

118. Magazine kiosk in Shanghai, 2001.
Today it is possible to start a newspaper or magazine in China as long as it refrains from criticizing the government. Economic, computer, and women's magazines are becoming more fashionable. Those that focus on celebrations are all the rage, revealing the lives of the Chinese stars of Hong Kong and Hollywood. Home-decorating magazines that follow Western models have completely transformed interior design for the wealthy classes.

119. Painting Maoist slogans on the Avenue of Celestial Peace in Beijing, 1985.
These men are painting the last Maoist slogans, once visible at the main intersections of thoroughfares in the big cities. Today, they have been replaced by advertisements for the world's top brands.

From left to right and top to bottom:

120. Construction site of the "Three Gorges" Dam on the Chang River (Hubei), 2000.
The construction of this dam, in front of which two women knit, is the largest site in the world. Its completion is scheduled for 2009. Hotly debated, this dam is designed to tame the flooding of the Blue River. The lake it creates will spread for 560 miles (900 km) and furnish water for several surrounding regions.

121. Chongqing train station, 1998.
People waiting for a train try to strike up a conversation, as in every station around the world.

122. Forbidden City, Beijing, 1985.
At this time, Communist prohibitions still affected relationships. It was not unusual for couples to be sentenced to prison for inappropriate behavior.

123. Beijing train station, 1985.
Almost 1 billion travelers a year pass through the old Beijing train station that looks like a Stalinist ocean liner crowned with pagodas. Sprawled out on a bench, two exhausted travelers are sleeping. In China, it is common practice to take a nap in the most surprising and incongruous places, and no one takes offense if a neighbor falls asleep on his or her shoulder.

124. Shenyang (Liaoning), 1986.
This propaganda poster located at the entry to a factory touts the advantages of the single-child policy. It isn't easy to play jump rope with a piece of elastic when there are only two of you.

125. Huangguoshu (Guizhou), 1986.
This weeping woman has just discovered that her child, whom she had been holding in her arms, has died of starvation. Passersby lecture her, telling her that they would have given the child a few grains of rice to eat if she had asked them. There is no longer hunger in China today. In 1986, the last famine took place in this province.

126. Beauty salon in Ningbo (Zhejiang), 1996.
This beauty salon is located on the sixth floor of a department store. The clients are having their eyes bathed and their eyebrows plucked. It is also possible to get beauty masks, facials, and manicures. Chinese women are more and more mindful of their looks. Beauty salons like this one—where women don't hesitate to bring their babies—are cropping up.

127. Shenzhen (Guangdong), 1995.
The view of this modern megalopolis—whose buildings are sprouting like mushrooms—is unobstructed from this panoramic revolving restaurant. All the cities of China now have restaurants on the top floor of a skyscraper. Wealthy Chinese families come here to dine in a fashionable setting, while they look at the fascinating spectacle of the extraordinary growth of Chinese cities.

128. Shenzhen (Guangdong), 1995.
This photograph was taken from a height of 1,400 feet (430 m) from the top of what was at the time the highest tower in Shenzhen, which was then being completed.

129. People's Square, Shanghai, 2001.
In a Japanese restaurant, customers eat sushi. It is now possible to find all sorts of restaurants in Chinese cities that offer cuisine from around the world. In the background, as in most large urban squares, the giant screen gives the public access to stock market quotes, as seen here, but also to news bulletins on the state television, images of fashion shows, and, of course, advertising.

130. Pudong district, Shanghai, 2000.
Thought of as a new Manhattan, the Pudong district wants to become the largest financial center in the world by 2020. This photograph was taken from the former Bund, the promenade that was the city's glory during the foreign concessions. This new international center, whose construction began at the end of the 1980s, boasts some of the world's tallest skyscrapers, reaching close to 1,600 feet (500 m) in height. In the center, an immense globe houses the international commercial center.

131. The Franco-Chinese painter Zao Wou-Ki in his studio in Paris, 2003.
Considered in China and the world as one of the greatest living artists, Zao Wou-Ki has integrated traditional Chinese painting with more abstract Western painting. He is also one of the most famous representatives of this style.

132. Old neighborhood in Beijing, 1985.
Persimmons ripen on a windowsill in autumn. Hidden behind her miniature trees, a woman spies on what is happening in the street. Making miniature gardens, originally a Chinese practice, is a legacy of Taoism, for which there is always a relationship between large and small.

133. Young Khampa women during the summer festival at Tagong (Sichuan), 2000.
This ethnic group of Tibetan origin meets during one of the important one-week celebrations that punctuate the summer. In contrast to Chinese discretion, sexual customs are much freer here. These big Buddhist festivals are occasions for boys and girls to meet. The latter customarily click their teeth together to signify to the chosen of their heart that he is invited to approach them.

134. High plains near Maniganggo (Sichuan), 2000.
At an elevation of over 13,000 feet (4,000 m), the tents of Khampa nomads are planted in the middle of the grasslands where their immense herds of horses and yaks graze. These encampments are guarded by their ferocious mastiff dogs with brown coats tinged with red. These rich Khampa nomads are herdsmen and usually remain on the high plains for six months during the summer season, after which they return to the lower valleys.

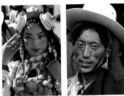

135. Khampa woman and man in Litang, 2000.
In July, the great Buddhist gathering of Litang offers attractions such as acrobats on horse for the thousands of spectators. This woman wears a traditional costume while this man, with a red scarf under a felt hat, is in everyday wear. The Khampa invest all their money in clothes and participate in costume contests that allow them to compare their hair styles, loaded with amber, turquoise, coral, gold, and silver, bearing witness to the strength of their traditions. Some of these costumes, made from the skins of tigers and snow leopards, studded with jewels, gold, and silver, can weigh several pounds, and have been sold abroad for more than $3 million.

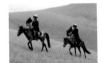

136. Khazakh eagle hunters near Yining (Xinjiang Uygur), 1988.
Hunting with eagles is done on horseback. A wooded triangle is installed so that the arm of the hunter can carry without fatigue the weight of the hooded bird of prey, which is around 28 pounds (13 kg). The eagles are trained to hunt wolves, foxes, rabbits, and wild goats. Eaglets are each raised on a swing to which they are attached with their eyes covered for a month, day and night, to break their instinct and cause them to submit entirely to the whistles and gestures of the man who feeds them. The nomadic hunters, who live in yurts, wear their traditional white hats.

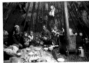

137. Interior of a yurt near Lake Sailimu (Xinjiang Uygur), 1988.
On the border of Kazakhstan, the women and children of a family of nomads warm themselves around a Russian-made stove. They are getting ready to eat wheat cakes and cheese made from horse and sheep milk. The red reflections in the photograph are due to a sheet of pink plastic that covers the central opening of the roof of this ample yurt at this time of the day.

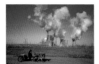

**138. Thermal power station near
Baotou (Inner Mongolia), 1985.**
This thermal power station was built in the begin-
ning of the 1980s by the French and furnishes
electrical power to the area northwest of Beijing.
In the foreground a Mongol farmer, for whom this
production of electricity has no use whatsoever,
transports cabbages in temperatures of -22°F (-30°C).

139. A street in Beijing, 1985.
Concerned about protecting their skin from the sandy
wind from the Gobi Desert, it is not unusual to see Chinese
women completely cover their heads with muslin.
Northern China, sun-drenched in winter and stormy
in summer, is often swept by storms. For several years,
very strict regulations have led to a dramatic reduction
in pollution, although there is still much left to do.

**140. Gate of a fortified Hakka house
in southern Fujian, 1996.**
The circular or square Hakka houses, built from large
adobe bricks, can shelter as many as one hundred families
at the same time, forming a clan. At night, the single
door is closed and guarded. Inside, all the residences
open onto a central courtyard, where the whole clan
lives together. The Hakka continue to build and inhabit
these fortresses. At the beginning of the nineteenth
century, this area within Guangdong Province was the
origin of a substantial part of the Chinese diaspora.

**141. Wooden houses in Baxie in Dong country
(Guangxi Zhuangzu), 1989.**
Don houses may be six stories tall. Built according to
sacred rules of architecture, without nails, lashing,
mortice, and tenon joints, they rest directly on the
ground, without foundations, on simple slabs of stone.
Their tenants, seen on the balconies and at the windows,
agreed to pose only after long discussions, in which the
interpreter, the village schoolteacher, had to intervene.

142. Same location.
Every year, Dong women weave strips of cotton almost
165 feet (50 m) long, intended for making traditional
costumes for the entire family. Six months' work is
required to complete the fourteen steps necessary to
produce this cloth, which will be beaten and lacquered.

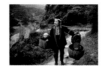

**143. Mother and her children in Dong country
near Baxie (Guangxi Zhuangzu), 1989.**
This young woman, who is singing educational songs to
her two children, is coming back to her village, returning
from the "Bridge of Rain and Wind," seen here in the back-
ground, and which the village men are repairing. There
are forty-four kinds of songs in Dong country, each with its
own strict musical rules. Learning these songs takes place
in three cycles of six years and lasts until the age of twenty.

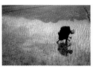

144. Same location.
The planting of the rice crop takes place twice a year.
Here, a grandmother plants the rice, singing educational
songs, as she carries her grandson on her back.

145. Same location.
In Dong country, on the day of the festival of the
Hundred Marriages, just after New Year's, the principal
dowry of the bride is a pig painted in its own blood.

**146. Summit of the Yellow Mountain
in Dong country (Guizhou), 1990.**
In every Dong village a "buffalo-king" is raised. This
animal incarnates the village's honor. Every year at
the beginning of autumn, all the villages bring their
buffaloes to the summit of the Yellow Mountain to
fight. Here, just before combat, the animal is paraded
around men playing mouth organs and carrying red
flags. These banners, symbols of the village's honor, will
be carried off by the winners at the end of the fight.

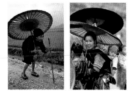

147. Elderly woman near Nanning (Guangxi), 1989.
This quite elderly woman, with a hunched-over
back from rice picking, is going to visit her daughter
in the neighboring village. In a red cloth in her
hand she carries all that is precious to her.

**148. Annual Great Feast of the Dong
at Fulu (Guangxi Zhuangzu), 1990.**
On the third day of the third lunar month, the annual
Great Feast of the Dong is held and assembles 200,000
people for a week. This woman of the neighboring Miao
people, with an oiled-paper umbrella, has walked 18 miles
(30 km) through the mountains for the celebrations.

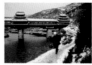

**149. Bridge of Rain and Wind in Baxie
(Guangxi Zhuangzu), 1990.**
Nine days after the New Year, this young Dong woman takes
sticky rice dyed red or yellow to her father in a basket of
finely woven bamboo. This is an ancient custom common
throughout China, which illustrates the place held by par-
ents in the hearts of all the women who leave their families
when they marry to live with their husband's relatives.

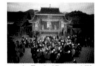

150. Hani farm near Yuanyang (Yunnan), 1993.
Apu, very proud to have been going to school for two
years, is the grandson of the Great Dragon wizard, whose
buffalo, "Immense Knowledge," he looks after. "Immense
Knowledge" has just brought Great Dragon home alone,
as Great Dragon slept on his back. Apu is getting ready to
rub the animal down with moistened rice straw to keep his
skin from cracking before putting food into his trough.

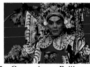

151. Dong opera in Baxie (Guangxi Zhuangzu), 1990.
The covered stage of the opera is located on the main
square, as in all Dong villages, across from the Drum
Tower. Every winter the young men and women who
want to get married write a new opera. In the springtime,
they leave to perform it from village to village in
search of a kindred soul. Before marrying, the lovers
must sing love songs to each other every day in the
presence of their relatives for five years, so that they can
verify the harmony of the couple they are forming.

152. Opera singer, Beijing, 1999.
The singers in classical Chinese opera, which is extremely
theatrical, are characterized in a very strict fashion by
their costume and makeup. Here, we see a warrior called a
wusheng, recognizable by the flags he carries on his back.

153. Yue opera in Ningbo (Zhejiang), 1996.
The actresses, who are leaving the stage, have played male roles. In Zhejiang, the women revived the tradition of this kind of opera after forty years of prohibition. Previously, all the roles were played by male actors.

154. Beijing, opera singer, 1999.
The faces of some actors in classical Chinese opera may also be entirely painted, for example, in flat white with black lines representing wrinkles, or on the other hand in bright colors. Every category of character is so stereotyped that it is played by specialized actors.

155. Hani funeral near Yuanyang (Yunnan), 1993.
The Great Dragon wizard, his head covered with a dragon mask made from papier-mâché, performs a ritual dance before a table set in front of the house of the deceased. At its foot is the head of the buffalo that belonged to the deceased upon which a bowl of rice and a bottle of rice wine have been placed. The animal was beheaded by the Great Dragon away from the village, and will be buried with its owner.

156. Christian burial on Pingtan Island (Fujian), 1996.
The southern coast of China is where the greatest number of Christian communities has been found since the arrival of the Jesuits in China at the beginning of the seventeenth century. In China, white is the color of mourning. Two women carry a photograph of the deceased. Behind them, under a banner bearing the Christian cross, preceded by an orchestra, family and friends march along.

157. Taoist monk of the Wudang Mountains (Hubei), 2001.
The praying Taoist monk just placed incense sticks in the bronze urn on the stone promontory shaped like a dragon head pointed toward the Golden Peak of the Nanyan monastery. According to legend, a monk in the Wudang Mountains wrote the book of the Tao. Five thousand years ago Prince Tai lived here for more than forty years in order to meditate and practice the martial arts. From this spot he leapt into the abyss to save a beautiful young woman, who in vain attempted to seduce him and stop him from meditating, and pretended to jump. During his fall, five dragons bore the prince to the Golden Peak.

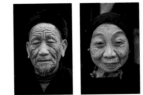

158. Elderly fisherman near Wenling (Zhejiang), 1996.

159. Elderly Dong woman near Baxie (Guangxi Zhuangzu), 1990.

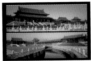

160. Wumen Gate in the Forbidden City, Beijing, 2001.
To enter the Imperial City, which was forbidden to commoners, you have to go through the Tiananmen Gate, the Wumen Meridian Gate, and cross the marble bridges of Jinshui Moat (Stream of Golden Waters). Inside stands the Taihe, Gate of Supreme Harmony, where the emperor came to hear his ministers and grant audiences during the Ming and Qing dynasties. The Forbidden City is the most popular monument in China. Thousands of Chinese families rush through it all year, as if on a pilgrimage.

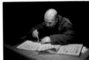

161. Buddhist monk in Suzhou (Jiangsu), 1985.
The calligraphy, representing prayers and prophecies made by this monk in a large notebook of rice paper, are destined for pilgrims who request them, in return for an offering. They are supposed to bring luck and happiness to those who receive them. The photograph does not show the row of soldiers surrounding the temple, preventing the faithful, who came in great numbers on this day of the feast of lanterns, from entering. Today, both Buddhist pagodas and Taoist temples are completely open, carefully maintained, and filled with worshipers of all ages. New religious buildings are springing up to accommodate interest throughout the country.

162. Interior of the Forbidden City in Beijing before its renovation, 1987.
The Forbidden City is now the most visited place in China. Every day, arriving from the four corners of the world, the crowd hurries to discover the treasures of the Imperial past. This heritage, which was forbidden to the people for so long, is now being reclaimed. Since the time this photograph was taken the buildings have been completely restored, and the gigantic columns have regained their original brilliance.

163. Taoist ceremony at the Monastery of the Empyrean Purple in the Wudang Mountains (Hubei), 2001.
The three nuns, dressed in ritual costumes of embroidered silk, bow in the Taoist manner before the effigy of the Jade Emperor and the "True Warrior." To the left, three monks stand in front of an altar upon which percussion instruments and a mouth organ are placed. These members of religious orders commemorate the birth of Prince Tai, whom the Jade Emperor named "The True Warrior," the guardian of the north of heaven. This ceremony takes place on the third day of the third lunar month. Every year these festivals attract more than five million pilgrims to the mountains.

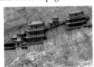

164. Hanging Buddhist monastery of Xuankong Si in Hengshan (Shanxi), 1988.
Located 40 miles (65 km) southeast of Datong, the monastery of Xuangkong Si clings to the cliff of the Jinlong Gorges at a dizzying height. The wooden buildings of the sixth-century monastery are linked by bridges and catwalks. Inside are many bronze and stone statues. Among them, in the temple called "Temple of the Three Religions," statues of Lao-tzu, Confucius, and Buddha are displayed side by side.

165. Construction of a new Buddhist temple in Ningbo (Zhejiang), 1996.
Financed by a billionaire of the diaspora to replace an ancient building destroyed in the 1950s, this immense Buddhist temple bears witness to the keen interest the Chinese have for this great rediscovered religion of Salvation. Just as the photograph was taken, the monk began to weep, moved by having found a place of worship once again after being deprived of one for so many years. In the foreground, the statue of the Bodhisattva Guanyin is almost 20 feet (6 m) high.

166. Great Temple of Confucius at Qu Fu (Shandong), 1994.
This disciple of Confucius prepares to strike a gigantic ritual drum in front of the huge columns of stone decorated with dragons, at the place where, according to tradition, the master philosopher uttered his teaching to three thousand disciples under an apricot tree. On this day, the date of his birth, considered to be a national holiday until 1911, ceremonies rehabilitating the great sage after eighty years of prohibition took place in the village of his birth.

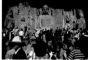

167. Buddha Vairocana at Longmen (Henan), 1998.
Longmen is one of the oldest Buddhist sites in China. Since the Northern Wei dynasty (AD 494), its cliffs have been sculpted and dug with more then 1,300 grottoes. This unique sanctuary, containing 97,000 statues representing the entire Buddhist pantheon, is often visited by the Chinese. The great Cosmic Buddha Vairocana, seated in the lotus position, is almost 33 feet (10 m) high.

168. Taoist monastery on the Yellow Mountain in Yun'an (Shaanxi), 1998.
The monk, with his kind smile, bids a friendly goodbye to the visitor, as if he wanted to thank him for having made the effort to climb up to this little monastery overhanging the city of Yun'an. It was here that Mao Tse-tung set up his headquarters in a cave at the end of the Long March.

169. Tibetan prayer flags in the Ganzi district (Sichuan), 2000.
The monasteries of Kham—an ancient Tibetan kingdom where the religious traditions of Buddhist Lamaism have again become extremely strong—are often surrounded, as here, with a regular forest of prayer flags. These cultural ornaments have mantras written on them. The ritual formulas, characteristic of Tibetan Lamaism, are repeated over and over by the monks. The good words that they contain are supposed to be spread by the wind to the four corners of the world.

170. Buddhist school in the Ganzi district (Sichuan), 2000.
Amidst clouds of incense pouring out of a bronze jar in the middle of a courtyard decorated with multicolored plastic flowers, novices absorbed in prayer listen fervently to a sermon by a great Lama—not seen here—who delivers his sermon by microphone from his quarters located on the fourth floor of the building. One third of the male population of the ancient kingdom of Kham have joined religious orders since the monasteries of the region were rebuilt at the end of the 1980s.

171. Sculpted cliffs at Dazu Xian (Chongqing), 1998.
This gigantic representation of the Wheel of the Law, a symbol of Buddhist teaching, is one of the most famous polychrome Buddhist sculptures at this site. Located 93 miles (150 km) northeast of Chongqing, the creation of this group took place nearly seventy years, around AD 1200. It is said that Chou En-lai personally ordered the Red Guard to spare it during the Cultural Revolution. The largest piece at Baoding Shan is a reclining Buddha 102 feet (31 m) long and more than 16½ feet (5 m) high.

172. Young Taoist martial arts master at the Monastery of the Empyrean Purple in the Wudang Mountains (Hubei), 2001.
Balancing on a stone guardrail, the Taoist monk, Little Zhong, assumes a defensive posture, although he looks as if he is about to leap. He has been one of the disciples of Grandmaster Zhong for twelve years. Grandmaster Zhong officiates in the Temple of the Empyrean Purple, carrying on the teaching of Zhang Sanfong, the Taoist monk considered in China to be the founder of the "internal" style of martial arts. Since this photograph was taken, this monk has left his temple to teach the "internal" style of martial arts in cities like Shenzhen and Shanghai.

173. Taoist monk opening the gates of the Monastery of the Empyrean Purple in the Wudang Mountains (Hubei), 2001.
The gate forms the symbol of the great principle of order, Yin and Yang, the very essence of Taoist thought. The monk is one of the most skilled adepts in "internal" martial arts in China. According to tradition, the book of the Tao was written near the Monastery of the Empyrean Purple by the monastery's caretaker to whom Lao-tzu, "seated on the mythical buffalo which bore him to the West," is supposed to have dictated the five thousand characters of the *Book of the Way and of Virtue*.

174. Itinerant Taoist monk on a pilgrimage in the Wudang Mountains (Hubei), 2001.
Some sixty hermits live in these mountains, where they meditate in harmony with nature, like this one seated on a rock in the middle of a torrent. This monk carries a dragon-headed staff, and nothing else besides the little black bag marked with the Yin and Yang symbol, in which he keeps the Book of the Tao and a few personal belongings. At the time this photograph was taken, he had been walking through China for fifteen years retelling stories and Taoist legends.

175. Taoist monk and martial arts master at the Monastery of the Empyrean Purple (Hubei), 2001.
This martial arts master, a disciple of Grandmaster Zhong, is stretching to prepare for combat. Every year, the Taoist school of "internal" martial arts (martial arts based on defense) meets the Buddhist school of "external" martial arts (based on offense) from Shaolin. In 2001, the winner was Wudang, which carried the day with five wins, with just one victory for Shaolin.

176. Corridor in the Summer Palace in Beijing, 1998.
Along Lake Kunming, located 12 miles (20 km) from Tiananmen Square, three sweepers bustle about early in the morning just before this park opened to the public. The Changlang, a covered gallery 2,300 feet (700 m) long decorated with mythological paintings, is located on the northern edge of the lake in the summer residence of the last Chinese emperors. The Park of the Summer Palace is now a favorite walking place for residents of Beijing.

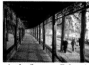

From left to right and top to bottom:

177. Park of the Birds in Beijing, 1991.
Escaping Beijing's summer humidity, these strollers gladly come to sit and sing opera arias under this covered gallery, where the lake is visible on both sides. The lake served as a point of departure for the Imperial Grand Canal linking Beijing and Hangzhou. In China, it is customary to roll up pant legs like a pair of shorts when it is hot.

178. Humble Administrator's garden in Suzhou (Jiangsu), 1999.
Created at the beginning of the sixteenth century and extending over more than 12 acres (5 ha), this garden, the most famous in China, also houses a teahouse and museum. Here the principles of the Chinese art of gardening are explained. The art is based on a subtle mixture of chaos and harmony that always joins four elements: water, stone, plants, and architecture. In spring, pollen and catkins settle on the lakes and the flowerbeds, sprinkling small white spots over the entire countryside.

179. Garden of Harmonious Pleasures in the Summer Palace, Beijing, 2000.
This elegant wooden pavilion, which is reflected in Lotus Lake, was a place of refuge for the court's scholars; they came to enjoy themselves in the refined pleasures of the arts of calligraphy, music, and poetry. The Garden of Harmonious Pleasures is one of the most typical examples of the garden aesthetics of northern China.

180. Hall of Thirty-six Mandarin Ducks in the Humble Administrator's garden in Suzhou (Jiangsu), 2000.
The caretaker takes a little nap against the grid work. Here we see a body of water and pavilion on the shore used for rest and meditation that the master of the place had built five centuries ago. This park, in which architecture, rocks, trees, bushes, flowers, and water work together harmoniously, also known as the "Garden of the Policy of Medicinal Herbs," is one of the most famous in Suzhou, and in all of China. It was designed and constructed at the beginning of the sixteenth century and covers more than 12 acres (5 ha).

181. Terraced rice paddies near Shaoxin (Guizhou), 1989.
In Dong houses, the second-floor balcony, which opens on the main room, always faces south. The cotton, which this young woman has hung out to dry, will be used during the winter to weave clothing for her family. The melancholy look of this young Dong woman as she contemplates the autumnal landscape is the result of the difficulties she was having in finding a husband. According to her family, she did not sing well enough to attract a young man.

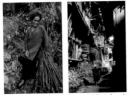
182. Bouye woman near Shitoucai (Guizhou), 1986.
Resting along the road is certainly understandable when you are carrying two such enormous bundles of wood balanced on a shoulder pole. Some embarrassment shows in this woman's expression. She wears the blue-and-white batik turban characteristic of her ethnic group, the Bouye minority. This is the first time that she had ever been photographed or encountered a Westerner.

183. Alley in Sanlidong (Guizhou), 1990.
In this dark and narrow alley, where the houses lean closer together as they rise until they touch at roof level, a Dong farmer brings vegetables from her garden back to her house. All Dong villages are veritable labyrinths of alleys, paved with large stones, bordered with tall wooden houses, where the light of day can hardly shine through.

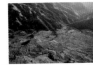
184. Terraced rice paddies in Yuanyang (Yunnan), 1993.
This photograph was taken in the springtime, when the rice paddies have not yet been flooded because the shoots of rice were not yet planted. With every season, and with every new perspective, the landscape changes. One month later these terraces, cut into the mountainside by the farmers, will be a lush green. In the foreground to the left, at the top of the hill, we see a rice barn that was built in the middle of the rice paddy for storing tools and for taking a nap after eating.

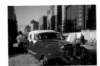
185. Reconstruction of Wangfujing Avenue in Beijing, 2000.
In this street commonly called the Chinese Champs Élysées, the countless buildings spur on a dizzying allure, like everywhere in China. There's a neverending limousine, a red convertible made in China, to be hired out for weddings and festivities across the country.

186. Beach number one at Qingdao during the first paid vacations in China, 1987.
In the eyes of this little girl, an only child, all the uncertainties about the radical changes that she could see taking place around her in China are visible. The first paid vacations in 1987 mark the beginning of domestic tourism, which allowed many Chinese to rediscover the natural and cultural heritage of their country.

187. Two elderly Beijing residents, 1986.
The photographer triggers the cheerful mockery of his subjects. The elderly, who are still the object of great respect in China, often sat in the streets to keep an eye on what was happening before going to give their daily report to the person in charge of the neighborhood.

188. Gathering of Hani women at Yuanyang (Yunnan), 1993.
Arriving from all the Hani villages, these women wearing wool turbans topped with bamboo hats have gathered together to help build new rice paddies, cut into the mountainside, which will be given to young newlyweds. The sight of a foreigner explains the shock visible on some of their faces.

189. Park of the Temple of the Heavens in Beijing, 1999.
The practice of Tai Chi Chuan and dancing with red fans are a common sight early in the morning in parks in Chinese cities, in squares, and along major thoroughfares. A large gathering of a sports club took place this day in the park of the Temple of the Heavens in Beijing; it had been widely advertised the night before on television.

190. Marriage near Ansai (Shaanxi), 1998.
This young woman just learned that her future husband has been slightly injured riding his motorcycle on the way to the wedding. The amount of her dowry had been negotiated between the families, without her having had anything to say about this arranged marriage. Behind her under the character *Xi,* or "double happiness," the groom's family sits. They live in a cave dwelling dug into the loess, whose interior has been decorated for the wedding.

191. The painter Fang Lijun in Dongxian near Beijing, 1998.
This painter, born in Hebei in 1963, is currently one of the most sought-after on the international art market. Dongxian has become an important arts center, home to an increasing number of artists and sculptors. For a decade or so, contemporary Chinese art has enjoyed great success in the United States, Europe, and Japan.

192. Street scene in Chongqing, 1998.
The farmers, who have come to the city to sell their labor, can eat a bowl of rice and vegetables topped with pork fat for one yuan ($0.15). Millions of workers, pouring in from the poverty-stricken countryside, are employed on the innumerable construction sites that are rapidly transforming the country's urban landscape. Today, the city-province of Chongqing has some 40 million inhabitants.

193. Restaurant in Chongqing, 1997.
A beauty pageant has been organized in the immense dining room of this popular Sichuan hotpot restaurant. The hotpot, heated by gas, is set in the center of the round table. In it the diners boil vegetables, meat, mushrooms, fish, and shellfish. Sichuan cuisine is one of the most highly spiced in the world.

194. Crossroads in Guangzhou, 1995.
This small green space has been set up in Guangzhou at the foot of a billboard that sings the praises of Deng Xiaoping. Present-day China owes its modernization to this great historic leader who died in 1997. His portrait is accompanied by the slogan: "Let us go forward for a thousand years on the road to modernization mapped out by Deng Xiaoping."

**195. Young woman in a fishing village
in the province of Zhejiang, 1996.**
This young woman mending fishing nets was caught
going about her everyday life in this poor village in
the south of the province of Zhejiang. Wearing a short
leather jacket and carefully made-up, she exemplifies
the generation gap, increasingly visible in China since
the country has begun to experience globalization.

**196. Dancers in the Park of the Temple of the Heavens
in Beijing, 1994.**
In order to set the stage for what the people call a "good-
humored day," all kinds of dancing—rock, cha-cha, tango,
waltz—are practiced in the morning in parks, as are
martial arts and impromptu calligraphy, while sitting on
the ground. Here, two retirees do a rock-and-roll step.

197. Family shop in Chongqing, 1997.
In this minute space, which is really the front hall of their
house, three generations of women (grandmother, mother,
and daughter) sell a few necessities, as well as use of a
telephone. Such commerce was forbidden until the begin-
ning of the 1980s. Today, anyone can set up shop at home as
a storekeeper, restaurateur, hairdresser, tailor, or scribe.

198. Clothing market in Chengdu (Sichuan), 1988.
In 1983, open markets, to which the Chinese have always
been profoundly attached, were tolerated once again, at
the same time as women were allowed to display a certain
amount of stylishness in their dress. Here, in the capital of
Sichuan, jeans have already replaced the Mao costume.

199. Young woman in Shanghai, 2001.
In 2003, China celebrated its hundred-millionth cell phone
customer. It is common in the upper classes, to which this
well-connected woman obviously belongs, to have two
phones: one for work and the other for personal use. A car
costs more in China than it does elsewhere. Ownership of
a cell phone, often decorated with jewels, flashing lights,
or fluorescent holograms, has become a symbol of social
success. In a country that has gone directly to the cell
phone, a stationary telephone remains the exception.

200. Tea shop on Wangfujing Street, Beijing, 1998.
Now similar to its counterparts in the great cities of
the world, Wangfujing Street, famous for its luxury
boutiques, is the main commercial thoroughfare
in Beijing. It was restricted to pedestrians in 2000.
In the refined setting of this store, teas are sold as if
they were perfume or top-of-the-line cosmetics.

201. Yinchuan Street in Ningxia Huizu, 2002.
Men playing checkers on the ground, in front of a
department store's luxurious display. The Chinese
passion for games and gambling, which makes
them play in the most unexpected places without
the least embarrassment, always astonishes the
Westerner traveling in China for the first time.

202. Beijing, 1998.
The bicycle is still the most common means of transporta-
tion in the capital, even in the middle of the Beijing's traffic
jams. This father is taking his only son, tenderly asleep
against his back, to go for a walk in the Forbidden City.

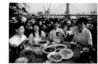

**203. Outdoor restaurants on the banks
of the River of Pearls in Guangzhou, 1995.**
Before opening for the day, the waiters in an outdoor
restaurant with more than three thousand tables are
seated around Cantonese specialties: spinach, steamed
fish, boiled pork, and duck with beans. Spontaneously,
as is common in China, they invite "the good old
foreign friend" to toast in order to celebrate "the new
friendship between all the peoples of the world."

204. Skyscraper in Pudong in Shanghai, 2001.
From the top of the 54th floor of a hotel that has 36, a pan-
orama worthy of science fiction is visible, illustrating how
large Chinese cities are now becoming. Chinese authori-
ties want to make Pudong the Manhattan of tomorrow.

**Page 8. A giant panda in training for a
circus number at the Beijing zoo, 1985;
Temple of a Thousand Buddhas (Sichuan), 1987.**
As in many Buddhist monasteries, they close their eyes
at more than 50 feet (15 m) and walk to try to invoke from
their hand the character *Fu*: happiness, luck, wealth.

**Page 12. At the foot of the sacred Taoist
mountains of Wudang (Hubei), 2001.**
Mrs. Li, in her tiny temple at the foot of the mountain,
is revered as the oldest Chinese person at the age of 138,
between the reality and legend of Taoist immortality.
She says, "To live a long life, you must shun vanity, eat
garden vegetables, and drink spring water;" Beijing,
1986. In the Temple of the Sky, a guard plays Frisbee.

Page 14. Beijing, 1985.
At the start of the open markets, where anything is
possible, Japanese household electronic appliances
become the dream of all Chinese families; Datong
(Shanxi), 1988. A joiner cheerfully delivers a wardrobe
on his tricycle in front of one of the doors shaped
like a pagoda from the city's ancient fortifications.

Page 19. In Baxie, Dong country (Guangxi), 1990.
A man playing a bamboo mouth organ, a *lusheng*,
is preparing for the contests between village.
Guizhou, 1986.
During a series of portraits in front of a background
painted by "Kaltex" artists, a farmer spontaneously just
showed off a ten-yuan (one-dollar) bill like a dream and
a protest sent out to the world and at his own future.

For all use of images and information:
Yannlayma.com or yanlei.com

ACKNOWLEDGMENTS

To my mother, Michèle, who gave me so much love, a passion for the arts, for color, for light, and so many other things. She always encouraged me to discover the world and to open myself to others while she maintained a haven of peace and harmony.

To my father, Jean-Pierre, for teaching me honesty, respect for others, love for work well done, and a passion for beautiful things.

To my whole family, an internal refuge: my sister Claire Layma, my grandparents Georgette and René Triste, and my uncle Alain Triste.

To Paul Berger, a great master, who found in me a disciple to transmit his knowledge and a passion for an art of observation: entomology. Thanks to his patience, I learned to love learning with my eyes, in nature, building a way of seeing step-by-step.

To Dr. Yves Le Floch, a marvelous spiritual father, for all those beautiful and fundamental conversations; for having taught me the basics of photography at a decisive moment and for having looked after me so graciously all my life.

To Serge Renard, who taught me the duty and passion of travel.

To Catherine Zittoun, for the great comfort of her friendship, her invaluable help, and her enlightened advice.

A great thanks to Emmanuel Transon, who was able to help me by offering me the gift of his remarkable eye and who came to guide my artistic direction and organize twenty-two years of work with the necessary wisdom and perspective, displaying a rare and profound humanism at the right time.

To Frédéric and Nathalie Fougea for their friendship. They encouraged me to direct, and they themselves produced my first film that bore a passion in me and gave me new horizons.

To my great friends who have always been able to share the moments of joy while offering a solid shoulder and invaluable assistance during difficult times: to the super Véronique Béranger, to the super Jérôme Cecil Auffret, Jean-Pierre and Sabine Filiu, Simon Pradinas and Zhu Xiaoling, Anita Bonan, Andy and Christine Friend, Jean-Marc Fiess, Dominique Gentil, Na Risong, Joris Ivens and Marceline Loridan, Great Dragon, Serge Dumont, Géraldine Rodier, Tao Ran, Philippe Bonan, Yan Méot, Laurence Guillain, Liu Jiaxiang, Beni Ortiz, Laurence Derimey, Corinne Thorillon, Laurent Despont, Chen Haiwen, Claire and Bruno Fulda, Ju Yi, Jeanne Estager, Jan Duclos Maïm, Basile Ader, Sonia Dona Perez, Catherine Roy, Phoenix Varbanof Song, Liu Zilong, Liu Qian, Anne-Marie Ader, Pierre Bailet, Laurent Béranger, Lilia and Barthelemy Fougea, Stéphanie Olivier, Nathalie Duclos, Anne-Marie Paquet, Chen Chenhuang, Master Zhong, Anne Loussouarn, Quentin Descourt, Sylvie Levey, Ma Liwen, Thomas Doubliet, Lionel Perez, Michel Fessler, Yves Sieur, Philippe Lesprit, Paul Frèches.

To my extraordinary companions on the road: Anne Georget, Pascal Dupont, Simon Pradinas, Florence Delva, Richard Poisson, Soizic Arsal and Willy Pierre, Tao Ran, Andy Friend, Jean-Pierre Filiu, Frédéric Laffont, Pierre Gaillard, Maurice Soutif, José Frèches, Lucien Bodard, Laurent Ballouhey, Elisabeth D., Olivier Bergeron, Pierre Pradinas, Na Risong, Liu Jiaxiang, Helena Novakova.

To my two spiritual mothers, who have been able to encourage and help educate a beginning photographer with love, Franca Speranza and Rose Marie Wheeler-Tuohy.

To my photographer friends, who with magical meetings and moments have by their support, their ability to listen and their good advice opened the doors that allow us to go farther: Yann Arthus-Bertrand, Raymond Depardon, Steve McCurry, Pascal Maître, Marc Riboud, Raghubir Singh, Wang Miao, Robert Van der Hilst, Hans Sylvester, Leong Katai, Stephane Lagoutte, Philippe Bourseiller, Robert Doisneau, René Bun, Li Yuxiang, Roland and Sabrina Michaud, Abbas, Peter Menzel, Josef Koudelka, Michel Setboun, Bruno Barbey, Philippe Laffont, Raphael Gaillarde, Xavier Zimbardo, François Lochon, Jean-Luc Manaud, Pierre de Vallombreuse, Olivier Föllmi, Harry Rossner, Gilles Rigoulet, Catherine Henriette, Zeng Nian, Alain Buu, Adian Bradshaw, Zhu Hongning, Alain Evrard, Yves Gellie.

To GEO magazine for having started my vocation, and particularly to Robert Fiess, Yan Méot, Jean-Luc Marty, Sylvie Rebbot, Danielle Casseau, Nicolette Lemaire, Christine Laviolette, Christianne Breustaedt, Ruth Eichhorn, Duck Il Li, Sujong Song, Mercedes Velasquez, Akiko Hirota.

And to all those who have brought my passion to life: Pascal Bessaoud, of Figaro Magazine with Marie-Sylvie Demarest and Wanda Shmollgrueber, Claudine Maugendre and Alain Bizot of Actuel, Odile Domalin, Emmanuel Transon, and Yan Méot of Grands Reportages, Brigitte Huard of Ça m'intéresse, Didier Rapaud, Roger Théron, and Marc Brincourt of Paris Match, Michel Philippot of Monde 2, Natacha Chassagne and Frédérique d'Anglejean of VSD, Kent Kobersteen of National Geographic, Cathy Ryan of The New York Times, Michael Rand and Suzanne Hodgaert of the London Sunday Times, Benni Ortiz and Chema Conessa of El Mundo, Volker Lensch, Harald Menk, and Frank Mueller-May of Stern, Eva Ohms of Merian, Jean Jaques Naudet and Eric Colmet Daâge of Photo.

For the warm reception by the agencies that distribute my images: to Michel Buntz of Explorer at Pêcheur d'Images, to my great friend Véronique Béranger of Explorer at Getty, Regina Anzenberger, Dominique Charlet of Getty, Olivier Binst of Planet, Freddy Wulff of Lobo Press, Heidi Johansson of INA, and especially to Marc Grosset, who first encouraged me, and Sylvie Languin in the days of La Compagnie des Reporters.

To Patricia Tartour and to Fabienne Leriche of La Maison de la Chine, who with kind friendship from the beginning have always helped and encouraged me. Thanks also to their whole staff.

To Madame Valérie Terranova, Representative for the President of the French Republic, as well as to the Comité des années croisées France-China: Alain Lombard, Sonia Zillhardt, Daniel Blaise, Bruno Delaye, and Mr. Pu Tong.

To Dr. William de Carvalho, without whom this book may never have happened.

To the French diplomats in China, to whom I owe a great deal: Paul Jean-Ortiz, Claude Hudelot, Jean-Claude Thivol, Nicolas Chapuis, Daniel Blaise, Philippe Doillon, Bruno Gensburger.

To Mr. Tian Qingmin, who was able, with his kindness and understanding, to come to terms with China; to Mrs. Li Beifen, Mr. Shi Guanggen, Mr. Jin Chunlei of the Office of Information of the Chinese Ministry of Foreign Affairs, who have helped me so greatly to live in harmony with my passion.

To Hervé de La Martinière, who again showed that he knows better than anyone else how to rekindle hope for photographers by opening up new horizons.

To Benoit Nacci of Éditions de La Martinière, "a great heart with an exceptional eye," for his great understanding, his enlightened opinions that make him the great master of photography books, and his many other virtues.

To the whole staff of Éditions de La Martinière: Valérie Nacci-Roland, Willy Persello, Céline Moulard, Sophie Giraud, Sylvia Leuthenmayr, Marianne Lassandro.

To Jean-François Leroy and Cédric Kervich of the international photojournalism festival "Visa for the Image" in Perpignan, France.

To Jean-Pierre Hamadache, Michel Hellert, Gaël Gouinguéné, and the entire staff of Leica France.

To Fujifilm, especially Bruno Baudry, for their support.

To the Association of Chinese Photographers, most especially to Lu Houming, Yu jian, Liu Bang, Ren Shugao, Sun Yanchong.

To François Mitterrand, who by opening the doors of the Presidency of the French Republic to me in 1984 contributed to the start of my career.

To all those who, one day, helped me so that the road was good to me, the memory of their kindness remains forever in my heart.

The calligraphy on page 6 was created by Laurent Long.
The map of China was created by Alain Cazalis and Izumi Mattéi-Cazalis.

Project Manager, English-language edition: Susan Richmond and Magali Veillon
Editor, English-language edition: Lenora Ammon
Jacket design, English-language edition: Shawn Dahl
Designer, English-language edition: Shawn Dahl
Production Manager, English-language edition: Jules Thomson
Editorial assistance by Sarah Mann

Library of Congress Cataloging-in-Publication Data
Layma, Yann.
[Chine. English]
China / Yann Layma ; captions by Jose Frèches ; texts by Anne Loussouarn . . .
[et. al] ; translated from the French by Jack Hawkes.
p. cm.
Includes bibliographical references and index.
ISBN 978-0-8109-4669-9 (original hardcover edition)
ISBN 978-0=8109-7091-5 (reduced-size paperback edition)
1. China—Pictorial works. I. Frèches, José. II. Loussouarn, Anne.
III. Hawkes, Jack. IV. Title.
DS706.L3713 2003
951.06—dc21
2003013681

Original hardcover edition published in 2003.

Printed and bound in Italy
10 9 8 7 6 5 4 3 2 1

HNA ▌▌▌▌▌
harry n. abrams, inc.
a subsidiary of La Martinière Groupe

115 West 18th Street
New York, NY 10011
www.hnabooks.com